MOBILE & HAVANA:
SISTERS ACROSS THE GULF

MOBILE and HAVANA
SISTERS ACROSS THE GULF

JOHN S. SLEDGE and ALICIA GARCÍA-SANTANA
PHOTOS by CHIP COOPER and JULIO A. LARRAMENDI

Ciudad de Guatemala, Guatemala
2024

TABLE OF CONTENTS

STORIES OF TWO CITIES / 7

MOBILE AND HAVANA: SISTERS ACROSS THE GULF / 11

ACKNOWLEDGEMENTS / 12

FUNDAMENTALS: HAVAGUANEX, THE EXILE, THE MOUND DWELLERS,
AND DON ALONSO / 14

BEGINNINGS: THE ADELANTADO, THE CACIQUE, AND THE LEGENDARY
DEVOTION OF ISABEL DE BOBADILLA / 25

ESTABLISHMENT: THE FOUNDER, THE PÉLICAN GIRLS,
AND THE PERIPATETIC PRELATE / 39

TWO SIEGES: THE "BLACK PRINCE," THE ENGINEER,
AND THE GENERAL / 55

SHIPS, PEOPLE, AND COMMERCE: FEMALE WRITERS, SEA DOGS,
AND THE DYING POLITICO / 67

WAR GAMES: THE DARING BLOCKADE RUNNERS,
AND THE TOWN BALL BOYS / 85

FEVER DREAMS AND THE FROZEN BOND: THE MARTYR,
THE DOCTORS, THE SCHOONER MEN, "MR. JIMMY,"
THE RUM RUNNERS, AND FIDEL / 97

VISIONARY RENEWAL: THE HISTORY MEN / 113

SOURCES CONSULTED / 127

LA HABANA-MOBILE: THE SHARED HERITAGE / 139

ACKNOWLEDGMENTS / 140

REASONS FOR A BOOK / 142

THE PLACE OF THE ENCOUNTER / 145

HAVANA: THE SPANISH-CREOLE LEGACY / 161

ST. AUGUSTINE, FLORIDA: AN ENCOUNTER BETWEEN SPANISH
AND ENGLISH INFLUENCES / 177

NEW ORLEANS: WHERE FRENCH AND SPANISH MEET / 191

MOBILE: THE CONTRIBUTION FROM THE UNITED STATES / 213

DISSEMINATION OF THE COURTYARD GARDEN HOUSE / 231

SOURCES CONSULTED / 249

Editorial Director: Julio Ángel Larramendi
English editor for John Sledge's text: Lynn Sledge
Design: Joyce Hidalgo-Gato Barreiro
Photographs by: Chip Cooper and Julio Ángel Larramendi
English translation and proofreading of Alicia García-Santana's book: Yvonne López
Cover engravings and chapter headers: *Detail of Plan and View of the City of Mobile*, by Goodwin and Haire, engraved by Robert Tiller, Philadelphia, 1824. Library of Congress, Washington, D.C.; and "Havana, 2nd View Taken from Casa-Blanca" by Federico Mialhe, published in Viaje pintoresco alrededor de la Isla de Cuba, 1847-1849. José Martí National Library of Cuba.
Back cover photographs: Chip Cooper (left) y Julio Ángel Larramendi (right)

© John S. Sledge
© Alicia García Santana
© Chip Cooper {CC}
© Julio Ángel Larramendi {JL}
© This edition: Ediciones Polymita, 2024
 Society Mobile-La Habana, Inc., 2024

Cooper Group of Companies
Mr. Bruce McGowin
Mr. & Mrs. T. J. Potts
Mr. & Mrs. Grey Redditt
Mr. & Mrs. Michael C. Rogers
Mr. & Mrs. Irving Silver

ISBN: 978-9929-667-37-2

Prepress and printing: EGONDI, Artes Gráficas

EDICIONES POLYMITA S.A.
Guatemala City, Guatemala
edicionespolymita@yahoo.com

All rights reserved. No part of this work may be reproduced or transmitted by any means or medium without written permission from the publishers.

STORIES OF TWO CITIES

In memory of Eusebio Leal Spengler (1942-2020)

In the December 6, 1885, issue of *La Habana Elegante*, a magazine "dedicated to the fair sex," it was reported that the young modernist poet Julián del Casal, who had published his first poems in that magazine, was rejoicing at the proximity of a family reunion:

> "Monday was a special day for him because, very early in the morning, he had the pleasure of embracing his charming sister, Carmela del Casal, who comes from Mobile, where she has received a most brilliant education. Carmela is back in Cuba after an absence of five years up North, and her compatriots are now pleased to be able to include her among the cultivated Cuban women who add so much brilliance to our society."[1]

María del Carmen Casal, the future mother of avant-garde Cuban painter Amelia Peláez, had been a boarding school student at the Convent and Academy of the Visitation, a complex of Catholic buildings in the French Renaissance style, located on Spring Hill Avenue. In Julian's letters to his sister, circa 1880, he wrote:

> I was pleasantly impressed when I read your first letter, so well written, in which you describe the emotions that had captivated you in the presence of the mighty Mississippi River. The former shows your rapid progress, and the latter the greatness of your spirit upon beholding the wonders of Creation.... Work hard, dear sister, do not lose heart for a single instant, and aim high, because those who aim at nothing achieve nothing.[2]

Some twenty years earlier than Carmela Casal, in 1864, three young men from Havana also came back home after years studying at Spring Hill College, where they shaped their characters and learned many useful things, including a pastime that was unknown on the island—baseball or "town ball," a game that would eventually become one of the central themes in Cuban nationalist imaginary. Their names were Enrique Porto, Nemesio and Ernesto Guilló. Like them, dozens of young Cuban men and women of the nineteenth and twentieth centuries were sent to the city of Mobile for their education, and returned to Cuba influenced by the cultured and modern spirit of their teachers.

Inspired by that spirit of enlightenment, the authors of this beautiful book, *Mobile and Havana, Sisters Across the Gulf*, have explored with artistic care the rich history of human, economic, cultural, social and political exchanges between Alabama and Cuba, in particular, between the major cities of Mobile and Havana. Historians John S. Sledge and Alicia García-Santana are both scholars who have studied

[1] *La Habana Elegante*, III, no. 49, December 6, 1885, 10

[2] Julián del Casal, *Epistolario*. Transcription, compilation and notes by Leonardo Sarría, La Habana, Editorial UH, 2017, 15-16.

this centuries-long shared relationship, which they know not only because they have learned about it from books, but also because they have traveled to different places and admired the natural and human landscape of both nations; each one of them has intelligently and comprehensively integrated the knowledge of different disciplines into this volume. These texts are complemented by a beautiful collection of photos by Chip Cooper and Julio Larramendi. These pictures are much more than just a graphic storyline—they are the expression of very personal poetics and a profound aesthetic refinement.

John S. Sledge's narration of the happenings and vicissitudes that led a variety of individuals to establish a centuries-old dialogue between the two shores of the Gulf of Mexico reads like a delightful novel. Parading before our eyes, as in a theater of dreams, are Hernando de Soto and his abandoned wife, Isabel de Bobadilla; Pierre Le Moyne d'Iberville, the founder of Mobile, buried in Havana; the British military engineer Elias Durnford; the no less resolute Bernardo de Gálvez; the sophisticated Swedish traveler Fredrika Bremer; the adventurer Harry Maury; the pro-slavery politician Rufus King; the Guilló brothers; José Martí; and other more or less famous military men, writers, merchants, smugglers, journalists and diplomats.

John is a meticulous and highly imaginative writer; his narrative achieves that rare condition of historiography that balances the precision of historical data with the excellence of his writing. Fact and fiction run through these pages with picaresque flair and vivid empathy, as were the lives of his protagonists involved in the whirlwind of voyages of exploration, war conflicts, trade exchanges and existential adventures.

Alicia Garcia-Santana is the most important contemporary historian of Cuban architecture and urbanism, a favorite disciple of the Catalan archaeologist, historian, illustrious professor and enthusiastic restorer Francisco Prat Puig. Alicia's work in the field of urban history boasts a rich and extensive bibliographical production, packed with findings from archives in Europe and the Americas, accompanied by a solid academic work in several countries.

This book is merely a condensed fragment of such a significant work, whose core lies in the presentation of the ways of building and inhabiting urban spaces in the New World, each territory marked by historical and cultural specificities of the process of European conquest/colonization in the Americas.

Havana's splendor, initially as a key port for the Spanish Treasure Fleet and then as an opulent slaveholding metropolis, was a determining factor behind the imposing and unique military, civilian and domestic architecture that still amazes both locals and foreigners alike. The subordinate condition of Spanish Florida on the imperial frontier of the Caribbean Sea, and the very notable French and British influences reveal building typologies and architectural solutions adapted to the vernacular context. Even so, Spanish architectural similarities and features can be found in the cities bordering the

Gulf of Mexico in a valuable example of urban transculturation.

From its ambitious literary vantage point and powerful imagery, this book is an eloquent testimony of shared cultures. Hence, it joins landmarks in Havana that preserve the link in the evolution of the two cities—the bronze sculpture of the courageous Le Moyne d'Iberville, "the greatest hero of New France"; and a plaque in a small park in El Vedado that recalls the presence of the boys who played baseball at Spring Hill College.

The book is also a tribute to two unique beings, both in love with the history and legends of their respective cities: Eusebio Leal Spengler and Prieur Jay Higginbotham, who are remembered with quiet gratitude from the pages of this book—which they foresaw with their admirable work—and who did so much to keep the memory of a common history alive.

<div style="text-align: right;">

Dr. Félix Julio Alfonso-López
Academy of the History of Cuba
September 2023

</div>

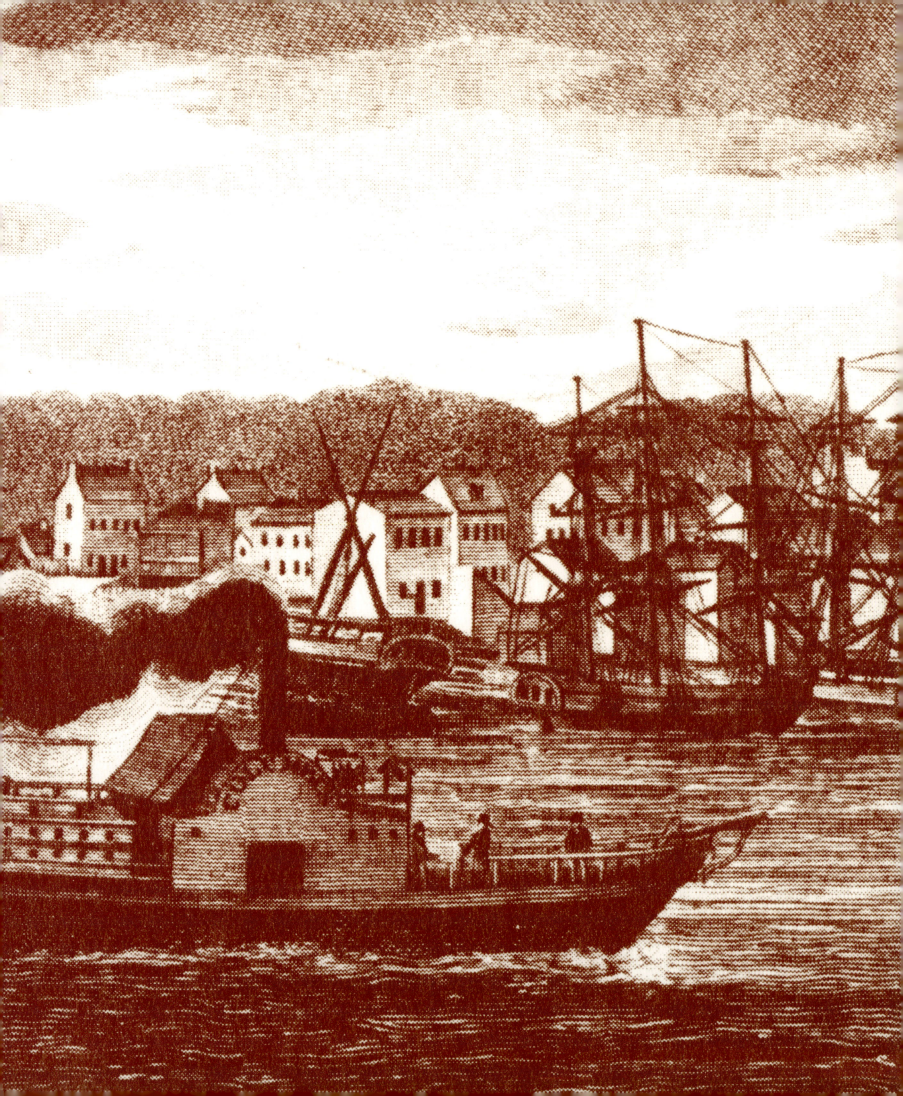

MOBILE AND HAVANA: SISTERS ACROSS THE GULF

John S. Sledge

ACKNOWLEDGEMENTS

First, warm thanks to my co-authors, Chip Cooper, Julio Larramendi Joa, and Alicia García Santana, whose confidence overcame my initial doubt that there was enough material to make this book. How wrong I was! Secondly, I am grateful to the Society Mobile-La Habana and its members including Grey Redditt, Ben Harris III, Maria Mendez, and Giselle Gomez San Roman-McColgan who agreed to sponsor this endeavor, and did everything in their power—from arranging travel details to providing translation assistance—to keep it moving forward. Thirdly, the City of Mobile led by Mayor Sandy Stimpson has been a mainstay. Members of the Mayor's staff including Matt Anderson, George Talbot (since moved on), Katelynn Machado, and Karen Williamson offered numerous services both small and large. Greg Holliday of the Information Technology Department cheerfully resolved several aggravating computer issues along the way. At the Mobile Historic Development Commission, I deeply appreciate the support of Christine Dawson, director, and Bridget Daniel (alas now deceased), Annie Allen, Meredith Wilson, Dana Foster, and Hannon Falls. All of these colleagues expressed interest in the project and graciously tolerated my writerly absent-mindedness.

The team that prepared this book would like to thank Mobile County Commissioner Connie Hudson and her staff for their generous contribution to the production of this book.

In Cuba, many wonderful people helped in numerous ways. They include Sonia Virgen Pérez Mojena, President of the National Council of Cultural Heritage; Magda Resik, Communications Director for Havana's Office of the Historian; and Félix Julio Alfonso López, then dean of San Gerónimo College of Havana. During our 2019 and 2022 Havana trips, Mildred Diaz of Invicta Group Services made the travel go smoothly; Jorge Foyo was a veritable Nostromo (in a word, indispensable); Gladys Collazo, Heritage Director at Havana's Office of the Historian, Director of the Santa Clara College for the Arts of Conservation and Restoration and of the Transcultura Project, provided enviable insider access to several historic properties, including Ernest Hemingway's Finca Vigía and the 17th-century Convent of Santa Clara of Assisi; Yunia and Jimmy Lao of Villa Mía, along with their charming *hija*, Mia, were consummate hosts; and Yamelis Monzón of Havanatur supplied astonishing knowledge and good cheer.

On the Mobile history front, many people were essential, including Director Edward Harkins, Pamela Major, and Tamara Callier of the Mobile Municipal Archives; Bret Heim, Katy Young, and Laura Williamson at the Burke Memorial Library, Spring Hill College; Director Meg Fowler, Nick Beeson, and Chuck Torrey of the History Museum of Mobile; Phillip Jordan of the Alabama Humanities Alliance; and friends Scotty Kirkland, Paula Webb, and Mike Bunn.

As ever, my old literary pals, Eugene LeVert and Roy Hoffman, proved handy sounding boards. Lastly, my family has been wonderful. My mother, Jeanne A. Sledge, read sections as I wrote them and provided valuable comments before her passing in November 2022; my lovely wife, Lynn, edited with a practiced eye; and my children Matthew and Elena expressed interest and encouragement from afar. Needless to say, any errors of fact herein are my own.

Mobile, October 2023

FUNDAMENTALS: HAVAGUANEX, THE EXILE, THE MOUND DWELLERS, AND DON ALONSO

Before there was anything else in either place—people or history or song—there was the sun-warmed sea linking them together. Now, millennia later, the sea links them still. Every second of every day, 80 million gallons of Caribbean water gushes northward through the Yucatán Channel into the Gulf of Mexico, forming a prodigious current 125 miles wide and 2,500 feet deep. Depending on the season and many variables that have to do with Earth's rotation, tides, deep-water upwelling, freshwater inflows, shore currents, temperature, salinity, and surface winds, the so-called Loop Current occasionally approaches and sometimes overtops the Continental Shelf, coming to within just a few miles of Alabama's Mobile Bay. Eddies and gyres break off and spin east or southwest, everywhere the Gulf in constant motion. Meanwhile fresh upcountry river water pushes into Mobile Bay through five channels—the Blakeley, the Apalachee, the Tensaw, the Spanish, and the Mobile—blending with Gulf salt to form a brackish mix. If the rivers are at full flood, the entire bay can flush as fast as every 10 days. Once out in the Gulf, the brack water is relentlessly tossed, tugged, and pushed until the Loop captures it. Writhing, undulating, and jerking like an unattended garden hose at full blast, the Loop whips east and south, scouring down the Florida shelf toward the island of Cuba.

Positioned between the Gulf and the Caribbean, Cuba resembles nothing so much as a crocodile on maps. On its northern side, where the tail begins to narrow, lies Havana Bay, the pocketed waters of which are mostly salt, though the short Luyanó and Martín Pérez Rivers spill into its southern end. Because Havana Bay is so close to the open sea, its water cycles out every seven days where the Gulf Stream sweeps it along with that Mobile Bay water through the Straits of Florida at a phenomenal five miles an hour, one of the world's fastest ocean currents (FIG. 1).

Despite the joining sea, it is doubtful that the first peoples beside these two bays knew of each other's existence. Cuba's gentle Taínos dwelt in round huts called *bohíos* fashioned of palm-tree trunks and fronds, slept in those delightful New World appurtenances *hamacas*, went about naked as the day they were born, and lived off nature's bounty. Six hundred miles to their north the Mobile Indians erected flat-topped earthen mounds, wore animal skins, and darted around their bay in dugout canoes to check their fish traps. Both peoples had their own trade networks, but long-distance, open-water passages were risky. The native people of south Florida visited the Taínos, but those of more distant Mobile Bay almost certainly did not (FIG. 2).

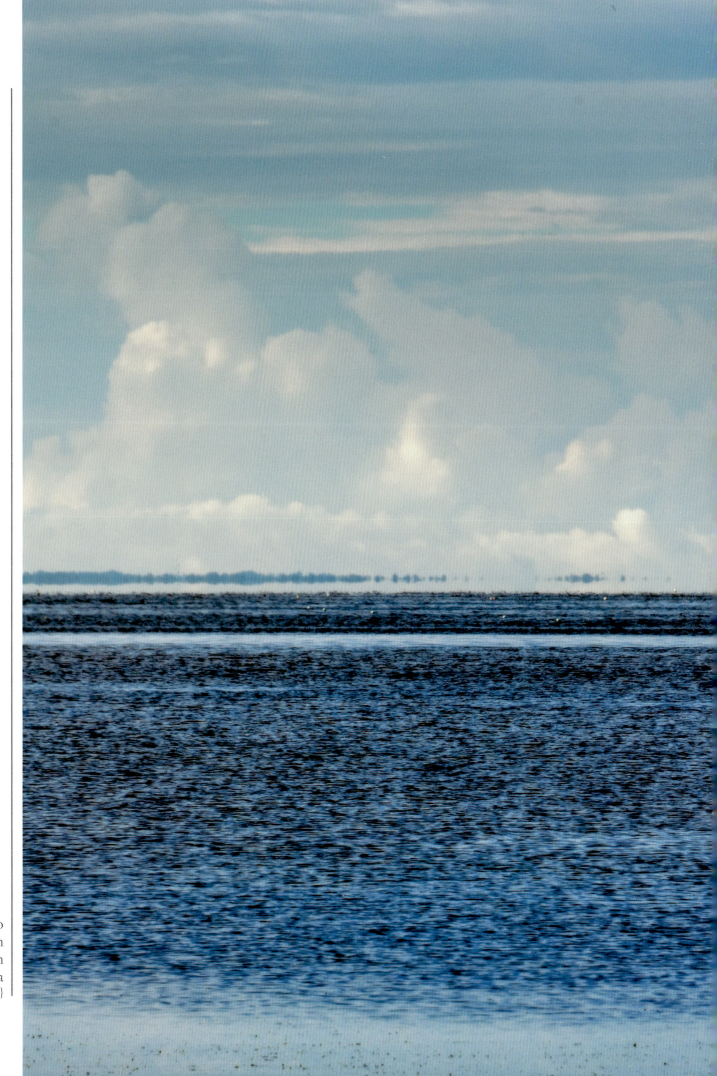

1. The Gulf of Mexico has long offered an inviting route between Mobile and Havana {CC}

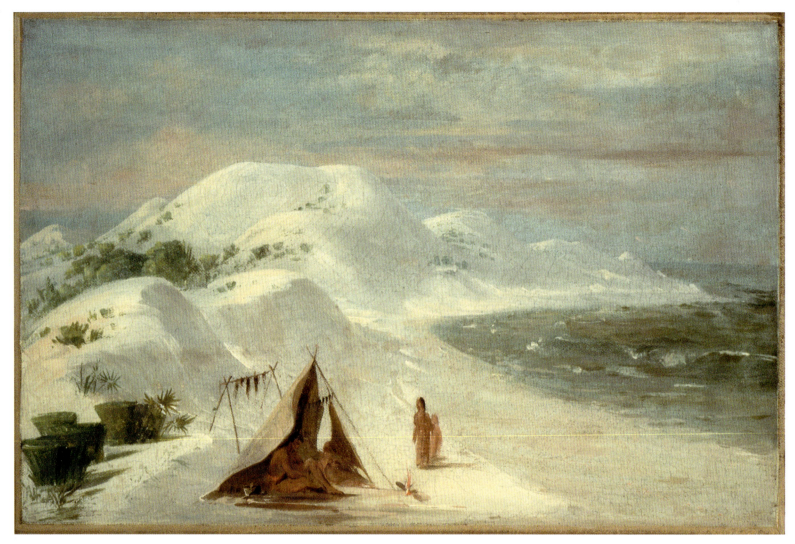

2. George Catlin, *White Sand Bluffs, on Santa Rosa Island, Near Pensacola,* oil on canvas, 1834-1835. Indians of the northern Gulf Coast collect salt and fish. Smithsonian American Art Museum

Havana and Mobile Bays entered recorded history a mere 13 years apart, and Catholic Spain first mapped them both. Surprisingly, Christopher Columbus never circumnavigated Cuba even though he explored portions of it, and he never saw the Gulf of Mexico. He went to his grave believing that Cuba was part of Asia rather than an entirely new world. But he heard about what lay beyond his direct experience, writing, "there are in the western part of the island two provinces which I did not visit; one of these is called by the Indians 'Avan,' and its inhabitants are born with tails."[1] The name derived from that of the local cacique, or chief, Havaguanex. Iberian tongues pronounced this *La Abana,* eliding the *h* and softening the *v* to *b*. As for people with tails, they were an invention of Columbus' fevered medieval imagination.

Columbus doubted that Cuba was an island though the Taínos told him it was, and the question remained officially unresolved at the time of his death in 1506. In order to settle the matter, the governor of Hispaniola ordered a reconnaissance by Sebastián de Ocampo that very year. The latter was an exile from Spain, cast out for some grave offense and forbidden by

[1] Cluster and Hernández, *The History of Havana,* 1

the crown to leave Hispaniola lest he face extradition and execution. Apparently, Ocampo did not scare easily and, after all, was very far from royal authority. He had earned a reputation as a respected merchant who voyaged frequently through the islands, trading and making friends. He understood ships and men and was a good choice to head the Cuban mission.[2]

Ocampo sailed in two lateen-rigged caravels safely after hurricane season. He jogged west along Cuba's northern shore, sounding for shoals and seeking rivers. Unfortunately, his vessels proved leaky, and he had to stop and make repairs. Happily, a promising cove presented itself, and the caravels maneuvered inside. The place was a mariner's dream, entered through a narrow, half-mile-long passage edged by limestone bluffs topped by greenery on the east side and a cape with low hills on the west, where Havana would later develop.[3] Inside, the bay opened into a triple-lobed, deep-water anchorage fringed by ceiba and palm trees. On later maps it resembled a garlic head. The entire expanse covered just over two square miles. The Spanish cleric Bartolomé de las Casas visited shortly thereafter and enthused, "There are few harbors in Spain, and perhaps not in any other parts of the world, that may equal it."[4] It would be easy to defend and could hold the entire Spanish navy with room to spare.

Ocampo's men hauled the caravels onto the shore where they hove them down and careened the hulls. This was a messy process that involved scraping encrusted barnacles and slimy marine growth from the hull, then replacing rotten strakes and re-caulking. While the Spaniards worked, curious Taínos watched from the shade of ceiba trees and pointed toward nearby petroleum seeps, which the sailors used to waterproof the hulls. Ocampo named this refuge Puerto de Carenas because he careened his ships there. It would soon after be known as Bahía de La Habana.

With repairs completed, Ocampo sailed west from the bay, rounded Cabo San Antonio, tacked into the Caribbean, and returned to Hispaniola, thus proving Cuba an island. He also reported that there was gold, and that the Indians were docile, neither of which augured well for the inoffensive Taínos.[5]

The Spanish conquest of Cuba quickly followed, with the native people slaughtered, worked to death, or ravaged by diseases to which they had no immunity. Among the earliest towns established afterward was San Cristóbal de La Habana, founded in 1514 on Cuba's southern coast. The Span-

[2] Fernández de Navarrete, *Colección de los viages*, 520-521. Ocampo owed his freedom of movement to the fact that, as the saying went, "Heaven is high and the king is far away."

[3] Mira Caballos, "En torno a la expedición de Sebastián de Ocampo a la isla de Cuba (1506)," 202. Heretofore Gulf Coast historians have cited a 1508 departure date for Ocampo's voyage. However, in his article, Mira Caballos employs contemporary Spanish documents to argue that Ocampo departed in 1506.

[4] Cluster and Hernández, *History of Havana*, 2. Today the three harbors are called Marimelena, Guasabacoa and Atarés.

[5] Weddle, *Spanish Sea*, 21-22; Humboldt, *The Island of Cuba*, 138.

iards honored three individuals at once with its ponderous name—a saint and the explorer as well as the Taíno cacique. Appropriately, only the last would stick. Unfortunately for the earliest settlers, the site was decidedly unsuitable. It lacked a decent harbor, was swampy and mosquito-plagued, and never consisted of more than a few rude huts and a rough church. Four years later the Spaniards decided to shift north to the mouth of the Almendares River, well within Havana's modern limits but four miles west of the harbor entrance. By 1519 the settlers at last realized the harbor site's superiority, and they moved their town a second time. Mobile would copy this pattern almost two centuries later.[6]

The year of Havana's last move, a small expedition sailed from Jamaica to explore the northern Gulf Coast. The irascible Ponce de Leon had recently discovered both Florida and the Gulf Stream, but there was yet much uncertainty about the extent and resources of this new land. Some thought that it might be an island even bigger than Cuba and that a seaway into the Pacific might lie hidden over the horizon. To find out, in the spring of 1519, Jamaican governor Francisco de Garay dispatched Alonso Álvarez de Pineda in four small ships. Other than his name and a few particulars of his voyage, not much is known of this intrepid explorer. He entered the Gulf through the Yucatán Channel, sailed north, and then worked his way along the littoral in both directions until he ascertained that Florida was a large land mass that stretched along a broad curving coastline between Mexico and the Florida Straits. There was no passage to the Pacific. His voyage was most significant for the crude map it produced, the first of the Gulf of Mexico, and historians since have spilled considerable ink guessing which river or bay is which along its shore. Contrary to the contention of several Alabama scholars, Álvarez de Pineda's Río del Espíritu Santo was the Mississippi River rather than Mobile Bay, but he did discover the latter and probably sailed into its expansive lower portion.[7]

If so, he would have seen the same things a modern mariner sees when approaching from the Gulf—curling surf along a low shoreline of bright white sand backed by lush greenery, towering pines, and wind-sculpted live oaks (FIG. 3). Closer in, Mobile Bay's 413 square miles beckon, cradled by a barrier island on the west side of the three-mile-wide mouth, and a long peninsula on the east. Within the bar the bay is relatively deep, but shallows north with an overall average depth of just 12 feet. If accurately outlined, the bay looks like a gun stock, a curiosity first recorded by the Flemish cartographer Abraham Ortelius, who labeled it

[6] Sanderlin, *Bartolomé de las Casas: A Selection of his Writings*, 63-65. Cluster and Hernández, *History of Havana*, 3. Arrate, *Llave del Nuevo Mundo*, 39. The Spanish conquest of Cuba was brutal. The compassionate cleric Las Casas, who was an eyewitness, described it in vivid detail.

[7] Hamilton, *Colonial Mobile*, 10-11. Weddle, *Spanish Sea*, 104-5. Álvarez de Pineda's map is reproduced in Weddle, 101. The Spanish considered all of what is now the southeastern United States to be Florida at that time.

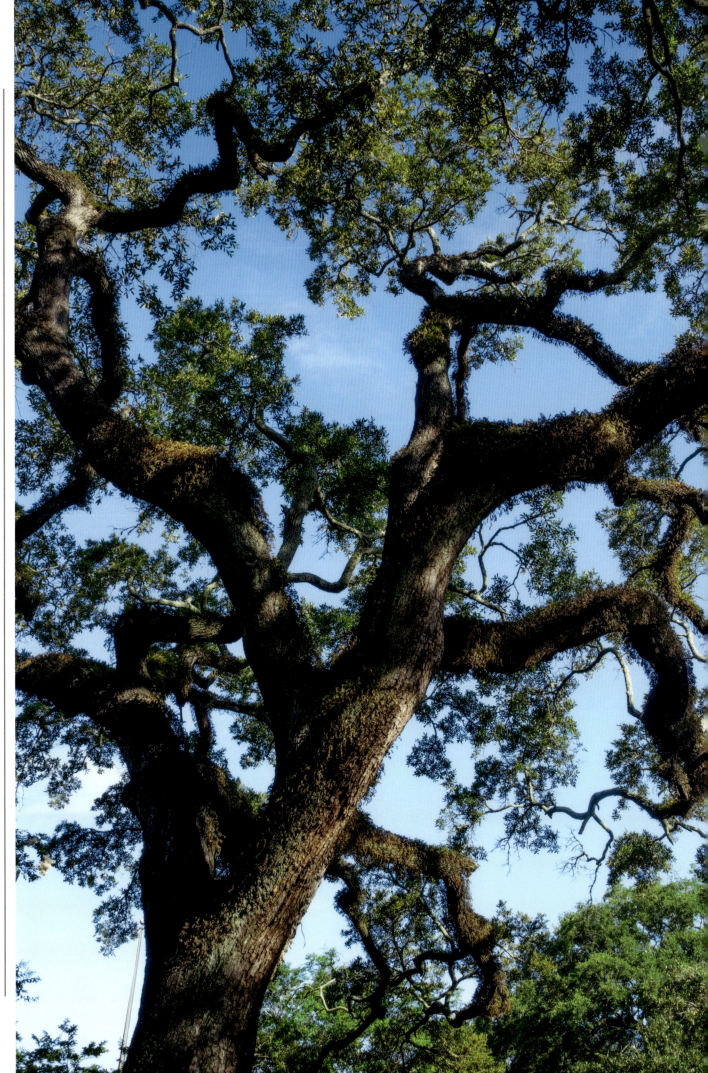

3. Mobile's beautiful live oak trees impart an historic coastal vibe redolent of mound dwellers and conquistadors {CC}

Bahia de la Culata, or Gunstock Bay, on his colorful 1587 world map.

Álvarez de Pineda's little ships drew only six or seven feet, and if he had chosen to, he could have easily reached the head of the bay, 34 miles distant from the Gulf breakers. The western side of the bay presents low-lying land with swampy margins and timber, while the eastern shore features a ribbon of brown sand backed by pine, live oak, cedar, and laurel trees. A red-clay bluff presents a prominent sea-mark at modern-day Montrose. A Spaniard who explored the bay area several decades later was impressed by the timber "suitable for making masts and yards" (Fig. 4) and the clay perfect for "making jars."[8] North of the bay stretches the vast Mobile River delta, threaded by bayous, streams, and sloughs. It transitions south to north from waving marsh grass to cypress trees trailing

[8] Priestly, *The Luna Papers, 1559-1561*, vol. 2, 335.

4. Pine forest reflected in the water. One early Spanish explorer noted Mobile Bay's abundant pine trees were "suitable for making masts and yards" {CC}

graceful tendrils of Spanish moss (Fig. 5), to upland hardwood forest. Indigenous villages were numerous prior to European contact, surrounded by fields of corn, beans, and pumpkins. Game and seafood were abundant and the people curious about strangers.

Historical events conspired at last for a human connection between Havana and Mobile bays. A sea-borne empire had discovered and mapped both places; conquered Cuba, Mexico, and South America; made the Gulf a lake; and tentatively begun to probe La Florida. No one knew yet how far inland it stretched or what wonders it might contain. Greedy men believed that since Mexico and Peru yielded golden kingdoms theretofore unimagined by the wildest romancers, surely La Florida would too. It lacked only the man resourceful and ruthless enough to seize the opportunity.

In November 1535 tiny Havana lay beneath the sun's effulgence—several dozen

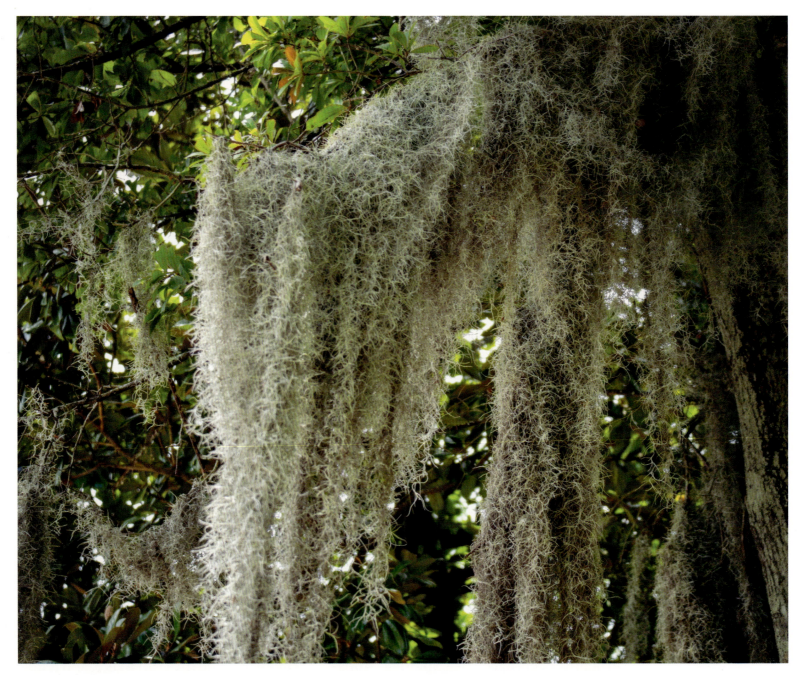

improvised *bohíos* and a church, home to 40 whites, 120 free Indians, 200 enslaved black and Indian people, two clerics, and one chaplain. Only a few days sail north with a favorable wind, Mobile Bay lay serenely beneath the same smiling rays. The flourishing indigenous villages surrounding it contained thousands of inhabitants in a sophisticated and stratified social milieu. It only remained for the two peoples—God-fearing Spaniards and sun-worshipping Indians—to embrace and, alas, clash for these places' theretofore separate histories to touch and then braid.

The first actors in the 500-year drama to follow were a proud Mobile cacique so tall the Spaniards considered him a giant, a battle-hardened conquistador, and a noblewoman whose legendary devotion spanned the Gulf. There would be many others—a bewigged French-Canadian naval hero, a covey

5. Spanish moss, or "tree hair" as the Indians called it, was used to temper pottery, brew medicinal tea, and provide females a modesty cover {CC}

of Parisian convent girls chaperoned by two nursing sisters, a British military engineer, a haughty Spanish general bent on greatness, a mustachioed American naval officer, an antebellum Mobile socialite, a Swedish novelist, innovative builders, an ailing American vice president, fulminating filibusters, fearless Confederate blockade runners, Cuban students enamored of a new game, no-nonsense schooner captains, tile makers, entrepreneurs, excited tourists, courageous physicians, and a pair of gifted historians who revived and warmed an old bond too long chilled by 20th-century politics.

Mobile and Havana: Sisters Across the Gulf explores in both word and image the colorful stories of these people, the places they frequented, and the connections they represent between these two intriguing cities. It is a collaborative effort by two historian/photographer pairs, one American and one Cuban, all deeply imbued with a love of their craft and native soil. The work builds on an earlier project by Chip Cooper, Elizabeth M. Elkin, Julio Larramendi, and John S. Sledge that celebrated the 25th anniversary of Mobile and Havana's sister-city relationship in 2018. The Mobile Museum of Art and Havana's Cuban Museum of Fine Arts exhibited Cooper's and Larramendi's photographs and published them with Elkin's and Sledge's essays as *Common Ground: Photographs of Havana and Mobile*.[9] During an October 2019 trip to Havana to open the exhibition, Cooper, Larramendi, Sledge, Mobile and Havana civic officials, and the members of the Society Mobile-La Habana decided to produce a book, larger and more ambitious than *Common Ground*, that would fully illumine its subject. Alicia García-Santana, a Cuban architectural historian, joined the creative team, and the book you now hold was born.

Over 20 years ago, Mobile's visionary municipal archivist Jay Higginbotham remarked, "Mobile, Alabama, and Havana, Cuba, have only three things in common. The past, the present, and the future."[10] Hopefully this book will demonstrate just how much that is the case.

[9] *Common Ground: Photographs of Havana and Mobile*, by Chip Cooper, Julio Larramendi, Elizabeth M. Elkin and John S. Sledge, was published by the Mobile Museum of Art in 2018. The 2019 exhibit at the Cuban Museum of Fine Arts in Havana coincided with that city's 500th anniversary.

[10] Luxner, "Cuba's Links to 3 Gulf Cities: Mobile, New Orleans, and Tampa," 14.

Vicente Rodilla Zanón, 1967.
Statue of Hernando de Soto, 1967, in Spanish Plaza, Mobile.
"Adventurer, soldier, dreamer," the plaque reads in part.
Mostly he dreamt of gold
{CC}

BEGINNINGS: THE ADELANTADO, THE CACIQUE, AND THE LEGENDARY DEVOTION OF ISABEL DE BOBADILLA

He was the first to know both Havana and Mobile, or at least the latter's aboriginal namesake. Hernando de Soto was born about 1500 in the southwestern Spanish province of Extremadura. It is a pitiless region—the name means "extremely hard"—infamous for its hammering sun, bitter cold, and grinding poverty. During the 16th century its lack of opportunity drove energetic, ambitious young men like Vasco Núñez de Balboa, Hernán Cortés, Francisco Pizarro, and De Soto to seek their fortunes in the recently discovered Americas. Little wonder tourist brochures call Extremadura "the Land of the Conquistadors."[11]

Not much is known of De Sotos's youth. As a minor noble he probably spent his time riding, hunting, jousting, and visiting far-flung neighbors. While yet an adolescent he joined the expedition of Pedrarias Dávila to Darién (now Panama) and subsequently accompanied Francisco Pizarro in the conquest of Peru, where he served as a captain of dragoons. Whether in steaming Isthmian jungle or arid Andean valley, De Soto proved a strict disciplinarian and a brave if ruthless fighter. One chronicler wrote that he was "very given to hunting and killing Indians," an activity that usually involved riding down fleeing men, women, and children and lancing them from the saddle. After 20 years of hard campaigning, De Soto returned to Spain fabulously wealthy. His reputation was considerable, and he became a regular at court, where his money, trim physique, and bronzed countenance attracted fawning attention. Despite these advantages, his attempt to gain a governorship in Central America was frustrated. Steely-eyed realist that he was, De Soto knew that he needed an influential wife to improve his prospects.[12]

Among the many women at court, Isabel de Bobadilla was neither young nor probably very pretty. She was about De Soto's age and may have been a widow. But she was from a prominent Castilian family, the daughter of Pedrarias Dávila, the very man whom De Soto followed in the New World, and her dowry consisted of significant assets, including a Panamanian cattle ranch, horses, slaves, and thousands of gold ducats. De Soto's personal secretary, Rodrigo Rangel, described Bobadilla as "a woman of great essence and goodness." She was soon to prove that she could also be a capable governor and champion of her own affairs. Her and De Soto's marriage late in 1537 may not have been a love match at first, but within a 16th-century context it was sensible and advantageous for

[11] Milanich, "The Hernando de Soto Expedition," 14.

[12] Clayton et al., eds., *The De Soto Chronicles, The Expedition of Hernando de Soto to North America in 1539-1543*, vol. 1. *The De Soto Chronicles* is the most comprehensive published collection of documents relating to the expedition. The two-volume set includes the entire texts of the four primary accounts by the Gentleman from Elvas, Luys Hernández de Biedma, Rodrigo Rangel, and Garcilaso de la Vega, or El Inca.

both. After the nuptials and a sizeable monetary gift to the Crown, De Soto was at last handsomely rewarded when the King made him governor of Cuba and *adelantado* of Florida. The latter title, conveying important civil and military powers far from official oversight, was much coveted among conquistadors. Of course, De Soto had to conquer Florida first and at his own expense, but if it proved as rich as Mexico or Peru, the prospects were juicy indeed.[13]

It is not difficult to imagine the excitement that greeted news of De Soto's endeavor. According to the Mestizo chronicler Garcilaso de la Vega, more familiarly known as El Inca, "from every part of Spain came many knights of very illustrious lineage, many noblemen, many soldiers practiced in the military art ... and many citizens and laborers." After mustering 600 men at Seville, De Soto marched them down the Guadalquivir River towards its mouth and the village of San Lucar. There he held a review, and the men paraded beneath fluttering white, red, and gold banners backgrounded by dun buildings and a cerulean sky. Some of the knights displayed glittering armor and rode brightly caparisoned horses. According to at least one witness, the footmen were not as splendidly attired but rather "wore poor and rusty coats of mail, and all [wore] helmets and carried worthless and poor lances." Well-equipped or no, De Soto's soldiers were animated by a blinding greed. El Inca said it best: "The first idea in the minds of these cavaliers, was to conquer that kingdom and seek gold and silver, and they paid no attention to anything that did not pertain to these metals."[14]

On April 6, 1538, the army sailed into the gray Atlantic on board seven ships "amid great festivity" of blaring trumpets and booming artillery. Besides the men and horses, there were four clerics to convert the Indians and several women, including Doña Isabel and three white slaves "to serve her and her household." The latter were probably north Africans, since Isabel had to swear that they were "Christians before they had turned twelve years old." On Easter Sunday the fleet made La Gomera in the Canary Islands, where Isabel's uncle was governor. During a week's stopover the ships were re-provisioned. Upon departure, the governor entrusted his 17-year-old daughter, Leonora de Bobadilla—El Inca wrote that her "beauty was remarkable"—to De Soto and her aunt Isabel, in hopes that the girl would make a good marriage in the Indies. Instead, De Soto's second-in-command, Nuño de Tobar, seduced her. One can imagine the scene when the Adelantado and his wife learned of it! They were somewhat mollified when Tobar promised to marry the pregnant Leonora, but De Soto stripped him of his command nonetheless.[15]

[13] Ibid., 178 and 251. Seaman, ed., *Conflict in the Early Americas*, 2-3.

[14] Clayton, *The De Soto Chronicles*, vol. 1, 401-402 and 50. Weddle, *Spanish Sea*, 218.

[15] Clayton, *The De Soto Chronicles*, vol. 1, 51, 451-452 and 470; vol. 2, 78. Weddle, *Spanish Sea*, 212.

The fleet arrived off Santiago, Cuba, on June 9. Rather than extending a hearty welcome, the locals feared pirates and waved the vessels toward submerged rocks. Fortunately, they realized their error in time and then managed to steer the friendly ships away from catastrophe. As it was, the lead vessel banged an obstacle, rattling everyone's teeth and breaking so many bottles below deck that the pumps gushed water, vinegar, wine, and honey. Safely on shore, De Soto received a more appropriate greeting and quartered his men throughout the town. He spent two months enlisting men and buying pigs and horses before sending the infantry, Isabel, and the household staff west by ship around the island to Havana, while he marched the cavalry overland to meet them there. Neither party had an easy time. The fleet battled storms, and the cavalry traversed muddy, mosquito- and snake-infested swamps before everyone finally reunited in Havana that Christmas.[16]

Compared to the magnificent cities of mid-16th-century Spain, Havana was little more than a distressed settlement. Recently sacked by French pirates, it consisted of several dozen forlorn huts, a plain church (pirates had stolen its bell), and a small plaza bayside. The residents were a traumatized mix of whites and black and Indian slaves. De Soto's first order of business as Cuba's new governor was to begin the construction of a harbor fortress. Havana occupied a vital strategic position that needed defending. Its excellent bay was a natural way station for Spanish treasure ships after they threaded their way through the Caribbean and along the Mexican Gulf coast loading gold, pearls, hardwoods, and chocolate and, beginning in 1565, spices, porcelain, lacquerware, and silver from the Orient. When the galleons crowded into Havana harbor, ambitious locals helped resupply and repair the vessels. Others took the opportunity to fleece the sailors, plying them with drink and relieving them of their lust and hard-earned pay. After a few weeks, the ships sailed into the Florida Straits and rode the powerful Gulf Stream home.[17]

Not surprisingly, De Soto had little interest in governing Cuba. He and his men were eager to launch their invasion of Florida, "for it seemed to them that was the richest land which had yet been discovered," as one participant later wrote. But before he departed, the Adelantado appointed his wife governor in his stead and gave her his power of attorney. Far from mere gestures, these were extraordinary acts conveying genuine authority. De Soto obviously knew his wife well and greatly respected her business acumen

[16] Wright, *The Early History of Cuba, 1492-1586*, 167-170. Irene Aloha Wright (1879-1972) was an extraordinary scholar who spent two decades in the Spanish archives researching and translating colonial documents. She was the first person to lay eyes on these papers since the sixteenth century.

[17] Oliva Suárez et al., "Génesis y desarrollo de San Cristóbal de La Habana," 103. Haring, *Trade and Navigation between Spain and the Indies*, 201-208. Beginning in 1551 Spain switched to a highly organized fleet system to haul American treasure. Havana remained a critical port on the route.

and presence of mind. His confidence was well placed. Even as he and his army sailed away on May 18, 1539, Isabel, now Cuba's first (and to date only) woman governor, pushed forward the work on the fortress and challenged her husband's former business partner, Hernán Ponce, when he attempted to intimidate her into paying money that he claimed De Soto owed him.[18]

De Soto landed his army in late May at what is now Tampa Bay. During the next year and a half, the Spaniards bullied and fought their way northward and then along an extended looping route through what are now the states of Florida, Georgia, South and North Carolina, and Tennessee before crossing into what is Alabama in the autumn of 1540. The results of the *entrada* to that point were disappointing. The Mississippian Indian cultures the soldiers encountered did not have gold like those of Mesoamerica, and all De Soto had to show for his efforts were several dozen dead men and a few sacks of river pearls.[19]

No doubt tired, grieving their lost comrades, and unhappy about their meagre plunder, the conquistadors proceeded down the Coosa River Valley and into the fertile region between the Alabama and Tombigbee Rivers. Here they passed through numerous small villages that abounded in maize, beans, and squash. This was the province of the feared Chief Tascalusa, whom one of De Soto's men described as "an Indian so large that, to the opinion of all, he was a giant."[20] Cacique and conquistador first met at Athahachi, near present-day Montgomery, Alabama.

De Soto's standard operating procedure was to take hostage the cacique of each province in order to ensure the army's safe passage to the next chiefdom. Additionally, he demanded food, bearers, and women. Tascalusa was well aware of these practices and had no intention of tolerating them. When De Soto asked him for bearers, the proud cacique responded that, in the words of eyewitness Luys Hernández de Biedma, "he was not accustomed to serving anyone, rather that all served him before." Unmoved, De Soto took Tascalusa prisoner, which enraged the cacique and his people. Biedma declared this was why the formidable Indian chief "committed the ruin that afterward he inflicted on us."[21] Helpless amid the heavily armed conquistadors, Tascalusa promised that he would supply their needs at Mabila, another of his towns nearby. De Soto soon reached Mabila with his advance guard, Tascalusa, and some bearers. The rest of the army lagged behind, pillaging as it traveled.

The exact location of Mabila has excited much speculation among historians and archaeologists, who have proposed at least a dozen possible sites. These range from the Mobile River delta to the Alabama Black

[18] Clayton, *The De Soto Chronicles*, vol. 1, 56. Johnson, "Introduction: Señoras...no ordinarias," 2-3.

[19] Clayton, *The De Soto Chronicles*, vol. 1, 308.

[20] Ibid, 232.

[21] Ibid.

Belt, an agriculturally rich swath of dark soil that stretches across the lower half of the state like a wide belt. Scholars believe Mabila derives from a Choctaw word, *moeli*, that means "to skim, and also to paddle," a logical name in a region noted for its many rivers, lakes, and streams. Recent archaeological investigations near Selma, 139 miles north of Mobile Bay, appear to be closing in on the village at last (FIG. 6).[22]

There is less doubt about what Mabila looked like. According to Biedma, it was "a small and very strongly palisaded town" situated on a plain. It contained 80 buildings, more than Havana at the time. The town walls consisted of wooden poles with cross pieces and interwoven vines, the whole clay-slathered to look smooth. There were at least two gates, numerous loopholes to shoot arrows, and several towers.[23]

Rather than wait for the rest of his army to arrive, De Soto elected to enter Mabila with his small party and the chief. Once inside, the bearers dropped their baggage, the horsemen dismounted, and all gawked at the surroundings. In an effort to distract the Spaniards, Tascalusa had 20 young women dance for them. Pleasing as this was to the soldiers (their average age was 24), there was a palpable tension. Other than the dancing girls, there were no Indian women or children visible, only men. One Spaniard peeked into a structure and spotted cached weapons and crouching warriors. Tascalusa abruptly excused himself and entered a dwelling. De Soto asked him to come back out, but he would not. When another Spaniard grasped a townsman and ordered him to retrieve the cacique, he wrenched free and refused. The infuriated conquistador swung his sword, severing the warrior's arm.[24]

It was as if he had slashed a hornet's nest. Mabilians boiled out of the huts and down off the walls amid clouds of arrows. Five Spaniards instantly fell with ghastly wounds, and the panicked horses yanked at their tethers. The conquistadors were at a decided disadvantage in a crowded space where they could not fight on horseback. De Soto desperately ordered his men outside and stumbled twice racing for the gate. Arrows continually flew, hitting the horses, snagging in the men's quilted armor, and glancing off their iron morions.[25]

The evidence of battle—fighting men shouting, weapons clashing, wounded horses and men screaming, Spanish trumpets blaring, Indian drums pounding, and an immense cloud of dust—rose above the plain. Alerted by the chaos, the rest of De Soto's army hurried to the scene. Locked out of the town, they could only watch as the

[22] Swanton, *Early History of the Creek Indians and their Neighbors*, 160. Yurkanin, "Alabama Researchers Closing in on Site of Spanish Explorer's Pivotal Battle with Chief Tascalusa." There are numerous variations of the name Mabila, including Mauvila, Mauilla, Mavila, Mowill and, of course, Mobile, which was the French preference.

[23] Clayton, *The De Soto Chronicles*, vol. 1, 233. Jenkins, "The Village of Mabila," 74-77.

[24] Weddle, *Spanish Sea*, 219.

[25] Ibid.

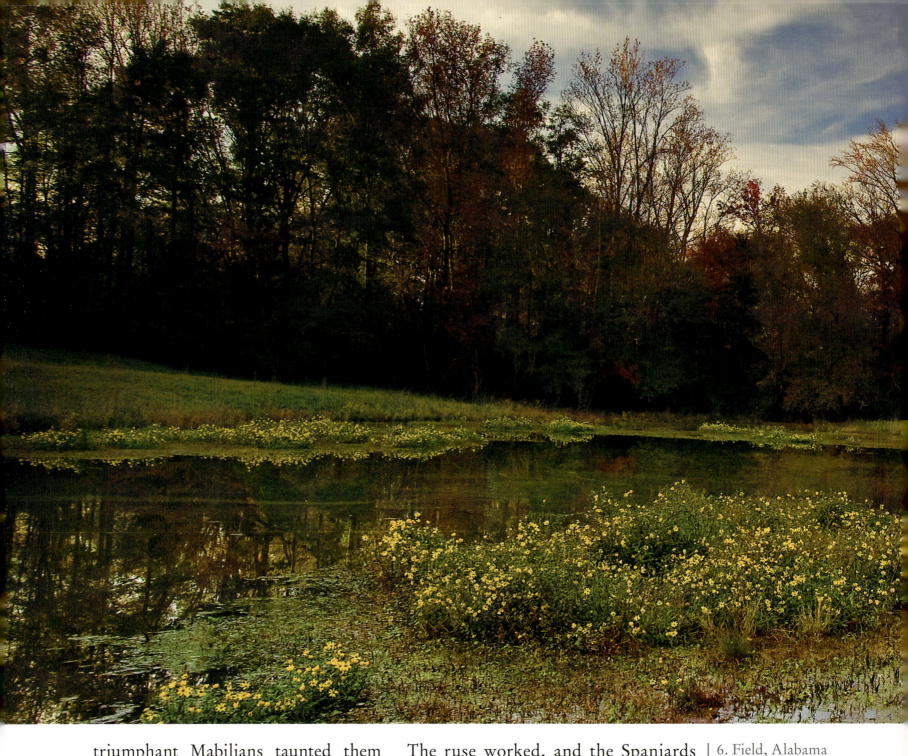

triumphant Mabilians taunted them and displayed their plundered baggage from the walls.[26]

Although surprised at the suddenness and violence of the assault, De Soto was a veteran. He understood strategy and was an adept killer. In an attempt to draw out the Mabila defenders, he ordered his horsemen to feign a retreat. The ruse worked, and the Spaniards turned and thundered after those Indians who had rushed outside the protective walls. The Mabilians scattered, chased by yelling lancers and howling war dogs. Even when cornered, they lost none of their ardor. "We fought that day until it was night," recalled Biedma, "without one Indian surrendering to us, rather they fought like fierce lions."[27]

6. Field, Alabama Black Belt. Archaeologists believe they are close to finding Mabila {CC}

[26] Clayton, *The De Soto Chronicles*, vol. 1, 235. Hernández de Biedma's account, referenced here, is the most vivid on the fighting.

[27] Ibid, 235.

With the remaining Mabilians inside the walls, De Soto ordered his men to attack from all sides and burn the town. His soldiers hacked the clay walls and scaled them, hurling torches onto the thatch rooftops. Others dropped down inside wielding their weapons. Biedma was brutally succinct: "We killed them all, some with the fire, others with the swords, others with lances."[28] Estimates of Indian losses vary, but a figure of 2,500 or so is likely. Tascalusa presumably died in the blaze. Twenty conquistadors perished, and the survivors counted 750 arrow wounds. The Spaniards lost all their baggage, including the pearls, the only tangible spoils of their *entrada*.

The aftermath was bleak. De Soto's army remained at Mabila a month licking its wounds and ravaging the chiefdom. Eager to see them gone, surviving Indians reported ships on the coast. Diego Maldonado, whom De Soto had ordered to

[28] Ibid.

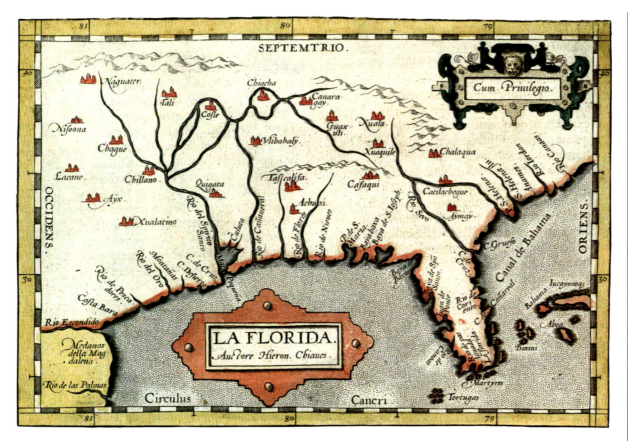

7. Hieronymo Chiaves, *La Florida*, 1584. This map is notable for information on the interior provided by Hernando de Soto's surviving veterans. University of South Alabama Center for Archaeological Studies

rendezvous with him at what is now Pensacola Bay with more supplies and soldiers, had arrived. Doubtless Maldonado had a ship or small boat posted at Mobile Bay as well, but De Soto had no intention of ending his ill-starred adventure until he could demonstrate at least some measure of success. So he turned his demoralized army northward and tramped on to further strife. He died of a fever, and his body was consigned to the Mississippi River on May 24, 1542. After numerous hardships, roughly half his original force made its way downstream and along the coast into Mexico and an end to the whole bloody business (Fig. 7).[29]

It was some time before Isabel learned her husband's fate. That she was genuinely concerned seems clear, given her consultations with Maldonado and requests that he continue to search the northern littoral months and then years after the last reports. The captain obeyed and according to El Inca "coasted along the shore… to see whether the Spaniards might have come out at some other point to the east or west. Wherever they went they left signs on the trees and wrote letters, which they put into their hollow trunks" (Fig. 8).[30] They also fired guns, posted scouts at various points, and pressed passing Indians for news, all to no avail. This continued for three years, until Maldonado put into Veracruz and learned of the survivors and De Soto's death.

On December 6, 1543, two days after receiving the news, Doña Isabel appeared before a Havana magistrate

[29] Weddle, *Spanish Sea*, 220-222.

[30] Clayton, *The De Soto Chronicles*, vol. 2, 551.

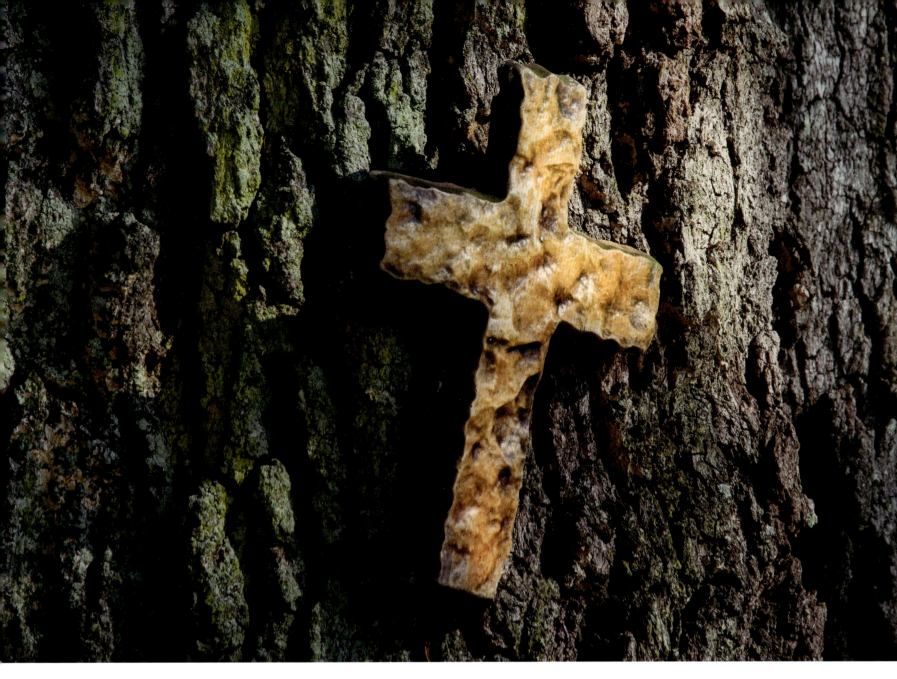

8. Cross on tree, Mobile. Isabel de Bobadilla urged those searching for her missing husband to leave him signs so that he might return safely to her at Havana. Who left this one? {CC}

and notary and requested "an inventory of all the assets that the aforementioned adelantado, my lord and husband, and I have at the present time, and that have resulted from our marriage." Within a week she appeared before them again to swear to the truthfulness of the resulting tabulation. It was both impressive and sad, a roster of a conquistador and his lady's earthly accumulation, most of it rather the worse for wear. It included a couple of ranches outside Havana with 56 turkeys, 650 pigs, 30 cows, nine horses "for burden," 200 bushels of sweet potatoes, and 500 bushels of yucca; Isabel's town house furnished with a wooden bed, two "old plain tables," three rickety chairs, and two threadbare rugs; a nearby thatched roof storehouse; a Moorish slave and several Indian and black slaves; 24 lances, two shields; a "gilded chest" that held linens, two blue damask tablecloths, five brushes, "a ruffled traveling hat," a Portuguese smock, white velvet stockings, a frayed scarlet petticoat, a black velvet jacket, a pink satin pinafore, "some Latin prayers of Our Lady," and a wooden crucifix "that cost two pesos." There was precious little

gleaming treasure to show for all their years in the Americas—just a dozen gold bracelets, a pearl necklace, a gold buckle, a rosary of small gold beads, some worked silver, and a broken chalice. Still, it was considerably more than most of New Spain's residents could claim, not to mention the forlorn survivors of De Soto's *entrada*.[31]

Isabel auctioned most of these things, garnering enough funds to return to Spain. One scholar has written that "unpoetic documents prove that she lived for many years longer" there, battling on in the courts against her husband's former partner. But in the curious way of things, Isabel's history soon transmuted into an inspiring legend, first in Havana and then, centuries later, across the Gulf where she had never set foot. El Inca, more romancer than historian, appears to have lit the spark when he declared that her grief for De Soto, the "waste and loss of his property, the fall of his estate, and the ruin of his house" was so overwhelming that "she died soon after learning it." This was a compelling storyline to be sure, a powerful conqueror dead in a distant land, his devoted wife so stricken that she grieved herself to death. The most tangible manifestation of this tale was shortly to appear atop the Castillo de la Real Fuerza, the successor to the very fortress De Soto had begun to build and Isabel had finished.[32]

The De Sotos' Castillo was little more than a small bulwark manned by a dozen or so citizen volunteers. Not surprisingly, it fell to French pirates in 1555, who destroyed it along with much of the town. In 1558 King Philip II ordered a stronger stone fortress for the harbor, and construction began right away. The project took years, plagued by internal bureaucratic squabbles. The end result is a square keep guarded by angled bastions at each corner and surrounded by a moat with a drawbridge. The walls are 18 feet thick and 30 feet high, and after construction they bristled with bigger guns and more men than the former structure. Masons added a cylindrical bell tower in 1632, capped by a bronze weathervane crafted by the local artist Gerónimo Martín Pinzón.[33]

La Giraldilla (FIG. 9), "she who turns," is Cuba's oldest sculpture, likely modeled on La Giralda, a 16th-century weathervane in female form atop the cathedral in Seville. But Pinzón gave his creation a particularly West Indian allure. At just three-and-a-half feet in height, she holds a Calatrava Cross (representing a Spanish military order) in one hand and a palm frond (representing victory) in the other, while thrusting out her proud chin and hiking her dress well up her right leg. Exactly when or how is unknown, but probably not long after her placement above the city, *La Giraldilla* became intertwined with El Inca's

[31] Ibid, vol. 1, 489-498.

[32] Wright, *Early History of Cuba,* 172. Clayton, *The De Soto Chronicles,* vol. 2, 552.

[33] Fuente, *Havana and the Atlantic in the Sixteenth Century,* 1-2. Delgado, "Cuba's Castillo de la Real Fuerza."

9. The *Giraldilla*, beloved symbol of Havana, assumed also as a tribute to Isabel's fidelity
{CC}

story of Isabel's early death. It did not take much imagination to believe that the lovely weathervane twisting in the trades, her countenance often pointed north, represented the devoted Isabel anxiously awaiting the reappearance of her long-absent husband. Little wonder that the figure became a beloved symbol of the city, her form reproduced on everything from buses to the Havana Rum label. In 1926, a hurricane damaged the sculpture, prompting its removal to the safety of a museum. An exact replica replaced it atop the bell tower.[34]

Not surprisingly, Isabel's romantic appeal readily translated across time and culture. Exactly how is its own story. In 1941, John R. Peavy, a former Mobile city engineer with a long-standing interest in Gulf Coast history, authored an 11-page pamphlet titled *A Legend of Dauphin Island*. Like many mid-20th-century local-history publications, it wove a fanciful tale, best not examined too closely. In it, Peavy claimed that Isabel de Bobadilla had originally planted the island's abundant fig trees. He admitted that there was no historical "proof positive" of this, but said the story had been floating around the island for years. Proof or no, he believed "the laws of psychology,

[34] Cluster and Hernández, *The History of Havana*, 17. Some tour guides have greatly embellished the story. One variation claims that Isabel actually scanned the horizon from the bell tower. Though appealing, this ignores the fact that the tower was not built until ninety years after Isabel's departure from Cuba! On the legend's origin see also Johnson, "Introduction: Señoras," 4.

heredity, deduction and probability" strongly favored it.[35]

Just as the legend of *La Giraldilla* harkened back to El Inca, Peavy similarly suggested that Dauphin Island's Isabel association owed its inspiration to an early account, in this case by the Gentleman of Elvas, an anonymous Portuguese knight who accompanied De Soto. According to this knight, when the adelantado and his wife landed in Cuba they were impressed by the abundance of figs, "as big as the fist, yellow within and of little flavor." Peavy therefore concluded, "I think that here was born the idea of transplanting these fruits to la Florida."[36]

According to Peavy, when Maldonado sailed in search of De Soto, Isabel and Leonora went along. While the ships lay at anchor in Mobile Bay, the ladies rambled about the island. Near what is now Indian Shell Mound Park, Isabel decided to plant a garden "and ordered the fruit trees and vegetable seeds sent ashore." The soil's fecundity was "due to the fact that it was a burial ground of an ancient race of giants," Peavy wrote, "if one judged by the size of the skeletons uncovered by the planting operation." Peavy further imagined Isabel happily dwelling in a log cabin waiting for news, an elaborate conversation between her and De Soto's secretary, and even a near-affair with Maldonado: "No word of love passed their lips, but their eyes spoke volumes." In the end she orders the ships westward to the Rio Grande to continue her vigil.[37]

Less than a decade after Peavy's booklet, another writer amplified the legend. In 1950, Hatchett Chandler, an eccentric curator at the 19th-century brick fort on Mobile Point opposite Dauphin Island, penned the booklet *Little Gems from Fort Morgan*. Playing off Peavy, Chandler informed his readers that Isabel had also planted the first oleanders on the Gulf Coast and was responsible for their exotic name. He imagined "the figure of a beautiful Spanish lady … waiting, waiting, waiting." Her pet name for De Soto was Leander, he claimed, and as she watered the plants with her tears she moaned, "Oh, Leander! Oh, Leander!" By Chandler's lights, this outright fabrication was "a torch held by the hand of Truth."[38]

Charming as these stories are, they have not made Isabel a widely recognized symbol on the Alabama coast like *La Giraldilla* at Havana. But they remain colorful fodder for travel blogs and light magazine features with one writer labeling them "good coffee

[35] Peavy, *A Legend of Dauphin Island*, 3.

[36] Ibid., 5. Pt. Isabel, on Dauphin Island's north side, appears on an 1864 federal siege map, indicating that Bobadilla's association with the island does indeed go back quite far. See "Line of Investment of Fort Gaines, Dauphine Island. Legend aside, the island's fig trees have long excited comment. During 1713, in the French period, Gov. Lamothe Cadillac toured the island and wrote that "there are a dozen fig-trees that are very fine and that produce black figs." He did not associate them with Isabel de Bobadilla or De Soto's expedition. See Rowland and Sanders, eds., *Mississippi Provincial Archives, 1701-1729, French Dominion*, vol. 2, 166.

[37] Peavy, *A Legend*, 7.

[38] Fair, "Hatchett Chandler and the Quest for Native Tradition at Fort Morgan," 176-177.

10. Courtyard at the Church and Convent of San Francisco de Asís, Havana. Water splashes, fronds rustle, and legends are conjured easily here {CC}

shop conversation." Thus does Isabel's legend bridge the Gulf and, combined with the all too real bloody deeds of her conquistador husband, form the earliest direct linkages between two important cities (FIG. 10).[39]

[39] Cullen, "Dauphin Island." Other Alabama raconteurs who repeated the Isabel stories were Julian Lee Rayford in two articles in the *Dauphin Island News* (July 18 and October 25, 1957), Caldwell Delaney in *A Mobile Sextet* (1981), and Kathryn Tucker Windham in *Alabama: One Big Front Porch* (2007).

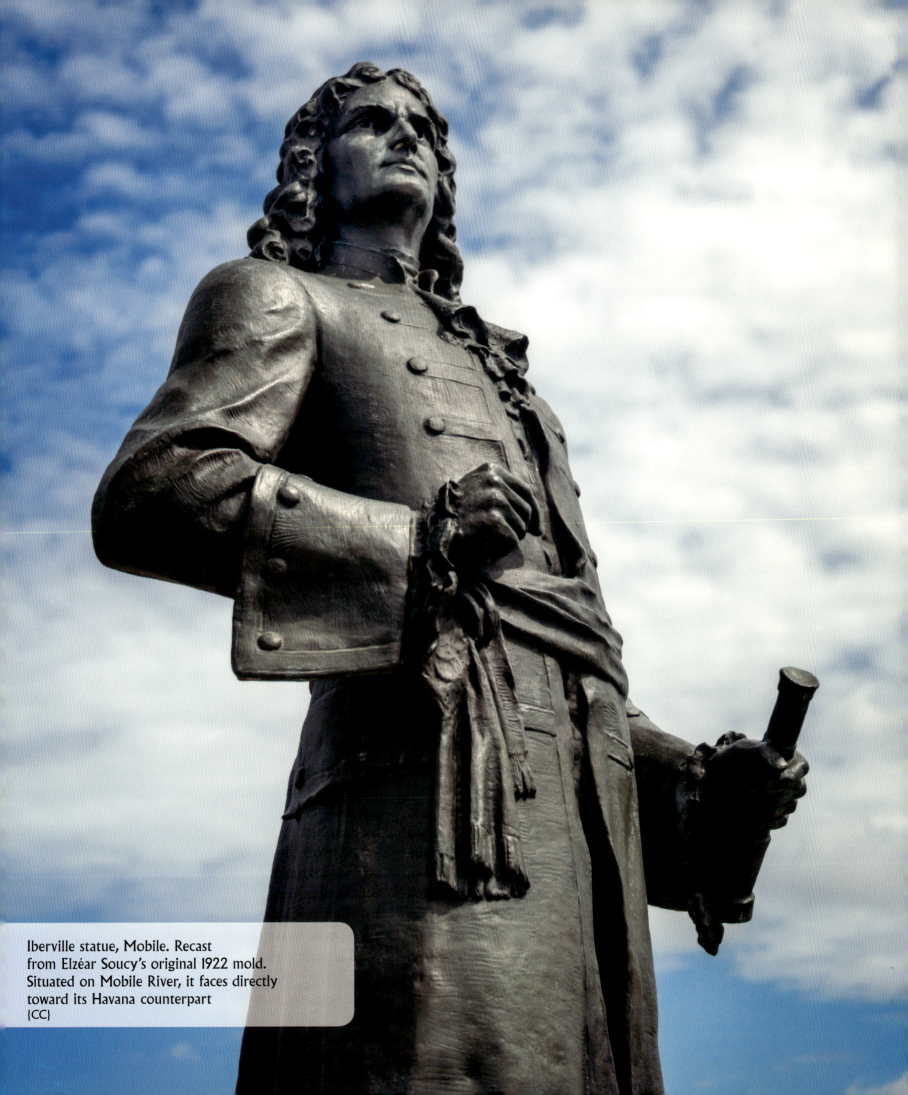

Iberville statue, Mobile. Recast from Elzéar Soucy's original 1922 mold. Situated on Mobile River, it faces directly toward its Havana counterpart {CC}

ESTABLISHMENT: THE FOUNDER, THE *PÉLICAN* GIRLS, AND THE PERIPATETIC PRELATE

The elegant French liner SS *Cuba* of La Compagnie Générale Transatlantique glided into Havana Harbor during the early morning hours of March 24, 1937. Her 150 passengers constituted a distinguished list of French government officials, businessmen, scholars, clergy, press, and even royalty (Princess Achille Murat) on a tour to commemorate a series of important anniversaries significant to France's history in the Americas. These included the 300th anniversary of Father Jacques Marquette's birth, the 250th of René Robert Cavelier de La Salle's death, and the 225th of Mobile's founding by Pierre Le Moyne d'Iberville.[40]

Havana was the site of Iberville's burial, hence the delegation's stop there, and Cuban dignitaries were on hand to welcome the travelers at the wharf. The combined group then proceeded to the Plaza de la Catedral for the unveiling of a bronze plaque recognizing Iberville's achievements. The local lawyer and author José Agustín Martínez delivered an "eloquent peroration" for the occasion, and the French judge Gabriel-Louis Jaray, vice-president of the Comité France-Amerique, responded. A military band concluded the ceremony with spirited renditions of "La Marseillaise" and the Cuban national anthem, "La Bayamesa." More speeches and a reception followed that evening at the Palacio de los Capitanes Generales. After a full and eventful day, the French bade their new friends farewell and boarded the *Cuba* for Mobile, their first U.S. destination.[41]

After a smooth and uneventful gulf passage, the *Cuba* nosed into a berth at the Alabama State Docks just before noon on March 26. Mobilians were excited about the visit and did their best to make the delegation's short time there memorable. The festivities began with a welcome luncheon at downtown's Cawthon Hotel hosted by the Chamber of Commerce. After the meal, Raymond Laurent, mayor of Paris, presented a bronze plaque identical to the one in Havana. "Is it not fair that our pilgrimage should have its first halting place here in Mobile," he asked the audience, "the foundations of which were laid by d'Iberville?" Mobile Mayor R. V. Taylor accepted the plaque "as a perpetual reminder to all the succeeding generations" and praised the two nations' long friendship. Vocalists then sang "La Marseillaise" and "The Star-Spangled Banner." The formalities concluded with a reception

[40] *Diario de la Marina*, March 25, 1937. Interestingly, the *Comité* based Mobile's 225th anniversary calculation on the 1711 date, when it was moved downriver to its present site. Iberville founded the city in 1702, but was dead by 1711 and his brother Bienville coordinated the move. No doubt the French chose the latter date because 225th was crisper than 235th!

[41] Ibid. Today Havana's Iberville plaque is in perfect condition and displayed inside the Palacio de los Capitanes Generales. Mobile's is displayed outside on a large flat stone at the northwest corner of Bienville Square and is consequently weathered, but still easily legible.

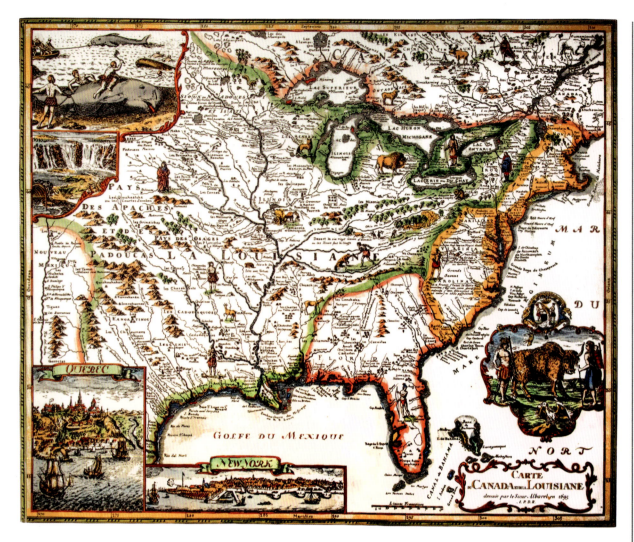

11. Le Sieur Albarel: *Carte du Canada et de la Louisiane*, 1695. Early French knowledge of the Gulf Coast was limited until Iberville penetrated the region. This early map has obviously been updated, since it shows cities like Mobile and New Orleans founded after the map's original date. History Museum of Mobile

that afternoon on board the *Cuba*. By sunset the French were bound for New Orleans and further stops throughout the U.S. and Canada. That they chose to highlight Havana and Mobile at the beginning of their tour was significant. It emphasized the fact that Iberville's nascent colony might not have survived but for Spanish Havana.[42]

All of Louis XIV's top advisors knew Pierre Le Moyne d'Iberville, if not personally at least by reputation. Born the son of a prominent fur trader in Montreal, Canada, in 1661, he learned the use of a musket on shore and a cutlass at sea, was a gifted explorer and navigator, owned a broad strategic vision, could be polished or tough as required, and was a natural leader of men. In 1697, during King William's War, he defeated three English ships at Hudson Bay with a lone vessel, earning the moniker "the most famous son of New France."[43] Therefore, when the Treaty of Ryswick ended the war and the Sun King found himself free to secure the Mississippi Valley for France, Iberville was the obvious choice to carry the project forward (Fig. 11).

French strategists, including Iberville, had long argued for the Mississippi's

[42] *Mobile Register*, March 26, 1937.

[43] R. G. McWilliams, *Iberville's Gulf Journals*, 3.

colonization. Not only would this give France control of a highly lucrative fur trade, but it would hem the English on the Eastern Seaboard and put New Spain's rich mines within striking distance. "If France does not seize this most beautiful part of America and set up a colony," Iberville emphasized, "the English colony which is becoming quite large, will increase to such a degree that, in less than one hundred years, it will be strong enough to take over all of America and chase away all other nations."[44]

Iberville made three voyages to the Gulf between 1698 and 1702 in pursuit of this scheme. During the first he successfully located the Mississippi's labyrinthine, muddy outlet from the sea, a task that had eluded La Salle, and he even explored upriver some distance. The marshy, log-cluttered expanses along the river's lower reaches were unsuited to human habitation, so he built Fort Maurepas at Biloxi to hold France's claim. He would have preferred Pensacola Bay, the deepest along the northern littoral, but the Spanish, alarmed by French plans, had already erected a pine-log fort there. On his second voyage Iberville further probed the coast, looking for a better place to settle. Upon his return to France, he recommended Mobile Bay. Though generally too shallow for vessels drawing more than eight feet, it possessed significant advantages for the French. To begin with, there was a very good harbor at its mouth, on the southeast side of Dauphin Island, that could accommodate the largest ships.

Secondly, it was closer to the English colonies than the Mississippi, and its river system penetrated the interior, providing handy canoe routes. The French could use these watery highways to forge alliances with indigenous groups that would deter English influence. Lastly, the friendly Mobile Indians dwelt on a high bluff 27 miles north of where the river spilled into the bay. These descendants of Tascalusa's brave people were much reduced by disease and war since De Soto's *entrada* and were eager for French protection (FIG. 12).[45]

After a third successful Atlantic crossing, Iberville's flag ship *Renommée* hove into Pensacola Bay on December 16, 1701. A painful abscess in his side prevented his proceeding directly to Mobile Bay, where he had already ordered his younger brother Bienville to clear Twenty-seven Mile Bluff. France and Spain enjoyed a tentative alliance, partially reinforced by their shared fear of the English, and Iberville hoped for some recuperation at Pensacola before sailing west to join the arduous task of carving a settlement out of the wilderness.[46]

[44] Isbell, *The Mississippi Gulf Coast*, 3.

[45] Giraud, *A History of French Louisiana*, vol. 1, 31-39. All further references to this source, unless otherwise specified, are to vol. 1. The French initially called Dauphin Island Massacre Island for the profusion of human bones they discovered there. These turned out to be the remains of Mobile Indians who died in an epidemic and were deposited on the island. In order to soften the coast's reputation, the French renamed the island Dauphine after the French princess, which was soon shortened to Dauphin. See Sledge, *The Mobile River*, 39.

[46] Higginbotham, *Old Mobile*, 26-29.

Pensacola's Spanish commander, Francisco de Córcoles y Martínez, was not happy about Iberville's mission but, cognizant "of the close alliance of the two Crowns," he pledged whatever help he could offer. As it was, he could not offer much other than a pilot and permission to anchor, since the Spaniards were practically destitute. Their fort was already rotting, the men were disgruntled, and they had no vessel reliable enough to reach either Havana or Veracruz for supplies. Iberville graciously proffered his assistance, "whether men, provisions, or stores," hoping De Córcoles y Martínez would make "use of them as if they were entirely at your disposal."⁴⁷ During several weeks' layover at Pensacola, Iberville ingratiated himself by sharing food and lending a boat to the garrison, knowing peaceful relations were critical to his sovereign's purpose. All signs pointed to a mutually

⁴⁷ Ibid, 30 and 32.

12. Mobile Bay. Iberville first saw it through chilly mist in 1699. A subsequent visit convinced him that, though shallow, it suited French purposes {CC}

beneficial if occasionally uncomfortable coexistence.

At last, on a blustery March 1, Iberville was healthy enough to journey to Fort Louis de La Louisiane, as the French officially dubbed their town. Informally, however, everyone called it Mobile, in honor of their new indigenous allies. On March 3, Iberville wrote in his journal: "We reached the settlement, 1½ leagues above the place where we stopped for the night. I found my brother De Bienville there, busy building a fort with four bastions, laid one upon another and dovetailed at the corners, having the trees cleared away, and supervising the work on the pinnace [a small sailing vessel], her timbers soon to be bent."[48] The fort was tiny by European standards, only 140 feet long per side, but adequate. One of the carpenters described "six

[48] R. G. McWilliams, *Iberville's Gulf Journals*, 167-168.

pieces of cannon"⁴⁹ at each bastion and four buildings within—Bienville's balconied quarters, a warehouse, barracks, and a chapel. Iberville had ordered the pinnace built in order to better manage both the shoals and choppy expanses of area waters (FIG. 13).

Once on site, Iberville immediately pitched in, helping to lay out the streets and dispatching men in different directions for timber, tools, and a dozen other things. Satisfied that matters were proceeding well at the fort, he journeyed upstream to broker peace between the warring Chickasaws and Choctaws and ally them with the new colony. To the delight of the Mobile Indians, beleaguered by the Chickasaws, he succeeded. After less than a month at the bluff, Iberville departed once again for France. He stopped briefly at Havana hoping to broker trade deals, but the threat of yellow fever sped him on his way.

On May 25, 1703, a Spanish infantry captain visited the new French settlement and was impressed by what he saw. "In one year [they] have made a very elegant fort," he informed his superior at St. Augustine, Fla. "They have built more than a hundred very pretty houses in the plaza, and the lands and forests are very good, [so] that if they remain, these will make a great place." Most of the dwellings were half-timbered, which the French dubbed *poteaux-sur-sole* for post-on-sill, with the spaces infilled by *bousillage*, a rough blend of clay, grass, and moss. Based on the large number of nails archaeologists have uncovered at the town site, the houses were probably also weatherboarded. Palmetto fronds secured by terracotta ridge tiles formed the roofs. Wooden shutters protected the windows since there was no glass in the colony. Vertical planed boards served as doors. Thanks to a nearby clay pit there were brick thresholds and hearths. Stick-and-mud chimneys thrust above rooflines and, not surprisingly, presented a fire hazard. Most houses had two rooms, and floors were bare earth, soon packed and polished by activity. Furniture included tables, chairs, puncheon benches, and rope beds with Spanish-moss mattresses. Almost every house had a little garden and chicken enclosures made of stick palings. The town's livestock included nine oxen, 14 cows, 100 pigs, and 400 hens. There were no large farms due to the paucity of laborers.⁵⁰

The early population stood at around 350. A 1704 census counted 27 families "that have only three little girls and seven young boys from one to ten years of age," 11 enslaved Indians, 180 soldiers, one Jesuit priest, and three seminary priests. Iberville believed that black slaves were essential to the colony's survival and his brother Bienville had two in his household as early as 1707, but enslaved Africans were not brought in significant numbers until 1719. Canadian *coureurs de bois* (forest runners) regularly came into the settlement to market their peltry and then stayed. Many

⁴⁹ R. G. McWilliams, *Fleur de Lys and Calumet,* 59

⁵⁰ Boyd et al., *Here They Once Stood,* 43. *Old Mobile Archaeology,* 13-17 and 10.

13. *Plan of the town and fort of La Mobile*, 1702. Early French Mobile depended heavily on Spanish help from Havana. Overseas National Archives, Aix-en-Provence, France

of these rowdies preferred to live in the woods with their Indian concubines. Given the dearth of European women, French officers also bedded their slaves. The priests baptized the resulting children and fulminated, but in far off France the indefatigable Iberville was at work on a solution.[51]

As early as the summer of 1701, Iberville requested European women for the colony. "If you want to make something of this country," he wrote to the French Minister of Marine, Comte Pontchartrain, "it is absolutely necessary this year to send some families and a few girls who will be married shortly after their arrival." In a follow-up letter he emphasized that they should be "sensible and well-built." Pontchartrain agreed, but was adamant that they be "young, well raised girls" rather than the "debauched" denizens of the workhouses or jails. He sweetened the deal by promising to support them for a year. The Bishop of Quebec, whose diocese included Louisiana, was in France at the time and agreed to select the girls. During the summer of 1703, he recruited over 20, mostly the convent-schooled daughters of middle-class artisans. He assured the minister that they had been "raised in virtue and piety" and knew how "to work." He neglected to add that he had portrayed Louisiana as an earthly paradise.[52]

The girls were certainly young, ranging in age from 14 to 19. They included Marie Briard, Elisabeth Deshays, Catherine Christophe, Marie Philippe, and Gabrielle Savarit. In the autumn they made the arduous 300-mile journey from Paris to the seaport town of Rochefort, where Louisiana was far better known, and the girls doubtlessly heard unsettling tales of wild Indians, sterile soil, and ravening hunger. Nonetheless, 24 of them courageously boarded the 56-gun *Pélican*, along with two nuns hired as chaperons, a midwife, a tool maker, a carpenter, a near-sighted priest, several families, and two companies of soldiers. Unfortunately, due to illness, Iberville could not join them.

The ship rode the swell in the roadstead for weeks, awaiting favorable weather, the passengers and crew packed uncomfortably close. Despite that, the girls' chaperons made sure there was no mingling between the vessel's rougher elements and their charges. The *Pélican* finally departed on April 19, and nearly three months later arrived off Havana (Fig. 14). Since none of the girls left diaries or letters, it is impossible to know exactly what they were thinking. Doubtless they were relieved that the months of tedious tossing were nearly over. The tropical heat was a disagreeable change from cool, gray Paris, but the *Pélican* had already been weeks in warmer seas, easing the transition. Ranging the ship's rail, the girls could see Cuba's green hills and swaying palms, and then the inviting enclave of Havana Bay, where they could rest and stretch their legs before the final portion of the voyage.[53]

51 Waselkov, *Old Mobile Archaeology*, 10. Giraud, *A History of French Louisiana*, 177-181. Higginbotham, *Old Mobile*, 132.

52 Allain, "Manon Lascaut et ses Consoeurs," 18. Giraud, *A History of French Louisiana*, 150 and 151.

53 Giraud, *A History of French Louisiana*, 153-154.

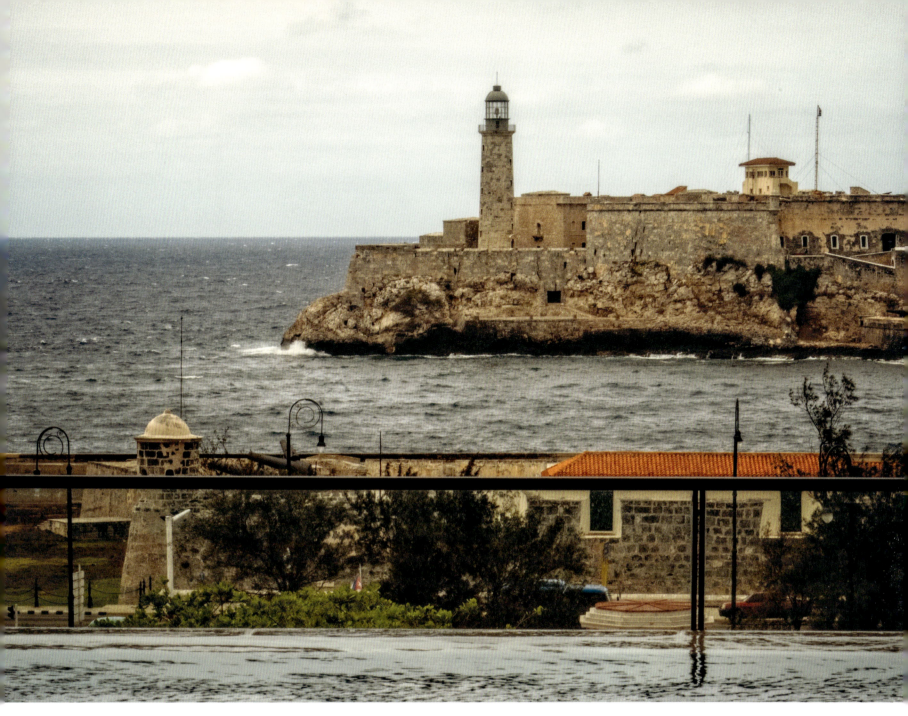

14. The Morro Castle at the entrance to Havana harbor. The *Pélican* girls passed beneath these same battlements over three centuries ago {CC}

The city that the *Pélican* Girls encountered was far different from that of De Soto and Isabel de Bobadilla nearly two centuries earlier. Three stone forts now guarded the harbor. The Castillo del Morro, featuring a formidable battery dubbed the "Twelve Apostles," perched on the east side of the entrance. The Castillo de la Punta sat opposite. At night a large chain stretched between the forts sealed the harbor. Farther in on the west side brooded the much-improved Castillo de la Real Fuerza with *La Giraldilla* visible atop its tower. Deeper inside yet was the Royal Shipyard with cranes, wharves, administrative offices, carpenter's shop, ironworks, and tool sheds. An Italian adventurer named Giovanni Francesco Gemelli Careri visited in 1697 and described the city as "half a league in compass," with one-story houses protected by "poor, low walls on the land side." In actuality, these walls were five feet thick and 20 feet high, intended to deter both small pirate raids and fully equipped European armies. Gemelli

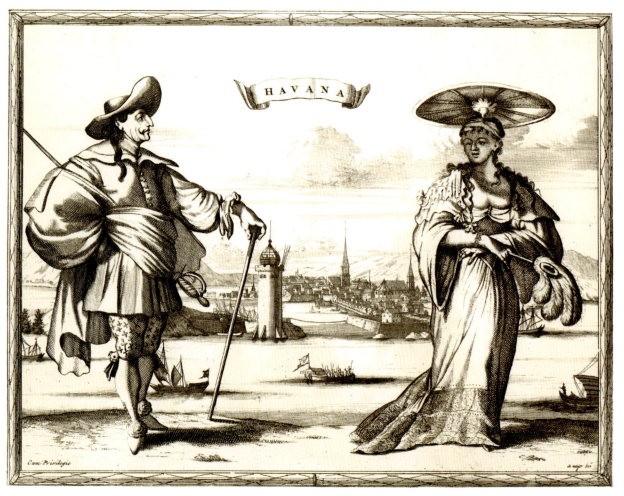

15. Aldert Meijer, Havana, ca. 1700. The *Pélican* girls encountered a city that was nothing like the fanciful images published in Europe, often the work of illustrators and engravers who knew the city only from travelers' accounts. New York Public Library

Careri went on to enumerate the cathedral, churches, a monastery, convents, and other examples of Catholic devotion including monastic cells, altars, and clergy in the streets. As for the people, who numbered around 25,000, he pronounced them a mix of "Spaniards, Mulatos, and Blacks," the women "beautiful" and the men "ingenious" (FIG. 15).[54]

As soon as the *Pélican* anchored in the harbor, Diego Evelino Hurtado de Compostela, Bishop of Cuba, appeared and welcomed the girls. Diego Evelino was a native Spaniard, well into his seventies, deeply learned, gentle, soft-spoken, pious, and a talented administrator. He walked everywhere rather than ride in a pretentious carriage and ministered to high and low alike. In 16 years, he had established numerous rural parishes, built churches, founded convents, schools, and orphanages, and endeared himself to everyone. The bishop received the girls with "charity and magnificence" and whisked them off to the Collegium Virginium (College for Young Women) where they could refresh themselves and recover from the long voyage. During the following week he personally toured them through Havana's charming gardens and religious landmarks (FIG. 16). The girls' accommodations were good, but there was no relief from the tropical heat at night,

[54] Gemelli Careri, *A Voyage Round the World*, 567.

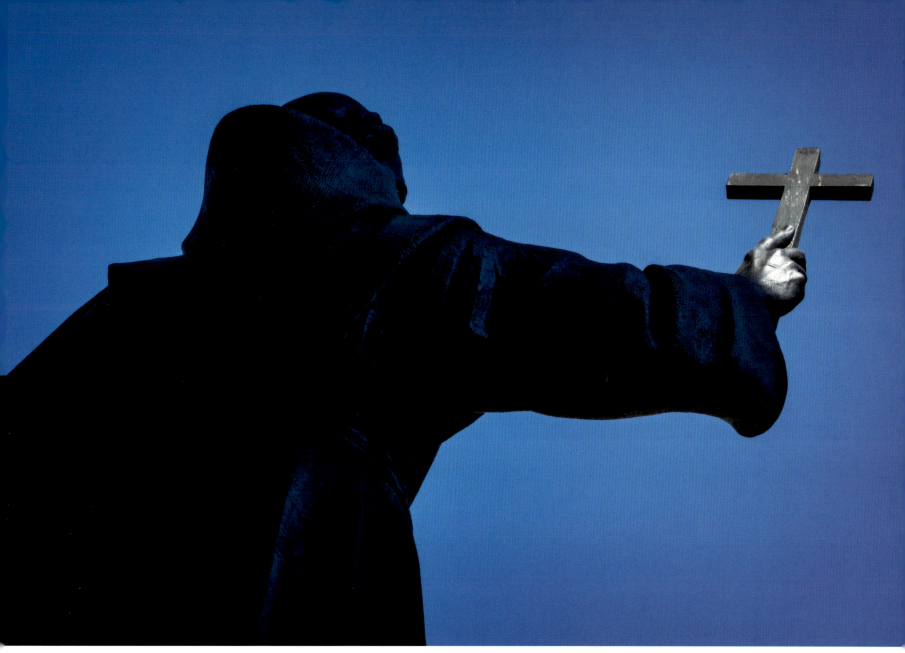

16. Courtyard statue, Church of San Francisco de Asís, Havana. Catholic symbols abound in the city today, just as they did during the early 1800s {CC}

and whining mosquitoes made sleep difficult.[55]

While the girls were enjoying Diego Evelino's hospitality, the *Pélican's* captain attempted to trade with the local merchants. Unfortunately, the negotiations were complicated by the Spanish government's draconian limits on buying or selling foreign goods. This augured poorly for sustained commerce between Mobile and Havana, but the French did manage to sell a few barrels of flour and acquire a healthy milk cow for the girls.

Finally, on July 14 everyone was back on board and the *Pélican* set sail. She was hardly a day out of port, however, when people began to sicken and die. Mobile's long-awaited brides now carried a fearful contagion, yellow fever.[56]

The *Pélican* dropped anchor at Dauphin Island after an eight-day run. She was at that point an afflicted and burdened vessel, a pest ship. On shore, burials were the first order of business. It is not hard to picture the girls, feverish and huddled together on a desolate sandy island, the only buildings visible a few thatch

[55] Currier, "The Church of Cuba," 135. Higginbotham, *Old Mobile,* 170.

[56] Higginbotham, *Old Mobile,* 171-173.

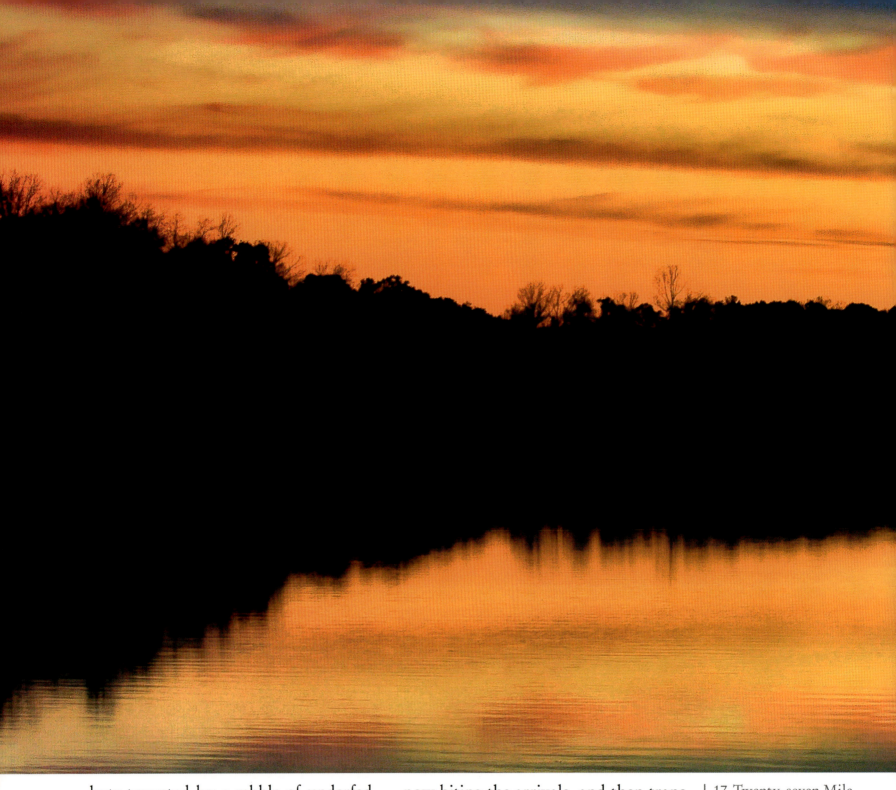

huts tenanted by a rabble of underfed, sunburned rustics, while the priest squinted in the bright Gulf sun and mumbled prayers over the departed. They did not reach Fort Louis until August 1, ferried upstream in small boats and canoes (Fig. 17). When they arrived, a gaggle of soldiers and settlers eagerly crowded the riverbank for a glimpse of the long-anticipated brides. Unfortunately, local mosquitoes were now biting the arrivals, and then transmitting the dread fever to the residents. By the time the resulting epidemic was over weeks later, three of the girls had perished, along with over 40 settlers and an unknown number of Mobile Indians. The fearful disease did its work at Havana as well, and among those lost was the beloved Diego Evelino. During his funeral service, distraught mourners attempted to tear off bits of his clothing

17. Twenty-seven Mile Bluff, Mobile's original site, is nearly 60 miles from the Gulf. "Lonely enough those Frenchmen must have felt in their river fort," a local historian wrote, "far from the sea, and thousands of miles from France" {CC}

as relics. Life, however, went on at both places. In Mobile, an artisan remarked that the girls "were quite well behaved, and so they had no trouble in finding husbands." Eventually there were children, and some of the unions appear to have even been happy. But Gulf Coast living was to be a struggle for all.[57]

The War of the Spanish Succession (1702-1714), which pitted France and Spain against England, thwarted Iberville's intention to return to Mobile. In 1705 he commanded a fleet that conquered the British islands of Nevis and St. Kitts. He then sailed into Havana Bay, where he began planning an attack

[57] Ibid, 175-177. Waselkov, *Old Mobile Archaeology*, 23-24. Torres-Cuevas, *En busca de la cubanidad*, tomo 1, n.p. R. G. McWilliams, *Fleur de Lys and Calumet*, 97.

18. Letter from Cuban Governor Luis Chacón to the Spanish King on the death of Captain General Pedro Alvarez de Villarín and Pierre Le Moyne d'Iberville (identified as Berbille in this letter), who both died July 8, 1706 of yellow fever in Havana. Mobile Municipal Archives

on Charleston with Cuba's new governor, Pedro Álvarez de Villarín. While there he illegally sold goods and iron tools—an astonishing 25,000 pounds of the latter—that he had secreted in the holds of his ships. Virtually everybody of any importance in the French fleet was involved, from captains to clerks and mates, and the resulting scandal prompted an official French investigation that dragged on for 35 years. Pontchartrain was disgusted and grumbled that Iberville was guilty of "misery" and "disorder."[58]

Unfortunately for Iberville, he did not live to enjoy his profits. Havana's summer of 1706 was just as pestilential as that of 1704 when the *Pélican* had arrived. Yellow fever was again winnowing the population, and both Iberville, 45, and Álvarez de Villarín,

42, died on July 8. Sobered by the passing of two such prominent figures on the same day, numerous officers, soldiers, officials, and common folk attended the funerals. The Church of San Cristóbal held their remains. The present Cathedral replaced this modest building after an accidental explosion in 1741 (Fig. 18).[59]

Even though Iberville's remains were lost, neither Havana nor Mobile forgot him. In fact, his memory proved a useful tool to rebuild their old acquaintance. On June 21, 1994, over 57 years after the *Comité France-Amerique* presented its handsome bronze plaque at the Plaza de la Catedral, Mobile Mayor Mike Dow and members of the Society Mobile-La Habana visited Cuba. Eusebio Leal, Havana's eloquent City Historian, gave them a guided tour. With characteristic flair, Leal ushered

[58] Giraud, *A History of French Louisiana*, 114-125 and 123.

[59] Higginbotham, *Old Mobile*, 284-285.

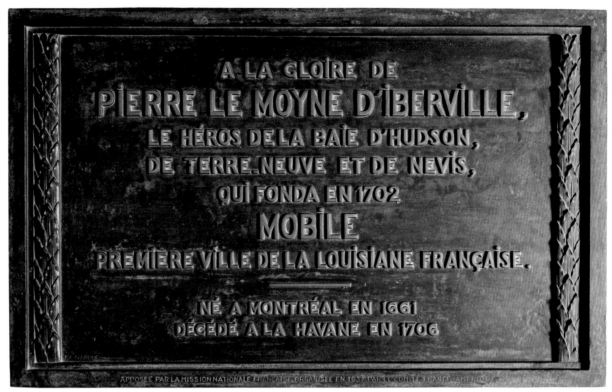

19. Plaque in honor of Iberville at the Palacio de los Capitanes Generales in Havana {JL}

the Mobilians into the Palacio de los Capitanes Generals, and proudly pointed to the beautifully maintained Iberville marker with its handsome block letter French inscription. In translation it reads: "To the glory of Pierre Le Moyne D'Iberville, the hero of Hudson Bay, Of Newfoundland and Nevis, Who founded in 1702 Mobile, First City of French Louisiana. Born in Montreal 1661, Died in Havana 1706." The largest words on the plaque are Iberville's name and Mobile (Fig. 19). "You are at the very heart of our relationship," Leal proclaimed. Visibly moved, Dow exulted, "This is magnificent!" Camera shutters clicked, and the guests pressed forward to bask in the artifact's aura. Dow's visit was not to be the last celebration of Iberville's binding role. Another was to come, and its waterfront manifestations were to be more visible and imposing in both cities.[60]

[60] *Mobile Register,* June 22, 1994.

The British captured Havana in 1762 despite its formidable defenses, like these cannons that guarded the entrance to the bay. The forces that fought on both sides clashed again 18 years later in Mobile
{JL}

TWO SIEGES: THE "BLACK PRINCE," THE ENGINEER, AND THE GENERAL

The Castillo del Morro stood wreathed in smoke from the British bombardment, its gray-stone gun embrasures desultorily spitting flame and iron in response. Lt. Elias Durnford, 24, of the Royal Engineers observed the awesome spectacle from a battery several hundred yards away. Massive 13-inch mortar shells traced fiery arcs high into the air before descending into the Castillo to explode with resounding booms. Long black cannons belched 24-lb. shot that hurtled into the stout bulwarks, sending white dust and stone chips flying. Hard by the fortress's sea side, British warships maneuvered close and unleashed rippling broadsides that harmlessly pocked the cliff face below the actual fortress.[61]

It was the summer of 1762, well into the Seven Years War that pitted Britain against France and Spain in what was very nearly a worldwide conflict. As part of its overall strategy, Britain determined to seize Havana, Spain's prized Caribbean asset. Their invasion force, consisting of over 150 warships and transports loaded with 25,000 soldiers, sailors, and enslaved laborers, arrived in early June, achieving complete surprise. The Spaniards trusted their formidable harbor fortifications, boom chain, yellow fever, and the hurricane season to humble the audacious foe. The overall British commander, George Keppel, the Third Earl of Albemarle, was abundantly aware of his vulnerability and expected men like Durnford to reduce the harbor defenses, especially El Morro, before disease decimated his ranks. But by July 30 the siege was nearly two months underway with no surrender in sight. Thousands of soldiers and sailors were feverish, and many were dying daily.[62]

Durnford was no neophyte. He had already seen action in France and was a useful man, lauded for his invention of a machine to make "stale and nauseous water sweet." Born in 1739 to an official at the Tower of London, he joined the Royal Engineers at a callow 20, demonstrating a talent for surveying and drawing. Nicknamed the "Black Prince" for his dark good looks, he was energetic and popular with the troops. Despite his father's somewhat privileged position, Durnford "embarked for the siege of the Havannah, without a single recommendation to any General Officer in the army, trusting to my inclination and zeal for my King and country's service as the surest and best path to their notice."[63] It was a good gamble. Albemarle was so impressed by Durnford's ability that he made him an aide-de-camp.

Under fire in Cuba, Durnford knew to keep out of the way of the sweating artillerymen

[61] Schneider, *The Occupation of Havana*, 131-134.

[62] Cluster and Hernández, *History of Havana*, 22-23.

[63] Hamilton, *Colonial Mobile*, 534. Stapley, "Making Stale and Nauseous Water Sweet!" Durnford, *Family Recollections,* 23 and 81.

as they bustled beneath the searing sun. His primary responsibility was to maintain the siege works, which thanks to the rocky ground were a less than substantial barrier of sand bags lugged up from the beach and bundles of tree limbs called fascines.[64] The Spaniards' well-aimed counterbattery fire scattered both sandbags and fascines and knocked the siege guns off their carriages. Durnford would then rush men to the spot for emergency repairs.

Inside the Castillo, Second Lt. Antonio Fernández Trevejo de Zaldivar had a much tougher job. Like Durnford, he was a wellborn 24-year-old who had already done much to distinguish himself. A good student, especially in mathematics, he had joined the Regimiento de Infantería Fijo de la Habana (Havana Fixed Infantry Regiment) as an engineer at age 14. His first assignment when the British invaded was to help hold a fortified tower on the Almendares River. Trevejo proved brave in action, but the tower became untenable when the troop's ammunition was exhausted. The defenders evacuated, and Trevejo transferred to El Morro. Fortunately, the Spanish held the harbor and could ferry supplies and replacements over regularly.[65]

Even with that advantage, conditions inside the Castillo were hellish. Trevejo endured suffocating heat and humidity, earth-shaking explosions, and flying debris. Orders were almost impossible to hear amidst the noise and confusion, and smoke and dust limited vision. Like Durnford, Trevejo had to respond to damage as quickly as possible. In his case, this meant directing enslaved laborers toward the problem areas. These men were incredibly brave, remounting heavy gun tubes and refilling blasted openings even as the bombs fell around them. Hundreds perished.[66]

On July 30 the deadlock finally broke when the British successfully detonated a mine under the Castillo's eastern bastion. One besieger described hearing "a very grand explosion in oure faver." A large breach yawned, and debris spilled down the cliff face into the surrounding dry ditch and the sea. Two thousand British grenadiers rushed the gap with what another witness called "coolness and intrepidity." Their blood up, the grenadiers put to the sword numerous defenders at the lighthouse, including slave laborers. Trevejo escaped such a fate, likely because he was an officer. The British paroled him and his fellow officers and sent them to Spain on condition that they would not fight for the remainder of the war (FIG. 20).[67]

Havana surrendered on August 14, and the British occupied it for the next 11 months. Durnford wrote that during this period he was "employed constantly" in surveying the city and

[64] Schneider, *The Occupation of Havana*, 134.

[65] Pezuela, *Diccionario geográfico, estadístico, histórico de la Isla de Cuba*, 597. Some sources, including Pezuela, spell the name Trebejo, but I have chosen the more common Trevejo.

[66] Schneider, *The Occupation of Havana*, 114-120. One source counts 900 enslaved laborers killed at El Morro during the entire siege. See Pezuela, *Diccionario geográfico*, 51.

[67] Park, "A Journal of the Expedition Against Cuba," 242. *An Authentic Journal of the Siege of Havana by an Officer*, 34. Pezuela, *Diccionario geográfico*, 597.

20. July 30, 1762, the defenders of El Morro had no alternative but to surrender {CC}

surrounding country. Lord Albemarle also recognized his artistic talents and requested that he sketch noteworthy scenes. Durnford dutifully produced several beautiful drawings. These were sent to London where they were engraved on copper plates, printed, and published in 1764 as *Six Views of the City, Harbour & Country of the Havana by Elias Durnford, Engr.* Widely praised since as the first accurate depictions of Cuban scenery and life, the portfolio includes three landscapes: a harbor scene "taken within the wrecks" (behind the Spanish obstructions looking outwards), the Church and Convent of San Francisco de Asís (Fig. 21), and the market square, now the location of Plaza Vieja. The landscapes highlight palm trees, banana trees, and aloe, all considered exotic plants by the northern Europeans at the time, with the city in the distance. The two urban views carefully depict sophisticated architectural elements like the basilica's 130-foot-tall bell tower and the market square's plashing fountain surrounded by arcaded first stories, balconied second stories, and barrel-tile roofs. Durnford outdid himself in the market square scene, which is notable for its animated human foreground—redcoats in formation, jack tars glaring at three huddling Franciscans, two boys stick fighting, a woman with a basket on her head, and a coach-and-four clattering by.[68]

Fortunately for Durnford, he escaped the yellow fever that laid so many of his comrades low, and he returned to England after the occupation. A request that he meet with King George III to explain the siege using a large model of El Morro failed to reach him, causing him to lament, "I lost the opportunity of being known to my sovereign at the time."[69] There was no such near brush with fame for Trevejo, but he rejoiced in his return to Cuba from Spain.

The various treaties that ended the Seven Years War radically altered the European balance of power in the Americas, including relations between Havana and Mobile. France was the big loser, ceding Canada, Louisiana (including New Orleans and Mobile) and the entire Mississippi Valley. Spain regained Havana and won Louisiana west of the Mississippi River and New Orleans east of it. Excluding the latter city, the British took Louisiana east of the Mississippi, which gave them Baton Rouge and Mobile, and Florida, which gave them St. Augustine and Pensacola. They promptly formed a new colony named British West Florida, which stretched between the Mississippi and Apalachicola rivers. The capital was at Pensacola, and Mobile, which the French had moved downstream to its present-day site in 1711, became an important outpost and trading center.[70]

[68] Vega García, "La Habana durante la ocupación inglesa. Grabados de Elias Durnford," 181 and 184. Several color renderings of Durnford's work by the painter Dominic Serres are included in the plate gather between pages 144-145 of Schneider's *The Occupation of Havana*. The most stunning presentation of Durnford's work that I have seen is in Lapique Becali and Larramendi Joa, *La Habana: Imagen de una ciudad colonial*, 79, 84-91.

[69] Durnford, *Family Recollections*, 8.

[70] Sledge, *The Gulf of Mexico*, 79-80. Bunn, *The Fourteenth Colony*, 6-9.

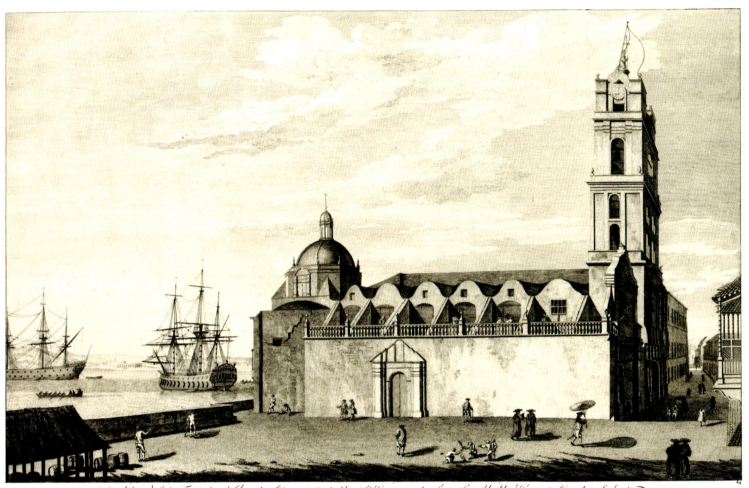

21. Elias Durnford, *A view of the Franciscan Church & Convent in the City of Havana*, 1764. Sketched after the British siege. Library of Congress

Durnford and Trevejo were both put to further work by their respective empires. Durnford's outstanding achievements netted him an appointment as Surveyor General and Provincial Engineer of British West Florida on June 23, 1764. Trevejo's engineering skill under pressure earned him important roles in repairing El Morro and constructing a massive new bastion along the bluffs to the south, the Fortaleza de San Carlos de la Cabaña. He briefly served at New Orleans in 1769. Little is known of his efforts there, but shortly afterwards he returned to Havana, where he worked on some of that city's most iconic landmarks, including the Palacio de los Capitanes Generales, the Palacio del Segundo Cabo, and the promenade at the Alameda de Paula.

Among Durnford's first tasks in Florida were a town plan for Pensacola and surveys of area waters. In 1771 he produced a detailed map of Mobile Bay for the Admiralty, complete with depths, shorelines, feeder streams, and prominent place names. Conditions at his new post were considerably more primitive than in long-settled Cuba. Pensacola and Mobile were lightly peopled military garrisons surrounded by a few plantations and vast numbers of indigenous groups of shifting loyalties. Sobered by his vulnerability, Durnford wrote to his overall commanding

officer, "we are certainly the Western Barrier of America."[71]

Durnford became the colony's lieutenant governor in 1769 and 10 years later commandant at Mobile's Fort Charlotte. War was once again looming as the American colonies agitated for independence, France sought an advantage against its old foe, and Spain itched to avenge Havana. Mobile would be difficult for Britain to defend. It was a far cry from Havana's formidable stone forts, sophisticated churches, cobbled plazas, and multi-story shops and houses. In 1775 a visitor remarked that it was "mostly in ruins, many houses vacant and mouldering to earth."[72] There were, of course, some durable buildings left from the French period, brick-and-plaster one-story dwellings with wide verandahs and attractive gardens. But the population stood at only 800, compared to Havana's 70,000.

As at Havana, the summer heat was enervating, disease omnipresent, and hurricanes an annual menace. One 1772 storm drove boats and logs well up the riverside streets, and according to one eyewitness, "all the vegetables were burned up by the salt water, which was by the violence of the wind, carried over the town." The brick fort was in appalling condition, with weak walls, rotted gun platforms, leaking buildings, and bad well water. Additionally, hogs rooted about the fort's eroded and overgrown glacis.

One British officer opined that the bastion was "not tenable against a party with small arms." Jacinto Panis, a Spanish spy, agreed. "The fortifications are in a very bad condition," he reported. "Almost all the artillery is dismounted, and the trenches in some places are choked up." As if all that wasn't enough, Durnford commanded a sickly force of only 113 regulars, 60 seamen, 54 civilians, two surgeons, and 51 armed blacks, some enslaved and some free.[73]

And then came Don Bernardo de Gálvez, a virtual force of nature. When the Thirteen Colonies rebelled against King George III, he was serving as the governor of Spanish New Orleans at only age 30, but already owned a long military career that included European service and Apache wounds. He was a determined and brave officer, fair-minded in war and gentlemanly in peace, genuinely popular, and his uncle was the powerful minister of the Indies. When Spain allied with France against Britain in 1779, Baton Rouge, Mobile, and Pensacola immediately became attractive targets to the aggressive governor. Even though the Spanish sovereign did not officially recognize the infant United States, the shrewd Gálvez grasped their common interest, namely defeating the British. War declared, he acted quickly and moved a small force upriver, seizing Baton Rouge in a nearly bloodless campaign.[74]

[71] Bunn, *The Fourteenth Colony*, 40; Rea, "Redcoats and Redskins," 9.

[72] Van Doren, ed. *The Travels of William Bartram*, 324.

[73] Romans, *A Concise Natural History of East and West Florida*, 5. Rowland, *Mississippi Provincial Archives, 1763-1766*, vol. 1, 9. Ferreiro, *Brothers at Arms*, 137. Gray, "Elias Durnford, 1739-1794," 68.

[74] Hamilton, *Colonial Mobile*, 310-312.

Mobile was next, and there were good strategic reasons for attacking it. To begin with, it was next closest, and would provide an important base from which to hit the better-fortified Pensacola. Should a Pensacola attack go badly, Mobile represented a strong fallback position. Perhaps more importantly, Mobile's abundant cattle could feed an army, and Gálvez preferred it be his rather than the enemy's. Taking Mobile would also cut off the British from their Choctaw and Chickasaw Indian allies. Lastly, Gálvez believed the local French residents would welcome rule by fellow Catholics rather than English Protestants.[75]

Gálvez knew that he did not have enough troops in Louisiana to topple the British outposts to the east. At most he could muster some 800 men, a mix of Spanish regulars, militia, free blacks, slaves, and a few Americans. Therefore, he lobbied Havana officials for naval and troop support, prompting one of them to exclaim: "What do we have with Mobile and Pensacola? This [Havana] is more valuable than fifty Mobiles and Pensacolas." That was certainly true, but British West Florida represented a potential threat to Cuba, as Gálvez insisted. Eventually Havana sent a frigate, two brigantines, a sloop, and a galley carrying over 500 soldiers from the Navarra and Havana Fixed Infantry regiments. But just getting to Mobile proved vexatious for Galvez. During January 1780, contrary weather scattered his fleet when it exited the Mississippi River, and the Havana squadron battled Gulf storms.

Finally, Gálvez's contingent made the mouth of Mobile Bay where churning waves and strong currents grounded six ships on sandbars. Ignoring naysayers who urged he cancel the attack, the resolute general put his men ashore on Mobile Point and refloated three of the vessels.[76]

During the following days the ships moved further up the bay, even as the Cuban reinforcements arrived. Gálvez remained constantly visible, inspiring his men and urging them forward. By late February he had established a camp on Dog River and sent the row galley *Valenzuela* to harass the British. Not surprisingly, Trevejo was in the ranks, there being much work for an engineer. By month's end the intrepid Spaniards had a battery under construction within 2,000 yards of Fort Charlotte (roughly where Broad Street is today). It was time to parley.[77]

On March 1, Gálvez sent forth a young officer with a note addressed to Capt. Durnford. As Durnford watched the officer approach under a flag of truce, he could not have felt confident about his chances. He was 40 years old and still fit, but his garrison was "in a sorry state," as he himself declared. By way of preparation, he had done little more than burn the surrounding houses to clear fields of fire and reposition his cannon. Gálvez's emissary cordially greeted Durnford, and the two

[75] Duval, *Independence Lost*, 168.

[76] Ibid, 169. Medina Rojas, *José de Ezpeleta, gobernador de La Mobila, 1780-1781,* 9. The translation is my own.

[77] Coker and Hazel, *The Siege of Mobile, 1780, in Maps,* 76-79.

retired to the latter's quarters where they dined and toasted each other's sovereigns. Gálvez's missive informed Durnford of the disparity between their forces, emphasizing the wisdom of a British surrender. If Durnford chose to fight, it darkly stated, the British faced "all the extremities of war." While the emissary waited, Durnford penned a polite but firm reply. "The difference of numbers I am convinced are greatly in your favor, Sir, but mine are much beyond your Excellency's conception, and was I to give up this Fort on your demand, I should be regarded as a traitor to my king and country. My love for both and my own honor direct my heart to refuse surrendering this Fort until I am under conviction that resistance is in vain" (FIG. 22).[78] With Durnford's answer in hand, the Spanish officer bid him farewell.

While the Spaniards continued advancing their zigzag siege trenches and the English warily watched, Durnford and Gálvez engaged in further correspondence and an exchange of coded gifts. On March 5, Durnford sent a sergeant under a flag of truce to check on British prisoners. The sergeant carried a short note from Durnford, a dozen bottles of wine, a dozen chickens, a lamb, and freshly baked bread. Besides the stated business, the gifts were meant to communicate an important message, namely that the garrison was well-supplied and ready for a long siege. Gálvez responded in a like spirit, writing, "I am deeply honored by the courtesy you have done me by sending me a snack." In return he sent Durnford lemons, oranges, biscuits, cakes, bottles of Spanish wine and French Bordeaux, and a case "of cigars from Havana." The food items highlighted the besiegers' own abundance; the wines, their powerful alliance with France; and the Cuban cigars, their navy's control of the Caribbean and Gulf basins.[79]

Meanwhile, a British relief force was en route from Pensacola, but bad weather and muddy roads prevented its timely arrival. At last, at 10 a.m. on March 12, Gálvez ordered his batteries to fire. The British guns replied, and all day the balls flew back and forth. Just as Gálvez had predicted, the contest was an unequal one. The Spaniards' shots dismounted several British guns and breached the fort's weak walls in two places. Despite the racket and destruction, casualties were low with only one redcoat killed and a few wounded. But the British ran out of ammunition, and at sunset a white flag fluttered from Charlotte's ramparts. After a brief negotiation, Gálvez allowed Durnford's troops to march out of the fort's breaches with flags flying and drums beating. The redcoats stacked muskets outside, but the officers were allowed to keep their swords in accordance with military custom. Durnford proudly reported, "No man in the garrison stained the luster of the British arms."[80]

[78] Sledge, "The Siege of Mobile, 1780," 73. Quintero Saravia, *Bernardo de Gálvez*, 167. Hamilton, *Colonial Mobile*, 314.

[79] Quintero Saravia, *Bernardo de Gálvez*, 168 and 169.

[80] Duval, *Independence Lost*, 170-171. Hamilton, *Colonial Mobile*, 315.

22. Fort Condé reconstruction, 1976, Mobile. One third of the fort was reconstructed at four-fifths scale for a U.S. Bicentennial project. The original was not so impressive. At the time, Durnford considered it "in a sorry state" {CC}

Gálvez proved to be a gracious conqueror. He agreed to transport the British soldiers to a friendly port provided they promise not to take up arms against Spain for 18 months and was solicitous toward Durnford's wife and their newborn child. As for his own men: "I thanked them on behalf of the king for their resolution in facing all of the hardships we endured, and for the zeal, courage, and determination that they displayed to achieve success." In addition, he offered them a third of the value of everything taken at the fort and doled out promotions. It was a stunning success, hailed on both sides of the Atlantic. In Paris John Adams heard the news and exulted that "the English are on the losing hand."[81]

Gálvez capped his triumph the following spring when he took Pensacola. British West Florida was now Spanish West Florida. Given command of the entire northern littoral

[81] Quintero Saravia, *Bernardo de Gálvez,* 171. Duval, *Independence Lost,* 176.

in recognition of his services, he was subsequently appointed captain general of Cuba, and shortly after that viceroy of New Spain, or Mexico. He died in 1786.[82]

Havana and Mobile became more closely linked than ever. Schooners, sloops, and brigantines regularly plied the Gulf, ferrying north dispatches and foodstuffs like corn, wheat, rice, and salted meat, as well as specie and materiel for the soldiers at the renamed Fuerte Carlota. On return trips the vessels hauled peltry, lumber, turpentine, pitch, and tar, the latter products vital to Havana's busy shipyards.[83]

As for Durnford and Trevejo, men who had faced one another twice in sieges on opposite sides of the Gulf, each both a victor and a loser in the final balance, they never met. Durnford, promoted colonel in 1794, returned to the West Indies and died of yellow fever at Tobago at age 55. Trevejo briefly remained at Mobile after the siege, tasked with repairing Fuerte Carlota's breaches and adding a *hornabeque*, or hornwork, essentially

23. Spanish Plaza, 401 Government Street, Mobile. This recently refurbished 1960s park celebrates Mobile's Spanish heritage. During the city's Spanish period (1780-1813) Mobile was governed out of Havana {CC}

[82] Quintero Saravia, *Bernardo de Gálvez*, 277-279.

[83] Medina Rojas, *José de Ezpeleta*, 592 and 611.

a bastioned outwork. He served with distinction at Pensacola and returned to Havana where he continued to design and build until his death in 1800. Three men, two empires, two cities, their braided destinies but one yarn in the venerable strand binding Havana and Mobile (FIG. 23).[84]

[84] Hamilton, *Colonial Mobile*, 535-536. Medina Rojas, *José de Ezpeleta*, 216.

Georgia Cottage, ca. 1845. Mid-nineteenth century visitors to Mobile delighted in the city's columned country homes set amid abundant greenery {CC}

SHIPS, PEOPLE, AND COMMERCE: FEMALE WRITERS, SEA DOGS, AND THE DYING POLITICO

The steamboat *Florida* pushed eastward across Lake Pontchartrain late on January 7, 1851, its sidewheels chopping the clear, placid water. A glorious winter sunset painted the western horizon red and gold, while rickety gray wharves, white cottages, and a darkening tree line lay ahead. The boat was making its regular New Orleans-to-Mobile run hauling mail, freight, and passengers.[85] Among the latter was a 49-year-old woman whose securely tied bonnet partly obscured her long face and plain features. But Fredrika Bremer was no ordinary coastal passenger. She was a famous Swedish novelist and women's-rights champion, well into a United States tour. Though her interests primarily concerned social causes, her active, wide-ranging mind devoured everything in front of it. Nathaniel Hawthorne wrote that she was "worthy of being the maiden aunt of the whole human race" (FIG. 24).

Bremer was on her way to Mobile to see yet another celebrity, Madame Octavia Walton LeVert. The 41-year-old LeVert was a prominent socialite and writer whose paternal grandfather was a signer of the Declaration of Independence. She was married to a Mobile doctor, presided over a cultivated salon in their Government Street home, and was a slave owner, which was of particular interest to the abolition-minded Bremer. Madame LeVert greeted her guest at the city quay and ushered her into a nearby carriage. "I found her a short, handsome lady," Bremer recalled. Unfortunately, LeVert was suffering the recent loss of two children and a brother, and so she displayed none of her noted "vivacity and grace"[86] (FIG. 25). But she was too well-mannered and conscientious to shirk her responsibilities to her guest, and she endeavored to cheerfully show off her city and its people.

The Mobile Bremer encountered had greatly changed from the struggling colonial outpost that Durnford, Trevejo and Gálvez had known. It was now the third busiest port in the nation thanks to King Cotton, with a population of 20,000, roughly a third enslaved or free black people. The city's upper echelons consisted of cotton factors, commission merchants, bankers, insurers, lawyers, and doctors. It was a place of business first and foremost, with all the attendant bustle. "With the exception of New Orleans and Havana," one antebellum traveler opined, "there was no commercial mart on the Gulf of Mexico as thriving as Mobile." The riverfront and bay were "crowded with vessels and ships of every possible description," he continued, "while from their masts

[85] Bremer, *The Homes of the New World*, vol. 2, 215-216. Benson, *America of the Fifties: Letters of Fredrika Bremer*, xi.

[86] Bremer, *Homes of the New World*, vol. 2, 216.

24. Alonzo Chappel, *Fredrika Bremer*, 1873, steel engraving. The Swedish novelist exclaimed: "I flourish in Mobile." New York Public Library

25. Thomas Sully, *Octavia Walton LeVert*, 1833, oil on canvas. Historic Mobile Preservation Society

floated the flags of nearly every nation on earth"[87] (Fig. 26). Roustabouts unloaded steamboats arrived from Montgomery and piled the 400-pound cotton bales into teetering stacks. They subsequently stored the bales in brick warehouses, where other workers compressed them to a third of their original size, and then steam tugs lightered them down to the big sailing ships in the lower bay for transport to New England's and Europe's spinning mills.

[87] Amos, *Cotton City*, 86. Morris, ed., *Wanderings of a Vagabond*, 459-460.

MOBILE.
Taken from the Marsh opposite the City near Pinto's residence

26. William J. Bennett, Mobile. *Taken from the marsh opposite the city near Pinto's residence*, 1842, hand-colored aquatint. "There was a good display of shipping at the wharves," one visitor wrote, "vessels of light draughts, and a fine view of steamers, taking in and discharging cotton, the great staple." History Museum of Mobile

In a letter to her younger sister, Bremer enthused about her time in Alabama's seaport. To begin with, the temperature had turned mild, as it often does between cold fronts on the northern Gulf Coast, and her walks on sandy Government Street were pure delight. She marveled at the profusion of "beautiful villas surrounded by trees and garden plots" and gloried in the magnolia blossom-scented air and festoons of Spanish moss (FIG. 27). One afternoon Madame LeVert took her down the Bay Shell Road where the lapping waves charmed, and that evening they attended the theater. The ladies also paid a visit to an encampment of remnant Choctaw Indians on the edge of town, "wild people" who walked into town each day carrying baskets full of kindling to sell. On a visit to the slave market "a few mulatto girls" asked Bremer to buy them. Despite slavery's pall, Bremer enjoyed the city. "I like Mobile, and the people of Mobile, and the weather of Mobile," she exulted to her sister. "I flourish in Mobile."[88]

[88] Bremer, *The Homes of the New World*, vol. 2, 217 and 219.

27. Tree-canopied allée, Stewartfield, Mobile. Madame LeVert took pride in touring Bremer all over town
{CC}

By week's end the two women had grown quite close despite their differences regarding the slavery issue. LeVert agreed that the institution "is a curse" but nonetheless heavily depended upon Betsy, her personal servant. Bremer admired Octavia and Betsy's mutual affection. She invited her new friend to accompany her to Cuba, where she believed the tropical scenery would prove restorative to her depressed spirits. LeVert agreed and decided to bring Betsy, who spoke fluent Spanish. Both Mobile and New Orleans enjoyed regular steamship service to Havana at the time. The trio travelled to New Orleans first, probably because the sailing schedule more closely conformed to Bremer's needs. Unfortunately, their hotel burned and Madame LeVert felt compelled to cancel, leaving Bremer to journey south alone.[89]

After numerous vexing delays, Bremer finally departed New Orleans January 28 onboard the SS *Philadelphia*. She chose a cabin in the vessel's stern, where she enjoyed "a little solitary three-cornered cell" with a porthole. Bremer unfastened the porthole for some air and reveled in the experience of the open Gulf. "The billows foamed and hissed close to my window," she wrote to her sister, "and soon came into my bed." Nonetheless, she preferred the fresh sea breeze with occasional warm water soakings to "the suffocating air of the cabin." The following morning the ship entered Havana harbor, and Bremer thrilled to the sight of big rollers smashing against the Morro and throwing up great curtains of spray (FIG. 28).[90]

Like Mobile, mid-19th-century Havana had changed much since the 18th-century sieges. It was now home to 200,000 people, a mix of whites, enslaved blacks, free blacks, and a smattering of Asians imported as labor. Whites were a minority, and a significant portion of them were Spanish soldiers stationed at the fortresses. Visitors almost always commented first upon the crowded harbor. Spain had relaxed its draconian trade restrictions, and it showed. No less a mariner than Richard Henry Dana, the famous author of *Two Years Before the Mast*, arrived in 1859 and exclaimed: "What a world of shipping! The masts make a belt of dense forest along the edge of the city, all the ships lying head in to the street, like horses at their mangers; while the vessels at anchor nearly choke up the passage-ways to the deeper bays beyond."[91]

Havana rivaled New York and New Orleans as a major American entrepôt, exporting sugar, coffee, tobacco, and rum and importing cotton, machinery, textiles, lumber, and a thousand other things. It was also a market in the ongoing slave trade, despite growing foreign pressure to abolish it. Small boats containing customs officials, porters, and eager vendors immediately

[89] Ibid, 221. Webb, *Such a Woman*, 204-205. The Greek Revival-style St. Charles Hotel sported a columned rotunda topped by a dome. Its destruction garnered national attention.

[90] Bremer, *The Homes of the New World*, vol. 2, 254 and 256.

[91] Jones, *Cuba in 1851; a Survey of the Island*, 28. Dana, *To Cuba and Back. A Vacation Voyage*, 20.

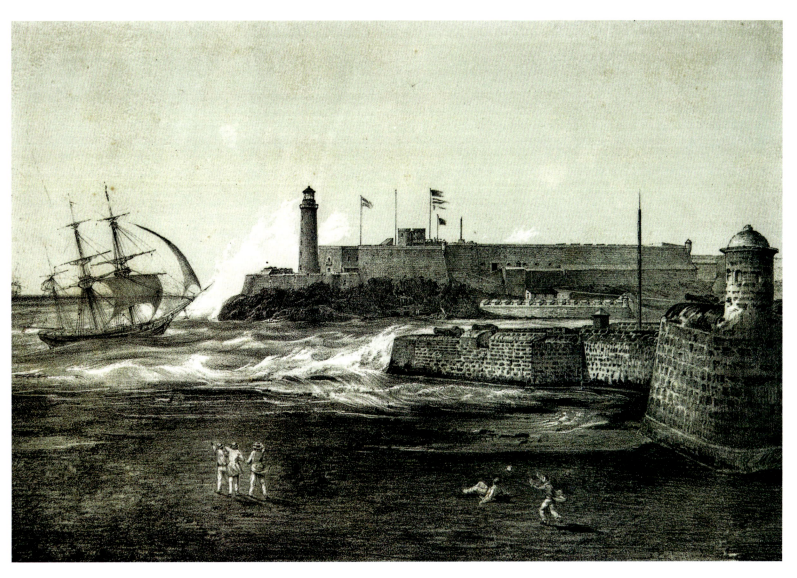

28. "Morro y entrada del puerto de La Habana" (Morro Castle and entrance to the port of Havana). Lithograph by Federico Mialhe, in *Viaje pintoresco alrededor de la isla de Cuba*, 1847-1849 {Courtesy of Emilio Cueto}

surrounded arriving merchant and passenger vessels. Only after much official delay and running a gauntlet of fruit and cigar vendors did passengers make the wharf.

Once onshore, Bremer admired the "low houses of all colors, blue, yellow, green, orange" amid the scattered palm trees (Fig. 29). By evening she was ensconced in a small hotel "with a marble floor," thrown open windows and doors, and an animated group of diners at table. During the following days Bremer drove the magnificent Paseo de Isabel II; observed the high wheeled *volante* carriages (Translator's note: known as *quitrín* in Cuba) with their raven-haired female passengers and extravagant, thigh-booted black postilions; ambled gardens studded by statues and fountains; visited the "handsome and light" Cathedral; explored narrow rain-puddled streets shaded by linen awnings; and attended the theater, where her friend and countrywoman Jenny Lind performed. She left enchanted by the plants and flowers but oppressed by the heat, dust, and the harsh conditions endured by the slaves.[92]

[92] Bremer, *The Homes of the New World*, vol. 2, 256, 258 and 269.

Madame LeVert was already familiar with these sights. Despite having to cancel her trip with Bremer, she knew Havana well, had many influential friends there, and considered the city a second home and a natural waystation on longer voyages. During her second European tour in 1855, she arrived in Havana harbor on board the steamer *Black Warrior* and spent several weeks at the Hotel Cubano before crossing the Atlantic. The hotel was a five-story pile located at 9 Teniente Rey, just steps from the Plaza Vieja. It featured a balcony over the street, stables, carriage rooms, a central courtyard onto which the apartments opened with little balconies, a marble stairway, red-tiled rooms, heavy wooden windows and doors, billowing sheers, and potted plants and flowers everywhere (Fig. 30).[93]

"We were received by Mrs. Brewer (who keeps the house)," LeVert wrote, "in the most friendly manner." Sarah Greer Brewer was the hotel's famed proprietress, and a native Southerner herself. One guest called her a "strange mixture" of "parsimony and prodigality, vindictiveness and gratitude, a grand woman withal, capable of doing heroic things."[94] She had been either

[93] *Diario de La Marina*, January 30, 1855. McHatton-Ripley, *From Flag to Flag*, 126-128.

[94] LeVert, *Souvenirs of Travel*, vol. 1, 288. Ripley: *Social Life in Old New Orleans*, pp. 288-289.

29. Mid-19th-century travelers often commented on Havana's vibrant colors. Bremer listed "blue, yellow, green, orange" and this custom has continued to this day {CC}

30. Site of the old Hotel Cubano, 9 Teniente Rey, Havana. Though this is a later building, its elegant façade and balconies are not dissimilar to the old hotel's {CC}

abandoned or widowed, the stories varied, at a young age and moved to Havana as a governess. She also worked as a seamstress, eventually opened a boarding house, prospered, and then bought the Hotel Cubano. Brewer specialized in familiar, easily digestible food, provided attentive English-speaking staff, and harbored ardent Southern, i.e., pro-slavery, sympathies, all of which assured a steady stream of guests. No wonder LeVert felt so at home there. In fact, she remarked the morning of her departure that it was her "last day in America."

Mobile and Havana's mid-19th-century commercial prosperity, Spain's relaxed trade restrictions, the efficiency of steam travel and Mobile's railroad connections, the presence of sympathetic friends, and comfortable accommodations like the Hotel Cubano, all combined for a robust affinity and trade between the two cities. As early as the mid-1820s, one visitor to Alabama's seaport noted the presence of Caribbean products on the store shelves. "There was nothing new to me," he recalled, "but some fruit shops, in which were excellent oranges from Cuba, at six cents a piece, large pine apples ... also from Cuba, at forty-two and three-quarter cents a piece ... besides bananas and cocoa nuts in abundance." Some 15 years later, *Hunt's Merchants' Magazine and Commercial Review* enthused, "Mobile is more accessible from the Gulf than New Orleans. She is nearer Havana than either New Orleans or Charleston, and is better situated than either of those cities for supplying the great valley with West Indian products."[95]

And so the goods and services flowed back and forth aboard steamships, schooners, sloops, brigs, and barks. Not long after Christmas 1841, for example, the schooner *Belle* hove into Mobile Bay out of Havana loaded with 931 sacks of coffee, 150,000 cigars, and numerous boxes of fruit. Not surprisingly Mobilians especially loved the tobacco. There were several cigar shops downtown, including that of J. G. Michaeloffsky at 39 Royal Street which advertised Cuban smokes "for cash only" (FIG. 31).[96]

Wood—logs, lumber, staves, ship masts and spars—was by far Mobile's most common antebellum export to Cuba. The island's good timber was long gone, and its sugar planters and ship builders desperately needed forest products. For years a self-sustaining trade loop operated. Cuban planters imported firewood to stoke their mills, lumber to erect their buildings, staves to make barrels for raw sugar, and shooks (slats) to fashion crates for refined sugar. The loaded barrels and crates then returned to Mobile, which shipped more staves and shooks.[97]

On the same winter day that the *Belle* made Mobile with the coffee, tobacco, and fruit, the schooner *Augusta* cleared

[95] Saxe-Weimar-Eisenach, *Travels through North America*, vol. 2, 41. Hunt, "The Mobile and Ohio Railroad," 583.

[96] *Mobile Register and Journal*, December 28, 1841 and December 2, 1841.

[97] Demeritt, "Boards, Barrels, and Boxshooks," 109.

suggest, Havana was Mobile's top lumber trading partner throughout the 1850s.[98]

Madame LeVert was not the only Mobilian who relished her time in Cuba's capital city. All of that trade meant numerous other Port City residents visited Havana. When not working they sampled its exotic pleasures. These included the renowned Havana Lottery and women. One Alabama sailor recalled his pre-Civil War attempts at winning the lottery. He and his mates quit unloading lumber at 2 p.m. when the Spanish customs officials knocked off due to the heat. "We all invested money in the Royal Lottery," he wrote, "but drew no prizes. The tickets were sold on the street by vendors, who received a commission on their sales. ... The tickets were in large sheets, sixteen dollars for a whole and proportionally, down to a sixteenth." On one trip he went to the drawing "in a building like a theatre." The prizes started at $250,000 and finished at $100. "A remarkable audience was in the seats: rich and poor, black and white, and of all nationalities." Excitement and interest dwindled after the biggest prizes, leaving the theater nearly empty at the end. Mobilians played because their local papers published the winning numbers and trumpeted area winners. These included a 14-year-old sailor boy who netted $20,000 and the dashing ship captain Harry Maury who won enough to build a grand house on Mobile Bay's Eastern Shore.

31. El Alabama, Cuban tobacco label, 1859, which depicts enslaved people loading tobacco bales onto a sailing ship. Mobile imported millions of cigars during the mid-19th century. Library of Congress

the bay channel for Havana with 1,333 barrel staves and the brig *Guadalette* with 2,500. The shipments steadily increased as the century progressed. In 1853-4 Mobile shipped 180 finished masts and spars and over two million board feet of sawn lumber to Havana, more than any other foreign port. At the end of 1856's first quarter, Havana harbor officials recorded 16 lumber vessels from Mobile and cleared 10 ships for the same port carrying 11,766 boxes of sugar and over two million cigars. As these statistics

98 *Mobile Register and Journal*, December 28, 1841. *Letter of the Secretary of State*, 317-321. *Alabama Planter*, July 19, 1856.

Happily, envious Mobilians did not have to travel to try their own luck. Downtown stores routinely sold tickets. In 1851, native Cuban José Luis Diaz offered lottery tickets at his 7 Government Street barber shop. Some merchants would even cash winning tickets.[99]

Victorian reticence chilled public discussion of Havana's sexual attractions. Mobile's own Raphael Semmes penned but never published a remarkably frank appreciation after an 1845 visit. Semmes was a junior officer on board the USS *Porpoise*. The vessel put into Havana on a diplomatic mission where Semmes remarked on all the women he saw. He admitted that in tediously patrolling the Gulf he was "deprived of the sight of the dear creatures for months together, I am prone to fall in love with the first petticoat I meet after landing." The objects of his fascination included "the pretty feet and ankles" of female shoppers, the "naked arms and busts" of the mixed-race market women, and the "naked arms and shoulders and heads dressed with natural flowers" among lady theatergoers. He also waxed eloquent on the "seductive" moonlight, the "feathery leaves" of palm trees, and the "graceful white muslin robes of the women." If Semmes did not relieve his lust, it wasn't for lack of opportunity. *Mujeres públicas* (public women), or prostitutes, were easy to find. According to one observer, they rented houses on "the best streets," where they gazed "out of the bars of high windows at nightfall, with a lit cigarette in their mouths."[100]

Mobilians' interest in Havana, and more generally Cuba, was not limited to its pleasures. After the 1857 publication of Madame LeVert's *Souvenirs of Travel*, a reviewer for *Brownson's Quarterly Review* wrote that "she lives in Mobile, where the desire to annex Cuba to the Union is stronger than in any other city we have visited."[101] As the issue of slavery tore at the North American body politic, Southern newspaper editors, politicians and, more dangerously, violently inclined filibusters saw Cuba's acquisition as key to maintaining power (FIG. 32). By their calculations, Cuba as a slave state with two senators and nine representatives would nicely counterbalance Kansas' and Nebraska's likely admission as free states. The more hotheaded among them joined forces with Latin American revolutionaries like Narciso López, whose desire to liberate Cuba from Spain dovetailed perfectly with their goals.

Among the Mobilians who acted on this perverted dream were businessmen who invested in armed expeditions and the sea captains,

[99] Waterloo, *The Story of a Strange Career*, 156-157 and 358. *Mobile Daily Advertiser*, April 20, 1854. "Royal Havana Lottery", broadside, May 7, 1857. Blount, "Mobile's Knights of Old: Harry Maury and the Baron," 72. "José Luis Diaz, Barbero y Flebotomiano" ad in *El Pelayo*, November 30, 1851. *El Pelayo* was a New Orleans Spanish language paper that published in 1851-1852. Diaz regularly advertised there.

[100] Semmes, "Cruise of the *Porpoise* in the Caribbean," 35, 15, 31, 34 and 21. Cluster and Hernández, *The History of Havana*, 47 and 67.

[101] "Le Vert's *Souvenirs of Travel*," 535.

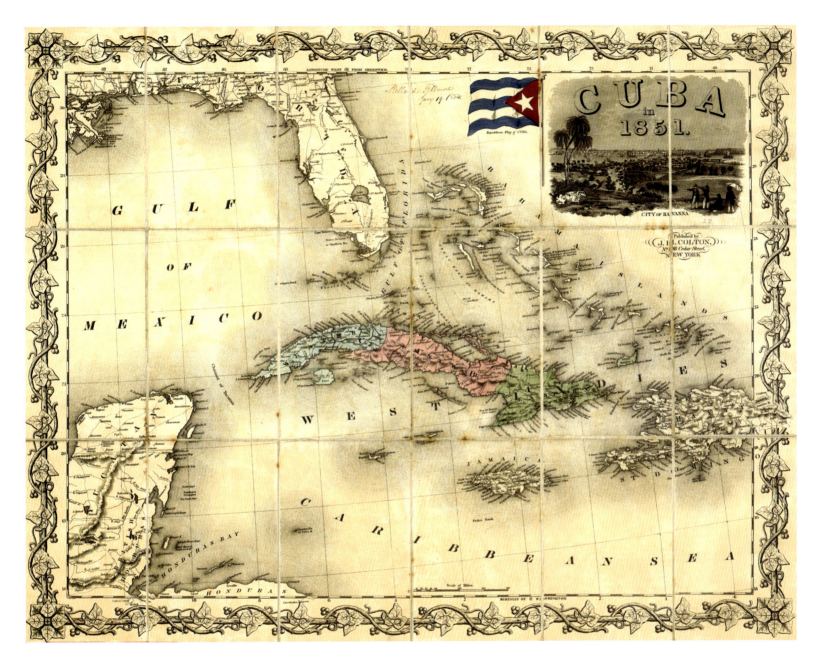

32. J. H. Colton, Cuba in 1851. Cuba's proximity to the slave South made it an irresistible target of violent filibusters. Library of Congress

Mexican war veterans, wharf rats, and bank clerks who signed on for the adventure. The most prominent of these was Harry Maury, who knew Havana well. If antebellum Mobile had a gentleman *beau ideal*, Maury was it. He was charming, sophisticated, well-traveled, and urbane. He was also a crack shot and knew how to handle rough men. Not surprisingly, he was a regular at Madame LeVert's salon, where another guest described him as "one of the finest looking men I ever saw. Afterward we had a good deal of him in a semi-public way. He was a fine horseman and when he rode up and down Government Street, he was admired for he made a very attractive looking spectacle." Maury supported filibusters like William Walker and John Quitman, and was even involved in López's 1851 attempt to take Cuba.[102]

[102] Craighead, *From Mobile's Past*, 160. Bagwell, "Rediscovering that Devil Harry Maury," 3-5.

Fortunately for him, Maury did not accompany López's doomed expedition onto Cuban soil. The Spaniards handily defeated it and executed numerous survivors, including López and at least one Mobilian. Predictably, when the news reached Alabama's shores there was outrage, which soon turned into a very ugly incident.

It is not likely that the Spanish crew of the *Ferdinand VII* knew anything about López's failure when they wrecked at Cape San Blas, Florida. But they soon became pawns in a raucous torchlit confrontation. When Mobilians learned that 57 shipwrecked Iberians were staying downtown under the protection of Spain's vice-consul Manuel de Cruzat, they angrily poured into the streets. Only by several prominent Mobilians' forceful intervention and Cruzat's deft management was murder avoided. A specially chartered schooner named the *Mobile,* captained by none other than Harry Maury, ferried the terrified Spaniards across the Gulf.[103]

According to the *Mobile Advertiser,* "Capt. Maury informs us that he

33. The steamship *Black Warrior*, shown here in an 1853 oil painting by James Bard, made regularly scheduled stops at Mobile and Havana. Vallejo Gallery

[103] Sedano, *Cuba: Estudios Políticos*, 58-61.

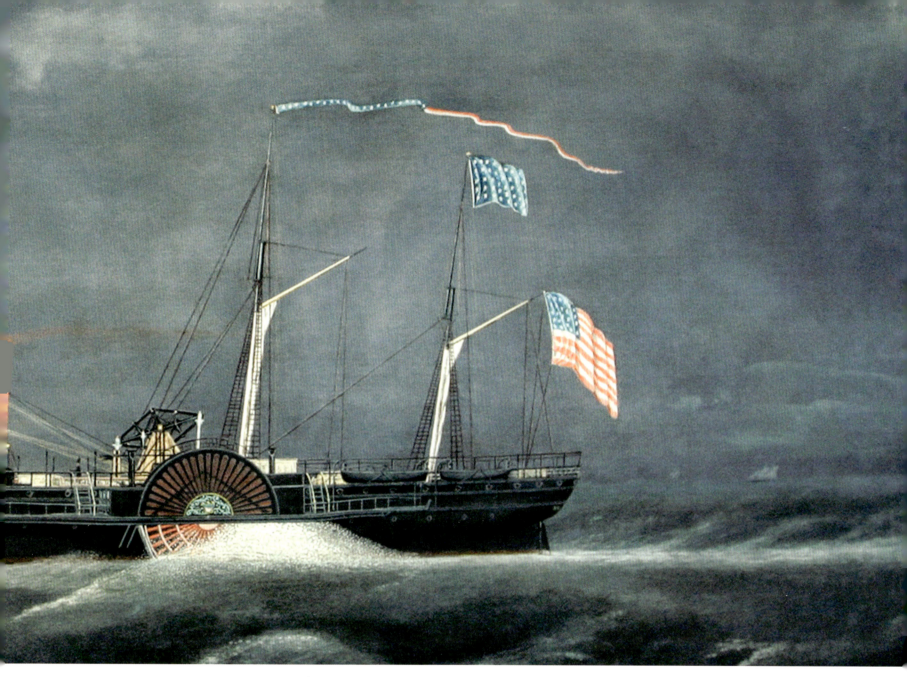

was received with a warm welcome by the authorities as well as people of Havana." He remained in the city over a week and visited 30 hospitalized filibusters. Maury met with Captain General José Gutiérrez de la Concha and requested permission to bring two Mobilians among them "home to their families and friends." Gen. Gutiérrez de la Concha said he wished that he had the power, but that the prisoners "had all been turned over to the Government of Spain."[104] It was likely on this trip that Maury won the Havana lottery. He always came out on top.

Thankfully, the *Ferdinand VII* crisis did not escalate. But only three years later Spain's seizure of the *Black Warrior* (FIG. 33) in Havana harbor almost provoked a war. The vessel departed Mobile on Feb. 25, 1854, with 900 bales of cotton and 17 passengers and arrived at Havana three days later. The ship's captain did not declare his cargo, since he was only dropping off mail in transit to New York. This was the usual procedure, with the letter of the law conveniently overlooked by all parties.

[104] *Mobile Daily Advertiser*, October 7, 1851.

But the heightened tensions surrounding filibustering caused the Spaniards to clamp down and they seized the *Black Warrior* and her cargo. Southern newspaper editors and politicians erupted, demanding a confrontation with Spain. Fortunately, after months of diplomatic correspondence, cooler heads prevailed. Neither President Franklin Pierce nor most U.S. congressmen wanted a costly foreign distraction, and the northern public was not as upset as the Southern slaveocracy. Spain eventually released the *Black Warrior*, returned the $6,000 fine, and eventually paid a $54,000 indemnity. The *Black Warrior* resumed her New York-Havana-Mobile route without further incident. Undaunted, several Southern hotheads coauthored the Ostend Manifesto on October 15, 1854. The document referenced the "unatoned" *Black Warrior* outrage and recommended the U.S. government acquire Cuba by purchase or, if Spain refused to sell (which they knew it would), by war. President Pierce and Northern public opinion instantly rejected the idea.[105]

William Rufus King did not live long enough to weigh in on the *Black Warrior* affair. As a moderate—pro-slavery but anti-secession—who helped craft the Compromise of 1850, he likely would have calmed matters. King was a native North Carolinian, a Jacksonian Democrat, a Unionist, and a slaveowner who moved to the Alabama Black Belt in 1818. Six feet tall, contemplative, and courtly, he enjoyed a distinguished political career, serving as a United States congressman, a senator, and Minister to France. In 1851, the Democratic National Convention nominated him vice president and Franklin Pierce president. They won, but a nasty case of tuberculosis forced King to seek warmer climes. He arrived in Havana by steamer, and a week later travelled to Matanzas and settled at John Chartrand's plantation Ariadne (FIG. 34).[106]

King's regimen included plenty of rest and the vaunted but ineffective "sugar cure," a regular inhalation of the hot vapors curling out of the sugar vats.[107] The steamer USS *Fulton* lay at nearby Matanzas harbor to convey him to his duties when possible. But King was too weak, so Congress passed a special act to swear him into office on foreign soil. To date, he remains the only high U.S. government official so privileged. Therefore, the same day that Pierce swore his presidential oath at blustery Washington, King wobbled unsteadily between friends who held him upright for an oath administered by the U.S. Consul from Havana.

A Washington D.C. correspondent was beguiled by the scene, "The clear sky of the tropics over our heads, the emerald carpet of Cuba at our feet, and the delicious breeze of coolness over us." King realized death was near and wanted to go home to Alabama. The *Fulton* carried him at full steam into Mobile Bay on his 67th birthday. An enthusiastic crowd that included a

[105] Rhodes, *History of the United States*, vol. 2, 16-17. Chez, "Cuba During the Buchanan Administration," 25.

[106] Purcell, *Vice Presidents: A Biographical Dictionary*, 135. Brooks, "The Faces of William Rufus King," 22-23.

[107] Learned, "The Vice President's Oath of Office," 249.

34. "Representation of the sugar plantation of Mr. Chartrand, near Limonar, Cuba," wood engraving by Frederick J. Pilliner. First published in *Gleason's Pictorial Drawing-Room Companion*, Boston, vol. 4, no. 18, April 30, 1853

band, militia companies, civic officials, and very possibly Madame LeVert fell into a deep hush when attendants lifted the "feeble and attenuated" vice president from the ship. They took him to the Battle House Hotel and later to his Dallas County plantation upriver. He died there on April 18, 1853.[108]

The calm voices receded. War clouds loomed. Madame LeVert, Sarah Greer, Raphael Semmes, Capt. Maury, Gen. Gutiérrez de la Concha, vice-consul Cruzat and all their friends and neighbors in Mobile and Havana anxiously watched developments, wondering what portent they held.

[108] Purcell, *Vice Presidents*, 135. Madame LeVert cannot be definitively placed on the wharf for King's arrival, but Alabama researcher Dan Brooks believes she was in town then, and given her affinity for King's views, it is difficult to imagine she would not have been present.

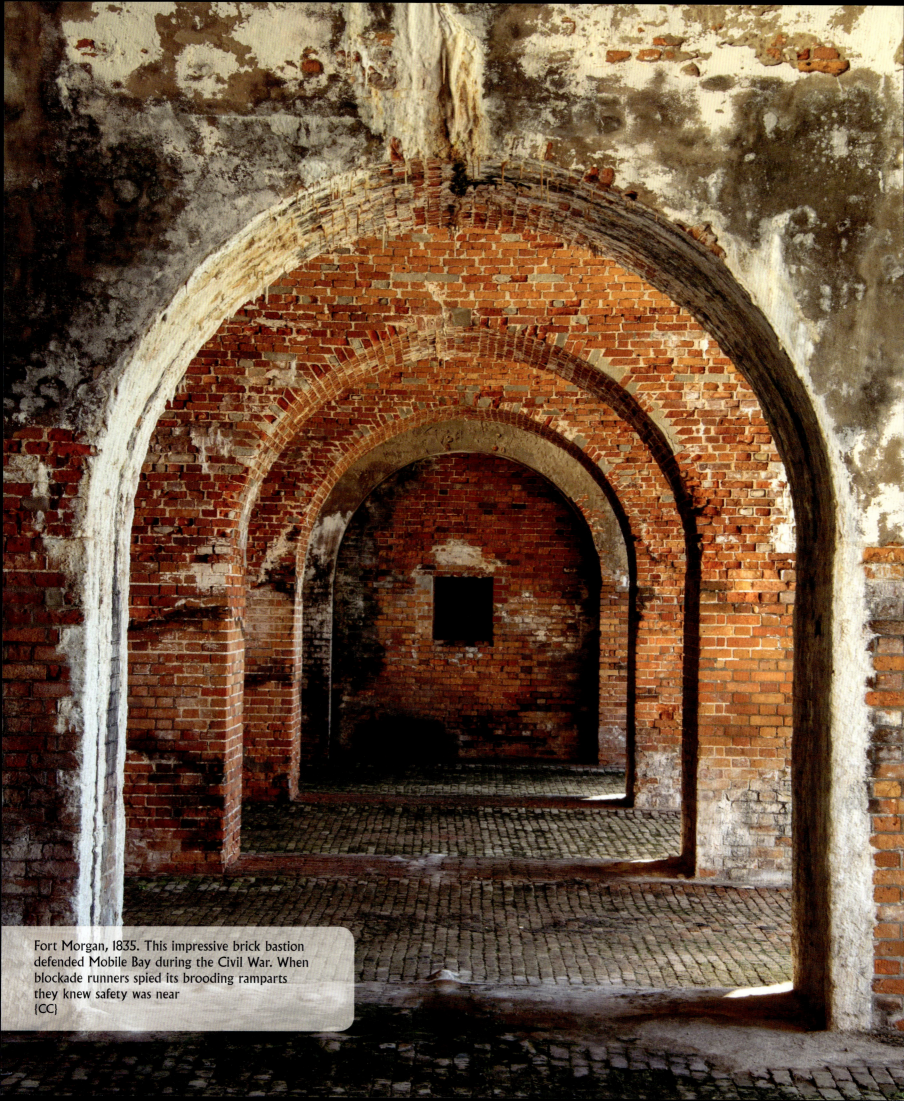

Fort Morgan, 1835. This impressive brick bastion defended Mobile Bay during the Civil War. When blockade runners spied its brooding ramparts they knew safety was near
{CC}

WAR GAMES: THE DARING BLOCKADE RUNNERS, AND THE TOWN BALL BOYS

John Newland Maffitt (Fig. 35) clung to the rail of his trembling ship. The CSS *Florida* was 20 hours out of Mobile Bay and practically flying before a strong norther, sails taught, stacks belching dirty black smoke, and screw spinning furiously free whenever a wave hove her stern above the roiling froth. Through his spyglass Capt. Maffitt could discern the sail stacks of pursuing Union warships. "Set more canvas," he noted in the ship's log for January 16, 1863, "and increased our revolutions of the engine." The *Florida* was now plunging ahead at 14-and-a-half knots, a greyhound on the Gulf. "Night coming on," Maffitt continued, "changed our course more to the westward, and at daylight there was nothing in sight but a foaming sea and black clouds."[109]

Three days later Maffitt captured and burned his first prize off the Cuban coast, the Boston-bound merchant brig *Estelle*. But if he was to continue plundering Union shipping, he first needed clothing for his "nearly nude" men and more coal for his ship's depleted bunkers. Thus, on the evening of January 20, he guided *Florida* into Havana harbor, the Confederate flag fluttering from her mainmast. Ignoring a hail from the Spanish guard boat, Maffitt eased his vessel to the coal wharves and "ordered the drum and fife on deck" to merrily play "Bonnie Blue Flag" and "Dixie." "In a few minutes," he declared, "our deck was crowded with visitors." A Northern correspondent glumly noted that Maffitt "is decidedly popular here, and you can scarcely imagine the anxiety evinced to get a glance of him." Popular or no, Maffitt had violated port regulations by entering at night and without a health officer's clearance. In an attempt to repair the breach, he paid a visit the following morning to Charles Helm, the Confederacy's capable agent in Havana. The pair then went to local authorities and apologized profusely. Maffitt obtained easy forgiveness and on the morning of January 22 steered the *Florida* forth to wreak further destruction.[110]

Havana's enthusiasm for Maffitt's brief visit demonstrated the warmer relations that existed between Spanish Cuba and the South during the American Civil War. Southern hotheads now channeled their belligerent energy onto the battlefields of Virginia and Tennessee and gave up their Caribbean filibustering schemes. By their reasoning, pro-slavery Cuba was an ally in all but name.

On July 22, 1861, R.M.T. Hunter, the Confederacy's secretary of state, wrote to Charles Helm notifying him of his appointment as special agent in the West Indies. "You will inform His Excellency, the Captain General

[109] U.S. War Department, *Official Records of the Union and Confederate Navies* [hereinafter cited as ORN], vol. 2, p. 668.

[110] Ibid. Sinclair, "The Eventful Cruise of the Florida," 421. Semmes, *Memoirs of Service Afloat*, 360.

of Cuba," Hunter ordered, "that it is the sincere desire of the Government and people of the Confederate States that the most friendly commercial intercourse should be established and extended with the inhabitants of that island." Hunter enumerated those commodities the South had to offer, including "lumber, tar, and turpentine," and expressed enthusiasm for Cuba's "fruits, sugar, molasses, and tobacco" that would "find a sure and profitable market at our ports burdened with no heavy taxation for revenue or other purposes."[111] Helm dutifully traveled to Havana and, like most other Southerners, took a room at Brewer's Hotel Cubano. The Captain General cordially received him shortly thereafter, and he got to work managing Rebel interests in the colonial city.

For its part, Spain was neutral, though sympathetic to the Southern cause. It felt increasing pressure by the United States and other nations to abolish the slave trade and worried about what that might do to Cuba's profitable sugar and tobacco crops. It acted carefully but determinedly. Just over a month after Helm's arrival, Captain General Francisco Serrano issued a three-part dictate to the island's port authorities. First, he commanded, "Vessels with the flag of the Confederation of the South will be admitted into the ports of this Island for the purpose of legitimate trade." Secondly, once in Cuban waters Confederate ships "will be under the safeguard of the neutrality proclaimed by the Governor," and third, that authorities "will consider the above vessels as proceeding from a nation having no consuls accredited in this territory." In short, Spain readily traded with the Confederacy and sheltered its ships but did not formally recognize it. The *New York*

35. John Newland Maffitt, captain of the CSS Florida, was a popular figure on both sides of the Gulf. At Havana, in 1863, he bragged that "our deck was crowded with visitors." History Museum of Mobile

[111] Richardson, ed., *A Compilation of the Messages and Papers of the Confederacy*, vol. 2, 47.

Herald Tribune quipped, "Spain, The Only Friend of the Rebels."[112]

As Madame LeVert and the sea captains well knew, Havana was an easy and convenient port to Mobile, only two days away by steamer, a bit longer by sail alone. Despite the presence of a dozen Union ships off Mobile Bay, savvy skippers took advantage of the area's complex geography to regularly run in and out. There were significant incentives to do so. According to a memo captured by the Federals, the Confederate government supplied the blockade runners with cotton cargoes and gave over half the value if the runners would deliver the other half to Havana. In recompense, Richmond asked for half the vessel's carrying capacity on the return trip. Agent Helm made sure those holds brought back vitally needed weapons, equipment, medicine, and supplies. While in Havana, the runners sold their portion of the cotton for an attractive sum and loaded up with sundries they could sell back in Mobile. Most routinely took private orders for luxuries like cigars, wine, hard candy, tea, sugar, soap, or stockings. The Mobile author Augusta Jane Evans, frustrated with the steel nibs wartime austerity forced her to use, delightedly received "the finest gold pen in Cuba" from one captain.[113]

The most successful blockade runner was Abner Godfrey, master of the *Denbigh*. Godfrey, born in 1825, moved into Mobile's Battle House Hotel in 1859 and worked as a stevedore dockside. When the war began, he briefly served as Confederate agent in England before taking command of the *Denbigh*, a rocket-fast, needle-nosed steamer with feathering sidewheels and low lines. Assisted by 19 crewmen, Godfrey owned the Mobile-Havana route, his runs so brazenly routine that Union jack tars referred to his ship as "the mail-packet." Federal officials were apoplectic. The U.S. Consul in Havana grumbled on June 10, 1864, "This morning the *Denbigh* arrived from Mobile, having made it in two days. Some effort should be made to put a stop to the career of the vessel." But Godfrey was too skilled, and he was in good company. In the spring of 1864, the Consul reported 16 vessels arrived from Mobile and 11 departed to the same port. Occasionally the Union navy captured one, but the odds were always in the runners' favor. At war's end their overall success rate on the route was an astonishing 80 percent.[114]

The American Civil War brought boom conditions to Havana. Cotton prices soared, and inflation drove up everything else. The U.S. Consul reported that prices were "beyond what is reasonable for a Consul's salary. In Havana you cannot open your mouth under a dollar and shut it under a doubloon." Pro-Southern sentiment was rife. One visitor reported, "I found that the friends of the Confederacy

[112] *Frank Leslie's Illustrated Newspaper*, September 28, 1861. Bowen, *Spain and the American Civil War*, 75.

[113] Wallace, *Cases Argued and Adjudged in the Supreme Court*, 343-346. Sexton, *A Southern Woman of Letters*, 101.

[114] Bergeron, *Confederate Mobile*, 116 and 125. ORN, vol. 21, 330. Browning, *Lincoln's Trident*, 336.

were completely in the ascendant in Havana." American vessels switched their registrations to the British flag, and sailors attracted by high profits and adventure deserted en masse to join the runners' rollicking rosters. Scores of "land-sharks and sea-lawyers" haunted the wharves "to prey upon the seamen," and everyone rubbed shoulders in the local taverns, played the lottery, puffed cigars (among the brands "Havana Rose" and "Lovely Cuban Woman's Whim"), attended the theater, frequented the brothels, purchased goods in the shops, and visited the landmarks. Capt. Godfrey traded at the Caballo Andaluz Talabartería (a saddlery) at 25 Teniente Rey St. and La Botica Sueca ("The Swedish Apothecary") at 52 San Ignacio St. to supply his customers' wants. Another runner toured the Cathedral and marveled at "the good state of preservation the building was in." Prisoners kept the streets swept, women promenaded in their *volantes* and bands regularly entertained passersby at the Plaza de Armas.[115]

Mobile remained picturesque and managed quite well during the war's first years. "Located at the head of her beautiful bay," one local writer declared, "with a wide sweep of blue water before her, the cleanly built unpaved streets gave Mobile a fresh, cool aspect. There houses were fine and their appointments in good, sometimes luxurious taste. The society was a very pleasure-loving organization, enjoying the gifts of situation, of climate, and of fortune to their full." Despite the omnipresent blockaders, Mobile developed a reputation as a pleasure capital during the war—the "Paris of the Confederacy." A *London Times* correspondent who visited in 1861 opined that the city bore a "'kinder-sorter'" resemblance to Málaga, Spain. He was charmed by the public market, "crowded with negroes, mulattoes, quadroons, and mestizos of all sorts, Spanish, Italian, and French, speaking their own tongues or a quaint *lingua-franca*, and dressed in very striking and pretty costumes." While actual fighting remained far away, parties and balls prevailed, with grey-coated officers and hoop-skirted belles dancing the "Virginia Reel." Common soldiers thronged the oyster saloons, prostitutes whispered from the shadows, and slaves labored on the city's elaborate ring of earthen defenses.[116]

By the spring of 1862, another traveler registered a more depressed aspect. "Mobile was stagnant commercially," he wrote, "business at a stand-still, many stores closed, and all looked gloomy." Blockade runners ghosting up to the wharves only "produced temporary and feeble excitement." Their arrivals were so "frequent," he noted, that "the novelty had worn off." Coffee, cigars, sugar, liquor, boots and shoes, petticoats, jackets, tools, ribbons and bobbins were al-

[115] Glover, "The West Gulf Blockade," 223. Worthington, ed., *The Woman in Battle*, 250. Watson, *The Civil War Adventures of a Blockade Runner*, 246 and 233. Cluster and Hernández, *The History of Havana*, 83. Arnold, *The Denbigh's Civilian Imports*, 112 and 131.

[116] DeLeon, *Four Years in Rebel Capitals*, 56. Bergeron, *Confederate Mobile*, 92. Russell, *My Diary North and South*, vol. 1, 190 and 191.

ways welcome, but never arrived in large enough quantity to trickle down to the city's poorer residents. Nonetheless, Rebel soldiers and sailors moved through town in enough numbers to keep the taverns and cafes active. One soldier remarked, "Coffee houses were in full blast where 'coffee' could be bought for a dollar a cup, with an 'ironclad' pie thrown in."[117] Fish and oysters remained plentiful, as did vegetables, and a band played in Bienville Square, but as the Union noose tightened and the Confederacy's prospects diminished, people worried (FIG. 36).

Among those affected by the blockade were the foreign students at Spring Hill College (FIG. 37). Michael Portier, Bishop of Mobile, founded this private school five miles west of downtown in 1830 and transferred it to the Jesuits in 1847. The school's 1859-60 *Catalogue* informed prospective students and their parents that the campus "is elevated one hundred and fifty feet above the level of the sea. It enjoys a constantly refreshing breeze, which renders its situation not less agreeable than healthy." Three study plans were available—a preparatory course, a commercial course and a classical course. The three-year commercial course proved especially attractive to business-minded fathers seeking someplace practical to send their sons. The regimen included "the study of the Living Languages, Arithmetic, the elements of Algebra and Geometry, History, Geography, and Book-Keeping."[118] Its educational advantages included religious and moral instruction.

Cuban brothers Nemesio (age 11) and Ernesto Guilló (13), and their friend Enrique Porto (12), were sent north by their wealthy fathers for an education (FIG. 38). There are conflicting stories about how they arrived at Mobile in 1858, whether directly from Havana by "fragile sailing vessel" or by transfer from a Pennsylvania academy. Spring Hill College at that time functioned like a modern boarding school rather than a four-year college, and the young Habaneros were typical of its high-spirited student body. Their classmates included Catholics (predominantly though not exclusively) from rural Louisiana, New Orleans, Baton Rouge, Charleston and New York, as well as Cuba, Mexico, and Spain. On the eve of the Civil War the enrollment stood at 243.[119]

The boys' daily routine was highly structured, and they needed permission to leave campus. They wore uniforms, dark pants with a dark blue coat in the winter, and white pants with a lighter jacket in the summer. Other kit included shirts, handkerchiefs, cravats,

[117] Stevenson, *Thirteen Months in the Rebel Army*, 188. Stephenson, "Defense of Spanish Fort," 119.

[118] *Catalogue of the Officers and Students of Spring Hill College . . . 1859-'60*, 28 and 129. Spring Hill College retains to this day the idyllic setting of that time, which featured a cool natural spring, shady groves, a chapel, an administration building, dormitories and classrooms.

[119] "Spring Hill College Register of Students, 1859-1873," 39. *Diario de La Marina*, January 6, 1926. *El Imparcial*, December 16, 1918. *Catalogue of the Officers and Students, 1859-'60*, 8 and 9.

36. Bienville Square, Mobile. This downtown square has provided sylvan calm amid the urban bustle since 1839. During the Civil War it hosted fireworks displays and frequent drills, parades and musters by local troops {CC}

37. Spring Hill College, Lucey Administration Building, Mobile. This 1869 building replaced an earlier one lost by fire. Spirited baseball games still take place nearby {CC}

38. Enrique Porto, and Ernesto and Nemesio Guilló recorded in the 1860 Spring Hill College registration book. "I thank the Lord we are in a good state," Ernesto wrote home in English, "but a little sorry for not getting letters so frequently as we used to do." The blockade was to blame. Burke Memorial Library, Spring Hill College

towels, napkins, shoes, a cap, silver table settings, pillows, sheets, a mosquito bar (upon which to hang fine meshed netting over a bed), and a white quilt "to cover the bed during the day."[120]

As war loomed, many boys could not contain their excitement, and some ran away to join the army. The Guilló brothers and Porto were neutrals and theoretically exempt from military service, but they suffered from the blockade's hardships like everyone else. The Jesuits complained about the lack of wine for Mass and salt, and the boys helped lessen the deficiencies by harvesting wild scuppernongs and Gulf salt. Faculty feared that the army would draft their students and perhaps themselves. Indeed, manpower-hungry Confederate officers enrolled the entire student body and faculty in the 89th Alabama State Militia, essentially a home guard. Happily, the Jesuits managed to get everyone furloughed for educational purposes. Nonetheless, the quasi-military association proved helpful, for it settled the boys and provided opportunities for them to play soldier and show off their skills drilling and marching without risking life and limb.[121]

Remarkable insight into the Guilló brothers' thoughts and feelings is provided by a cache of letters they wrote during the spring of 1862. The letters were on board the blockade-running sloop *Annie* seized April 29 by the USS

[120] *Catalogue of the Officers and Students . . . 1860-'61*, 28.

[121] Kenny, *Catholic Culture in Alabama*, 212-214.

Kanawha between Mobile and Ship Island. The *Annie* was a small 14-ton vessel that carried 40 cotton bales for Havana. The Union navy repurposed the sloop, and a New York court adjudicated her cargo. None of it reached Cuba.[122]

Nemesio's letters display neat handwriting and he comes across as well-rounded and mature, though occasionally still boyish at 15. In a letter to his father dated April 8, he references the "magnificent victory for the South," by which he meant Shiloh. This was before that battle's horrific cost became generally known. In another letter dated the same day, he relates that 2,000 Federal prisoners are coming to Mobile. "I would like to go this afternoon to see them arrive," he adds. Both of the brothers are ardently pro-Southern, yet homesick. In a third April 8 letter, this time to his sister Adela, Nemesio writes, "We watch the news every day, but the first thing I ask is if they are going to open the blockade so we can leave." Both the brothers inquire warmly after family and friends, beg for letters, and send hugs. Nemesio tells about their pet squirrel and its funny behavior.[123]

Unfortunately, the letters do not mention playing the game that would make the brothers Cuban sports legends.

"Town ball" some called it, others Village ball, or the more descriptive base ball. Youngsters played this early version of the sport in U.S. schoolyards before the Civil War, and soldiers and sailors subsequently spread it even further. Where the young Habaneros learned it is uncertain, though probably on campus, where students likely already knew it. "The Big Yard," an area hard by the administration building, made a perfect place to pitch, hit, and run. Some years afterwards the Big Yard became The Pit, and then Stan Galle Field, a viable candidate for the nation's oldest baseball diamond in continual use.[124]

Finally, sometime in 1864, the young Habaneros left for home, probably on a blockade runner. An article in the January 6, 1924, edition of *Diario de La Marina,* a Havana newspaper, mentioned that "they returned to Cuba on a ship as grown men with strong necks, broad chests, athletic and ready to support in any way the rights of men, so unknown in the colony of those days." Nor did they return empty-handed, for Nemesio had stuffed a bat and ball into his luggage. Within hours of landfall, they were throwing and hitting near the sea baths at Vedado, just west of Havana's old city walls. People took notice, others wandered over, and soon the young men were teaching the sport's basics. According to the newspaper, "three balls caught in the air or the first bounce were three outs and triggered the right to use the bat in turn.

[122] U.S. Navy, *Civil War Naval Chronology . . . Part I, 1861,* 57.

[123] U.S. National Archives, *Records of the District Courts of the United States. Record Group 21, 1685-2009,* Civil War Prize Case Files, 1861-1865. Letter from Nemesio, Spring Hill College to Papa [Pedro Guillo] April 8, 1862. Second Letter from Nemesio, Spring Hill College to Papa, April 8, 1862. Letter from Nemesio, Spring Hill College to Adela, April 8, 1865.

[124] Alfonso López, *Béisbol y nación en Cuba,* 19. Jordan, "A National Pastime, Shared," 25.

It was also out if the ball hit a wall and bounced … if it went over a tree they waited for it to fall to receive it and also count it as out."[125]

As more young men joined the Guilló brothers and Porto, makeshift teams evolved and then uniforms consisting of long white drill pants, white shirts, black high-tops, and straw hats. They formed the Havana Baseball Club in 1868 and shortly afterwards staged their first exhibition game. Appropriately enough, an American schooner crew loading sugar over at Matanzas challenged them. The Habaneros made the short trip and, according to *Diario de La Marina*, "gave a sovereign beating" to the Americans. They returned in triumph.[126] Predictably, the repressive Spanish government perceived this popular new game as a subversive threat and banned it during the bloody Ten Years War (1868-1878), one of several 19th-century independence struggles Cubans waged against Spain.

There could be no suppressing such a popular pastime, however, and the Havana Baseball Club reorganized right after the war. Porto went on to a distinguished medical career, eventually serving as Cuba's secretary of health, and in 1895 sent his own two teenage sons to Spring Hill College. Ernesto quit playing baseball during the 1870s, though he remained vitally interested in the sport. Nemesio played regularly and pursued a successful career as an accountant. In 1918, when Nemesio was 71, *El Imparcial* warmly wrote, "when we see him in the morning crossing newspaper in hand down Calle Obispo towards his office, neat, calm, balanced, we are delighted to see how the Sun still sends its kisses to the old sportsman who we all love as a brother." Nemesio died around 1935 and was inducted into the Cuban Hall of Fame in 1948.[127]

Baseball has famously flourished in both Mobile and Havana ever since. Mobile proudly claims five players—Hank Aaron, Willie McCovey, Satchel Paige, Ozzie Smith, and Billy Williams—in the National Baseball Hall of Fame and a long history of minor league teams and exhibition games. Cuban baseball players have earned their own exalted place in sports history—six island-born players are likewise ensconced at Cooperstown. As for this most famous and popular linkage between their cities, both Mobilians and Habaneros are doing their part to promote it. In 2019 Cuban baseball journalists Yasel Porto (a descendant of Enrique Porto) and Reynaldo Cruz visited Mobile and filmed an episode on the Guilló brothers for their "Béisbol de Siempre" series. That same year on October 19, Cuba's National Council of Cultural Heritage adopted a resolution recognizing baseball's importance to Cuban culture and emphasized its Alabama roots. In early 2023, representatives from Mobile's Society Mobile-La Habana

[125] *Diario de La Marina*, January 6, 1924.

[126] Ibid. See also Alfonso López, *Béisbol y nación*, 18-20.

[127] "Spring Hill College Register of Students, 1873-1903," 149-150. *El Imparcial*, December 16, 1918. Jamail, *Full Count, Inside Cuban Baseball*, 17.

39. Baseball, a bond between the two nations {JL}

traveled to Cuba and unveiled a historic marker, in both Spanish and English, highlighting the story. There can be no more eloquent summation than that of John Thorn, Major League Baseball's official historian. "Today," he explains, "even after decades of diplomatic hostility—never shared by the two peoples—the game older than either nation continues to be the tie that binds" (FIG. 39).[128]

[128] Jordan, "A national pastime, shared," 26. Porto, "El primer bloqueo al béisbol cubano." Liesch, "Cuban Official Seeks Relationship with U.S. as Filmmakers Connect Baseball History." Consejo Nacional de Patrimonio Cultural: Resolución 18, October 2021. Thorn, "Cuba, the U.S., and Baseball: A Long if Interrupted Romance."

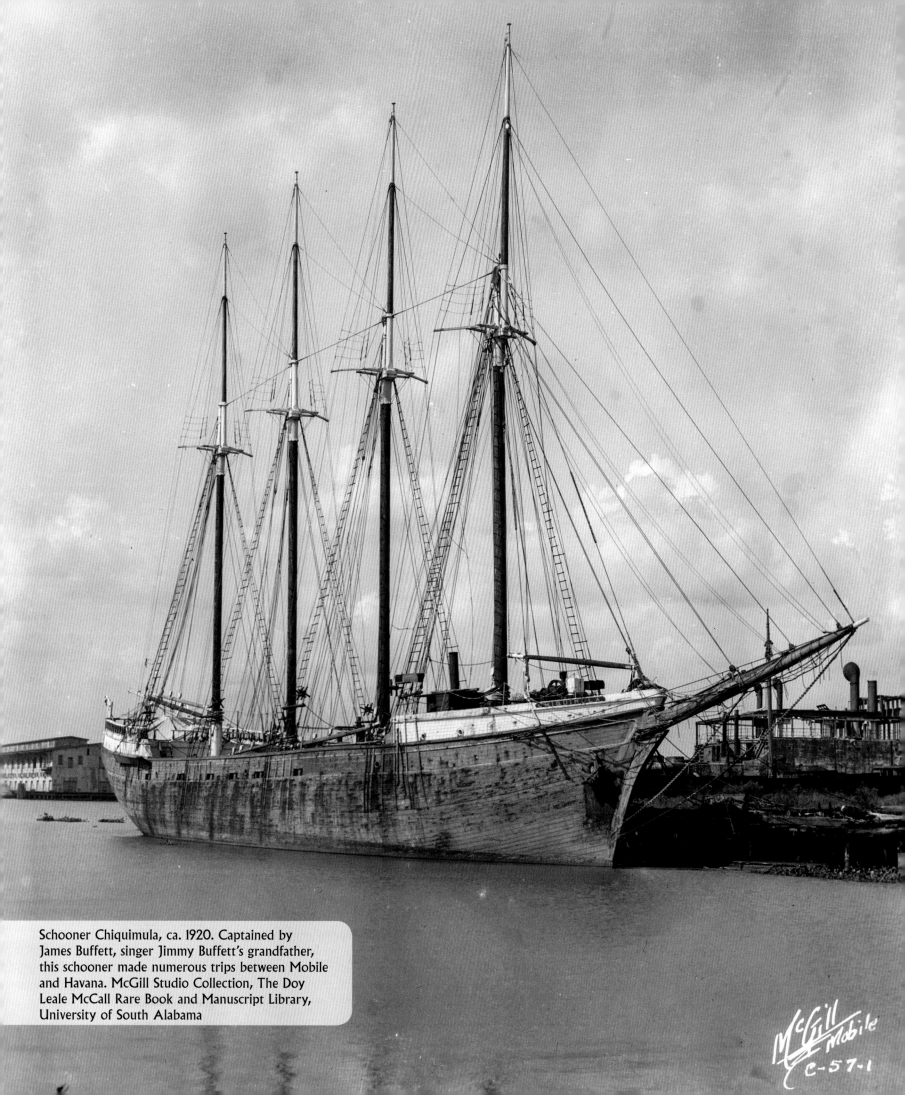

Schooner Chiquimula, ca. 1920. Captained by James Buffett, singer Jimmy Buffett's grandfather, this schooner made numerous trips between Mobile and Havana. McGill Studio Collection, The Doy Leale McCall Rare Book and Manuscript Library, University of South Alabama

FEVER DREAMS AND THE FROZEN BOND: THE MARTYR, THE DOCTORS, THE SCHOONER MEN, "MR. JIMMY," THE RUM RUNNERS, AND FIDEL

José Martí stood on the deck of the schooner *Brothers* at Great Inagua, Bahamas, watching the scene. "Beyond the beach's cerulean sea," he wrote, "the cargo ship unloads its wood from Mobile, Alabama, onto the raft that floats beside it, from stern to stern, on the turquoise swell. The wood is lowered and the workmen haul it and sing to it." He was an unimposing man—42 years old, short and balding, with narrow shoulders, a wide forehead, and an extravagant moustache. He looked more like a poet than a revolutionary. In fact, he was both (Fig. 40). His determination to liberate his native Cuba from its Spanish oppressors had led him to write numerous articles and poems, found the pro-independence Cuban Revolutionary Party, raise funds, and rally support. He arrived with a few followers at Great Inagua in April 1895, trying to reach Cuba, where an armed struggle had begun two months earlier.

Unfortunately, the captain they had hired to take them backed out and returned their money. Undeterred, Martí met with the Haitian consul at Great Inagua, who introduced him to Heinrich Löwe, captain of the German-flagged SS *Nordstrand*, yet another ship out of Mobile working local waters. Löwe, 37, an experienced captain with a steady job shipping lumber, was on his way to Jamaica from Alabama's port city with stops in Havana, the Bahamas, and Cap Haitien. Martí engaged him to take the little band to Cuba's southeastern coast and sweetened the deal with a $500 promissory note should Löwe lose his job over any diplomatic fallout from the incident.

The hopeful revolutionaries boarded the *Nordstrand*, and on April 4 sailed to Cap Haitien, where Löwe had to discharge cargo. That accomplished, the vessel returned to Great Inagua to drop off some laborers. While there Martí and his comrades retrieved a dingy and provisions they had earlier purchased. At last, on April 11, Löwe steered his ship through squally weather to within a mile of Cuba's southern coast. Martí and his brave men descended into their dingy and rowed the remaining distance. Unfortunately, the Apostle of Cuban Independence was killed in action on May 19, with only his young assistant at his side. Löwe returned to Mobile and lost his job.[129]

That Martí's rented steamer was out of Mobile should come as no surprise. The city was part of a vigorous Caribbean and Gulf trade network, and steamers, schooners, and barks sailed from and called there regularly. During 1895, Alabama's only seaport shipped 19,000,000 board feet of lumber to Havana alone, one of its principal trading partners.[130]

[129] Franzbach, "La guerra del 98 en el marco de los intereses alemanes," 28-31.

[130] *Appleton's Annual Cyclopedia and Register of Important Events of the Year 1896*, 10.

However, Cuba was politically unsettled, and three years later the sinking of the USS *Maine* interrupted business and catapulted the United States into the fray. While there were jingoes aplenty in Mobile as elsewhere, the *Daily Register's* scholarly editor Erwin Craighead counseled caution. In his February 17, 1898 column, he wrote that the event struck locally with especial force, since "we have here as public guests a number of members of the official family to which the officers and men of the *Maine* belong." Despite the charged atmosphere, Craighead saw "so far no evidences of treacherous conduct" and suggested that the explosion's cause "may never be known." Ten days later, he remarked that Mobilians "are not anxious for war. ... *We know too well what war means.*"[131]

Others did want it, however, and the United States opened hostilities on Spain two months later. By December it was over and the U.S. installed a military government. Cuba gained independence in 1902, though with onerous U.S.-imposed conditions. Mobile served as an important muster point during the war's early days, and Alabamians fought on the island. Nonetheless, as the military quickly discovered, the dreaded yellow fever proved a more potent foe than the Spanish, killing five times more Americans. Defeating yellow fever was the next challenge. Any further U.S. activity in the tropics, including a contemplated canal across the Panamanian isthmus, faced likely failure otherwise. As Craighead presciently noted immediately before the war, "When you get your gun, Johnny, don't forget your mosquito net."[132]

North Americans were both enchanted and repulsed by 1900 Havana. Robert T. Hill, a geologist studying the Caribbean islands' formation, described the city as "a picturesque and beautiful place." Just like the mid-19th-century travelers, he admired the colorful houses with their red-tiled roofs and surrounding

40. Photo taken from *Iconografía del apóstol José Martí*, Imprenta El Siglo XX, Havana, 1925

[131] *Mobile Daily Register*, February 17, 1898 and February 27, 1898. Time has proved Craighead right about the explosion's cause. There is still no official consensus as to whether it was an accident or a mine, despite half a dozen investigations between the sinking and 2002.

[132] T. S. McWilliams, "Erwin B. Craighead, the New South, and *Cuba Libre*," vol. 3, 2.

41. Wet cobbles, Havana. In his elegiac Havana memoir, Mark Kurlansky described the city's "sweet, sour, and bitter scents." During the early 1900s, reforming Americans believed these contributed to yellow fever until scientists discovered differently {CC}

greenery, all bathed in tropical light. He was also impressed by the orderly Paseo del Prado and its horse-drawn street cars. The high-wheeled *volantes* and their gaudy postilions of old were gone, but numerous small carriages crowded the "narrow, cobblestoned, medieval business streets." The well-to-do sported "light attire of duck and flannels and hats of straw" and shopped for fans, gloves, parasols, laces, jewels, silks and the like along Obispo Street. Still, he was not blind to the broader picture, noting a large industrial population relegated to "fever laden slums." An American army officer also found Havana "a dressy place" but focused on the city's negatives. He wrote that the famous bay was "foul with four hundred years of Spanish misrule and filth" and that all of the city's sewers emptied into it. Along the sea wall "a festering mass of corruption" threw a great "stench into the air."[133]

From the occupying Americans' perspective, Havana's filth rather than its mosquitos explained its yellow fever problem, and their solution was to give the city a good scrubbing (Fig. 41). Maj. William C. Gorgas, appointed Chief Sanitary Officer, went to work. Gorgas was a native Alabamian, born in Mobile County in 1854, where his father, an army officer, was in command at Mount Vernon Arsenal. In typical military-family fashion, the Gorgases moved around the country, until the father left the service and tried a variety of other ventures. When young Gorgas failed to get into West Point, he entered medical

[133] Hill, *Cuba and Porto Rico with the Other Islands of the West Indies*, 108 and 110-112. White, *Our New Possessions*, 556 and 552-553.

school and then enlisted in the U.S. Army Medical Corps. While stationed in south Texas, he contracted a mild case of yellow fever from which he recovered. Thus, when tapped for the Havana post, Gorgas knew as well as anyone the challenge before him. He perceived the Cuban capital as a veritable seed bed for a disease that regularly afflicted the United States, devastating Gulf Coast and Mississippi Valley communities. He immediately launched a sanitation campaign, removing rubbish and dead animals, and spraying the streets with electrozone, a disinfectant made from the electrolysis of seawater. The city's overall death rate declined, but yellow fever still raged. After two years of exhausting effort, Gorgas pronounced himself at "wits' end" (FIG. 42).[134]

Ironically, the solution was at hand, but Gorgas did not at first accept it. In fact, as early as 1847 a Mobile doctor named Josiah Nott had suggested that mosquitoes carried yellow fever, but the medical establishment rejected the theory. Thirty-five years later, Dr. Carlos Finlay, a native Cuban, pushed the idea further, to continued skepticism. Undaunted, he worked to advance the science. In an 1882 article for the *New Orleans Medical and Surgical Journal,* Finlay declared any theory "untenable" that "appeals to filth or neglected hygienic principles" as yellow fever's cause; rather, the mosquito was the culprit. Years later Gorgas wrote, "Indeed we all knew Dr. Fin-

42. William Crawford Gorgas photographed in 1914. "I think this yellow fever work will reflect great credit on our corps," he remarked. Library of Congress

lay well, and were rather inclined to make light of his ideas, and none more so than I." Fortunately, Dr. Walter Reed, of the army's Yellow Fever Board, was more open-minded, and building on Finlay's important work finally confirmed the mosquito vector in 1900. Reed later declared that Finlay "must be given ... full credit" for the discovery (FIG. 43).[135]

With the proper target identified, Gorgas vigorously attacked. Killing mosquito larvae, he wrote, was "the essential; everything else is secondary to it." To that end, he divided the city into 20 inspection districts, each with its own sanitary inspector.

[134] Wiggins, "William Crawford Gorgas." Gorgas, *Situation in Panama,* 40.

[135] Finlay, "The Mosquito Hypothetically Considered as an Agent," 601. Gorgas, *Situation in Panama,* 15 and 14. Interestingly, Dr. Nott attended Gorgas's birth!

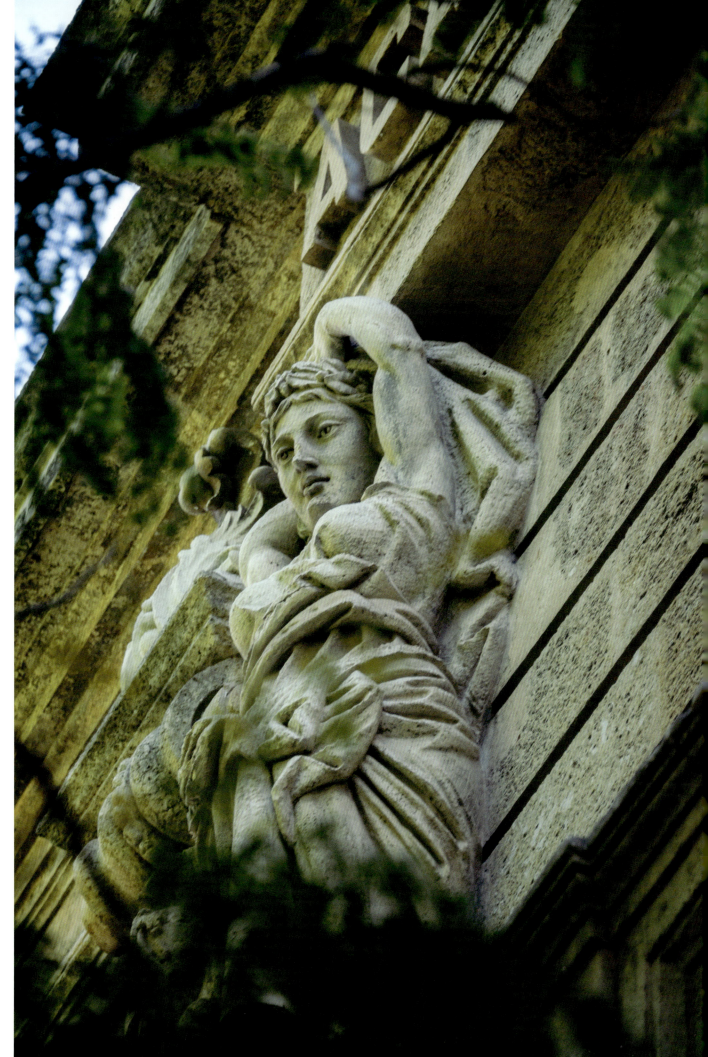

43. Detail of the front of the building that houses the Carlos J. Finlay National Museum of the History of Sciences, Havana. "My only desire is that my observations be recorded," Finlay wrote in 1881, "and that the correctness of my ideas be tested through direct experiments" {CC}

The "*Stegomyia* brigade" fanned out across town and the surrounding countryside, dozens of men emptying standing water from gutters, urns, flower pots, pitchers, barrels, buckets, and tin cans. Carpenters trundled work carts up and down the narrow streets, placing screened wooden lids over cisterns to prevent egg laying. Men sprinkled kerosene on stagnant water in ditches, ponds, pools, and fountains. Gorgas proudly wrote to Reed on May 22, 1901, "We have fifty men at this work, oiling and draining small collections of water in every house and putting oil in sinks and closets so that it will run down to the cesspools." The "dead larvae running out in considerable numbers" from the sewer mouths proved the tactic's effectiveness.[136]

Other squads fumigated houses, sealing up the rooms where yellow fever patients had suffered and burning "Persian Insect Powder," made of crushed chrysanthemums, that did not harm fabric. After two hours the room was reopened, the dead mosquitos swept up and burned outside. In July the Army ordered the Cuban people to screen their windows and doors. The campaign's results were astonishing. In January 1906, Finlay, who succeeded Gorgas as the island's chief health official, reported dwindling case counts to his old colleague. "I am glad to inform you, that we have got almost entirely rid of the yellow fever. Only two cases have been recorded during the present month; one of them a Cuban child, 7 years old."

44. Bust of Dr. Carlos J. Finlay, in front of the building of the Academy of Sciences of Cuba {CC}

Thanks to Finlay, Reed, and Gorgas, Havana went from a "pesthole" to a healthy tropical city (FIG. 44).[137]

Trade exploded between the U.S. and Cuba after the Spanish-American War. Leopoldo Dolz y Aranjo moved to Alabama's port city as Cuban consul in 1902. Besides tending to Cuban citizens' needs, he prepared annual reports that give a clear picture of Mobile and Havana's robust early 20th-century commerce.

[136] Gorgas, *Situation in Panama,* 61 and 79.

[137] Howard et al., *The Mosquitoes of North and Central America and the West Indies,* vol. 1, 430. Gorgas, "The Practical Mosquito Work Done at Havana," 176-177. Spears and López-Oceguera, "Carlos Juan Finlay, William Gorgas, and Walter Reed," 74. *Memorial Service Held in Honor of Major General William Crawford Gorgas,* 21.

In his 1905 report, he declared that "the trade of this port with those of Cuba grows each year," and that "special wharves exclusively dedicated to this service" were under construction along the city's riverfront. He counted 46 Cuban steamship arrivals and 45 departures during the month of December alone.[138]

From January to June 1905, he listed Mobile's Cuban imports, including over two million pounds of bananas, half-a-million pounds of coconuts, 10,796 tons of manganese, 19,308 barrels of oranges, 1,500 barrels of onions, 1,542 pounds of tobacco leaf, half-a-million pounds of coffee, as well as lemons, limes, pineapples, copper, sulfur, creosote oil, and even a few exotic birds. On the export side of the ledger were 5,707 head of cattle, 568 mules, 803,866 bushels of corn, 337,805 bushels of wheat, and 2,196 tons of fertilizer. Other exports included cotton, stone, machinery, lamps, shoes, leather goods, paper, salt pork, and butter, for a total value of over six million dollars. In fact, he proudly concluded, Mobile's Cuban trade exceeded that with all other world ports.[139]

Curiously, Consul Dolz did not include a detailed list of Mobile's lumber exports to Cuba. During the Southern yellow-pine boom, Mobile's harbor and rail facilities made it the lumberman's shipping point of choice. Sawn planks, logs, staves, and shingles flowed south in numbers that dwarfed the pre-war totals. Indeed, between 1901 and the late 1920s, three lumber fleets homeported at Mobile, a record unmatched by any other Southern city (FIG. 45). The earliest was that of James Feore, a native Irishman who relocated from Quebec to the central Gulf Coast, bought Mississippi timber land, and operated 23 wood- and steel-hulled schooners and barks at Mobile. Feore family tradition holds that one of James's schooners, the *Hiddie Feore*, was the first American ship into Havana harbor after the war. In 1910 John Scott and his brothers started a shipping business that eventually consisted of 22 schooners. The Scotts owned property in the Cayman Islands, as well as South American mahogany forests, Mississippi timberlands, and a Mobile sawmill. Three years later, the Whitney/Bodden family, which also boasted Cayman connections, joined the competition with almost two dozen three- and four-masted schooners. All told, some 70 windjammers plied the waters between Mobile, Havana, and other Caribbean ports throughout the teens and twenties. During one five-week period, 16 schooners carried an astonishing six million board feet to Havana, often racing one another south. Little wonder the *Birmingham Item* crowed in 1912 that Mobile not only held its lead in Cuban trade but "materially increased it during the year, and the exports from this port to Cuba now exceed by $1,000,000 the *combined* [my emphasis] Cuban exports of New Orleans, Philadelphia, Boston, and Baltimore, New York

[138] U.S. Department of State, *Register of the Department of State, Corrected to August 1, 1907*, 108. "Memoria comercial del cónsul de Cuba en Mobila correspondiente al año 1906," 77 and 78.

[139] "Memoria comercial del cónsul de Cuba en Mobila," 86, 78, 80-81, 79-80 and 85.

45. Forest products constitute a significant portion of Alabama's economy. Historically, Mobile led every other U.S. city in the export of lumber to Havana
{CC}

being the only rival Mobile has in the Cuban trade."[140]

Trade goods were not the only things traveling from Mobile to Havana. Winter-weary Mid-westerners lured by promotional brochures and magazines like *The Cuba Review & Bulletin* flocked south seeking relief. "To those who have wandered there," opined the latter in its December 1906 issue, "Cuba is a land of the lotus. To the northern dweller racked by climatic tortures … Cuba is a fair island, a land of sirens which beckon him to her shores for needed rest and enjoyment." In an attempt to capture this lucrative business, New York's Munson Steamship Line partnered with the Southern Railway and the L&N Railroad to comfortably carry tourists from Chicago or St. Louis directly wharf-side in Alabama's port city. On arrival, travelers could either refresh at the Cawthon Hotel or immediately board a fast steamer like the SS *Mobila* that departed for Havana twice weekly. For a $35 first-class roundtrip ticket, paradise-seekers settled into sumptuous staterooms with cushioned seats, over-under racks, electric fans, attended by prompt white-jacketed stewards to enjoy a 36-hour sea voyage (Fig. 46). The total travel time from Chicago's snowy canyons to a sunrise on Havana's balmy shore was less than three days.[141]

A number of Cuban businessmen pursued their own lucrative opportunities in Mobile. Planiol & Cagiga and Díaz and Brother, "wealthy merchants of Havana," partnered with Mobile's Benemelis Steamship Co. (owned by a Cuban native) to open the National Mosaic Flooring Company in 1907. The partners chose a 10-acre site along the L&N Railroad at Hurtel Street and erected several buildings, including a 165-by-330-foot main structure and dormitories for their 50-man Cuban work force. Their business was the manufacture of Adamantile, known popularly as Spanish tile. Workers placed gray cement powder into tinctured seven-inch-square metal molds and used hydraulic presses to stamp a pleasing variety of designs. The *Mobile Register* touted the handsome product for its "hygienic advantages." Another advertisement proclaimed: "This tile made Havana sanitary. For the sake of cleanliness and freedom from disease—for beauty's sake you ought to buy it." The product proved popular and by 1911 was in place at the Battle House Hotel, the Mobile County Courthouse, Mobile City Hall, the Convent of Mercy, Spring Hill College, numerous midtown bungalows, and Tampa's De Soto Hotel (Fig. 47). Local businessman Walter Bellingrath purchased the company in 1917, and Mobilians soon dubbed the product "Bellingrath tile."[142]

[140] Mike Feore, personal interview, October 9, 2020. Feore, "Brief History of Mobile," 6-9. *The Cuba Review & Bulletin*, August 1912, 21. According to Feore, a Mobile man operating a dredge boat in Havana harbor reported seeing the *Hiddie Feore*.

[141] *The Cuba Review & Bulletin*, December 1906, 11 and 69-76.

[142] "Concrete in Alabama," 39. McGehee, "What is Adamantile?" During a March 2022 stay at Villa Mía in Vedado, I delighted in the handsome Spanish tile on the front porch and in all the interior rooms.

46. 1906 ad for regular steamship service between Mobile and Havana. The price included a comfortable stateroom, an electric fan and an attentive, white-jacketed steward. Wikimedia

The Cuban Molasses Co. was another endeavor that found Mobile congenial. It built a two-million-gallon tank riverside and filled it with blackstrap molasses, a sugary refinery waste product delivered via tanker ships from Matanzas. The company then shipped the molasses via railroad tank car to St. Louis and mixed it with grains to feed livestock. Not surprisingly, several Port City Cubans and people of Cuban descent gravitated toward the tobacco industry, importing Caribbean leaf for their brands. Gilbert Faustina was one such entrepreneur, born in New Orleans of an Afro-Cuban father and a French mother. Despite restrictive Jim Crow laws, he founded a cigar factory in a two-story building and employed nine men who rolled brands like "Faustina's Best" and "Excelsior." Businessmen loved them.[143]

Clearly, there was much for Cuba's consul to do. In 1921 Andrés Jimenéz y Ruz, 39, assumed the Mobile post. "Mr. Jimmy," as he was affectionately known, lived on St. Louis Street and routinely walked down to the docks to meet arriving Cuban ships. During the

[143] *The Cuba Review & Bulletin,* December 1914, 33. Kranz, *African-American Business Leaders and Entrepreneurs,* 85.

47. Decorative encaustic tile, Christ Church Parish House, 115 South Conception Street, Mobile. Many of Mobile's porch tiles were locally made by Cuban immigrants {CC}

1926 hurricane, his daughter, Teresa, recalled watching the shadow of their two-story frame house swaying across the façade of the brick house opposite. Such dangers aside, Mr. Jimmy and his family enjoyed Mobile and fit in well. Teresa got to be May Queen of her 1932 elementary school class, and her father held his post until 1939. He remained in Mobile until his death in 1948. He was the city's last Cuban consul.[144]

Prohibition hugely increased traffic between Mobile and Havana, both legal and illegal, the latter artfully shielded from Mr. Jimmy and local authorities. After the 1919 passage of the Volstead Act, Munson's reservations department had their Havana trips booked a solid month in advance. But not all of these travelers were simply thirsty American tourists seeking a little relief in a Caribbean bar. Some were business-savvy smugglers working extensive mainland and island contacts.[145]

During a well-publicized 1924 corruption trial, the reach and sophistication of one Mobile-based smuggling network astonished newspaper readers. The ring included the president of the People's Bank, who regularly secured loans for Cuban liquor buys and made payments up and down the line to politicians, lawyers, schooner captains, shipping clerks, inspectors, stevedores, bag men, lookouts, and rough-handed fishermen. The ring would typically purchase hundreds of cases of beer, gin, rum, scotch, wine, and whiskey at a go. Ship captains then loaded it and claimed they were Honduras bound. Once out of Havana's harbor, however, they made a beeline north, heaving to outside the U.S. three-mile national limit along "rum row." Fast boats then scooted out of secluded Alabama bayous and coves to pick up the contraband and sneak it into Mobile. Local speakeasies and bigwigs bought some of it, but most headed to New Orleans, Chicago, and other points by truck or train. Just as with the Civil War blockade runners, the profits were stupendous, each shipment netting as much as $20,000 (approximately $322,000 today). Many locals applauded the smugglers' activities. A *New York Times* reporter wrote that after each shipment's arrival, "Mobile appears to beam pleasantly and to talk a little thickly." Authorities were less pleased and stepped up their efforts to disrupt the smuggling but enjoyed only limited success.[146]

Unfortunately, politics once again interrupted Mobile and Havana's easy relations, first during WW II when German U-boats prowled the Gulf and then during the Cuban Revolution. In an early effort to gauge the revolution's import and possible trade impacts, the *Port of Mobile News* sent a reporter and a photographer to cover Havana's July 26, 1959 celebration. The young Mobilian journalists worked a massive crowd that had "poured into the city from the

[144] Daugherty, "Teresa, Mr. Jimmy and the Mobile-Havana Connections," 114.

[145] *The Marine Review*, December 1919, 565.

[146] Dorr, *A Thousand Thirsty Beaches*, 48-49 and 5. Moss, *Southern Spirits*, 94.

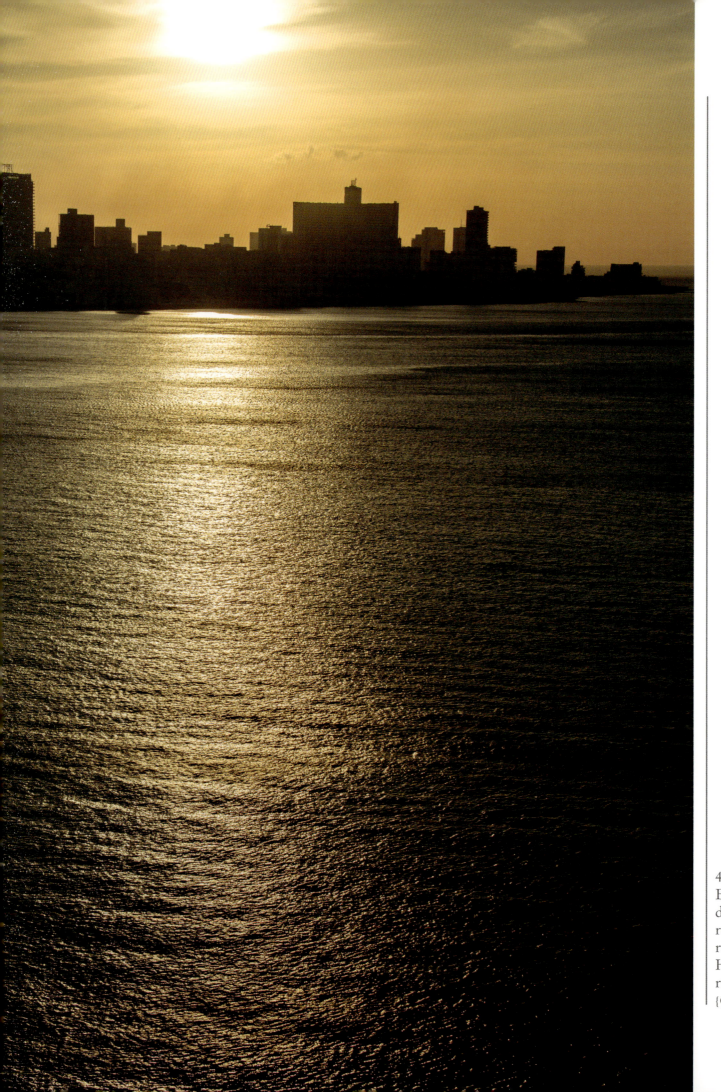

48. Sunset in Havana. Even during the darkest periods, there remained those who recalled Mobile and Havana's warm past relations {CC}

country, to pay homage to Fidel Castro." Their first interview, a gray-uniformed customs inspector, asserted: "I am neither Kremlin nor Washington. I am a Cuban." The reporter grasped the day's tone and explained: "They do not want to be thought of as Communists. Nor as poor cousins unavoidably linked to the United States by a sugar cane company." The Mobilians listened to a "short (for Castro) two and one half hour speech," to which the enthusiastic cane cutters raised their machetes "in a clanking chorus of approval." The reporter mused, "It was apparent that Castro is magic." Whether or not the island's future belonged to the "sickle of Communism or the machete," the reporter could not divine. The uncertainty did not last long, however, and the United States imposed a draconian embargo on the island in October 1960. Trade stopped, many fled the island, attitudes hardened. Mobile and Havana's 400-year-old bond froze. Yet even during the darkest days to come, there were those who remembered it and worked to revive it for the good of both peoples (FIG. 48).[147]

[147] Brady, "Sickle or Machete," 14 and 15.

Havana's play of light and shadow amid its noble columns has inspired more than one historian down the decades
{CC}

VISIONARY RENEWAL: THE HISTORY MEN

He was the son of a washerwoman. Of his father nothing is known. Eusebio Leal Spengler first saw light on September 11, 1942, in Central Havana. Surprisingly, although it was only a few blocks away, he did not visit Old Havana, that ancient quarter now so famously associated with him until he was seven years old. A relative took him there one day, and the resulting experience was a revelation. "I was amazed," he recalled in a 2018 *Smithsonian* magazine profile. "I had never seen stairways go up to that height! The magnificence of the cathedrals, the colors, the crowds of vendors selling everything in the street—the way they sang and danced—it was a really fascinating world!" Intrigued, he returned often, marveling at the elaborate architecture and the layered history it communicated (FIG. 49).[148]

Leal faced limited opportunities even before he dropped out of sixth grade to help support his struggling family. When the 1959 revolution made education free, he enthusiastically re-entered school and took advantage of well-stocked libraries, reading widely and deeply on art, architecture, and Cuban history. He also frequented the offices of Dr. Emilio Roig de Leuchsenring, Havana's revered city historian. "By ancient tradition, every old city in Latin America maintains the institution of 'chronicler,' who is named for life to save the memory of the city," Leal explained in his *Smithsonian* interview. Roig (1884-1964) a native Habanero, had held his post since 1935 and took an interest in the young man who wanted to learn everything. "He was very eloquent, very accessible," Leal later recalled. Soon, Leal was the chief historian's *de facto* apprentice—not an employee but rather a "confidant." When Roig died, Leal was his obvious successor (FIG. 50).[149]

His first big project was an important one—the restoration of the baroque Captain General's Palace fronting the Plaza de Armas. This complex job involved multiple disciplines and skills, from archaeology to masonry, roofing, and landscaping, and the 25-year-old Leal embraced them all. As he later recalled, "With the help of drawings, newspapers and photographs of the different historical stages of the building, we managed to restore the original sense of the stairs and the older spaces of the rooms" (FIG. 51).[150] Perhaps the most exciting episode occurred one morning when a big truck broke the pavement on Tacón Street, immediately in front of the palace. Leal rushed to the scene. Beneath the cracked asphalt were remnants of wooden bricks. As a local-history connoisseur, Leal knew that these unusual pavers dated from the early 19th century. Gov. Miguel Tacón y Rosique originally placed them to

[148] Perrottet, "The Man Who Saved Havana."

[149] Pedreira, *An Instrument of Peace*, 17. Perrottet, "The Man Who Saved Havana."

[150] García-Santana and Larramendi, *Treinta Maravillas del patrimonio arquitectónico cubano*, 181.

49. Entryways facing the courtyard of the convent adjacent to the church of San Francisco of Asís, Havana. The old city's many architectural details have transfixed visitors {CC}

combat mud and dampen the incessant racket of heavy carriage wheels that bothered the household.

The wooden bricks' chance exposure inspired Leal to re-create the famous street, and his considerable persuasive skills won official approval to do it. Before he could begin, however, a visiting international delegation prompted officials to order the street re-asphalted instead. It was one of those classic preservation versus progress moments, and Leal proved more than equal to it. Rather than argue or retreat, he lay down in front of the steamroller. "I realized I would lose the opportunity to create something unique and beautiful," he later said. The situation resolved when the mayor promised to let Leal restore the street later if he would

50 Eusebio Leal Spengler {JL}

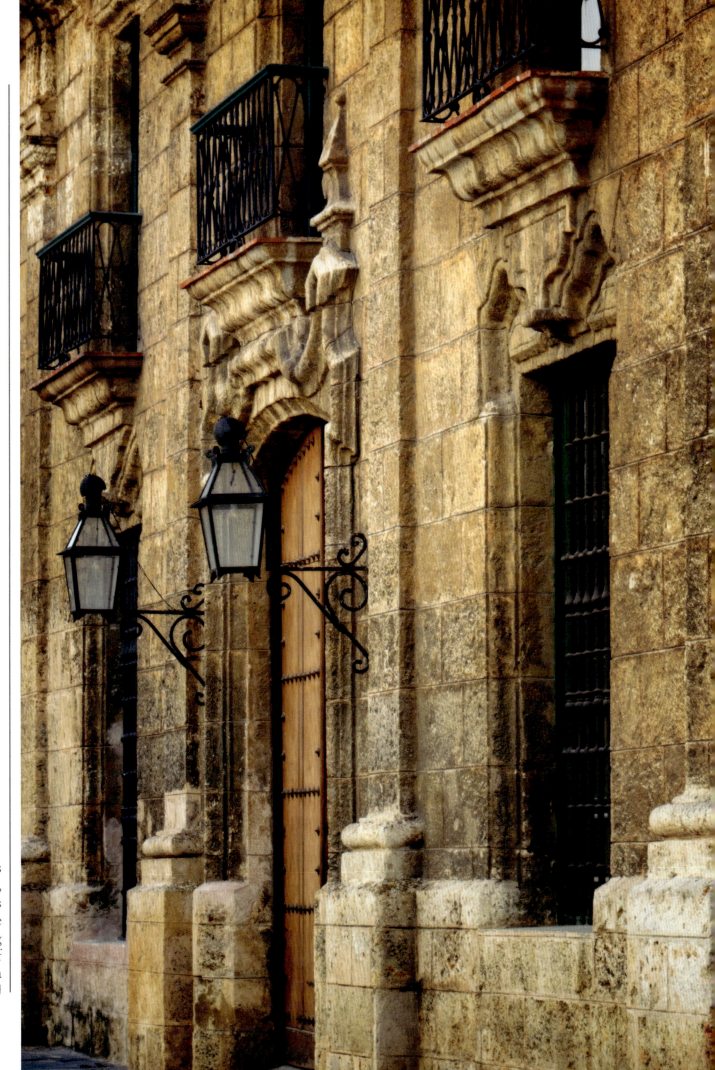

51. Captains General Palace, Havana. Nowadays this venerable administrative building houses the Museum of the City of Havana {CC}

only move. The result was an important victory for the old city and Leal's launch as a legendary advocate for it.[151]

His life's challenge was immense. Nearly a square mile in extent, Old Havana contained 3,744 buildings, 551 of them designated of "exceptional value" to Cuban history and culture (Fig. 52). Sadly, many were in poor condition and some on the verge of collapse thanks to the revolutionary government's policy of channeling resources into the countryside. While the scrapping of ghastly pre-revolution redevelopment schemes that called for wholesale demolition, new skyscrapers, and parking lots was good for the venerable quarter, the lack of maintenance was not. Yet it remained a living neighborhood, home to almost 70,000 people, whom neither the government nor Leal wanted displaced. The young historian worked feverishly to both educate the public and to refurbish the built environment. The creation of the Heritage Department of the Ministry of Culture in 1976, and the United Nations Educational, Scientific, and Cultural Organization's (UNESCO) designation of Old Havana as a World Heritage Site in 1982 considerably helped these endeavors (Fig. 53). There was significant progress by 1989. Employing 800 people and commanding a $7.8 million budget, Leal fully restored 68 buildings and claimed, "We have captured the hearts of the people by providing housing for doctors and old people." But large problems remained, including thousands more deteriorated buildings, crumbling infrastructure, poor to non-existent utility service, accumulating trash, and a filthy harbor.[152]

The 1991 collapse of the Soviet Union devastated Cuba. Billions of dollars in subsidies and aid vanished, and the island's trade plummeted an astonishing 80%. Fuel shortages, blackouts, rationing, and long lines became the order of the day. Combined with the ongoing American embargo, the result was grinding want. The government declared a "Special Period in Time of Peace," popularly known as the Special Period. Simply living was difficult for the city's two million residents. Amid such austerity, the restoration of Old Havana stopped.[153]

Again, Leal proved equal to the moment. He held an important government post and counted President Fidel Castro as a personal friend. In order to continue his efforts, he convinced the president that "without a sound financial basis, the idea of saving Old Havana is a utopia." He had an idea how to generate the capital needed, namely to found a tourist management company and allow it to reinvest profits into preservation work and tourist properties rather than turning them over to the government. If this sounded like capitalism, Leal assured Castro that

[151] Perrottet, "The Man Who Saved Havana."

[152] Black and Burisch, *The New Politics of the Handmade*, 167. Suárez García, "Cultural Heritage Legislation: The Historic Centre of Old Havana," 239-240. Judge, "The Many Lives of Old Havana," 281. Among Old Havana's other designations are Priority Conservation Zone (1993) and Zone of Special Significance to Tourism (1995). See Suárez García, "Cultural Heritage Legislation," 240.

[153] Cluster and Hernández, *The History of Havana*, 255-256.

52. Teniente Rey Street. On the far end, National Capitol Building, Havana. No matter which direction one looks, Old Havana dazzles with its incredible richness {CC}

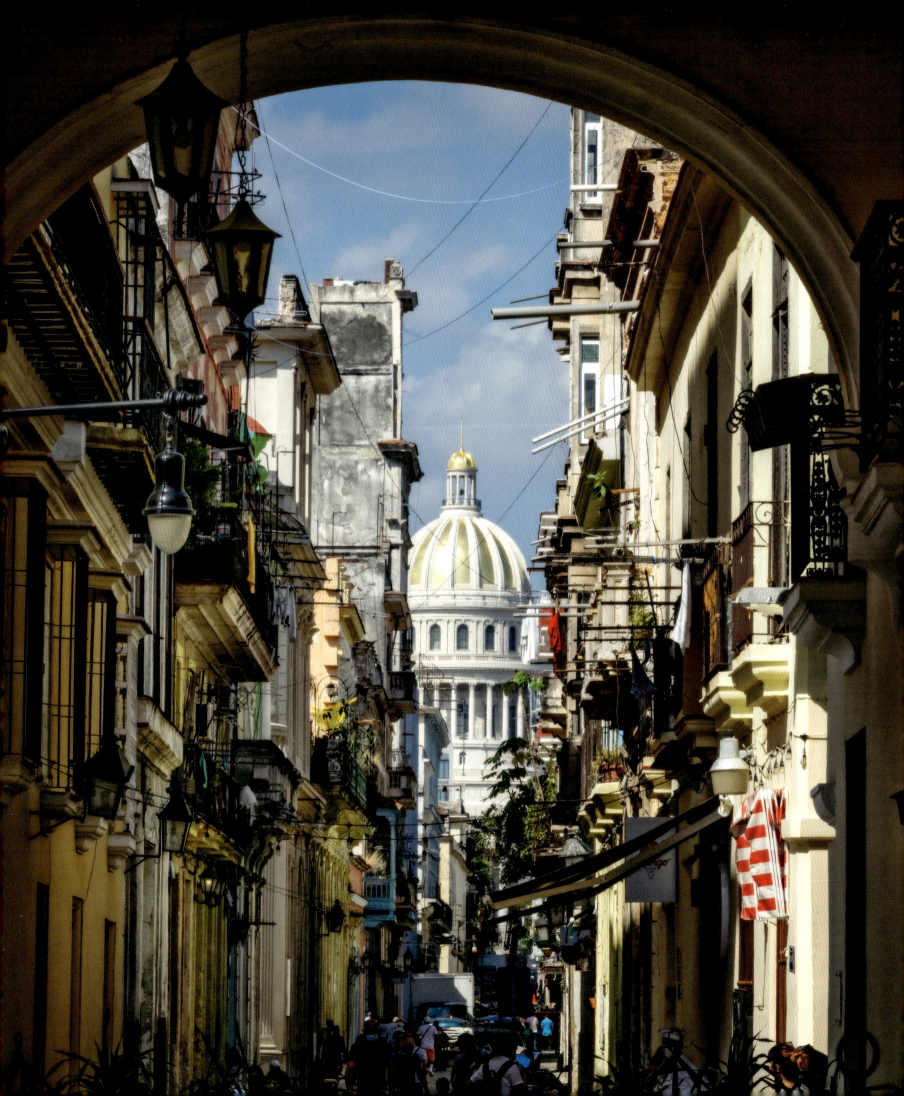

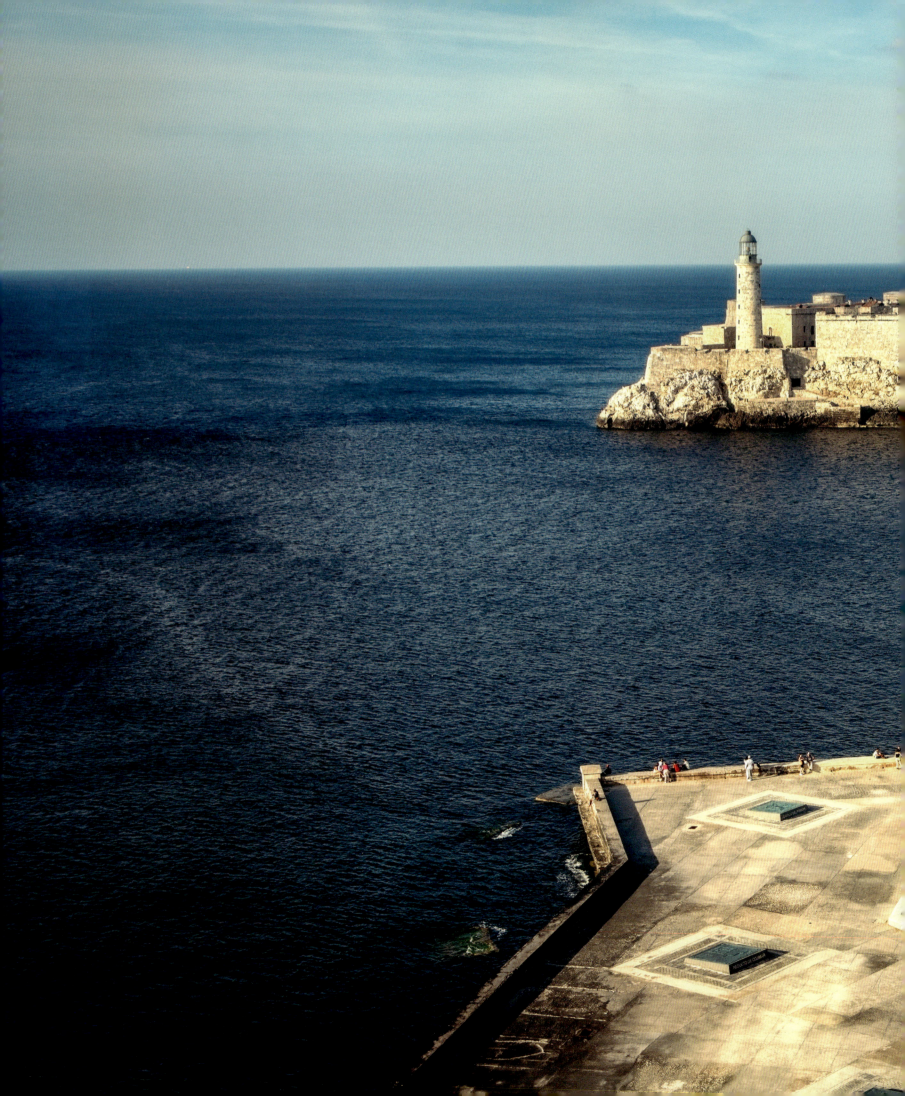

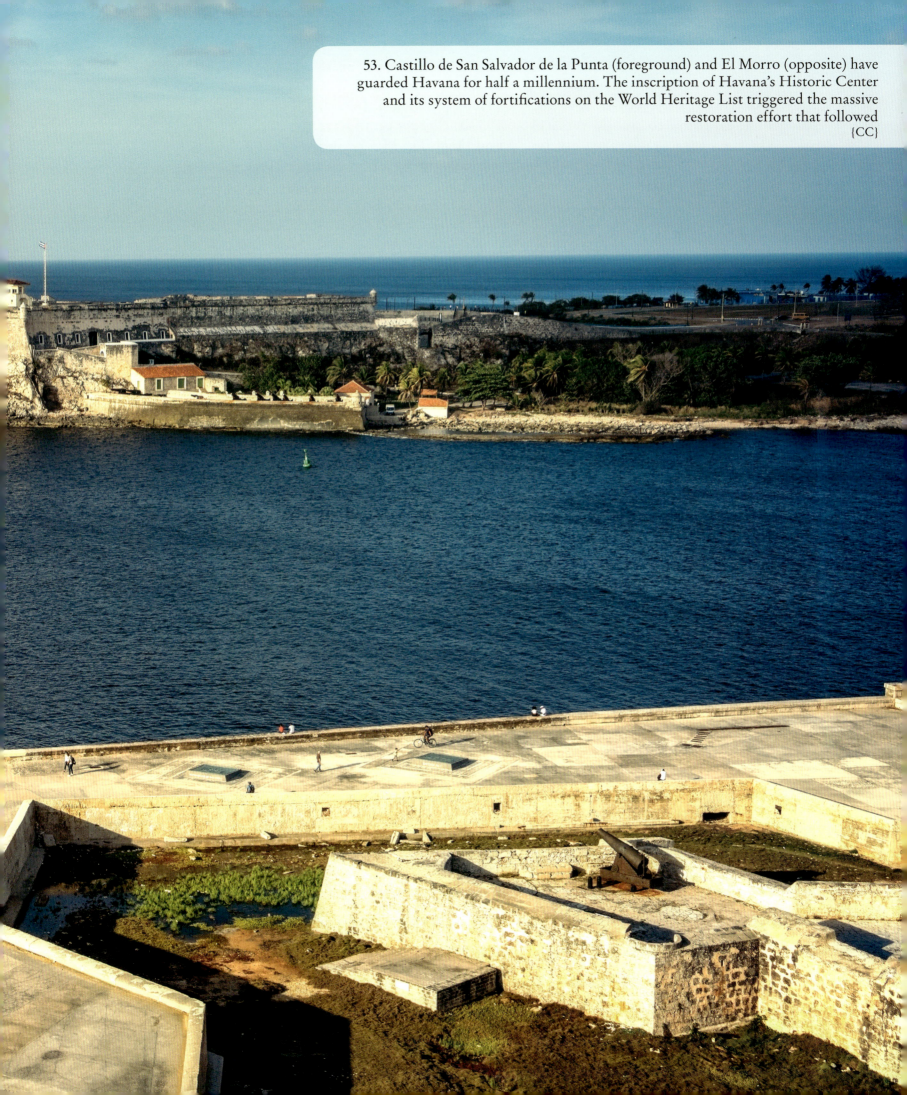

53. Castillo de San Salvador de la Punta (foreground) and El Morro (opposite) have guarded Havana for half a millennium. The inscription of Havana's Historic Center and its system of fortifications on the World Heritage List triggered the massive restoration effort that followed {CC}

they could do it differently, devoting some of the profits to public services and infrastructure. "We have to invest in schools, playgrounds, services for the elderly." Castro listened, approved the innovative economic strategy, and provided $1 million in seed money. By his calculus, tourism was to be the "gold mine through which the country can obtain foreign exchange." Thus was born Habaguanex, S.A. (Sociedad Anónima, or a corporation) on January 6, 1994, appropriately named for the Taíno cacique and managed out of Leal's office. Early projects involved restoration of the Hotel Ambos Mundos (where Hemingway famously lived for a time), and the reclamation of the Plaza Vieja from the underground parking deck created during pre-revolutionary days. Just three years after its creation, Habaguanex boasted $10 million in gross revenue.[154]

In February 1994, Leal traveled to Mobile to speak at a conference titled "Cuba: Today and Tomorrow." He came at the invitation of Jay Higginbotham, director of the Mobile Municipal Archives and the driving force behind the newly minted Society Mobile-La Habana. Like Leal, Higginbotham was an extraordinary figure, deeply connected to his city's history and dedicated to its preservation and promotion. Not surprisingly, the two men forged a warm and productive alliance, despite early bureaucratic and political challenges.[155]

Prieur Jay Higginbotham was born in 1937 and grew up in Pascagoula, Miss., and Mobile. He proudly traced his roots to the latter city's French founders and counted Edgar Degas among his ancestors. He graduated from the University of Mississippi, popularly known as Ole Miss, in 1960, did a brief stint as an assistant clerk with the Mississippi House of Representatives, took a teaching job at Mobile's Vigor High School, and subsequently as director of the Mobile Public Library's Local History Section. When not molding young minds or figuring department budgets, Higginbotham threw himself into adventuresome journeys and wrote books. He visited 42 countries, climbed Japan's Mount Fuji, swam the Nile, and rode the Trans-Siberian Railway. A devotee of local history and culture, he churned out well-written, accessible titles like *The Mobile Indians* (1966), *Mobile: City by the Bay* (1968), and his masterpiece, *Old Mobile: Fort Louis de la Louisiane, 1702-1711* (1977). The latter volume was the result of eight years labor, much of it beneath the fluorescent lights of the Freeman's Waffle House on Spring Hill Avenue. The 24-hour restaurant provided Higginbotham a special booth, where he could spread his papers and work long stretches, a steaming cup of coffee at his elbow. The resulting book illuminated early 18th-century Mobile, including its debt to Havana, and won a raft of awards.[156]

[154] Perrottet, "The Man Who Saved Havana." Grabar, "Havana on the Brink." Cluster and Hernández, *The History of Havana*, 264-265; Scarpaci, *Plazas and Barrios*, 190.

[155] "Cuba: Today and Tomorrow." Luxner, "Cuba's links to 3 Gulf cities," 14.

[156] Robertson, "Jay Higginbotham" (biography). Ned Harkins personal interview, August 5, 2022. Higginbotham's *Old Mobile* index provides 37 references for "Havana," see page 574.

In 1983, Higginbotham organized the Mobile Municipal Archives in an effort to preserve the city's extensive civic records. He served as its director until his 2001 retirement and director emeritus up to his 2017 passing. Throughout his tenure at the archives, Higginbotham skillfully employed his position to advocate for world peace. He corresponded with U.S. elected officials, including congressmen, senators, and even President Bill Clinton. He worked diligently and successfully to develop sister-city relationships, first between Mobile and Rostov-on-Don in the Soviet Union and, beginning in 1993, with Havana. Higginbotham most likely first visited the Cuban capital during the 1970s when he was researching *Old Mobile.* As he wrote in the introduction to its 1991 reissue, "I went to absurd lengths to ascertain the facts, once attempting to slip into Cuba from Veracruz to scour burial records in Havana." Apparently, he was successful, since he described Iberville's death and funeral in detail and listed the Archivo de la Catedral de San Cristóbal de la Habana in the bibliography.[157]

During the 1990s, Higginbotham traveled to the Caribbean metropolis frequently, where he met with then Mayor Pedro Chávez, Leal, and other officials in his efforts to establish the sister-city relationship. Between his meetings and especially in the mornings, Higginbotham went sightseeing. "Up early," he wrote in his travel diary after one ramble. "Walked around El Centro, mostly Vedado. For miles. Stopped in at Unión de Escritores y Artistas de Cuba [Union of Writers and Artists of Cuba]. Magnificent home in a tree-filled neighborhood." He noted everything—schools, hospitals, playgrounds. "So much to see all over Havana. Every block has something new and exciting. It would take years to see it all. Much more interesting than New York or Atlanta." The idea of constructive medical exchanges between Mobile and Havana particularly excited his imagination. "New knowledge and treatments would ultimately save the lives not only of Cubans but Americans as well," he wrote, "even as a native Mobilian, Dr. William C. Gorgas, once saved thousands of Cuban lives ... in the battle against yellow fever" (FIG. 54).[158]

Mobile and Havana's formal twinning took place in the fall of 1993. It was a historic move, the first such arrangement between and a U.S. and a Cuban city since the 1959 Revolution, and it garnered much publicity. Despite vocal opposition from the Florida Cuban exile community, some of whom traveled to Mobile to protest, Higginbotham redoubled his efforts through the Society Mobile-La Habana. In addition to organizing the conference where Leal spoke, the Society arranged sea-borne relief flotillas that carried medicines and religious materials, sponsored cultural exchanges, and advocated lifting the decades-old U.S. embargo. To the latter end, on March 17, 1994,

[157] Robertson, "Jay Higginbotham." Higginbotham: *Old Mobile,* 3, 284-285 and 548.

[158] Peterman, ed., *Selected Writings of Jay Higginbotham,* 263 and 326.

Higginbotham formally addressed the House of Representatives' Committee on Ways and Means. He touted the sister-city relationship and the recent "people-to-people" exchanges between Mobile and Havana. He continued, "All of our programs, however, constructive as they may be, have been carried out with great difficulty, due largely to the communication and transportation barriers imposed by the U.S. embargo." He pointed out that the Society had to cancel its first invitation to Leal and other Cubans to speak "after elaborate plans had been made to receive them." He closed by imploring Congress "to lift the embargo against our island neighbors, to extend a helping hand to the Cuban people, and to embark on a new, more constructive relationship that will enable both our people to realize their fullest potential, as nations and as individuals." Sincere and well-stated as it was, Higginbotham's address changed nothing in the complex political calculus of U.S.-Cuban relations.[159]

Unable to effect broad change, Higginbotham remained active with the Society's affairs. He and Leal enjoyed a close friendship, mutual visits, and a steady correspondence. A few weeks after Higginbotham's congressional testimony, Leal sent a warm letter, referencing the recent Mobile conference where he had spoken and presented drawings made by Cuban children "in homage" to the Alabama city. "Upon returning from my trip to Mobile," he wrote, "I told the children about that city and its people, and of its founder Pierre Le Moyne d'Iberville, of the distinct cultures that fused together to shape the identity of this town in the southern United States of America." He praised Higginbotham's efforts at the Municipal Archives and encouraged him to keep up the good work. Fundamentally scholars, the two men exchanged Gulf Coast history tidbits and books for each other's respective collections. Their letters repeatedly referenced Iberville, whom Leal would call "the very heart of our relationship." Appropriately enough, both cities were soon to celebrate that important linkage yet again.[160]

54. For Jay Higginbotham, "The essence of the sister city idea is this: By creative interaction in concrete and constructive ways, mutual problems and challenges can better be met." Doy Leale McCall Rare Book and Manuscript Library

[159] "History of the Society Mobile-La Habana, 1993-2005," 1-2. "Statement to the Congress of the United States by Jay Higginbotham," March 17, 1994.

[160] Eusebio Leal Spengler to Jay Higginbotham, April 4, 1994. *Mobile Register,* June 22, 1994.

Just as with the 1937 plaque, French speakers initiated the process. In 1999, Québec City officials used sculptor Elzéar Soucy's original 1922 mold of the Iberville statue that stands in front of their parliament building to make an exact cast. They presented the handsome bronze to the City of Havana, attended by a representative from the Society Mobile-La Habana. The statue faces north, interestingly enough directly toward Mobile, and is situated alongside the busy Malecón, the waterfront drive just inside the harbor entrance. Inscribed in Spanish and French, the attached plaque reads in part, "Québec remembers Pierre Le Moyne D'Iberville, Montréal 1661-La Habana 1706 … the greatest hero of New France."[161]

Inspired by the Canadian example, several Mobilians, including Mayor Mike Dow, former Congressman Jack Edwards, and members of the Hand Arendall Law Firm, commissioned another replica from the same mold and presented it to the City of Mobile. When workmen placed the Iberville sculpture riverside, Dow used a compass to ensure that it looked directly toward its Havana counterpart. The city's 2002 tricentennial observances provided the perfect occasion to unveil the figure, and Second Secretary Jose Luis Noa of the Cuban Interests Section in Washington, D.C. attended.[162]

Ceremonies, cultural exchanges, and conferences provided an all-important foundation for reinvigorated trade between the two seaports. When the U.S. Congress relaxed the embargo in 2000, both Alabama and Cuban interests leapt at the opportunity. The bipartisan deal allowed cash-only food and medical products sales to Cuba (but no sales of Cuban products in the U.S.) and liberalized individual travel. Officials at the Alabama Port Authority (APA) worked aggressively to exploit the opening. Perhaps more than any other U.S. port, Mobile enjoyed easy Gulf access with extensive rail, air, and highway connections (FIG. 55), and its officials were already friendly with their Cuban counterparts. "They [Cuba] are one of our closest neighbors, and a historical trading partner, and we've drifted too far apart," APA Director Jimmy Lyons told the *Los Angeles Times* in 2009. Cotton, corn, soybeans, poultry, railroad ties, and utility poles streamed south for the first time in over 40 years. Alabama's 2014 sales to the island reached an eye-opening $33 million.[163]

Prospects brightened further during the Barack Obama administration, when the U.S. embassy reopened in Havana and the president himself visited in 2016. Obama's motorcade through the rainy capital sparked a spontaneous and joyous outpouring of ordinary Cubans, thrilled that the frustrating barriers at

[161] Gelly et al., *La passion du patrimoine*, 36. The translation is my own.

[162] "Iberville Statue Erected in Mobile," 1. Celebrations of Iberville continue between Mobile and Havana. In 2019 a Mobile delegation led by Mayor Sandy Stimpson presented a square bronze plaque that features the city seal and reads, "In Friendship." It is placed below the Québec plaque. See Pedroso, "De Alabama a La Habana."

[163] *New York Times,* September 28, 2000. *Los Angeles Times,* May 7, 2009. Koplowitz, "Cómo podría Alabama beneficiarse del fin del embargo a Cuba?"

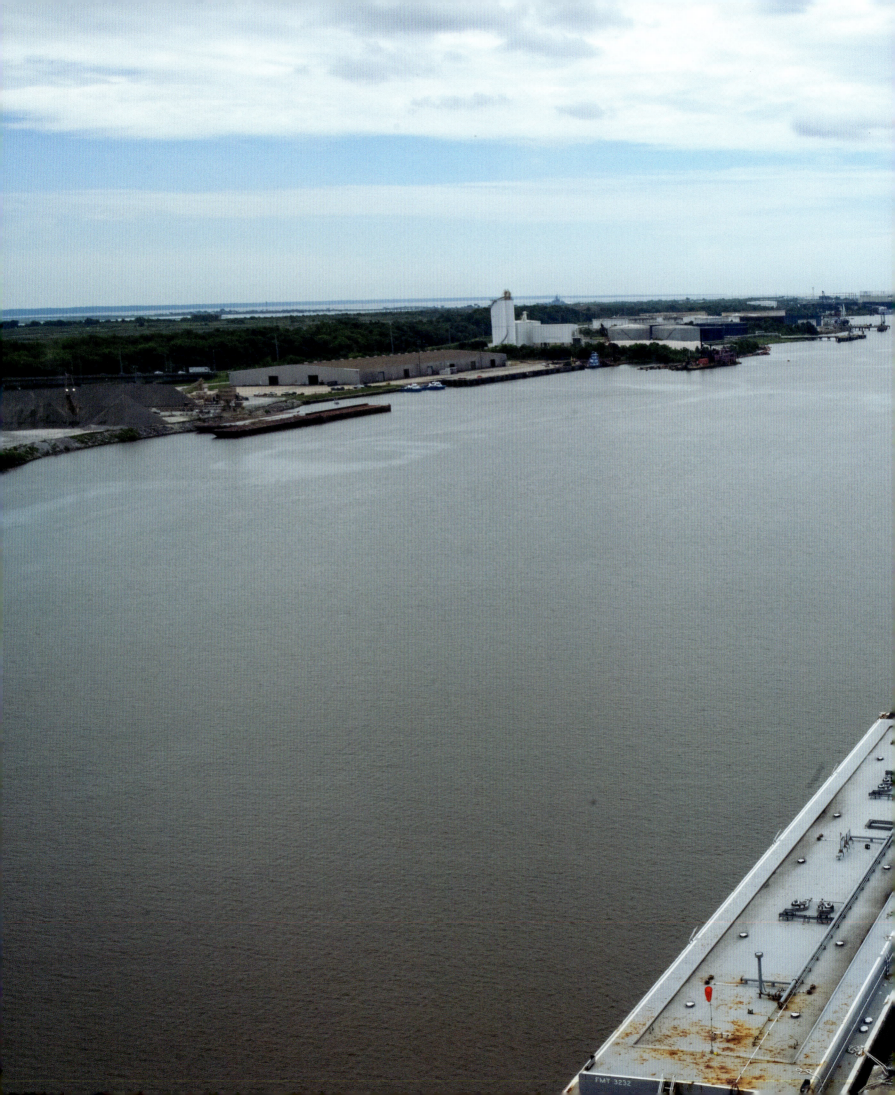

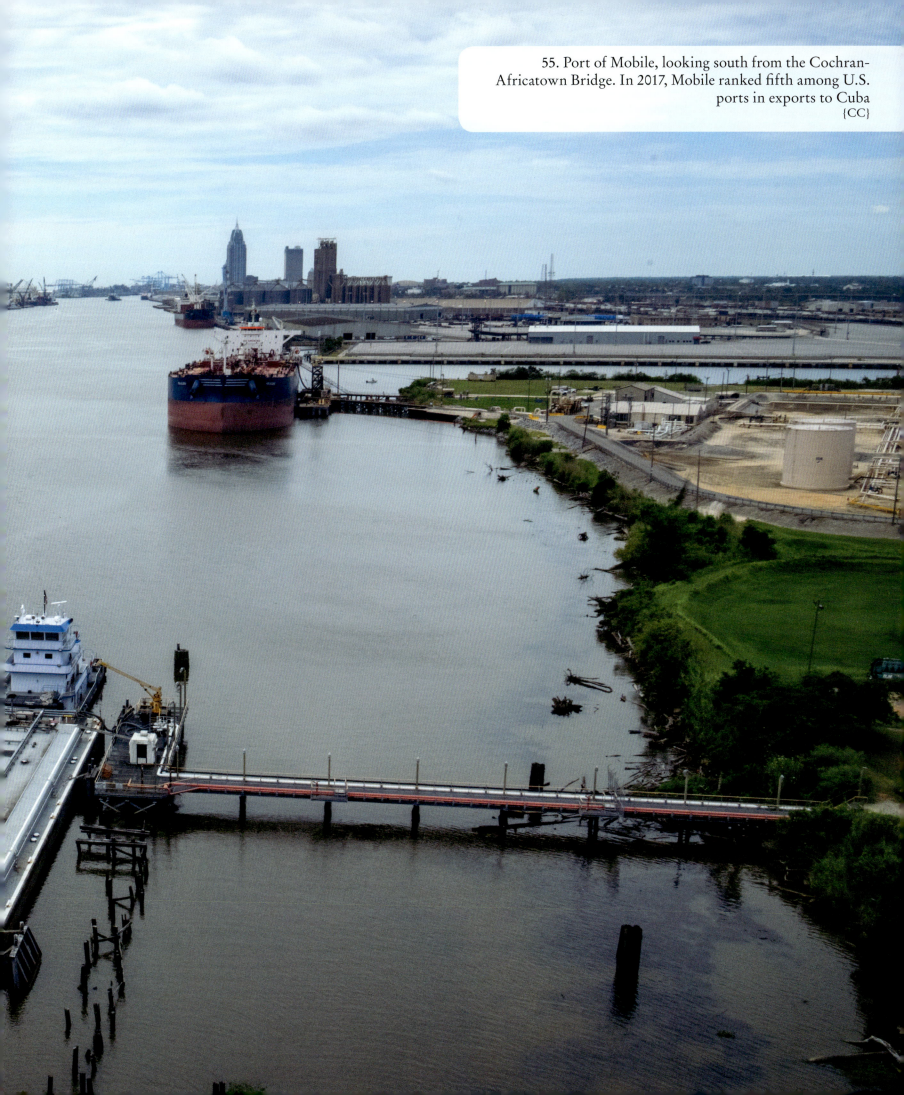

55. Port of Mobile, looking south from the Cochran-Africatown Bridge. In 2017, Mobile ranked fifth among U.S. ports in exports to Cuba
{CC}

last appeared dissolved. But in a dispiriting reversal, President Donald Trump threatened in 2017 to re-tighten trade and travel restrictions despite protests from the U.S. agricultural lobby. The director of the Alabama Poultry and Egg Association told the *Decatur Daily:* "We've been trading with them [Cuba] for some time. While Obama made it easier, it's still cumbersome. We're not allowed to give them credit. They have to pay us up front through a third party. Normalizing trade would make it a lot easier." Despite the political uncertainty, the Cuban trade continued, and in 2021 Mobile exported 90,000 tons of poultry. Still, Mobilians and Habaneros work for more, and continue to hold each other in high regard. As a Cuban official movingly told a group of visiting Mobilians nearly two decades ago: "We will never forget that you were the first. You will always hold a special place for us." If the past teaches anything, it is that Havana and Mobile's centuries-long linkage is indeed profound and unbreakable, whatever the strains of the moment.[164]

[164] *New York Times,* March 20, 2016. *Decatur Daily,* June 26, 2017. Judith Adams, Alabama Port Authority, personal email to author, December 15, 2021. Soto, "Alabama en Habana," 67.

SOURCES CONSULTED

Newspapers and Magazines

Alabama Planter, 1856

Decatur Daily, 2017

Diario de La Marina (Havana), 1855, 1924, 1926, 1937

El Imparcial (Havana), 1918

El Pelayo (New Orleans), 1851

Frank Leslie's Illustrated Newspaper, 1861

Lagniappe (Mobile), 2019

Los Angeles Times, 2009

Mobile Daily Advertiser, 1851, 1854

Mobile Daily Register, 1898

Mobile Register, 1937, 1994

Mobile Register and Journal, 1841

New York Times, 2000, 2016

Port of Mobile News, 1959

The Cuba Review & Bulletin, 1906, 1912, 1914

The Marine Review, 1919

Books, Articles, and Other Sources

ALFONSO LÓPEZ, FÉLIX JULIO. *Béisbol y nación en Cuba*. La Habana: Editorial Científico-Técnica, 2015.

ALLAIN, MATHÉ. "Manon Lescaut et ses Consoeurs: Women in the Early French Period, 1700-1731." In *Proceedings of the Meeting of the French Colonial Historical Society*, vol. 5, 18-26. East Lansing: Michigan State University Press, 1980.

ALLEN, ESTHER, ED. *Selected Writings of José Martí*. New York: Penguin, 2002.

AMOS, HARRIET E. *Cotton City: Urban Development in Antebellum Mobile*. Tuscaloosa: University of Alabama Press, 1985.

An Authentic Journal of the Siege of the Havana by an Officer. London: T. Jeffery's, 1762.

Appleton's Annual Cyclopedia and Register of Important Events of the Year 1896. Third series, vol. 1. New York: D. Appleton & Co., 1897.

ARNOLD, J. BARTO III. *The Denbigh's Civilian Imports: Customs Records of a Civil War Blockade Runner between Mobile and Havana*. College Station, TX: Institute of Nautical Archaeology, 2011.

Arrate, José Martín Félix de. *Llave del Nuevo Mundo. Antemural de las Indias Occidentales. La Habana descripta: noticias de su fundación, aumentos y estados.* La Habana: Comisión Nacional Cubana de la Unesco, 1964.

Bagwell, David A. "Rediscovering that Devil Harry Maury: Mobile's Antebellum Filibustering, Dueling, and Soldiering Swashbuckler." Unpublished manuscript, 58 pages. Accessed June 24, 2022. https://www.scvsemmes.org/uploads/3/4/4/7/34476354/history--maury_harry--dab_best_article.pdf

Bedini, Silvio A., ed. *The Christopher Columbus Encyclopedia,* vol. 1. New York: Simon & Schuster, 1992.

Benson, Adolph B. *America of the Fifties: Letters of Fredrika Bremer.* London: Oxford University Press, 1924.

Bergeron, Arthur W. *Confederate Mobile.* Baton Rouge: Louisiana State University Press, 1991.

Black, Anthea and Nicole Burisch. *The New Politics of the Handmade: Craft, Art & Design.* London: Bloomsbury, 2021.

Blount, Russell. "Mobile Knights of Old: Harry Maury and the Baron." *Mobile Bay* (May 2022): 72-75.

Bowen, Wayne H. *Spain and the American Civil War.* Columbia: University of Missouri Press, 2011.

Boyd, Mark Frederick, Hale G. Smith and John W. Griffin. *Here They Once Stood: The Tragic End of the Apalachee Missions.* Gainesville: University Press of Florida, 1952.

Brady, Phil. "Sickle or Machete." *Port of Mobile News* (August 1959): 14-15.

Bremer, Fredrika. *The Homes of the New World: Impressions of America,* vol. 2. New York: Harper Brothers, 1853.

Brooks, Daniel Fate. "The Faces of William Rufus King." *Alabama Heritage,* no. 69 (Summer 2003): 14-23.

Browning, Robert M., Jr. *Lincoln's Trident: The West Gulf Blockading Squadron During the Civil War.* Tuscaloosa: University of Alabama Press, 2015.

Bunn, Mike. *The Fourteenth Colony: The Forgotten Story of the Gulf South During America's Revolutionary Era.* Montgomery: New South Books, 2020.

Catalogue of the Officers and Students of Spring Hill College, Near Mobile, Alabama, for the Academic Year 1859-'60, Mobile Daily Register, Mobile, 1860.

Catalogue of the Officers and Students of Spring Hill College, Near Mobile, Alabama, for the Academic Year 1860-'61. Mobile: Mobile Daily Register and Advertiser, 1861.

Chez, Francis Graves. "Cuba During the Buchanan Administration." MA Thesis, University of Wisconsin, 1921.

Clayton, Lawrence A., Vernon James Knight, Jr., Edward C. Moore, eds. *The De Soto Chronicles: The Expedition of Hernando de Soto to North America in 1539-1543,* 2 vols. Tuscaloosa: University of Alabama Press, 1993.

Cluster, Dick and Rafael Hernández. *The History of Havana.* New York: Palgrave MacMillan, 2006.

Coker, William S. and P. Hazel. *The Siege of Mobile, 1780, in Maps: With Data on Troop Strength, Military Units, Ships, Casualties, and Related Statistics.* Pensacola: Perdido Bay Press, 1981.

"Concrete in Alabama." *Rock Products,* June 22, 1908.

Cooper, Chip, Julio Larramendi, Elizabeth M. Elkin and John S. Sledge. *Common Ground: Photographs of Havana and Mobile – En terreno común: fotografías de La Habana y Mobile.* Mobile: Mobile Museum of Art, 2018.

Craighead, Erwin. *From Mobile's Past: Sketches of Memorable Places and Events.* Mobile: Powers Printing Co., 1925.

Cuba, Consejo Nacional de Patrimonio Cultural. Resolución 18. October 2021.

"Cuba: Today and Tomorrow," program. Mobile Municipal Archives, Record Group 31, Series 5, Box 5.

Cullen, ed. "Dauphin Island." *Country Roads,* April 25, 2014. Accessed April 12, 2022. https://countryroadsmagazine.com/travel/outdoor-adventures/dauphin-island/

Currier, Charles Warren. "The Church of Cuba: An Outline from the Earliest Period to the Capture of Havana by the English (1492-1762)." *The Catholic Historical Review* 1, no. 2 (July 1915): 128-138.

Dana, Richard Henry. *To Cuba and Back. A Vacation Voyage.* London: Smith, Elder, and Co., 1859.

Darnell, Reaznet M. *The American Sea: A Natural History of the Gulf of Mexico.* College Station, TX: Texas A & M University Press, 2015.

Daugherty, Franklin: "Teresa, Mr. Jimmy, and the Mobile-Havana Connections." *Mobile Bay,* (March 2006): 113-116.

Delaney, Caldwell. *A Mobile Sextet.* Mobile: The Haunted Book Shop, 1981.

DeLeon, T. C. *Four Years in Rebel Capitals: An Inside View of Life in the Southern Confederacy, from Birth to Death; from Original Notes Collated in the Years 1861 to 1865.* Mobile: The Gossip Printing Co., 1892.

Delgado, Elio. "Cuba's Castillo de la Real Fuerza." *Havana Times,* December 25, 2011. Accessed July 21, 2021. https://havanatimesenespanol.org/fotorreportajes/castillo-de-la-real-fuerza-de-la-habana/

Demeritt, David. "Boards, Barrels, and Boxshooks: The Economics of Downeast Lumber in Nineteenth Century Cuba." *Forest and Conservation History*, vol. 35, no. 3 (July 1991): 108-120.

Díaz-Asencio, M., J. A. Corcho Alvarado, C. Alonso-Hernández, A. Quejido-Cabezas, A. C. Ruiz-Fernández, M. Sánchez-Sánchez, M. B. Gómez-Mancebo, P. Froidevaux, J. A. Sánchez-Cabeza. "Reconstruction of Metal Pollution and Recent Sedimentation Processes in Havana Bay (Cuba): A Tool for Coastal Ecosystem Management." *Journal of Hazardous Materials*, vol. 196 (2011): 402-411.

Dorr, Lisa Lindquist. *A Thousand Thirsty Beaches: Smuggling Alcohol from Cuba to the South During Prohibition.* Chapel Hill: University of North Carolina Press, 2018.

Du, Jiabi, Kyeong Park, Jian Shen, Brian Dzwonkowski, Xin Yu and Byung Il Yoon: "Role of Baroclinic Processes on Flushing Characteristics in a Highly Stratified Estuarine System, Mobile Bay, Alabama." *Journal of Geophysical Research: Oceans*, vol. 123, 4518-4537. Accessed March 9, 2022. https://doi.org/10.1029/2018JC013855

Durnford, Mary. *Family Recollections of Lt. Gen. Elias Walker Durnford.* Montreal: J. Lowell, 1863.

Duval, Kathleen. *Independence Lost: Lives on the Edge of the American Revolution.* New York: Random House, 2016.

"Eusebio Leal Spengler a Jay Higginbotham." Correspondence. Mobile Municipal Archives, Record Group 31, Series 5, Box 5.

Fair, John D. "Hatchett Chandler and the Quest for Native Tradition at Fort Morgan." *The Alabama Review*, vol. 40 (July 1987): 163-198.

Feore, Mike. "Brief History of Mobile." Unpublished manuscript. Mobile Historic Development Commission, 2019.

Fernández de Navarrete, Martín. *Colección de los viages y descubrimientos que hicieron por mar los españoles desde fines del siglo XV, con varios documentos inéditos concernientes á la historia de la marina castellana y de los establecimientos españoles en Indias*, t. III. Madrid: Imprenta Real, 1829.

Ferreiro, Larrie D. *Brothers at Arms: American Independence and the Men of France and Spain who Saved it.* New York: Vintage, 2016.

Finlay, Carlos. "The Mosquito Hypothetically Considered as an Agent in the Transmission of Yellow Fever Poison," in *New Orleans Medical and Surgical Journal* IX, no. 8 (1882) New Series: 601-616.

Franzbach, Martin. "La guerra del 98 en el marco de los intereses alemanes." In *Iberoamericana. América Latina, España, Portugal. Ensayos sobre Letras, Historia, y Sociedad. Notas. Reseñas Iberoamericanas*, vol. 22, no. 71-72 (1998): 22-43.

Fuente, Alejandro de la. *Havana and the Atlantic in the Sixteenth Century.* Chapel Hill: University of North Carolina Press, 2011.

García Santana, Alicia and Julio A. Larramendi. *Treinta maravillas del patrimonio arquitectónico cubano.* Ciudad de Guatemala: Ediciones Polymita, 2012.

Gelly, Alain, Louise Brunelle-Lavoie and Corneliu Kirjan. *La passion du patrimoine: La Commission des biens culturels du Québec, 1922-1994.* Saint-Nicolas, Québec: Les éditions du Septentrion, 1995.

Gemelli Careri, Giovanni Francesco. *A Voyage Round the World.* London: J. Walthoe, 1732.

Giraud, Marcel. *A History of French Louisiana.* Vol. 1: *The Reign of Louis XIV, 1698-1715.* Baton Rouge: Louisiana State University Press, 1974.

Glover, Robert W. "The West Gulf Blockade, 1861-1865: An Evaluation." Ph.D. dissertation, North Texas State University, 1974.

Gorgas, William Crawford. "The Practical Mosquito Work Done at Havana, Cuba, Which Resulted in the Disappearance of

Yellow Fever from that Locality." In *Washington Medical Annals*, vol. 2, no. 3 (March 1903): 170-180.

_____. *Situation in Panama.* New York: D. Appleton & Co., 1915.

GRABAR, HENRY. "Havana on the Brink: What will Happen to the Cuban City when American Tourists Arrive?" Accessed August 9, 2022. https://www.theatlantic.com/magazine/archive/2015/09/havana-on-the-brink/399380/

GRAY, ROBERT EDWARD. "Elias Durnford, 1739-1794: Engineer, Soldier, Administrator." Unpublished MA Thesis, Auburn University, 1971.

HAMILTON, PETER JOSEPH. *Colonial Mobile.* Boston: Houghton, 1910.

HAMILTON, PETER JOSEPH, ERWIN CRAIGHEAD AND W. K. P. WILSON. *The Mobile Bicentennial.* Mobile: Commercial Printing Co., 1912.

HARING, CLARENCE HENRY. *Trade and Navigation between Spain and the Indies in the Time of the Hapsburgs.* Cambridge, Mass.: Harvard University Press, 1918.

HIGGINBOTHAM, JAY. *Old Mobile: Fort Louis de La Louisiane, 1702-1711.* Tuscaloosa: University of Alabama Press, 1991.

HILL, ROBERT. *Cuba and Porto Rico and the Other Islands of the West Indies.* New York: The Century Company, 1899.

"History of the Society Mobile-La Habana, 1993-2005." Unpublished paper. Mobile Municipal Archives, Record Group 31, Series 5, Box 5.

HOWARD, LELAND O., HARRISON G. DYAR AND FREDERICK KNAB. *The Mosquitoes of North and Central America and the West Indies,* vol. 1. Washington, D.C.: The Carnegie Institution, 1912.

HUMBOLDT, ALEXANDER. *The Island of Cuba.* Trans., J. S. Thraser. New York: Derby and Jackson, 1856.

HUNT, FREEMAN. "The Mobile and Ohio Railroad." *Hunt's Merchants' Magazine and Commercial Review,* vol. 19 (December 1848): 579-593.

"Iberville Statue Erected in Mobile." *Havana Connection: The Newsletter of Society Mobile-La Habana,* (Winter 2003): 1.

ISBELL, TIMOTHY T. *The Mississippi Gulf Coast.* Jackson: University Press of Mississippi, 2018.

JAMAIL, MILTON H. *Full Count: Inside Cuban Baseball.* Carbondale: Illinois University Press, 2000.

JENKINS, NED J. "The Village of Mabila: Archaeological Expectations." In *The Search for Mabila: The Decisive Battle between Hernando de Soto and Chief Tascalusa,* edited by Vernon James Knight, Jr. Tuscaloosa: University of Alabama Press, 2009.

JOHNSON, SHERRY. "Introduction: Señoras…no ordinarias." *Cuban Studies*, vol. 34 (2003): 1-10.

JONES, ALEXANDER. *Cuba 1851; A Survey of the Island, its Resources, Statistics, &C., From Official Documents, in Connection with the Present Revolt.* New York: Stringer & Townsend, 1851.

Jordan, Phillip. "A National Pastime, Shared: Tracing the Roots of Cuban Baseball to Mobile's Spring Hill College." *Mosaic: The Magazine of the Alabama Humanities Alliance* (2022): 24-27.

Judge, Joseph. "The Many Lives of Old Havana." *National Geographic* vol. 176, no. 2 (August 1989): 278-300.

Kenny, Michael. *Catholic Culture in Alabama: Centenary Story of Spring Hill College, 1830-1930.* New York: American Press, 1931.

Koplowitz, Howard. "¿Cómo podría Alabama beneficiarse del fin del embargo a Cuba?" *Progreso Semanal* (October 30, 2015): 10.

Kranz, Rachel. *African-American Business Leaders and Entrepreneurs.* New York: Facts on File, 2004.

Lapique Becali, Zoila and Julio A. Larramendi Joa. *La Habana: Imagen de una ciudad colonial.* Ciudad de Guatemala: Ediciones Polymita, 2013.

Learned, Henry Barrett. "The Vice President's Oath of Office." *The Nation* vol. 104 (March 1, 1917): 248-250.

Letter of the Secretary of State, Transmitting a Report of the Commercial Relations of the United States with Foreign Nations for the Year Ending September 30, 1856. Washington D.C.: Government Printing Office, 1857.

LeVert, Octavia Walton. *Souvenirs of Travel,* vol. 1. Mobile: S. H. Goetzel and Company, 1857.

"Le Vert's *Souvenirs of Travel.*" In *Brownson's Quarterly Review.* New York Series 8 (October 1857): 528-541.

Liesch, Dale. "Cuban Official Seeks Relationship with U.S. as Filmmakers Connect Baseball History." *Lagniappe,* May 22, 2019. Accessed September 22, 2021. https://www.lagniappemobile.com/news/local/cuban-official-seeks-relationship-with-u-s-as-filmmakers-connect-baseball-history/article_2ab8d86b-215d-5f66-80d3-5530265935b6.html

"Line of Investment of Fort Gaines, Dauphine Island, by Maj. Genl. g. Granger's Expeditionary Corps, Aug. 1864." Accessed May 16, 2022. https://nara.getarchive.net/media/line-of-investment-of-fort-gaines-dauphine-island-by-maj-genl-g-grangers-expeditionary-0f24b0

Luxner, Larry. "Cuba's Links to 3 Gulf Cities: Mobile, New Orleans, and Tampa." *Cuba News* vol. 12, no. 11 (November 2004): 14-15.

Martínez, Michael. "In Cuba, a Hard River to Clean." *Chicago Tribune* (September 25, 2007): 1-11.

McGehee, Tom. "What is Adamantile?" Accessed July 18, 2022. https://bellingrath.org/what-is-adamantile-looking-back-on-mr-bellingraths-tile-company/

McHatton-Ripley, Eliza. *From Flag to Flag: A Woman's Adventures and Experiences in the South During the War, in Mexico, and in Cuba.* New York: D. Appleton, 1889.

McWilliams, Richebourg Gaillard. *Fleur de Lys and Calumet: Being the Pénicaut Narrative of French Adventure in Louisiana.*

Baton Rouge: Louisiana State University Press, 1953.

_____, ed. *Iberville's Gulf Journals.* Tuscaloosa: University of Alabama Press, 1981.

McWilliams, Tennant S. "Erwin B. Craighead, The New South, and *Cuba Libre.*" *Gulf Coast Historical Review*, vol. 3, no. 2 (Spring 1988): 20-41.

Medina Rojas, F. de Borja. *José de Ezpeleta, gobernador de La Mobila, 1780-1781.* Sevilla: Escuela de Estudios Hispano-Americanos/Consejo Superior de Investigaciones Científicas. Excma. Diputación Foral de Navarra, 1980.

Memorial Services Held in Honor of Major General William Crawford Gorgas. By the Southern Society of Washington, D.C., Government Printing Office, 1921.

"Memoria comercial del cónsul de Cuba en Mobila, correspondiente al año 1906." *Boletín Oficial del Departamento del Estado. Memorias comerciales.* La Habana: Imprenta y Papelería de Rambla y Bouza (1906): 77-90.

Milanich, Jerald T. "The Hernando de Soto Expedition and Spain's Effort to Colonize North America." In *The Expedition of Hernando de Soto West of the Mississippi, 1541-1543. Proceedings of the De Soto Symposia 1988 and 1990*, edited by Gloria A. Young and Michael P. Hoffman. Fayetteville: University of Arkansas Press, 1993.

Mira Caballos, Esteban. "En torno a la expedición de Sebastián de Ocampo a la isla de Cuba (1506)." *Revista de Indias*, vol. 56, no. 206 (1996): 199-203.

Morris, John, ed. *Wanderings of a Vagabond: An Autobiography.* New York: Privately printed, 1873.

Moss, Robert F. *Southern Spirits: Four Hundred Years of Drinking in the American South, with Recipes.* Berkeley, Calif.: Ten Speed Press, 2016.

Norton, Albert J. *Norton's Complete Handbook of Havana and Cuba.* Chicago: Rand, McNally & Co., 1900.

Oliva Suárez, Rosalía, Lisette Roura Álvarez and Osvaldo Jiménez Vázquez. "Génesis y desarrollo de San Cristóbal de La Habana," in *La Habana: Dimensión arqueológica de un espacio habitado.* Coordinator, Roger Arrazcaeta Delgado. Ciudad de Guatemala: Ediciones Polymita, 2020.

Ortelius, Abraham. *Théâtre de l'univers, contenant les cartes de tout le monde*, 1587. Accessed August 15, 2022. https://www.loc.gov/resource/gdcwdl.wdl_08978/?sp=1&st=image

Park, Roswell. "A Journal of the Expedition Against Cuba," edited by Julian Park. *University of Buffalo Studies*, vol. 1, no. 4 (December 1920): 231-244.

Peavy, John R. *A Legend of Dauphin Island.* Mobile: Author's edition, 1941.

Pedreira, Daniel I. *An Instrument of Peace: The Full-Circled Life of Ambassador Guillermo Belt Ramírez.* New York: Lexington Books, 2019.

Pedroso, Aurelio. "De Alabama a La Habana." *Progreso Semanal* (October 24, 2019): 20.

Perrottet, Tony. "The Man Who Saved Havana." Accessed August 8, 2022. https://www.smithsonianmag.com/travel/man-who-saved-havana-180968735/

Peterman, Jane, ed. *Selected Writings of Jay Higginbotham.* Bloomington, IN: Xlibris, 2008.

Pezuela, Jacobo de la. *Diccionario geográfico, estadístico, histórico de la Isla de Cuba,* vol. IV, Madrid: Banco Industrial y Mercantil, 1867.

Porto, Yasel. "El primer bloqueo al béisbol cubano." Accessed July 13, 2022. https://swingcompleto.com/historia-primer-bloqueo-al-beisbol-cubano/

Priestly, Herbert Ingram. *The Luna Papers, 1559-1561,* vol. 2. Reprint. Tuscaloosa: University of Alabama Press, 2010.

Purcell, L. Edward. *Vice Presidents: A Bibliographical Dictionary.* New York: Facts on File, 2010.

Quintero Saravia, Gonzalo M. *Bernardo de Gálvez: Spanish Hero of the American Revolution.* Chapel Hill: University of North Carolina Press, 2018.

Rayford, Julian. "Buried Treasure." *Dauphin Island News.* (July 18, 1957): 2.

_____. "Dauphin Island Jubilee." *Dauphin Island News* (October 25, 1957): p. 7.

Rea, Robert E. "Redcoats and Redskins on the Lower Mississippi, 1763-1776: The Career of Lt. John Thomas." In *Louisiana History*, vol. 11, no. 1 (Winter 1970): 5-35.

Rhodes, James Ford. *History of the United States from the Compromise of 1850 to the Final Restoration of Home Rule in the South in 1877.* Vol. 2: *1854-1860.* New York: The MacMillan Co., 1907

Richardson, James D., ed. *A Compilation of the Messages and Papers of the Confederacy Including the Diplomatic Correspondence 1861-1865,* vol. 2. Nashville: United States Publishing Company, 1905.

Ripley, Eliza. *Social Life in Old New Orleans. Being Recollections of my Girlhood.* New York: D. Appleton and Company, 1912.

Robertson, Ben. "Jay Higginbotham." *Encyclopedia of Alabama.* Accessed August 10, 2022. http://encyclopediaofalabama.org/article/h-3087

Romans, Bernard. *A Concise Natural History of East and West Florida.* New York: Printed for the author, 1775.

Rowland, Dunbar, ed. *Mississippi Provincial Archives, 1763-1766. English Dominion: Letters and Enclosures to the Secretary of State from Major Robert Farmar and Governor George Johnstone,* vol. 1. Nashville: Press of Brandon Printing Co., 1911.

Rowland, Dunbar and Alfred G. Sanders, eds. *Mississippi Provincial Archives, 1701-1729. French Dominion,* vol. 2. Jackson: Mississippi Department of Archives and History, 1932.

"Royal Havana Lottery," May 7, 1857. Accessed December 29, 2020. https://www.loc.gov/item/rbpe.17300500

Russell, William Howard. *My Diary North and South,* vol. 1. Boston: T.O.H.P. Burnham, 1863.

SANDERLIN, GEORGE, TRANS. AND ED. *Bartolomé de las Casas: A Selection of his Writings.* New York: Knopf: 1971

SAXE-WEIMAR-EISENACH, DUKE OF (BERNHARD). *Travels through North America During the Years 1825 and 1826*, vol. 2. Philadelphia: Carey, Lea, and Carey, 1826.

SCARPACI, JOSEPH L. *Plazas and Barrios: Heritage Tourism and Globalization in the Latin American Centro Histórico.* Tucson: University of Arizona Press, 2005.

SCHNEIDER, ELENA A. *The Occupation of Havana: War, Trade, and Slavery in the Atlantic World.* Chapel Hill: University of North Carolina Press, 2018.

SEAMAN, REBECCA M., ED. *Conflict in the Early Americas: An Encyclopedia of the Spanish Empire's Aztec, Indian, and Mayan Conquests.* Santa Barbara, CA: ABC-CLIO, 2013.

SEDANO, CARLOS DE. *Cuba: Estudios políticos.* Madrid: Manuel G. Hernández, 1872.

SEMMES, RAPHAEL. "Cruise of the *Porpoise* in the Caribbean." Unpublished manuscript, n.d. Alabama Department of Archives and History.

_____. *Memoirs of Service Afloat.* Baltimore: Kelly, Petit & Co., 1869.

SEXTON, REBECCA GRANT. *A Southern Woman of Letters: The Correspondence of Augusta Jane Evans Wilson.* Columbia: University of South Carolina Press, 2002.

SINCLAIR, G. TERRY. "The Eventful Cruise of the *Florida*." *The Century Magazine* 56 (July 1898): 417-427.

SLEDGE, JOHN. *The Gulf of Mexico: A Maritime History.* Columbia: University of South Carolina Press, 2019.

_____. *The Mobile River.* Columbia: University of South Carolina Press, 2015.

_____. "The Siege of Mobile, 1780." *Mobile Bay* (July 2020): 72-75.

SOTO, DOMINGO. "Alabama en Habana," *Business Alabama* (April 1999): 62-67.

SPEARS, ELLEN GRIFFITH AND ROSA LÓPEZ-OCEGUERA. "Carlos Juan Finlay, William Gorgas, and Walter Reed and the U.S. Army Yellow Fever Controversy: Competing Historical Memories." *Alabama Review*, vol. 74, no. 1 (January 2021): 62-76.

"Spring Hill College Register of Students, 1859-1873." Spring Hill College Archives. Mobile, AL.

"Spring Hill College Register of Students, 1873-1903." Spring Hill College Archives. Mobile, AL.

STAPLEY, KAREN. "Making Stale and Nauseous Water Sweet!" Accessed June 3, 2022. https://blogs.bl.uk/untoldlives/2016/06/making-stale-and-nauseous-water-sweet.html

"Statement to the Congress of the United States by Jay Higginbotham, President, Society Mobile-La Habana. March 17, 1994." *Hearing before the Subcommittee on Select Revenue Measures and the Subcommittee on Trade of the Committee on Ways and Means House of Representatives.* One Hundred Third Congress, Second Session. March 17, 1994. Serial 103-79. Washington: U.S. Government Printing Office.

STEPHENSON, PHILLIP D. "Defense of Spanish Fort." in *Southern Historical Society Papers*, vol. 39 (1914): 118-129.

STEVENSON, WILLIAM G. *Thirteen Months in the Rebel Army: Being a Narrative of Personal Adventures in the Infantry, Ordnance, Cavalry, Courier, and Hospital Services; with an Exhibition of the Power, Purposes, Earnestness, Military Despotism, and Demoralization of the South.* New York: A.S. Barnes & Burr, 1862.

SUARÉZ GARCÍA, MARÍA MARGARITA. "Cultural Heritage Legislation: The Historic Centre of Old Havana." *Art and Cultural Heritage: Law, Policy, and Practice,* edited by Barbara T. Hoffman, 239-243. New York: Cambridge University Press, 2006.

SWANTON, JOHN R. *Early History of the Creek Indians and their Neighbors.* Washington, D. C.: Government Printing Office, 1922.

THE EDITORS OF ENCYCLOPAEDIA BRITANNICA. "Calusa." *Encyclopedia Britannica*, July 11, 2007. Accessed March 9, 2022. https://www.britannica.com/topic/Calusa

THORN, JOHN. "Cuba, the U.S., and Baseball: A Long if Interrupted Romance." Accessed July 8, 2022. https://ourgame.mlblogs.com/cuba-the-u-s-and-baseball-a-long-if-interrupted-romance-7a20d217e90d

TORRES-CUEVAS, EDUARDO. *En busca de la cubanidad*, t. 1. La Habana: Editorial de Ciencias Sociales, 2018.

U.S. DEPARTMENT OF STATE. *Register of the Department of State, Corrected to August 1, 1907.* Washington, D.C.: Government Printing Office, 1907.

U.S. NATIONAL ARCHIVES. *Records of the District Courts of the United States. Record Group 21, 1685-2009.* Civil War Prize Case Files, 1861-1865. United States vs. Sloop *Annie.* National Archives at New York.

U.S. NAVY. *Civil War Naval Chronology, 1861-1865: Part I, 1861.* Washington D.C.: U.S. Government Printing Office, 1961.

U.S. WAR DEPARTMENT. *Official Records of the Union and Confederate Navies in the War of the Rebellion.* Series I, vol. 2. Operations of the Cruisers. From January 1, 1863 - March 31, 1864. Washington, D.C.: U.S. Government Printing Office, 1895.

VAN DOREN, MARK, ED. *The Travels of William Bartram.* New York: Dover Press, 1955.

VEGA GARCÍA, OLGA. "La Habana durante la ocupación inglesa. Grabados de Elias Durnford." *Revista de La Biblioteca Nacional de Cuba José Martí*, año 103, no. 2 (2012): 181-190.

WALLACE, JOHN WILLIAM. *Cases Argued and Adjudged in the Supreme Court of the United States, December Term, 1866*, vol. 5. Washington, D.C.: W.H. & O.H. Morrison, 1870.

WASELKOV, GREGORY. *Old Mobile Archaeology.* Mobile: University of South Alabama Center for Archaeological Studies, 1999.

WATERLOO, STANLEY. *The Story of a Strange Career: Being the Autobiography of a Convict.* New York: D. Appleton & Co., 1902.

WATSON, WILLIAM. *The Civil War Adventures of a Blockade Runner.* College Station, TX: Texas A&M University Press, 2001.

Webb, Paula Lenor. *Such a Woman: The Life of Madame Octavia Walton LeVert.* Point Clear, Alabama: Intellect Publishing LLC, 2021.

Weddle, Robert S. *Spanish Sea: The Gulf of Mexico in North American Discovery, 1500-1685.* College Station, TX: Texas A & M University Press, 1985.

White, Trumball. *Our New Possessions.* Self-published, 1898.

Wiggins, Sarah Woolfolk. "William C. Gorgas." Accessed July 15, 2022. http://encyclopediaofalabama.org/article/h-1048

Windham, Kathryn Tucker. *Alabama: One Big Front Porch.* Montgomery: NewSouth Books, 2007.

Worthington, C. J., ed. *The Woman in Battle.* Richmond: Dustin, Gilmore & Co., 1876.

Wright, Irene A. *The Early History of Cuba, 1492-1586.* 1916. Reprint, New York: Octagon Books, 1970.

Yurkanin, Amy. "Alabama Researchers Closing in on Site of Spanish Explorer's Pivotal Battle with Chief Tascalusa." Accessed October 4, 2021. https://www.al.com/news/2021/11/alabama-researchers-closing-in-on-site-of-spanish-explorers-pivotal-battle-with-chief-tascalusa.html

LA HABANA-MOBILE: THE SHARED HERITAGE

Alicia E. García-Santana

Things are often not what they seem in architectural history. Received information on American cultural landscapes, both popular and scholarly, is often incomplete, occasionally downright distorted. New myths are sometimes imposed upon old landscapes and old buildings. … Historical information occasionally simply gets lost. Entire forms or features once widespread in a region may simply disappear from the landscape, leaving little trace of their previous dominance. Yet, if we are willing to go to the trouble to learn how to interpret it, historical fact may be more interesting than historical fiction. Our regional historical types may prove to have roots, more significant and more ancient than we have suspected.

Jay D. Edwards, "Early Spanish Creole Vernacular Architecture in the New World and its Legacy"

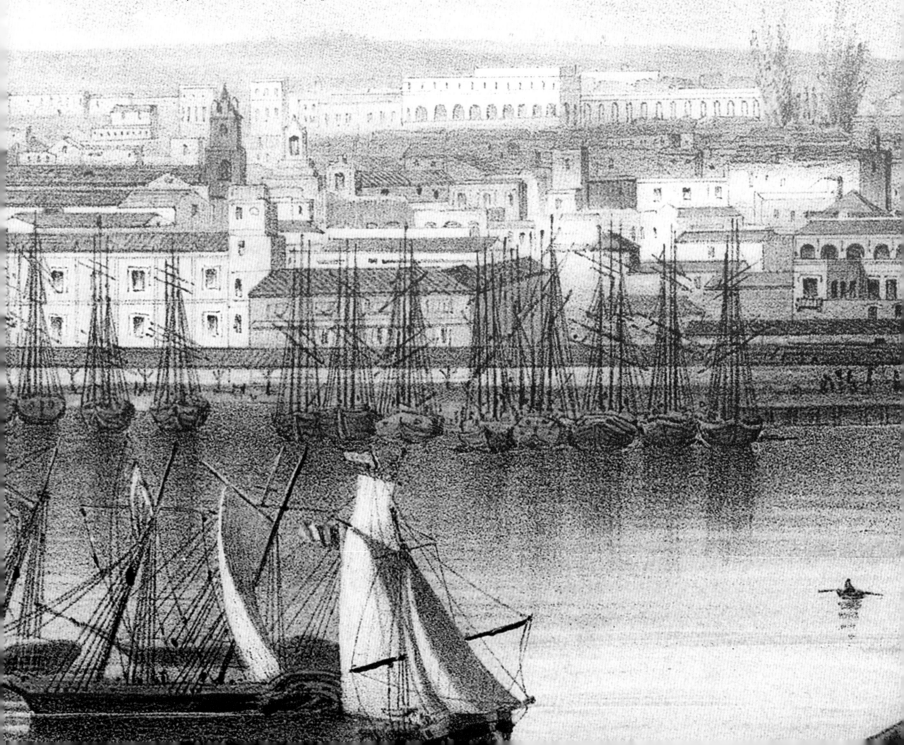

ACKNOWLEDGMENTS

This book brings together the efforts of authors from both sides of the Gulf of Mexico—on the northern side, it is an honor to share in the writing of this text with the distinguished architectural historian John S. Sledge, and to include photographs by the renowned photographer Chip Cooper. On the southern portion of the Gulf, I am joined by photographer Julio Larramendi, with whom I have had the privilege of producing a number of beautiful books. The making of this book has been sponsored by several institutions and individuals mentioned by Sledge, whose words of thanks I would like to make my own. I would also like to add that the National Council of Cultural Heritage of the Ministry of Culture of Cuba has also sponsored the publication of these pages.

My research on Mobile and its geographic and cultural context was made possible by a 1995 Fellowship Grant from the John Simon Guggenheim Memorial Foundation to study housing in the Caribbean—considering this territory in a cultural sense as a space that includes the Spanish-French-English of the United States, the Antilles and the coastal periphery of Central and South America—and a 2003 Guest Scholar Grant from the Getty Conservation Institute to expand the bibliographic study of the architecture of the region. As a Getty Conservation Guest Scholar, I received valuable guidance from geographer David Myers, architect Robert A. Myers and archaeologist Gregory A. Waselkov on the origins of galleries in French vernacular houses in the United States.

Since then, historian Paul L. Weaver has assisted me in my work on St. Augustine, Florida, and during my visits to the city I have drawn on the insights of Susan S. Parker and Stanley C. Bond Jr., who kindly provided me with a copy of his Ph.D. dissertation on St. Augustine. Charles A. Tingley, Senior Research Librarian at the St. Augustine Historical Society, was instrumental in my historical research on the city itself. I am forever indebted to architect Donald del Cid of Tulane University for the assistance he gave me during my visit to New Orleans. To Professors Dominique Rogers and Jean-Sébastien Guibert, of the Department of History at the University of the Antilles in Martinique, I am grateful for their hospitality when I was on that island and for the information they provided on its urban and architectural heritage.

Thanks to the support of the Guggenheim and Getty Foundations, I was able to conduct field research on houses in selected American cities and to carry out research at the Getty Library under the guidance of Reference Librarian Valerie Greathouse. I also had the opportunity to work at several other institutions, such as the aforementioned St. Augustine Historical Society, the Historic New Orleans Collection, the Special Collections of the Florida International University Library and the Library of Congress, Washington, D.C. In Puerto Rico, I had the support

of the Center for Advanced Studies of Puerto Rico and the Caribbean, whose director, Ricardo Alegría, placed the institution at my disposal and facilitated contacts with Puerto Rican historians, including Antonio Gaztambide Géigel, Ramonita Vélez and Néstor Murray. In Ponce and San Germán, I benefited from the advice of architect Javier Bonín. In Venezuela, our efforts were supported by the Mariano Talavera de Coro Foundation, and in Cartagena de Indias, by the Jorge Tadeo Lozano University. I am indebted to the professors of the Institute of History of the Faculty of Architecture of the National University of Tucumán, Argentina, with whom I exchanged views on these topics during the master's degree courses in the History of Latin American Architecture and Urbanism, which I have taught on several occasions.

In Cuba I had the collaboration of the Office of the Historian of Havana, its Archives and Library; the Network of Heritage Cities; the Research Center of Heritage Architecture; the respective Research Centers of the Offices of the Curator of Santiago de Cuba, of Cienfuegos, and of Trinidad; the Historical Archives of the province of Matanzas; the Municipal Historical Archives of the city of Cárdenas; the Historical Archives of the province of Cienfuegos; the Historical Archives of the city of Trinidad; the Archives of the Archdiocese of Havana; and the Matanzas Provincial Department of the Ministry of Science, Technology and the Environment. The National Archives and the José Martí National Library of Cuba have been a constant and irreplaceable source of information for all the studies I have undertaken over the years. I am deeply grateful to their staffs for the help and guidance they have given me.

I would also like to highlight the support received from museums, public and private institutions in different cities in the United States and Cuba for the realization of the photographs. In 2012, under the auspices of Ediciones Polymita, directed by Julio Larramendi, we went on a long trip around the U.S. to take pictures. This time, our guardian angel was Soledad Pagliuca, who accompanied us and provided us with detailed information and support of every kind. Finally, we cannot forget the hospitality extended to us then by Beverley M. Segal and George L. Paidas in St. Augustine, Florida.

Once again, I would like to express my gratitude to two prominent figures in Cuban culture who have been instrumental in my academic and professional development: Dr. Francisco Prat Puig and Dr. Zoila Lapique Becali. I would like to thank Silvana Garriga for her editing and to Yvonne López for the translation of the texts, which were carefully designed by Joyce Hidalgo-Gato. Finally, I would like to acknowledge the patient support of my family, including my relatives in Cuba and in the United States. I have caused them both a great deal of inconvenience in my effort to carry out the study that is now the content of this book. While I cannot mention each one by name, I must single out my cousins Grace Santana and Berta Cunningham, who represent the American side of the family, and my daughters Grace and Marcela de Lara, who represent the Cuban side.

Madruga, April 18, 2023

REASONS FOR A BOOK

Through two emblematic cities, Havana and Mobile, we will illustrate the ties that connected their architectural expressions and, in a broader sense, the ties that linked constructions of Cuba and the southern United States. Cultural exchanges between Cuba and the United States have been greatly hindered by political differences, despite the fact that in architecture, as in many other areas of life, we have children in common. Personally, I am indebted to these connections—my maternal grandmother, Grace B. Mendell, born in Gas City, Indiana, came as a Protestant missionary to Cuba in the early twentieth century. Here she built a large family through her marriage to my grandfather, Luis Santana y Calzada, a native of the city of Trinidad, and a member of a family with deep roots in the colonial town founded in the early sixteenth century. Grace was a descendant of John Mendall [sic] Jr. (1638-1670), one of the early settlers of Plymouth Colony, Massachusetts, founded in 1620 by the *Mayflower* Pilgrims.[1]

The archipelago of the Antilles and the lands surrounding the Gulf of Mexico make up a geographic and cultural region (FIG. 1) that has been characterized throughout its history by the presence of diverse peoples, including the native populations and peoples from other continents, mainly from Europe and Africa, but also from distant regions, such as India and China. The dominant European powers were Spain, England and France, with smaller contributions from northern Europeans—Belgians, Dutch and Germans—and southern Europeans—Italians. Europeans fought each other over the new lands that passed from one power to another. However, the fact that a territory changed hands did not mean that the traditions created by the defeated nation were lost. Sometimes, the victor adopted cultural elements from the vanquished, either because of their degree of acceptance or, in the specific case of architecture, because of their suitability to a particular geographic, socioeconomic and/or climatic context. There are many examples of this: the English essence remained in St. Augustine when it became Spanish and the French flavor persisted in Louisiana when it was taken over by the Spaniards. The same thing happened in Mobile and Pensacola when both were occupied by the English and the Spanish, and the French and Spanish influences would become an essential part of the architecture of these territories when they were incorporated into the United States of America. The interrelationships were so ancient that it is sometimes difficult to determine their cultural affiliation.

The transfer of building solutions from one to another was a complex process whose most important result was the emergence of new models that could only be explained by the fusion of the contributions of each of the nations that coincided in that geographical space. Models that, once created, fed back into the region giving rise to

[1] See Sidney D. Smith, *Descendants of John Mendall, Sr. (ca. 1638-1720)*.

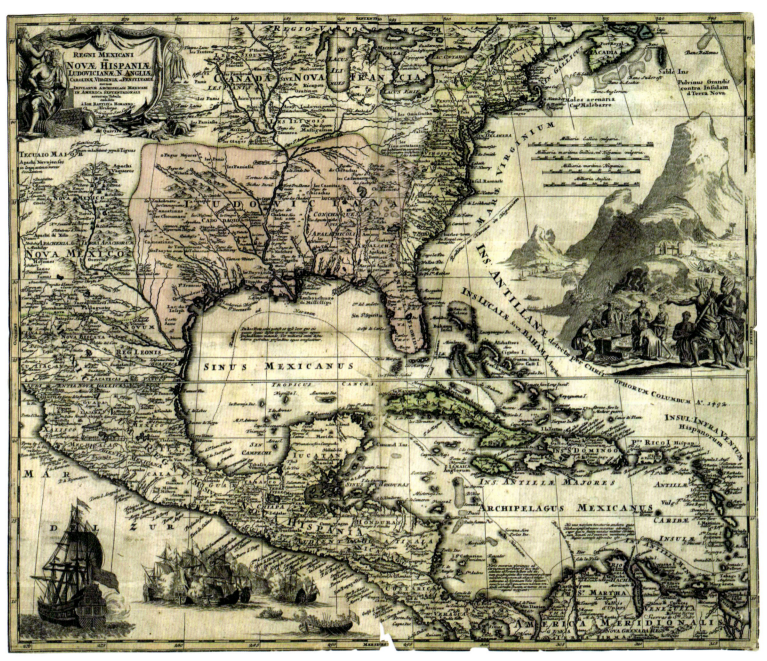

1. "Regni Mexicani seu Nova Hispaniae Ludovicianus, N. Angliae, Carolinae, Virginiae et Pensylvaniae," J. B. Homman, 1720. Historical Archives of the Office of the Historian of Havana

a curious phenomenon: the influences of the cultural metropolises (which remained a constant variable) merged with the "Creole" versions born in the proto-states of the Americas, a process that gave them color, definition and identity.

The influence of the Spanish, English, French and other Europeans on the culture and architecture of the territory of the United States and the Caribbean has been pointed out by many authors in some admirable studies. This is not a new observation. However, the Spanish contribution has not always been well understood, nor has the importance of the new domestic types—"American" in the most legitimate sense of the word—and their impact on the region been properly appreciated. The purpose of this book is precisely to highlight and recognize them as expressions of a shared heritage.[2]

[2] Typological considerations correspond to those of the dominant types. Reality is richer and more complex than any abstraction.

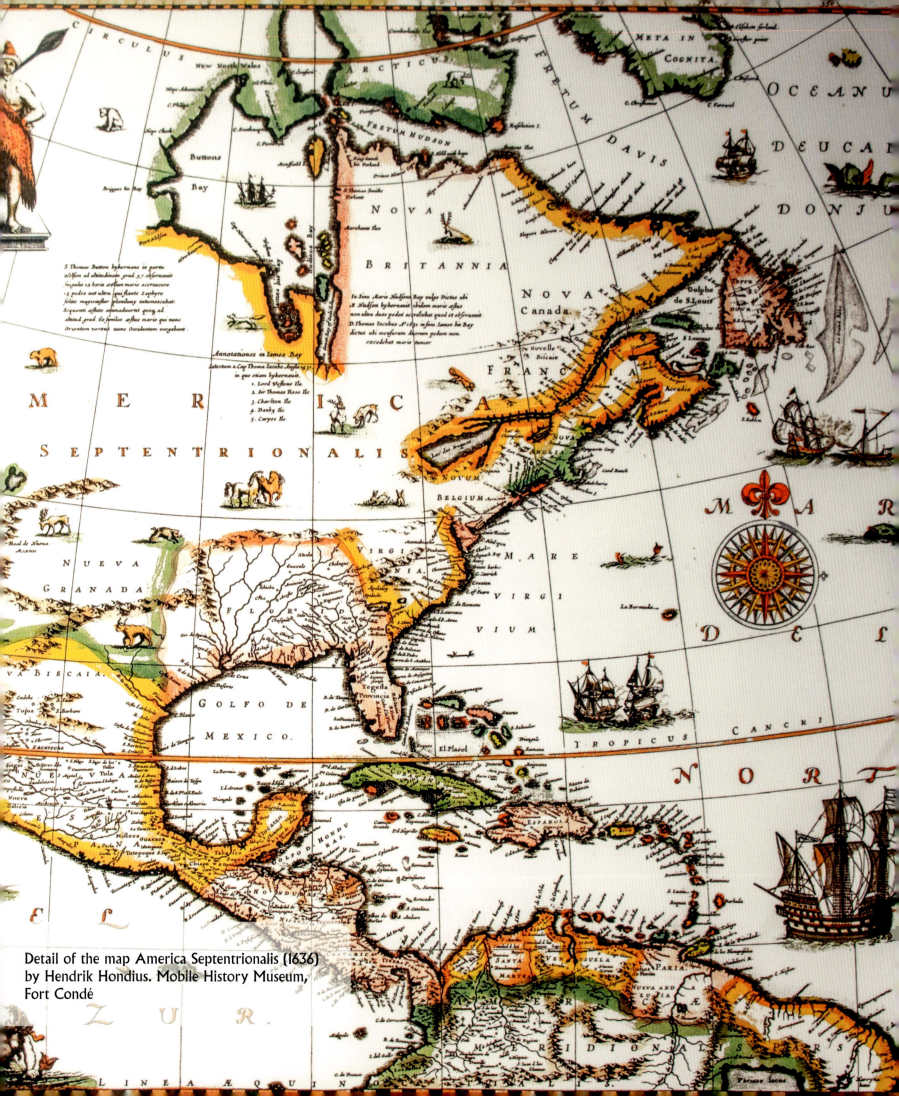

Detail of the map America Septentrionalis (1636) by Hendrik Hondius. Mobile History Museum, Fort Condé

THE PLACE OF THE ENCOUNTER

The discovery of the New World at the end of the fifteenth century was a crucial milestone in human history. The Antillean islands were the first to be sighted by Christopher Columbus on his first voyage in 1492, financed by the Crown of Castile. Although unknown to them, they felt from the beginning that they were in the presence of a much larger territory that was considered part of the Far East, which was the purpose of Columbus' voyages. This assumption gradually lost ground as they progressed in their exploration of the new lands.

The island of Hispaniola, the first Spanish settlement in the region, was the launching pad for the conquest and occupation of Jamaica, Puerto Rico and Cuba. From the latter two, expeditions moved north, discovering immensely rich empires, such as the Aztec, modern-day Mexico, and promising ones in Florida. Setting out from Mexico, they explored the neighboring lands to the north and south, while from Spain and from the enclaves established in the region, expeditions were organized that eventually outlined the true contours of Central America and those of the unfathomable South America. With the papal bull *Inter caetera* issued by Pope Alexander VI on May 3, 1493, and subsequent bulls, Castile and Portugal were granted lands whose extent was unknown. England and France, which were left out of this singular distribution, were not pleased and this gave rise to countless clashes with Spain over the centuries that followed. The archipelago of the West Indies and the area around the Gulf of Mexico were the main battlegrounds, as South America was geographically impregnable due to the Amazon jungle and the Andes mountain range.

The French were the first to ignore the Spanish claims to dominion over the lands in the Americas. Persecuted Huguenots in France tried unsuccessfully to establish colonies, but in 1564 they managed to establish Fort Caroline on the banks of the St. Johns River. Unwilling to tolerate such an "offense," the Spanish established St. Augustine of Florida in 1565 (Fig. 2) and attacked Fort Caroline, cruelly massacring the French and renaming the fort as San Mateo. In retaliation for the slaughter of their countrymen, the French attacked San Mateo and killed its defenders in the spirit of "an eye for an eye, a tooth for a tooth," an attitude that would characterize the clashes between the various nations fighting over the Americas.

But French exploration of North America began much earlier. In the time of Francis I, the great rival of the Spanish monarch Carlos V, the French tried to find a passage to the Pacific Ocean through the northern tip of the continent. It was in this direction that they discovered the lands of Canada. Sailing from Newfoundland, the French explorers reached the Gulf of St. Lawrence in 1534. They continued their journey up the St. Lawrence River, on whose banks they built Fort Sainte-Croix, the origin of Quebec, founded in 1608 by

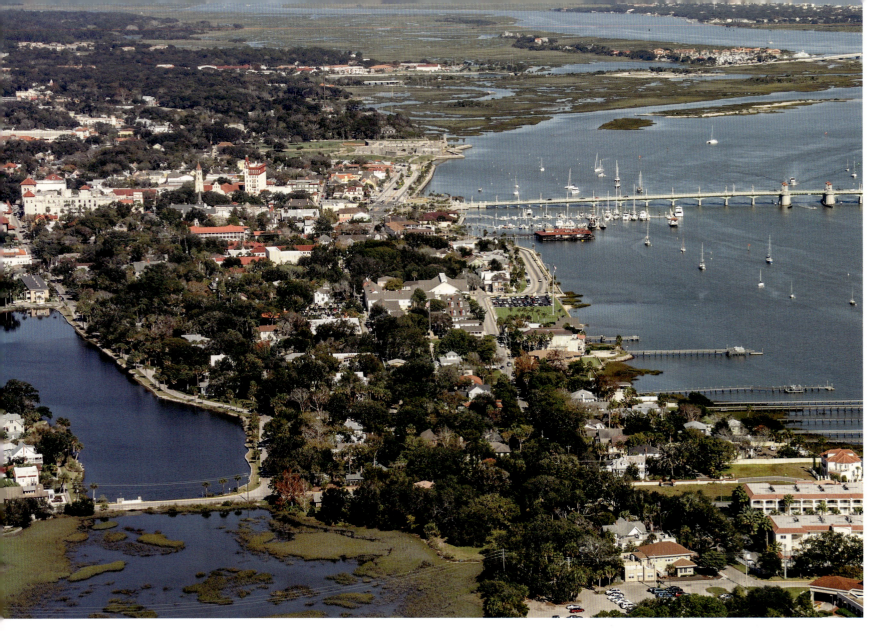

Samuel de Champlain, known as the father of New France. The vast territory from the mouth of the St. Lawrence River to the Mississippi Delta—through the Ohio Valley, with the Rocky Mountains to the west and the Gulf of Mexico to the south—belonged to the French during the sixteenth, seventeenth and mid-eighteenth centuries. New France occupied the central lands of North America and was traversed by the Mississippi River, which flows more than 2,300 miles through the states of Minnesota, Wisconsin, Iowa, Missouri, Illinois, Kentucky, Tennessee, Arkansas, Mississippi and Louisiana. Discovered by the Spanish adelantado Hernando de Soto in 1541, the great river was the main route of commerce and life in the interior of North America.

In 1682, René-Robert Cavelier, Sieur de La Salle, was granted permission to explore the Mississippi River in exchange for a monopoly on the fur trade and the right to build forts to consolidate the occupation of what he had explored. La Salle set out from near the source of the river and reached its mouth, where he took possession of the Mexican Gulf Coast in the name of Louis XIV, King of France. In 1685 he attempted to establish a settlement at the mouth of the river, but was unsuccessful. In those years, the Canadian-born

2. General view of St. Augustine, Florida, the first city founded in US territory in 1565 on the east coast of the Florida peninsula by Spaniards {JL}

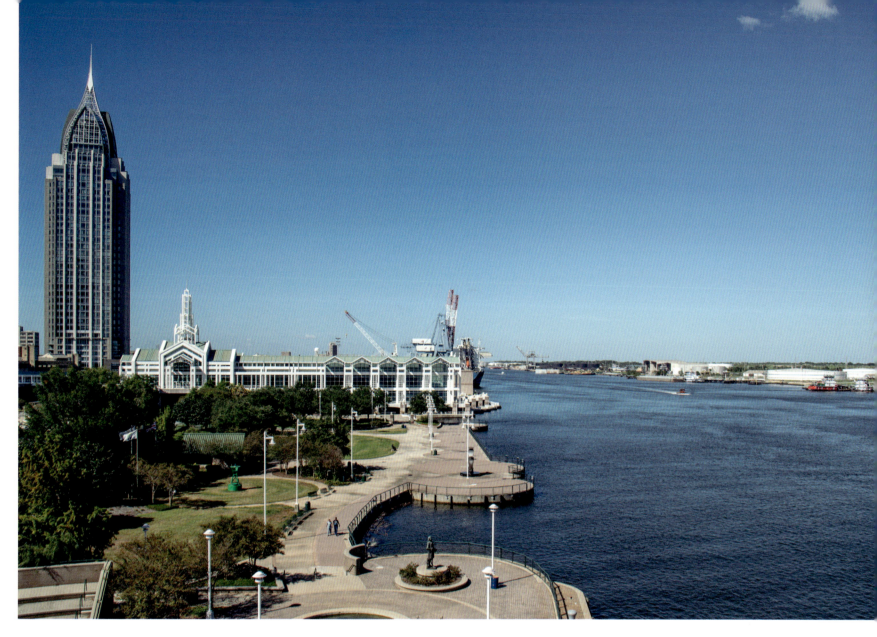

3. General view of Mobile, founded by the French in 1702 on the shores of the Gulf of Mexico, oldest city in Alabama {JL}

Pierre Le Moyne d'Iberville, in charge of exploring the river delta and accompanied by his brother Joseph Le Moyne de Sérigny, established a fort at Biloxi (1699) and another one at Mobile (1702), precursors of these cities. Years later, in 1718, his brother Jean-Baptiste Le Moyne, Sieur de Bienville, founded New Orleans, which became the capital of Louisiana in 1722 (Figs. 3 and 4).

The French were in constant conflict with the Indians and the English, who were the next to join in the struggle for dominance in the Americas. In 1580, the English introduced the doctrine of effective occupation, which recognized only colonized territories and considered the rest available for occupation. Beginning in 1588, English incursions into the New World increased after King Philip II's Invincible Armada failed to destroy England's naval power. The dreaded English pirates and corsairs ravaged Spanish possessions. Spain retaliated by fortifying its coastal cities and taking steps to protect its fleet by having its merchant ships travel together in convoys, guarded by warships. The Spanish Caribbean's impressive array of military fortifications was the result of Spain's fear of the British.

English attempts to establish colonies in the late sixteenth century were unsuccessful. In 1607, however, with the

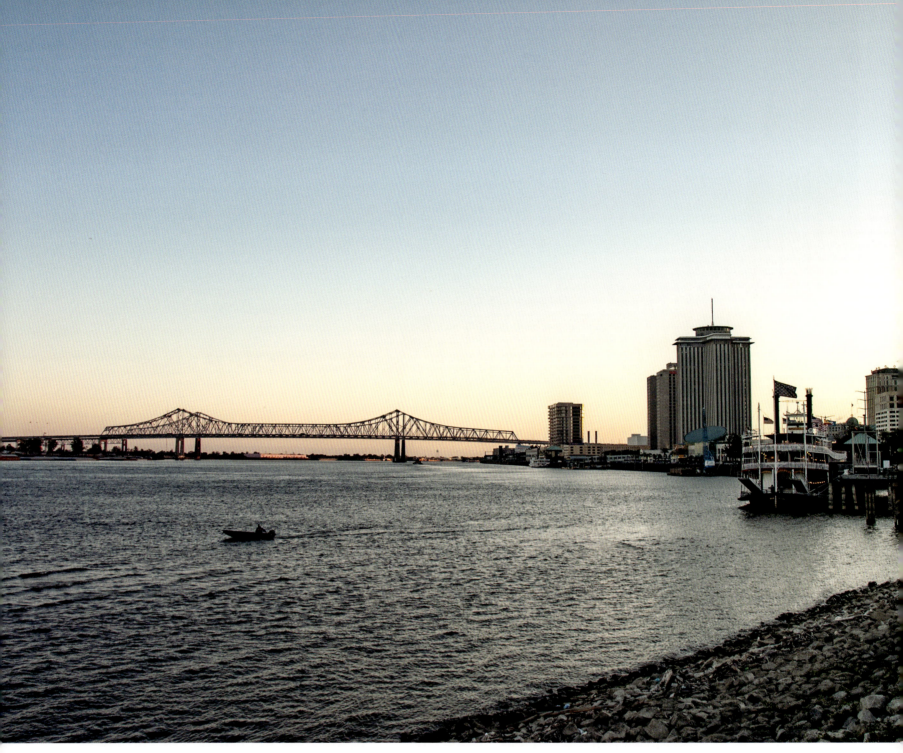

4. New Orleans, on the Mississippi River
{JL}

help of the Virginia Company (founded in 1606 as a trading company involved in the production of tobacco), they succeeded in establishing Jamestown Fort (Virginia), which was the origin of the colony of Jamestown. Important milestones of English colonization were the settlements of Virginia (1607); New Plymouth (1620); Boston, Maine, New Hampshire and Rhode Island (1630); Maryland (1634); New Amsterdam (New York, 1664); New Jersey (1673); Pennsylvania (1681); and Georgia (1732). In 1769, a North Carolina pioneer and frontiersman, Daniel Boone, crossed the Appalachian Mountains and reached the fertile Ohio River Valley despite resistance from Indian tribes.

Boone and his followers set in motion the westward expansion of the English colonists to the Mississippi. This led to clashes with the Spanish—the treaty

signed in 1763 resulted in France ceding Canada to the English, Louisiana to Spain, and Spanish Florida being exchanged for Havana, which had been captured by the British the previous year. In April of the same year, 1763, the Spanish had ceded Panzacola (Pensacola) to the British, who then took Movila (Mobile) as part of a plan that included the lands east of the Mississippi River. The territories thus gained were divided into two parts: East Florida and West Florida, with Saint Augustine and Pensacola as their respective capitals.

Feeling confident, the Thirteen Colonies revolted against British rule in 1775 and won their independence in 1783, forming the nucleus of the United States of America. During the War of Independence, the Spanish supported the rebels, capturing East Florida from the British in 1779–1780, and West Florida in 1781. From Cuba, "the Spanish Crown sent reinforcements to New Orleans, men who belonged to the *Regimiento Fijo de La Habana* [Fixed Regiment of Havana]. Next, members of the *Pardos y Morenos* [African descendants] militia battalions were sent to occupy Mobile."[3] At the end of the war, both Floridas went to Spain under the Treaty of Versailles in 1783. Together with Louisiana, they formed a vast territory in which the cities of Natchitoches, New Orleans, St. Louis and Mobile flourished, thanks to the commercial trade in furs, liquor and timber, as well as other activities, in which smuggling and the sale of slaves played an important role. Spain then had control of the waters of the Mississippi River and the coastal waters of the Gulf of Mexico, which was no small matter. Politically, the territories of Florida and Louisiana became part of the Captaincy General of Cuba.[4]

From 1776 to 1783, the rebels of the Thirteen Colonies had a close relationship with Spain and Cuba.[5] When Spain declared war on England

> the Patriot forces—commanded by George Washington—found in Havana an important supply center; the revolutionary fleets were repaired and rearmed in its shipyard and arsenal. Then an army under the Spanish banner—partly composed of Creoles from Cuba—landed in Florida and, thanks to its victories at Manchac and Panmure, advanced on Baton Rouge, clearing the Mississippi River of the British. These forces would later occupy Pensacola.[6]

With the war with Great Britain over and independence won, the relationship of the Thirteen Colonies with Spain

[3] Alberto Prieto Rozos, "Prólogo," in Gustavo Placer Cervera, *Ejército y milicias en la Cuba colonial*, xiii-xvi.

[4] For information on the Spanish-language bibliography on early Spanish territories in the United States, see Sylvia H. Hilton, "El Misisipi y La Luisiana colonial en la historiografía española, 1940-1949."

[5] Tradition has it that the wealthy ladies of Havana had sold their jewels to support the cause of independence for the northern colonies. However, José Ramón Fernández Álvarez has shown that this is a legend that, nevertheless, is rooted in reality—Havana landowners contributed money to support the expedition led by the French general Francois de Grasse in 1781. See José Ramón Fernández Álvarez, *Las damas de La Habana y sus joyas. Un mito persistente en la historia de Cuba.*

[6] Prieto Rozos, "Prólogo."

took a radical turn. When the Count of Aranda signed the Treaty of Paris in 1783 on behalf of the Spanish Crown, he declared that with American independence, the new nation would set its sights on "the entire possession of the Floridas in order to dominate the Mexican gulf. By this step, it will not only interrupt Spanish trade with the Kingdom of Mexico whenever it wishes, but will aspire to the conquest of that vast empire, which we shall be unable to defend from Europe."[7] Indeed, the westward expansion was fueled by a remarkable economic and demographic growth. The clash with the Indians living in the territory and with the Spaniards was inevitable—the former defending their ancestral lands and the latter controlling the waterways through which trade could flow. Traveling up the Appalachian Mountains to reach the ports on the East Coast was an arduous task, so the logical trade route was by river. But due to the inflexible monopoly policy of the time, the Spanish forbade the transit of American products across the Mississippi. However, aware of the danger posed by the aspirations of the United States, in 1795 Spain recognized their territorial sovereignty over the eastern bank of the great river and authorized maritime traffic for three years, against the opinion of the Baron de Carondelet, governor of Louisiana, who considered

> the aforementioned concession [the free navigation of the river] a temporary palliative, which will inevitably lead to and ensure the loss of these provinces in a few years, and consequently that of the kingdom of Mexico; the wandering, restless and independent nature of the American people will never be confined to the east bank of the Mississippi River; we can scarcely contain their raids on the other side at present ... [W]hat will happen when, attracted by the benefits of free navigation and the free port they request, the entire east bank of the river as far as the Ohio becomes populated? By what means will Spain prevent them from attracting all the trade? ... The entire population of the eastern part of the Appalachian Mountains will flock to the banks of the river, from which our allied nations [the Choctaw, Chickasaw, Creek and Cherokee Indians] will be driven away; the entire population of this city [New Orleans] will move to their towns, with merchants being attracted by the ease of carrying on smuggling and its trade.[8]

Time would prove Carondelet right. On July 22, 1798, Francisco Saavedra, governor of the Floridas, received a royal order advising him to be prepared because Spain had a well-founded suspicion that the United States "wants war and will spare no means to wage it ... that the object of its ambition is the Floridas and Louisiana and that these notions are supported by the English who have a strong commercial interest in the ex-

[7] Quoted by José Luciano Franco, *Política continental americana de España en Cuba 1812-1830*, 5.

[8] "Statement by Don Francisco Luis Hector, Baron of Carondelet, Governor of Louisiana, in a letter to Luis de las Casas, Captain General of Havana, who copied it and sent it to the Minister Count of Aranda, Spanish Minister, in 1792," quoted in Andrés Ortiz Garay, "El fluir de la historia. El río Mississippi: encrucijada de Norteamérica."

pansion of American possessions."⁹ On a visit made by the Spanish Ambassador in Paris to Prince de Talleyrand, head of state, the latter informed him that he had received letters from the United States in which a well-informed source assured him that the United States did indeed want the Floridas, "which they intend to seize without resistance. And that this is the perception that they have of the English, who are already expecting to take over the Spanish commerce of the Islands and of New Spain through this means."¹⁰ The Captain General of the Island of Cuba, José Cienfuegos, sent to Spain a report written by Brigadiers Vicente Folch¹¹ and Maximiliano de San Maxent regarding "the damages that have been and will continue to be caused from the violent occupation by the United States Government of the territories of Baton-Rouge and Movila and others in western Florida"¹² and in which they list "the long string of insults, violence and damages that Spain has suffered from the United States."¹³

Spain decided to return Louisiana to France, a decision that was kept secret.¹⁴ But Napoleon, aware of his inability to win a war in such remote lands and interested instead in dominating Europe, pragmatically decided to sell Louisiana to the United States for $15 million in 1803. Once in possession of Louisiana, the Americans, increased the strife when they "prevented the free navigation of the Mississippi; ... insulted our armed ships; invaded our coasts; and made various threats, which they finally carried out by taking Baton-Rouge and occupying Mobila in absolute peace."¹⁵ As Guillermo de Zéndegui aptly observed, "The Spanish frontier was no longer merely the line of least resistance, but also the flank on which the full weight of Anglo-Saxon colonization rested."¹⁶

Spain knew how fragile its control was. Despite enormous colonization efforts, it never achieved total occupation and, consequently, political domination of an unfathomable territory. Depopulation was the uprooting factor that distinguished the Spanish occupation of the northern lands apart from what happened in much of Spanish America, where Spanish rule was built on the shoulders of the pre-Columbian population, which was subjugated to their interests, a kind of control that was impossible to achieve over the rebellious Indians of North America.

9 Archivo Nacional de Cuba (hereinafter ANC), Fondo de Las Floridas, leg. 2, no. 25: "Real orden reservada sobre la influencia del Gabinete de Londres en el Gobierno de los Estados Unidos que ambicionan las Floridas y la Luisiana," July 22, 1798.

10 ANC, Fondo de Las Floridas, leg. 2, no. 17: "Reales órdenes reservadas a los gobernadores de la Luisiana y Florida y Comandante de Pansacola," June 26, 1798.

11 Governor of West Florida.

12 "Informe relativo a los actos de agresión, hostilidad, etc. cometidos por el gobierno de los Estados Unidos de Norte América contra los dominios de España en las Floridas y sus dependencias," quoted in ANC: Asuntos Políticos, leg. 16, no. 15, published in *Boletín del Archivo Nacional*, vol. XLIII, 187-195.

13 Ibid.

14 ANC, Fondo de Las Floridas, leg. 2, no. 43: "Real Orden disponiendo que cuando se verifique la entrega de la Luisiana a la República Francesa, la Florida Occidental queda a cargo del comandante Panzacola," September 16, 1803.

15 Ibid.

16 Guillermo de Zéndegui, "Panorama histórico a manera de preámbulo."

The pressure of the United States on the Spanish territories became unbearable. In 1810, the Republic of West Florida was proclaimed, which immediately called for the annexation of all of Florida to the new American nation. An attempt was made to establish a Republic of East Florida, which was supported by Georgia. The conflicts resulting from the Napoleon's invasion of the Iberian Peninsula and the revolt of the Spanish American colonies finally led Spain to sell the Floridas to the United States in 1819, in exchange for five million pesos and the promise to preserve the borders of New Mexico to the west. This agreement was not honored—in the decades that followed, much of the Mexican territory was incorporated into the United States. In 1821, the same thing happened to eastern Florida.

Similar changes took place in the Antilles. Spanish Jamaica fell to England in 1655, and part of Hispaniola would become the French colony of Saint-Domingue, now Haiti, in 1681. Trinidad was discovered by Spain in 1498 and finally occupied by the English in 1797. The small island of Tobago was British in 1625, Dutch in 1655, French from 1763 to 1783, and British again from 1793 to 1814. Grenada, which was French in 1650, was ceded to the British in 1763 and remained under their rule except for a brief French takeover from 1779 to 1783. St. Vincent was occupied by France in 1719 and ceded to the British in 1763. Barbados had been British since 1615 and St. Lucia since 1605. Martinique has been French since 1635, except for a brief English period from 1809 to 1814. Dominica was Spanish from its discovery in 1493 and English from 1627 to 1805. Guadeloupe was French in 1635, British in two different periods: 1759 to 1763 and 1784 to 1810, Swedish in 1813, and French again from 1816.

The changes in ownership led to countless conflicts over the possession or control of rural lands. A document concerning the lands of the English colonel Elias Durnford—a distinguished civil and military engineer—refers to the influx of Spaniards into lands previously occupied by the British and the need to determine property rights:

> Under article 2 of the Treaty of Friendship ... between our government [Spain] and the United States of the America signed at San Lorenzo del Real on October 27, 1795, a boundary was established between the two states and the Spanish territory of West Florida by a line beginning on the Mississippi River ... and from there straight east to the middle of the Apalachicola River. ... For this reason, there began a considerable emigration of people from the territory that had been left out of the Spanish dominion to settle ... south of that line ... claiming lands from the many crown lands and vacant lands that existed and others that had been abandoned by the English after the conquest of that province by our arms in 1779, 1780 and 1781, for which reason, in 1796, I requested from the Government of Louisiana and West Florida a notice of the English possessions that were to be honored pursuant to the capitulations.[17]

[17] ANC, Fondo de Las Floridas, leg. 9, no. 16, "Expediente formado para proporcionar al Excmo. Sr. Capitán General testimonios de las concesiones de tierras en las Floridas, solicitadas por el Coronel inglés Elias Durnford," 1823.

The greatest challenge for those who lived in these areas was the constant state of war, which prevented them from putting down roots in any one place. William S. Coker's account of the Moreno family's vicissitudes in the settlements along the Mexican Gulf Coast—Pensacola, Mobile, and New Orleans—and in Havana is common to most people who settled in these places.[18]

The effects of war and changes in sovereignty were very different. In Cuba, with the return of Havana to the Spanish in 1763 (Fig. 5), an administrative, economic and military reform was carried out to ensure the best development of the Island, while the defenses of Havana were improved with the repair of damaged castles and the construction of an impressive and very costly series of fortifications, including La Cabaña fortress and the castles of Atarés and El Príncipe. In addition, the deployment of military engineers to the war zones in the north delayed the construction of important buildings such as the Palace of the Captains General, begun in 1773 and completed in 1791. Other buildings, such as the Post Office Palace, begun in 1770 but destroyed when the front bays collapsed, could not be rebuilt until 1776/1780. Perhaps this explains why Havana Cathedral (1748-1778) was left unfinished, with a hasty finish and bare exterior walls, without the stucco that would have given it a greater visual appearance.[19]

Cuba is also a perfect example of the arrival of peoples from other places, with foreseeable consequences. Spaniards expelled from Jamaica arrived on the Island in 1655; Spaniards from St. Augustine, Florida, came in 1764; French-Haitians who fled Saint-Domingue in successive waves came from 1792 to the early 1800s; and French-Spanish from Louisiana arrived in the early decades of the nineteenth century. In addition, Spaniards and Creoles from all over Spanish America sought refuge on the Island as a result of the wars of independence. Among them were Spanish merchants from insurgent Mexico, who contributed more than ten million pesos, "an extraordinarily significant factor in the prosperity of trade and agriculture."[20]

The flow of people brought both benefits and disadvantages. The Spaniards, who arrived from Jamaica in the mid-seventeenth century, provided a powerful lever for the development of cattle ranching and the sugar industry in the central region. This attracted English pirates who ravaged the inland towns, and explains the behavior of the townspeople of the central region, who went from being tobacco farmers to active smugglers and pirates, activities from which they made considerable profit.[21] In 1763, with the approval of Count Ricla, governor of the Island, Manuel José de Jústiz de Santa Ana and his brother-in-law, Jerónimo Espinosa de Contreras, donated

[18] See William S. Coker, "The Moreno Family of the Gulf Coast."

[19] The walls of colonial buildings had a final rendering, or plastering. In the twentieth century, a misunderstood beauty of stone has left many buildings exposed.

[20] Franco, *Política continental americana*, 58.

[21] See Alicia García Santana, *Las primeras villas de Cuba*.

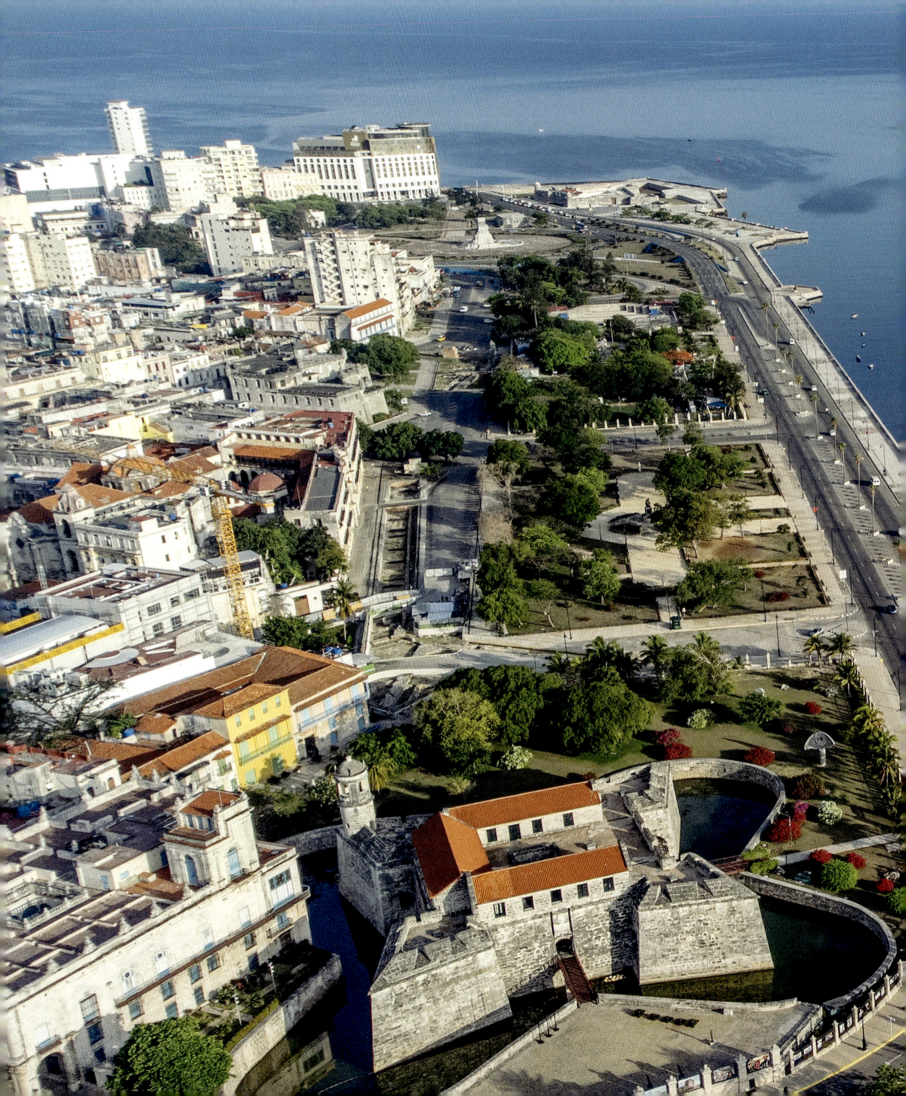

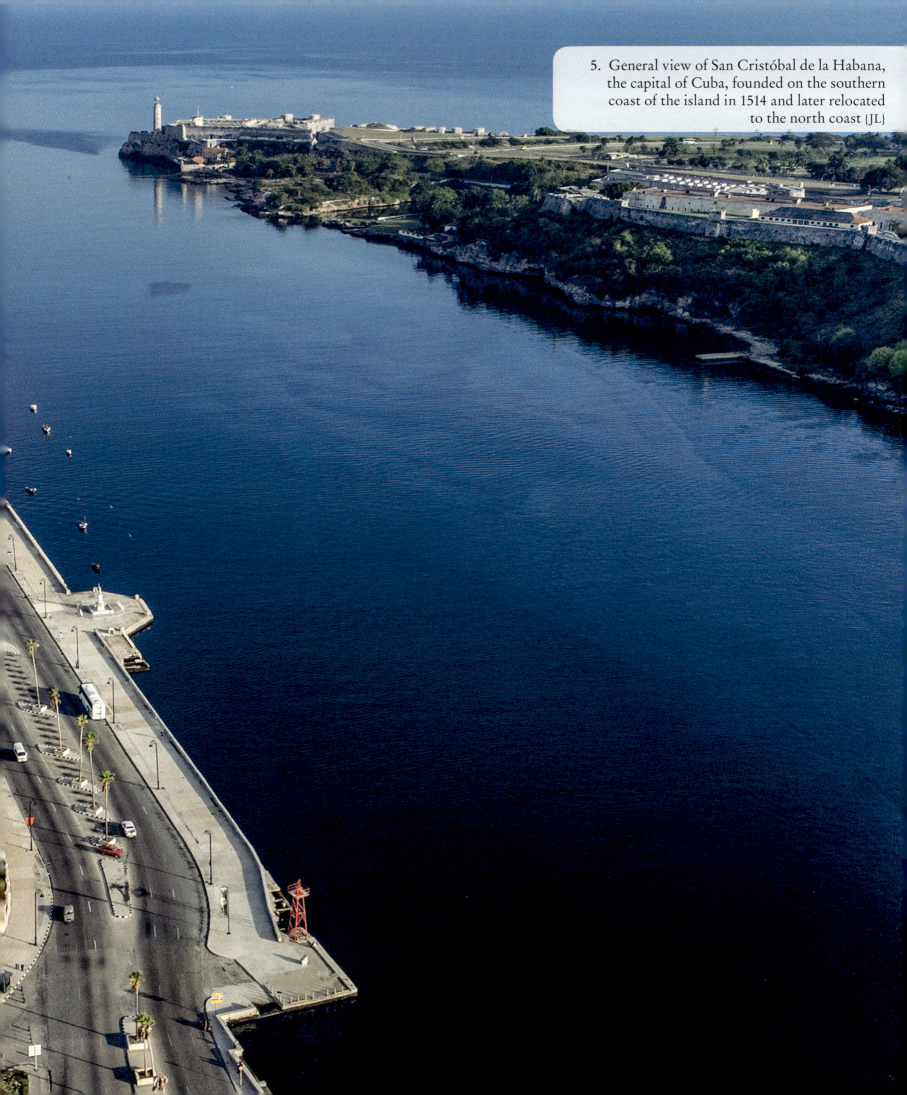

5. General view of San Cristóbal de la Habana, the capital of Cuba, founded on the southern coast of the island in 1514 and later relocated to the north coast (JL)

land in the jurisdiction of Matanzas[22] to establish a town under the name of San Agustín de la Nueva Florida, with families from the original town of the same name. These families were allotted a plot of land in the city and a farm in the countryside to grow tobacco. According to the custom of the time, this tobacco would be processed into snuff in the mills owned by Jústiz de Santa Ana, the nephew of Manuel José Jústiz Umpierre, a former governor of St. Augustine, Florida.[23]

The idea of bringing Floridians continued throughout the nineteenth century, when in 1842, some residents of San Agustín proposed to the Cuban government the establishment of a colony in Nuevitas, Camagüey.[24] This was the path that led to the cruel and arduous relocation of Native American "settlers" or poor Mexicans, Chinese and Spaniards to replace slaves, who were in short supply due to the prohibition of the slave trade and the certainty that African slavery would come to an end.[25] This despicable system of human exploitation marked the region in a historical sense, as it was painfully in force from the sixteenth to the nineteenth centuries.

The arrival of the French "Americans" at the end of the eighteenth century was of great importance. The ruin of Saint-Domingue in the last decade of that century offered a unique opportunity, as Cuba took the place of the rebellious colony in the world sugar and coffee markets. A wave of French-Haitians arrived in Santiago de Cuba and other Cuban cities, along with their domestic slaves. Despite the difficulties of their integration due to the Napoleonic invasion of Spain in 1808, many of them managed to settle in our cities, where they practiced different trades, some of which were practically unheard of on the Island, such as dressmaking, and in the mountains in the east, coffee plantations and French customs flourished, which had an enormous architectural impact. In the early nineteenth century, Spanish-French families from Louisiana came to Cuba and planted coffee in the Havana-Matanzas Plains, which became the most important coffee-growing area in the country in the first decades of the 1800s,[26] its prosperity attracting relatives and friends. Immigrants from Louisiana played an important role in the founding of

[22] See García Santana, *Matanzas, la Atenas de Cuba.*

[23] ANC, Gobierno Superior Civil, leg. 880, no. 29668, "Expediente sobre las suertes de terrenos de los que emigraron de Sn. Agustín de la Florida y formaron en esta isla el pueblo de la Nueva Florida," 1822. In 1764, 30 families from Spain, 43 from the Canary Islands, four from Germany, nine free mulatto families and four free black families settled in San Agustín de la Nueva Florida (Ceiba Mocha). The settlement was not as successful as expected and its founders dispersed in different ways. The town, however, survived and was mainly devoted to agricultural activities. See Robert L. Gold, *Borderland Empires in Transition. The Triple-Nation Transfer of Florida,* 78.

[24] ANC, Junta de Fomento, leg. 186 no. 8395, "Expedientes instruido a consecuencia de la solicitud de varios ciudadanos de los Estados Unidos de américa vecinos de S. Agustín de la Florida que pretenden establecer una colonia al norte de esta Isla," 1842.

[25] See Juan Pérez de la Riva, *Los culíes chinos en Cuba.*

[26] William C. Van Norman Jr., *Shade-Grown Slavery. The Lives of Slaves on Coffee Plantations in Cuba.*

Cienfuegos, one of Cuba's most beautiful cities. It was designated a UNESCO World Heritage Site in 2005.[27]

When Louisiana became part of the United States in 1804, Louis De Clouet, a French-Spanish man born in New Orleans, conceived "the idea of emigrating ... with my family and relatives, along with many other Spanish families, to the island of Puerto Rico to found a new settlement."[28] He was forced to abandon these plans, however, because he was told that it was necessary "to populate with good Spaniards the eastern part of the ... Mississippi"[29] that had remained under Spanish rule, but he was also ordered first to "carry out ... other confidential missions ... of the greatest interest to the State."[30] He remained "in Louisiana doing continuous work, traveling to Florida, the Kingdom of New Spain ... exposing myself to the risks that a spy faces."[31] And "in the year 13, I had to go with my family to Philadelphia to report about the Government of the United States of America to our minister, Don Luis de Onís, who was very pleased with the reports I gave him, which contained positive information."[32] Supported by these "accomplishments," De Clouet traveled to Madrid, where he was told of Spain's interest in increasing the white population of Cuba. In Cadiz, he met the newly appointed governor of the Island, José Cienfuegos, who instructed him to recruit "decent people" for a colony while passing through Bordeaux. He succeeded in doing so and in 1818 he arrived on the Island with about forty people.

Different views existed in Cuba regarding the establishment of new settlements and, especially, about where they should be located. To this end, De Clouet relied not only on travelers from Bordeaux but also on people of various "truly useful trades, farmhands and farmers, especially ... from Louisiana, former subjects of Our Lord the King."[33] Finally, in 1819 (Fig. 6), with the support of Intendant Alejandro Ramírez, the new colony was established on the land adjacent to Jagua Bay, owing to the interests that the powerful Honorato de Bouyon,[34] a Frenchman in the service of the Spanish Crown, had in the area. Among the founders of Cienfuegos from Louisiana were Federico Gennet, Lorenzo Jery, Pedro LeMaignen, Guillermo Doret, Juan Bamberet, Juan Lebedelle, Guillermo Guillen, his son Juan Guillen, Ramón Chevrefin and Luis Bonet.[35]

Through the individuals and situations mentioned above, we have tried to

[27] See Irán Millán Cuétara et al., *Cienfuegos, la perla de Cuba*.

[28] ANC, Gobierno Superior Civil, leg. 631, no. 19901, "Carta de De Clouet a Francisco Dionisio Vives con datos del surgimiento de Cienfuegos y en protesta de los cargos que le han hecho."

[29] Ibid.

[30] Ibid.

[31] Ibid.

[32] Ibid.

[33] Ibid.

[34] In 1806 Bouyon was promoted to director of the Havana Dockyard and in 1812 he was commissioned to build a new one. In 1816 he built a shipyard in the area that would later be part of Cienfuegos.

[35] ANC, Gobierno Superior Civil, leg. 631, no. 19901, cit.

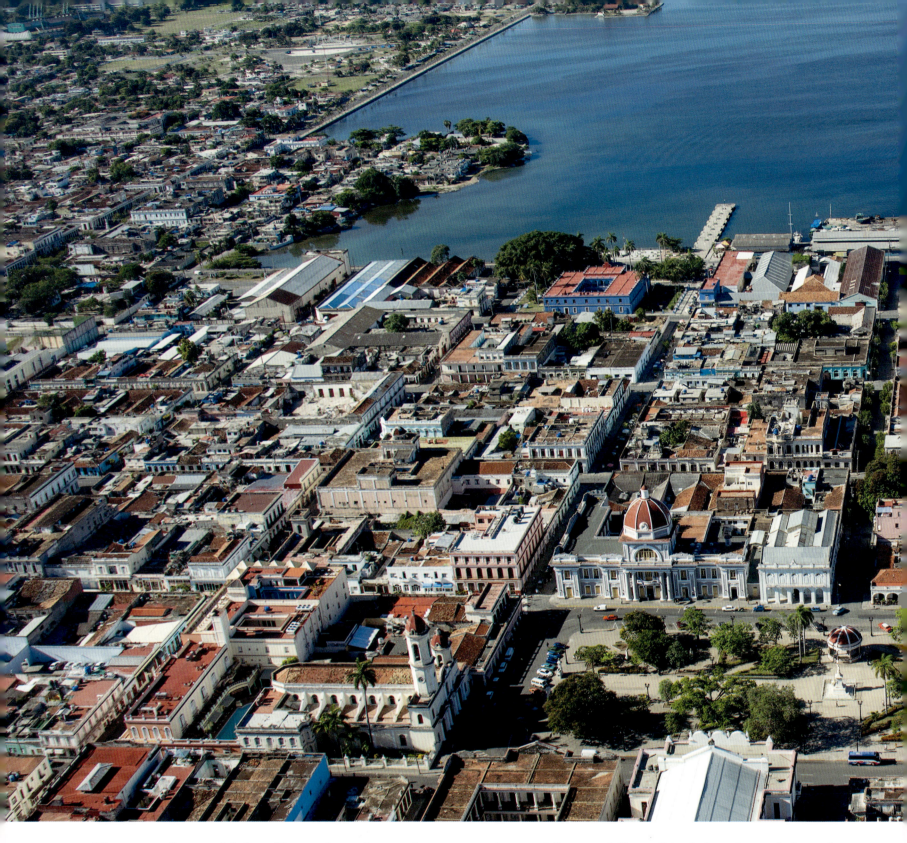

illustrate the multiple effects that the relocations have had on Cuba, an indication of what could be called the "historical destiny" of a region in which its people have been and continue to be in constant exchange. Individuals transmit the cultural values of an era whose evolution transcends geographic, linguistic, economic, social, or philosophical boundaries; it ignores conflicts of religion, race, or political beliefs. It is not fueled by what divides; it is the result of what is required in accordance with human efforts to secure existence and attain happiness. It depends on a given geographical setting and a given time.

6. General view of Cienfuegos, founded by Frenchmen from Bordeaux and New Orleans in 1819, on the banks of Jagua Bay in south-central Cuba. {JL}

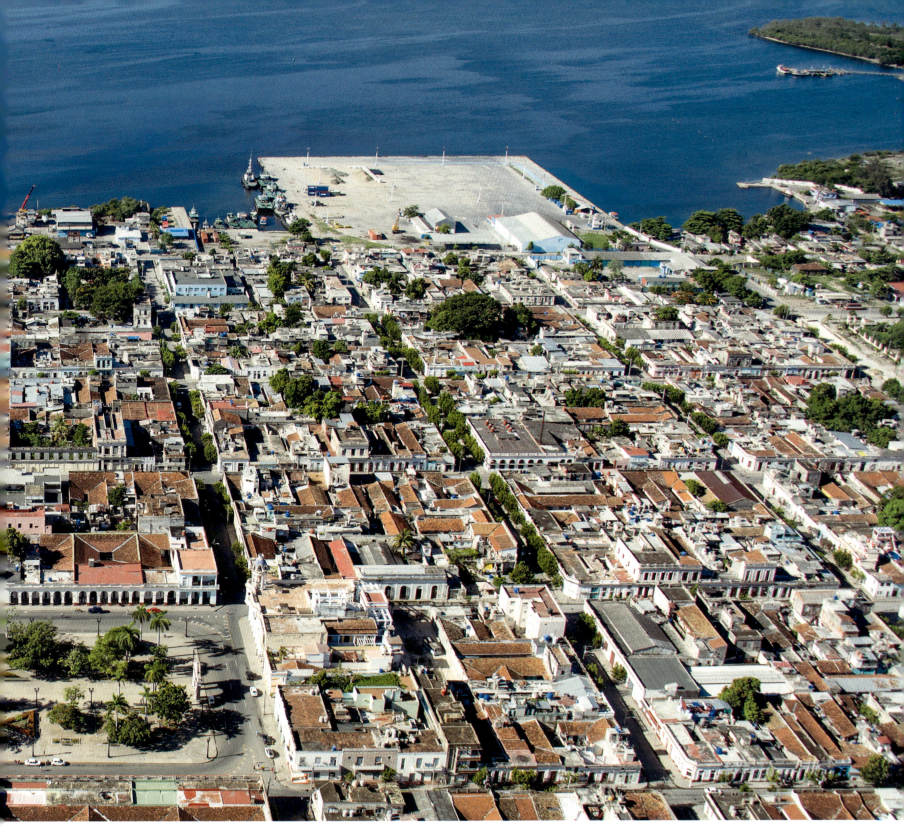

But it does not stop—at present, processes that we will treat as of the past are still ongoing, because the conditioning factor of space has not changed. Therefore, it is worth the effort to identify and understand the cultural event in its historicity.

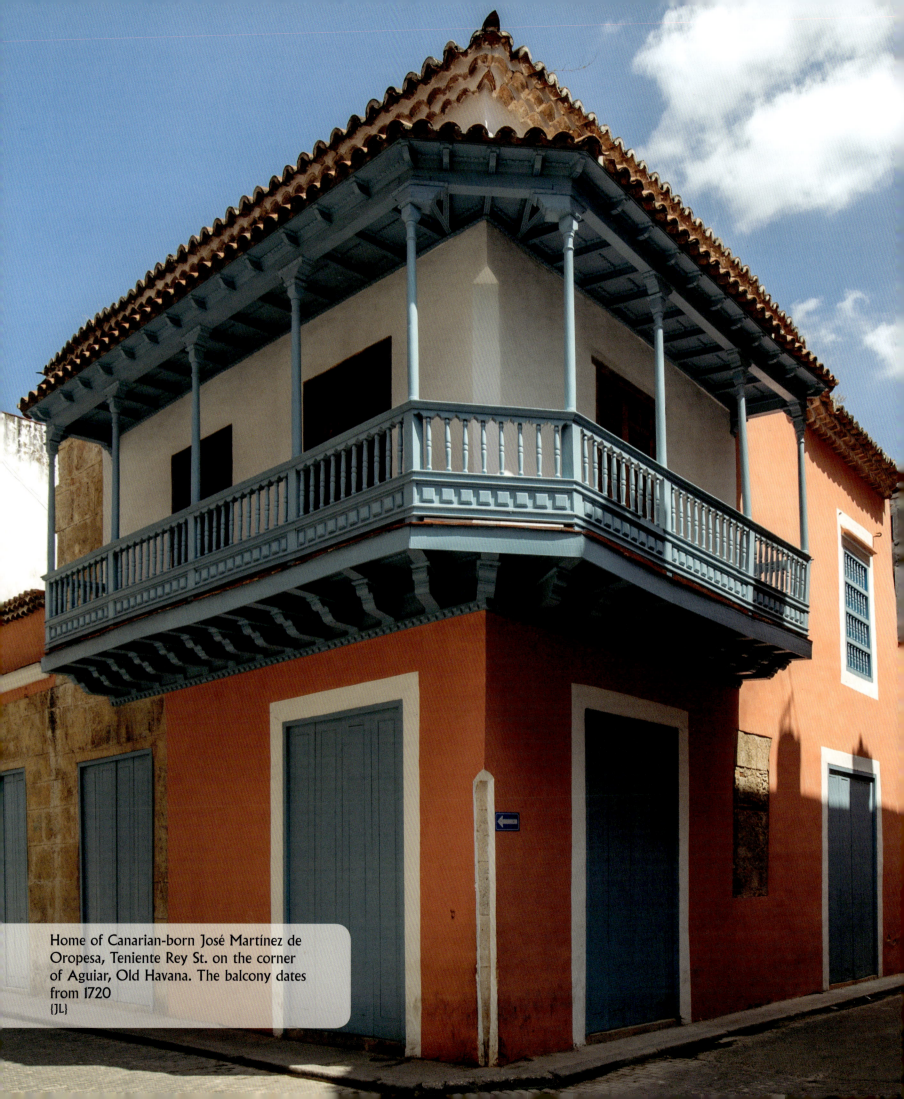
Home of Canarian-born José Martínez de Oropesa, Teniente Rey St. on the corner of Aguiar, Old Havana. The balcony dates from 1720
{JL}

HAVANA: THE SPANISH-CREOLE LEGACY

As far as the Spanish legacy is concerned, we should not start from the geographical division that defines the countries that make up the insular and continental Caribbean. The Spanish territories had a similar historical platform, which explains the architectural similarities between Santo Domingo and Mexico in the sixteenth century, between Havana and Cartagena in the seventeenth and eighteenth centuries, between Havana and the cities of the Yucatan Peninsula in the eighteenth century, and between Havana and San Juan, Puerto Rico in the nineteenth century, to mention just a few examples. The cultural unity of the Spanish Caribbean goes beyond the current political-administrative divisions, which can be explained by several factors, including the following:

- The quick definition of the colonization strategy of Spain in terms of procedures and actions, thoroughly established in the Laws of the Indies.

- The initial impact of the Crown of Castile, under whose aegis the conquest and colonization of the Americas took place.

- The regional influence represented by the Viceroyalty of New Spain.

- The establishment of a unique route for the Spanish treasure fleet (West Indies Fleet), which created a strong link between Veracruz (Mexico), Havana (Cuba) and Cartagena de Indias (Colombia); in other words, the permanent link between the northern, Antillean and southern territories of the Spanish Empire in the Indies, with Havana as the hub of the system, both in receiving and sending people and ideas.

- The defensive policy established by Felipe II for the area, through the creation of a vast system of fortifications in the Caribbean as a geographical unit, which implied a strong interrelationship between the different territories of a region that as a unit could be identified as the "Maritime Republic of Fortifications."

- The commercial contacts established between the port cities of the region.

- The actions of the same people in different parts of the territory in their capacity as conquerors, colonizers, ecclesiastics and military engineers.

This unity was gradually fragmented by internal factors that would eventually determine specific peculiarities, although the culturally related regions do not always coincide with the political division that has survived to this day. Nevertheless, the architecture of Spanish origin in the Caribbean radiates an aura of kinship that reveals its common origin.

The first dwellings were quite astonishing considering the time and circumstances. We are talking about the imposing palace-fortresses built in Santo Domingo, characterized by façades without any architectural additions, except for the doorways; by small openings;

by the absence of wooden balconies; by flat roofs and the lack of wooden frames; and by walls made of pebbles (Fig. 7). These are examples that, in the Americas, followed the characteristics of fifteenth-century Castilian Gothic-Mudejar palaces.

In the second half of the sixteenth century, when the military period was over and the colonization process of the conquered territories was in full swing, a type of dwelling derived from the Moorish or Mudejar houses[36] began to be introduced into our lands. These houses were very different from the ones in other European nations because they were the result of a very particular historical

7. Royal Houses, 16th century, Santo Domingo, Dominican Republic {Photo by Tomás García Santana}

[36] The dwellings of the Moors who converted to Christianity in Granada were called Moorish. They reflect the fusion of the Castilian Gothic-Mudejar tradition with that of the Muslims. Today, the Spanish examples derived from such a complex relationship tend to be called Mudejar.

circumstance. In Spain, the Greco-Roman legacy, which later became Christian, was contaminated by the legacy of the Muslims, who occupied almost all of the Peninsula from the beginning of the eighth century. From that moment on, a lengthy war between Christians and Muslims began, reaching a milestone in 1085, when the Christians took the city of Toledo, the capital of the Muslim kingdom. A complex process of transculturation[37] took place between Christian and Muslim ways, giving rise to the term Mudejar, initially used to refer to the Moors who continued to live in the lands that had been conquered by the Christians, and which would later take on cultural significance as it represented par excellence all that was Spanish in the late Middle Ages.[38] In both legacies, the house was organized around an empty interior space—the courtyard.[39] Castile brought the model of the courtyard house to the New World as an expression of the *hidalgo* ideal,[40] under which the colonization of Spanish America took place.[41] This ideal is the only thing that can explain the spread of the courtyard house in territories so different in terms of geography, climate and culture.

The courtyard house is a model associated with a compact form of urban development, in which the dwellings share a party wall. It does not include the garden between the houses, although the inner courtyard is embellished with useful and decorative plants. In Spanish America, the orthogonal urban layout merged with the courtyard house, just as it did in ancient times in the colonization cities established by the Greeks and later by the Romans. It is characterized by the placement of a square or plaza in the center of the city, which in turn is surrounded by porticoed galleries in the form of a large "collective courtyard." Courtyards and porticoed galleries are distinctive components of Spanish and Spanish-American housing and cities, a relationship whose origins are lost in time (Fig. 8). They are formed by stone columns and wooden corbels or uprights topped with bearing blocks, a Mudejar imitation of the columns themselves. The wooden galleries and balcony galleries, inspired by their Christian and Muslim ancestors, are contributions of the Spanish Mudejar house.

Among the many cities that were built in the Caribbean and Spanish America following these principles, Havana stands out as one of the few that has preserved examples from the sixteenth century to

[37] Transculturation is a process of the gradual fusion of elements from different cultures, with the subsequent emergence of a resultant new quality. The cultural products that emerge in this manner cannot be defined by one or the other of the previous cultures, each of which is considered a nourishing source, although it is common for one to develop in conditions of dependence on the other; this can change or be reversed over time, in what is always a conflicting relationship. See Fernando Ortiz, *Contrapunteo cubano del tabaco y el azúcar*. Introduction by Bronislaw Malinowski.

[38] See Rafael López Guzmán, *Arquitectura mudéjar*.

[39] See García Santana, *Los modelos españoles de la casa cubana*, vol. I.

[40] According to the Ordinances of Seville of 1527, the courtyard house is the "casa hidalga" [house of a nobleman]. Seville Town Council. Department of Culture, "Ordenanzas de Sevilla de 1527," facsimile reproduction of microfilmed versions.

[41] On the *hidalgo* ideal in the conquest of the Americas, see José Luis Romero, *Latinoamérica: las ciudades y las ideas*.

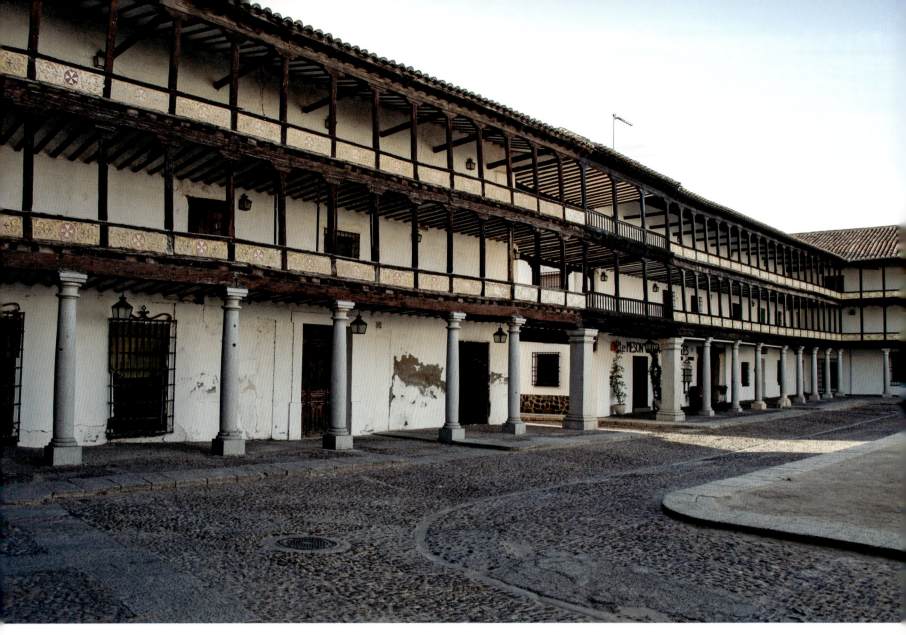

8. Main Square of the city of Tembleque, 18th century, Toledo, Spain {JL}

the present day. Most of its counterparts have undergone modernization processes that have altered their historical heritage. In spite of damages in terms of structural conservation, Havana still retains the urban coherence of its heritage area and many monuments have been restored. The process of evolution of the city and its houses, paradigmatic for the purposes of understanding the Spanish legacy in America, is revealed.

The information on the buildings of Havana during its first century is basically documentary. It was a period marked by the social and economic takeoff of the city based on the commercial activity of its port, its assistance in the conquest of Florida, trade with Campeche (Yucatan) and the presence of the Spanish treasure fleet in the bay for a good part of the year. For its protection, the port was fortified with works that were remarkable for their modernity and scope, "schools of architecture" that involved engineers, stonemasons and craftsmen of all kinds, of different nationalities. Havana became the capital of the country and one of the most important commercial enclaves in the region. And, as Alejandro de la Fuente has rightly pointed out, it was a multicultural city in which people of various origins coexisted: Indians (from Cuba, Yucatan, and other American territories), Africans (of very different ethnicities), Spaniards (mainly

from Castile and Andalusia), Canary Islanders, Portuguese, Italians, Flemish, Germans, and the Creole descendants of all these people.[42]

When Jacques de Sores[43] attacked Havana in 1555, the town had stone houses, but none have survived to this day. Most of the documentary references mention much simpler houses in which the courtyard was not a courtyard but a corral, an expression of a stage of historical development that went from being rural to being urban. Several complementary buildings were built on the plots. In term of layout, the first dwellings were structures arranged in a bay parallel to the street, made up of rooms inherited from Castilian Mudejar architecture: the living room and one or two bedrooms, a relationship that became a constant and unique component of the distribution of the house of Spanish descent. The living room-bedroom relationship does not come from the Greco-Latin tradition; it is derived from ancestral examples that are lost in the origin of humanity in the Middle East and was introduced by the Muslims into Spain, where it is found in examples from the Caliphate period, gained strength during the reign of the Almoravids and Almohads, survived in Granada during the Nasrid period and is a basic element of Castilian Mudejar housing—a close reference are the fifteenth-century houses in Toledo and the Moorish houses in Granada from the end of that century and the first decades of the following century.[44] After the rooms at the front, there was a gallery that served as a shelter from the sun and the rain.

Most of the houses were made of wood or rammed earth (*tapia*), an ancient construction system in which earth mixed with lime is compacted in wooden boxes where the mixture hardens. They are then placed on top of each other until a wall is formed. From the late sixteenth century, there is documentary evidence of the use of *embarrado*, a Spanish term used to describe walls made of raw earth mixed with plant fiber and supported by a framework of posts and a crisscross structure of sticks. Called *bahareque* or *quincha* in South America, it was used by Europeans, Amerindians and Africans, so it is impossible to identify its cultural lineage[45]. The simplest roofs used in *bohíos* with earthen-walls and plant elements or in *bohíos* with palm board walls consisted of a wooden frame made of round poles covered with dried royal palm leaves, called *guano* in Cuba (Fig. 9).

The seventeenth century saw an increase in the number of buildings built with durable materials (stone, masonry and brick), with flat or *terrado* [earthen] roofs, which were quickly replaced by timber roofs using rafters and collar beams or, more commonly, rafters and ridge board, structures that were exposed to view. By the early eighteenth century, the Havana house of rank had defined its essential features: two stories and arranged around a courtyard, very similar to the Canary Island versions.[46] Fernando Gabriel Martín Rodríguez believes that the "organization of this type of house is more Castilian than

[42] See Alejandro de la Fuente, *Havana and the Atlantic in the Sixteenth Century.*

[43] French Huguenot from Normandy, nicknamed "The Exterminating Angel."

[44] See García Santana, *Los modelos españoles*

[45] See *Arquitecturas de tierra en Iberoamérica.*

[46] Fernando Gabriel Martín Rodríguez, *Arquitectura doméstica canaria*, 170.

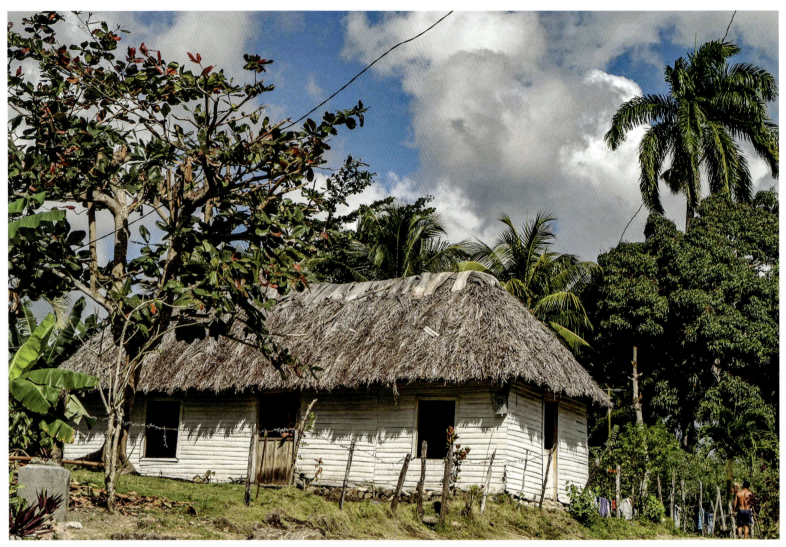

Andalusian. Throughout Castile houses have a courtyard as their nucleus, with the ground floor used as a work area and the upper floor as the actual home."⁴⁷ He adds that "the arrival of the wooden gallery, the cloister staircase and the importance of the upper floor are other factors that further associate the Canary Island house with its Castilian counterpart."⁴⁸ The Canarian, Havana and other Spanish-American houses are the "offsprings" of the Castilian Mudejar house (FIGS. 10 and 11), but the Spanish-American houses differ from the Spanish and Canarian houses due to the frequent, almost constant presence of two very well characterized spaces: the annexes and the stores located on the first floor.

Annexes were spaces to be rented out, typical of cities with high demographic indicators, such as cities in Mexico and Peru, or maritime cities like Havana, where people who were waiting for the departure of the Spanish treasure fleet had to stay there for months at a time. These annexes were located on the ground floor at the front of the house or at the side if it was a corner house, usually with no connection to the rest of the house. Similarly, the store could be on the ground floor at the front of the house, but was preferably located on the corner of the building.

⁴⁷ Ibid, 169-170.

⁴⁸ Ibid.

9. *Bohío*, a term of pre-Hispanic origin adopted by the Spaniards for houses made of palm boards and roofs of palm leaves. The *bohío* in the photo is from the region of Baracoa, in the easternmost part of Cuba, where the most authentic examples in the country are preserved {JL}

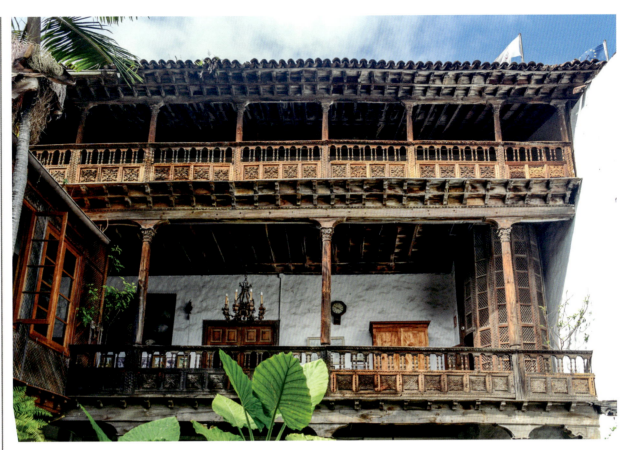

10. Galleries in the courtyard of Casa de los Balcones, 17th-18th centuries, La Orotava, Tenerife, Canary Islands
{JL}

11. Galleries in the courtyard of the Martín de Aróstegui House, first half of the 18th century, 4 Tacón St., Old Havana
{JL}

According to Alberto Nicolini, corner stores resurfaced in the Americas because of the grid plan adopted by the West Indies in urban planning.[49]

The main element of the façades was the balcony (FIG. 12). Its recent history began with the Renaissance. It was supported on stone corbels and protected by iron railings. Its widespread use coincided with the Spanish colonization of the Canary Islands and Spanish America, making it an integral part of domestic architecture in both territories, with a significant difference when compared to the Renaissance models: they were made of wood in the Mudejar style, which is to say "in the Spanish way." So far, it seems possible to identify two antecedents in its

12. Gaspar Riberos de Vasconcelos House (1756), 166 Obrapía St., on the corner of San Ignacio, Old Havana {JL}

[49] Alberto Nicolini, "Sobre la arquitectura y el urbanismo iberoamericano."

formation: one, of Roman origin, which, according to Torres Balbás, is continued in the *solanas* [sunlit corridor facing the midday sun], balconies and overhanging upper floors of Spanish rural architecture;[50] and another one, of Muslim roots, in the form of closed *ajimeces* [projecting wooden balconies] with latticework found in southern Spain. According to Fernando Gabriel Martín Rodríguez, both types coexisted in the Peninsula: the western type—open, overhanging balcony, with a roof and upright posts—found throughout central-northern Spain, and the Muslim type—closed, box-shaped balcony, with latticework and no uprights—found in the south of the country.[51]

In the Canary Islands "both types were combined, with a clear predominance of the western style from the northern half of the Peninsula, where it was widespread in the sixteenth century."[52] The Canarian balcony, a structure that was brought to Spanish America, consists of a projecting platform resting on brackets and covered with a roof supported by columns or upright posts (Fig. 13). It is interesting to note that they repeat the decoration and structure of the courtyard galleries. This explains Francisco Prat Puig's opinion that the balconies are "a faithful reproduction of the courtyard balcony galleries"[53] in that both "are suspended and rest on brackets, although the ones found in interior galleries do not always have carved heads. Also common, and in almost identical form, are the parapet railings, the upright posts and the small roof supported by a sill."[54] Similar to the late Canarian balconies, the wooden balconies in Havana and other Cuban and Spanish-American cities stretched across the entire width of the buildings' façades from the 18th century onwards.

One element that stands out in early houses is the *zaguán*, an atrium-like space between the exterior and the interior of the house that became a common feature in the houses of the wealthy classes in Spain, the Canary Islands and Spanish America. Special architectural embellishments were reserved for the entrance to the *zaguán*, including decorations enhanced with coats of arms of the nobility. The *zaguán* gave way to the courtyard and the gallery where there a staircase led to the upper floor, which was reserved for the family rooms. The living room was the most important space, notable for its large size. It had two distinct areas: a dais, or platform, for the women, who sat on cushions or low chairs, and a section with chairs for the men. In high-ranking households, women and men would sometimes occupy completely different spaces, a gendered division that reflected the patriarchal values of the aristocratic social classes. Sleeping quarters were generally located to the sides of the living room and to the sides of the courtyard. At the back, on the ground floor, were the service quarters, the kitchen (sometimes also on the upper floor) and the stables.

50 Leopoldo Torres Balbás, "De algunas tradiciones hispanomusulmanas en la arquitectura popular española."

51 See Martín Rodríguez, *Arquitectura doméstica canaria*, 105.

52 Ibid.

53 Prat Puig, *El prebarroco en Cuba, una escuela criolla de arquitectura morisca*, 181.

54 Ibid.

13. House at 12 Tacón St. (1725), Old Havana
{JL}

14. Pedroso Palace (1760), 64 Cuba St., Old Havana {JL}

Around 1730, a new type of courtyard house called stately or store and house was introduced in Havana. This type of house originated in the Renaissance and continued throughout the Baroque period. It was organized on two levels, the lower one with a mezzanine for offices (Fig. 14). The upper floor, as in the earlier types, contained the private rooms. Situated along the plazas, the stately house featured a loggia on the second floor with a corresponding wooden balcony, and on the ground floor, a portico with arches and columns along the entire front of the house (Fig. 15). This palace-like mansion was organized around a courtyard surrounded by arcaded galleries on columns on all four sides. Most of the owners were shareholders of the Royal Trading Company of Havana, some of whom acquired titles of nobility for services rendered and large financial contributions to the Crown.

The upper floor of the two-story houses followed the model of the one-story ones.[55] While the wooden balcony was the main element of the former, wooden

[55] In Havana, in addition to this parlor/bedroom model, a different floor plan became prominent, the description of which is not relevant for the purposes of this text and is therefore not discussed here. For information on this topic, see Alicia García Santana, *Urbanismo y arquitectura de La Habana Vieja, siglos XVI al XVIII*.

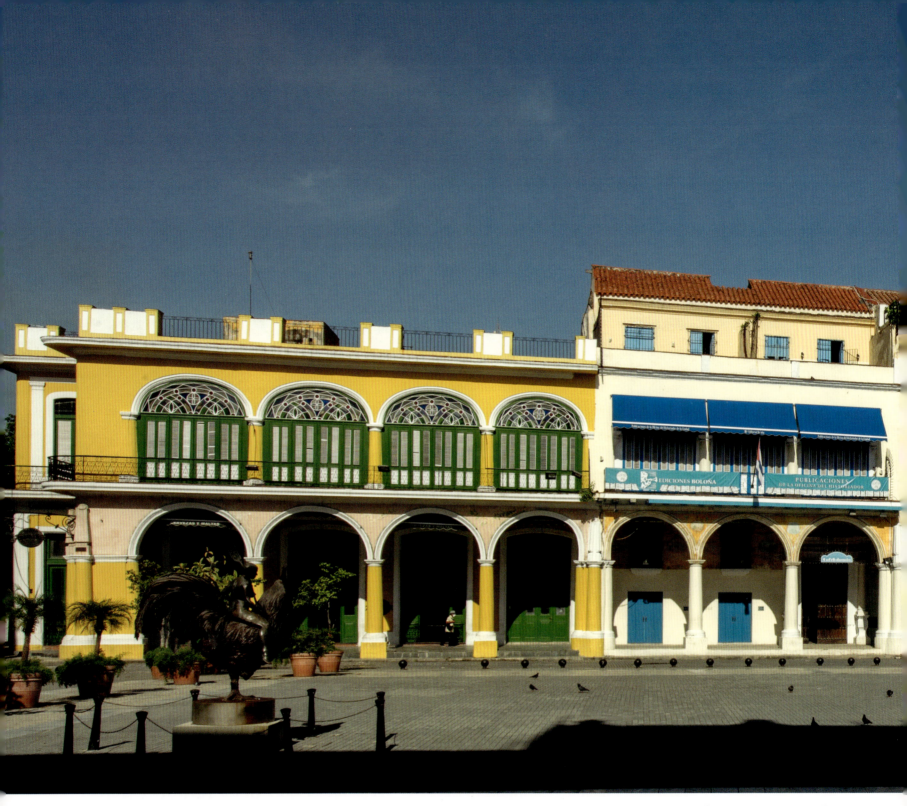

bars on windows—Spanish-American version of the iron bars—were the main feature of the latter, although wooden bars appeared at the end of the seventeenth century in places where there were no forges for iron. Before that, window openings were closed with stone or wooden grilles. For stone grilles, we have only documentary references, and for wooden grilles, we have only a few drawings. In Havana, there are no surviving examples of wooden bars that still characterize the façades of houses in Cuba's founding cities in the interior of the Island: Trinidad (Fig. 16), Camagüey, Sancti Spíritus, Remedios[56] and Santiago de Cuba. Inside, they

15. Mansions with loggias on the upper floors and porches on the first floor on San Ignacio Street, mid-18th century, Plaza Vieja, Old Havana {JL}

[56] Remedios is not a foundational town, but it was established in the first half of the sixteenth century.

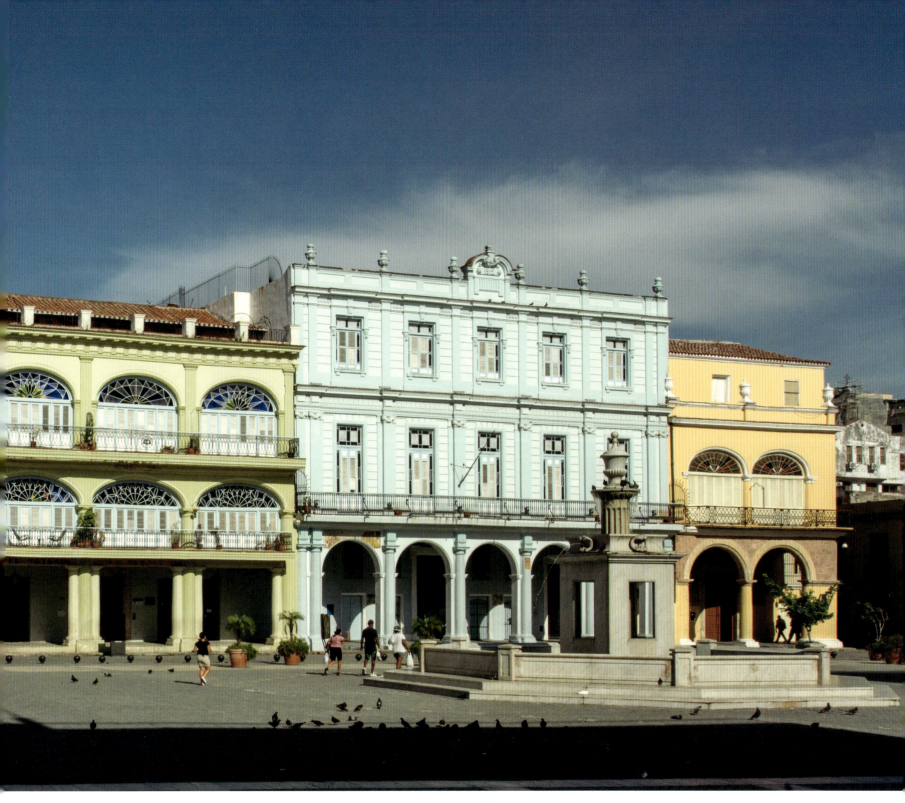

sometimes had seats or windowsills to look out onto the street.

The typical tiled eaves or brick-on-edge eaves courses, of ancient origin, ran along the top of the walls of the façades and were connected to the shingled wooden roofs. Older houses with flat roofs did not have eaves—the wall rose smoothly to the top, as can be seen in some old houses in Las Palmas de Gran Canaria, the first colonial city founded by Spain. The front door was positioned in the middle or to one side of the façade and led to the front rooms, which were arranged in the traditional manner of living room and bedroom, followed by a lean-to section (Fig. 17), which in some cases also appeared in the wings. In one-story Havana houses,

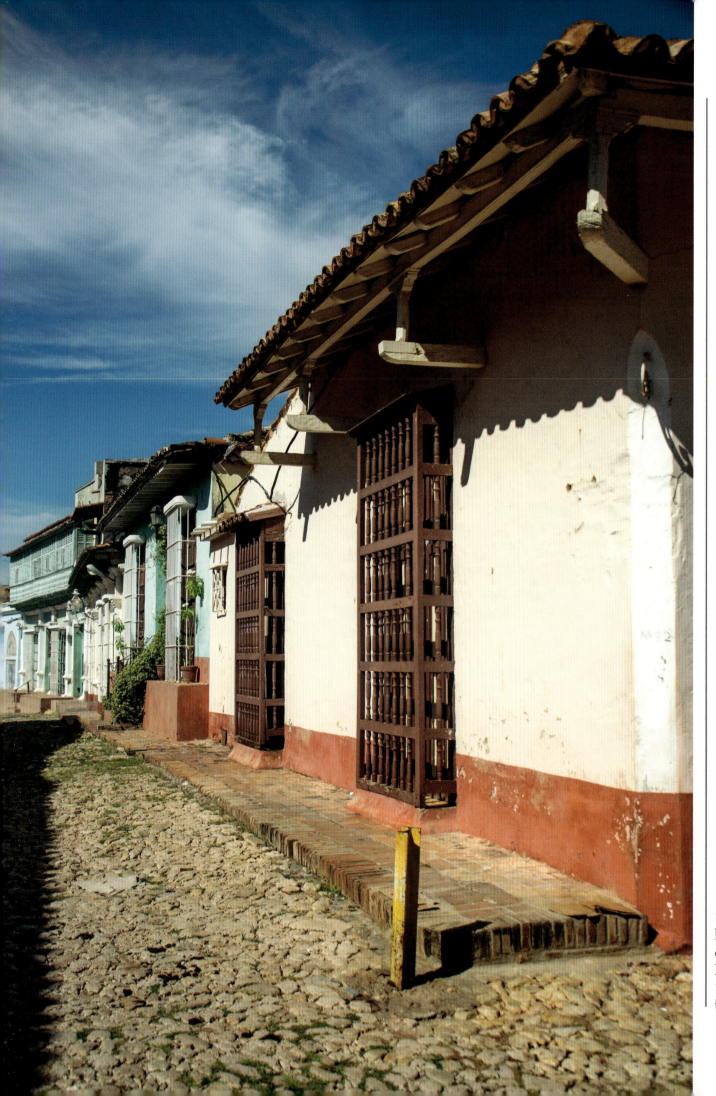

16. Wooden bars in the house on the corner of Amargura and Desengaño streets, 19th century, Trinidad {JL}

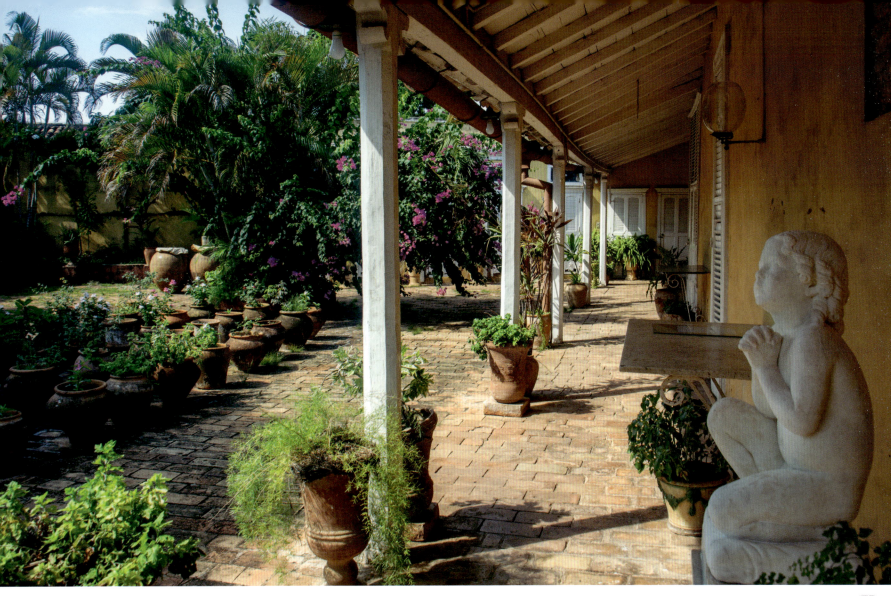

17. Gallery facing the courtyard of the Sanchez-Iznaga House, 18th/19th centuries, home to the Architecture Museum, Plaza Mayor, Trinidad {JL}

the courtyard was divided into two sections by a wall with arched openings or by a transverse bay—the front section was used as a drawing room, and the rear section for domestic services and slave quarters.

Stylistically, the eighteenth century gave the region's houses a baroque look with a distinct Andalusian accent. The repertoire includes the palace-like mansions of Havana, the impressive Mexican palaces, the portals in Coro, Venezuela, or its Curazao-style pediments; the very peculiar architecture with a "baroque feel" based on "classical" themes in Mompox, Colombia; the beautiful lobed arches of Camagüey, the ogee motifs of Trinidad—in short, an endless number of formal structures that characterize the region with a spectacular range of solutions. In the nineteenth century, the formal architectural repertoire was modernized under the influence of neo-classicism, which came from the military engineers who operated in Cuba and Puerto Rico, establishing an academic architectural and urban planning, but also by an influence coming from the United States, which in turn was permeated by the various cultural events in a definitely multicultural region.

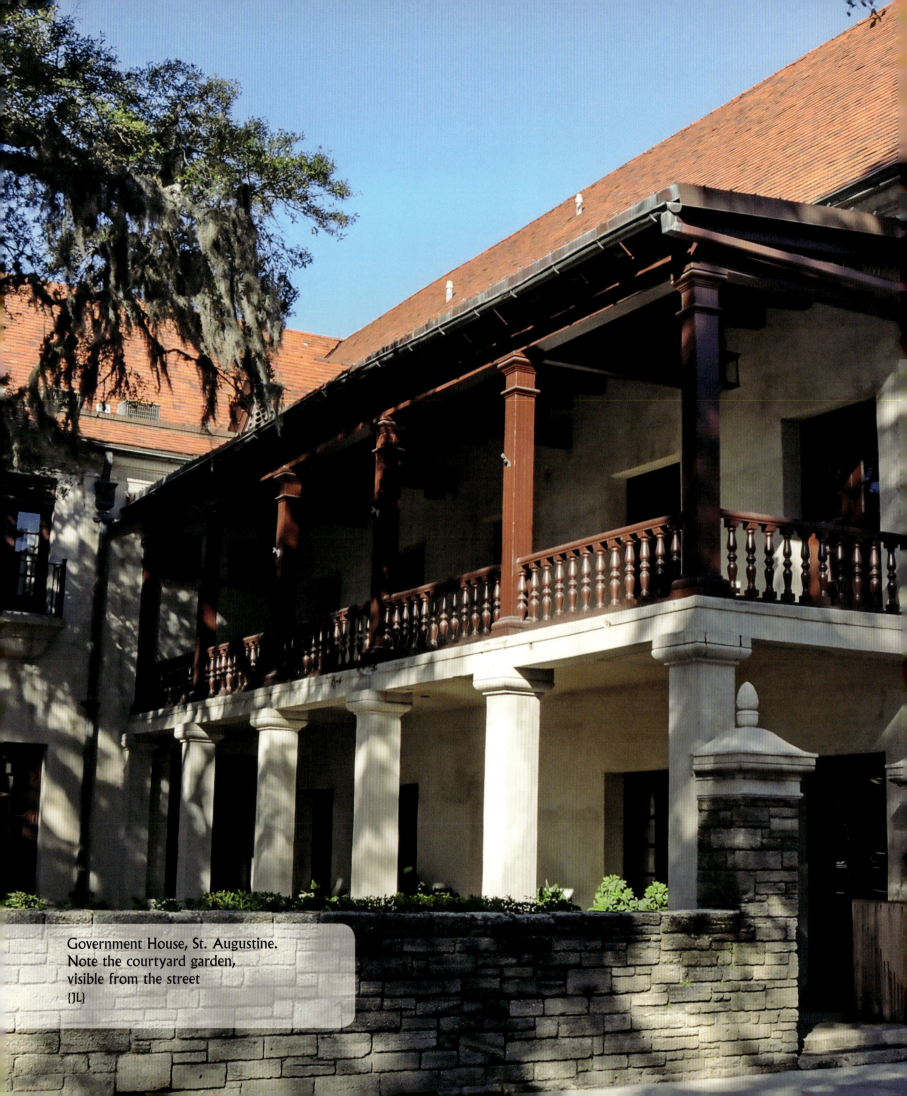

Government House, St. Augustine. Note the courtyard garden, visible from the street {JL}

ST. AUGUSTINE, FLORIDA: AN ENCOUNTER BETWEEN SPANISH AND ENGLISH INFLUENCES

St. Augustine, Florida, the first permanent settlement of the United States of America, is also the starting point of the cultural *mestizaje*, or mixing, between the Spanish and English legacies, a relationship that permanently marked its urban and architectural expressions. As we have seen, St. Augustine remained in Spanish hands from 1565 to 1763, when it fell under British control, until 1783, when it once again returned to the Spanish. In 1821, it was definitively incorporated into the United States. It is a beautiful city where a "new" type of house was born, the result of the blending, reconciliation, juxtaposition or fusion of the building traditions of the Spanish and the English, long at odds with each other, but forever united in the historic homes of St. Augustine.

Very little remains of the long First Spanish Period, despite the Spaniards' ambitions to build a great fortified city, as evidenced by the concessions granted for this purpose to the Adelantado Pedro Menéndez de Avilés, who "brought 500 settlers, including 100 soldiers and an equal number of sailors; 300 builders, artisans and laborers (200 of whom were required to get married); 4 Jesuits and 10 to 12 friars from other religious orders; and finally 500 slaves."[57] St. Augustine endured relocations, harassment by Indian tribes, attacks by Spain's enemy nations, floods, fires, famines and epidemics. The amazing thing is that, despite countless misfortunes, the permanent location of the city, founded in 1572 on the west bank of the Matanzas River, managed to survive[58] as a *presidio*, or military outpost, for the defense of the territory and where officers and soldiers were stationed.

The most significant Spanish influence during the First Period was St. Augustine's layout. The prevailing urban layout in Spanish America was the so-called grid plan, organized according to a regular pattern with an open space in the center, like a square, around which the church and the town hall were situated. The oldest street plans of St. Augustine reveal that, at the beginning, the site was simply a fortress protected by a palisade, with the parish church nearby and the Franciscan monastery a little further south. Destroyed by Francis Drake in 1586, the map of the attack shows a camp arranged in a grid and located to the south of the fort, in the manner of the Romans in their time, which occupied the area now limited by King Street and the bay to the east, Bridge Street to the south and St. George Street to the west.

[57] François-Auguste de Montequin, "El proceso de urbanización en San Agustín de La Florida, 1565-1821: Arquitectura civil y militar," 586.

[58] "After St Augustine's first nine months, the colonists moved the city across the Matanzas River estuary to the barrier island today called Anastasia Island. Six or seven years later, 1572 or 1573, the town relocated back to the mainland and began to resemble a Spanish city." See Susan Richbourg Parker, "St. Augustine in the Seventeenth-Century: Capital of La Florida," 555.

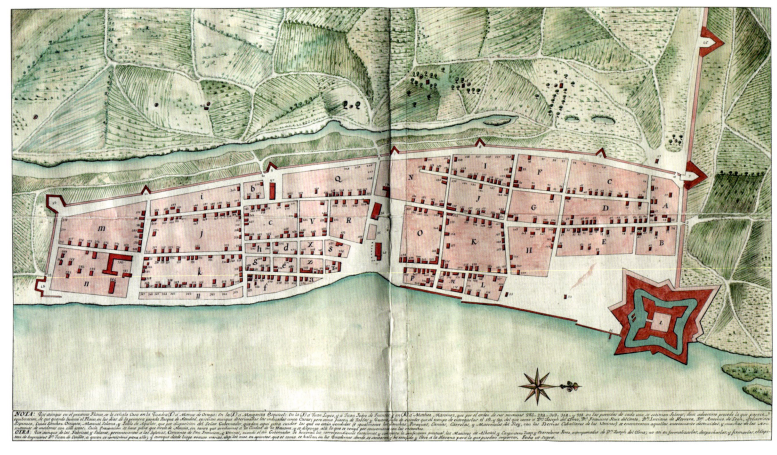

After a catastrophic flood at the end of the sixteenth century, Gonzalo Méndez de Canço, who was in charge of the government of St. Augustine from 1596 to 1603, rearranged the streets as much as possible and added six blocks, which gave rise to the original nucleus of the historic urban center. On the north side of the site, in a place that was significant because the parish church and the governor's house were built there, Méndez de Canço had both buildings rebuilt and added other civil and military buildings, such as the market, the guardhouse and a wharf.[59] The result was not typical of the Spanish world, with an open space attached to the side of an irregularly designed site. In the first half of the eighteenth century the streets were laid out, the area where the church was built was gradually transformed into a square and development began in the space between the square and the then recently built Castillo de San Marcos (1672-1687), located a little to the north of the original forts. The square became the focal point, and the settlement took on the urban layout that had become widespread in Spanish America (Fig. 18).

But the layout of St. Augustine is not strictly "Spanish." We are in the presence of a singular urban design made up of a network of streets that intersect each other almost orthogonally, forming blocks that are distantly rectangular in the original area of the Spanish campsite, while the expansion streets are very large and almost square as a result of the twenty years of British

[59] See De Montequin, "El proceso de urbanización en San Agustín, 595.

18. Map of the city of St. Augustine: "Plano de la Fuerza Baluartes y línea de la plaza de Sn. Agustín de la Florida: con su parroquial mayor, convento e iglesia de San Francisco, casas y solares de los vecinos. San Agustín de la Florida y Henero 22 de 1764," Juan Joseph Eligio de la Puente. St. Augustine Historical Society

occupation. With the exception of the original area, which has the largest urban concentration, the buildings do not share common walls and many are not located close to the street line, but are rather set back from the street. In some cases, what separates the houses from each other are low rammed earth walls facing the street in the front of the houses, delimiting a garden area; or they are separated from the streets along the front, side or back by low fences that delimit a paved or green space. From the point of view of Spanish cultural traditions, it is unthinkable that the low walls and fences would allow a glimpse of the "courtyard." But from an English perspective, the opposite is true, since it was quite astonishing that the parlors were visible from the street, as the journalist William Cullen Bryant reported during a visit to Cuba in 1849:

> In walking through the streets of the towns in Cuba, I have been entertained by the glimpses I had through the ample windows, of what was going on in the parlors. Sometimes a curtain hanging before them allowed me only a sight of the small hands which clasped the bars of the grate.... At other times, the whole room was seen, with its furniture, and its female forms sitting in languid postures, courting the breeze as it entered from without. In the evening, as I passed along the narrow sidewalk of the narrow streets, I have been startled at finding myself almost in the midst of a merry party gathered about the window of a brilliantly lighted room, and chattering the soft Spanish of the island in voices that sounded strangely near to me.[60]

The aforementioned urban peculiarities are related to the process of the configuration of the town and its houses. In 1588 Pedro Menéndez Márquez stated that the buildings were "of wood and mud, whitewashed both inside and out, and with their roofs made of lime,"[61] which suggests the type of earthen construction that in Cuba we call *embarrado* and that, as explained above, was a system of wooden posts with mud fillings in between, widespread in the Americas from north to south.[62] In St. Augustine it is called wattle and daub: "upright posts are placed in the ground, smaller branches are woven through them horizontally, and then earth, clay or straw ... is packed into the structure to form a wall."[63] The roofs were of the type called *terrado* in Cuba, consisting of flat structures made up of poles arranged from wall to wall, covered with layers of rammed earth and binded with lime. Roofs of this type were predominant in Havana in the second half of the sixteenth century, but they were

[60] "Cartas de un viajero. Carta XLVI. La Habana." Bryant (1794-1878) was a prominent journalist for the *New York Evening Post*, where he served as editor-in-chief from 1828 until his death. He has been called the founder of American poetry. He had a close relationship with Cuba, a country he visited in 1849 and 1872.

[61] Cited by De Montequin in "El proceso de urbanización en San Agustín", quoted in Pedro Menéndez Márquez, "Descripción de la Florida," January 15, 1588, Archivo General de Indias, I. G. 751, Ramo 15.

[62] Graziano Gasparini and Luise Margolies, *Arquitectura popular de Venezuela*.

[63] "Message from Sharyn Thompson to Soledad Pagliuca." From the author's archives.

replaced by wooden frames covered with tiles because the *terrado* roofs were vulnerable to rain. Earthen roofs similar to those mentioned in documents from Havana and St. Augustine have survived in the hot lands of the Coro desert and in the Paraguaná Peninsula, in Venezuela.

Early dwellings were also made of wood. In 1595, Friar Andrés de San Miguel commented: "All the walls of the houses are wood and the roofs are palm, the principal ones boarded.... The Spanish make the walls of their houses with cypress wood."[64] Presumably, these dwellings were similar to the Cuban *bohíos*. They also coexisted with more solid structures, such as Joseph Benedit Horruytiner's house, described in 1712 as follows: "Inventory is made of the houses of his residence with the site to which they belong, all enclosed by a wooden fence. Their bedroom and parlor have a stone structure on the north side, and palm thatch on the east and west (the latter with a palm thatch kitchen)."[65] This was a courtyard house, with a principal area of solid walls made of tabby, "a type of concrete made by burning oyster shells to create lime, then mixing it with water, sand, ash and broken oyster shells."[66] According to the botanist John Bartram: "Most of the common Spanish houses were built of oyster shells and mortar."[67] Or of coquina "a shell stone soft enough to be quarried with pick and axe, but which hardened when exposed to the air over a period of time"[68] (Fig. 19). Tabby or *tapia* is a construction technique of ancestral origin, widely used in medieval Spain and in early Spanish America, where very ancient walls are still standing, for example, in Havana's 17th-century Santa Clara Convent. These walls, like the ones made of stone or coquina, required plaster or stucco as a finishing material and "was put over the exterior tabby walls because they were very porous and would absorb water. Apparently the stucco was also used for aesthetic purposes, it covered the marks left by the forms when the layers of tabby were poured."[69]

Archaeological excavations led by Stanley Bond revealed structures with the front bay arranged in parlor and bedroom, according to the Spanish layout, with a wing on one or both sides of a central courtyard.[70] Despite subsequent transformations, many houses still bear traces of such living spaces. Bond and other authors argue that they lacked front doors on the main façade and consider that access was through a side entrance leading

[64] Cited by Parker, "St. Augustine in the Seventeenth-Century."

[65] Cited by John W. Griffin and Albert Manucy, "The Development of Housing in St. Augustine to 1783."

[66] See https://www.libertaddigital.com/cultura/historia/2020-04-27/localizan-un-misterioso-fuerte-espanol-del-siglo-xvi-hogar-de-las-primeras-misiones-jesuitas-1276656592/

[67] Cited by Albert Manucy, *The Houses of St. Augustine, 1565-1821*, 33.

[68] Jean Parker Waterbury, "The Castillo Years 1668-1763," 57-89.

[69] "Message from Sharyn Thompson to Soledad Pagliuca." From the author's archives.

[70] Stanley C. Bond, Jr., "Tradition and Change in First Spanish Period (1565-1763) St. Augustine Architecture: A Search for Colonial Identity." Ph.D. dissertation, 1995.

19. Coquina walls, Magnolia St., St. Augustine, Florida {JL}

into the courtyard, which is inconsistent with Spanish architectural traditions and contradicted by contemporaneous accounts. In 1766 Bartram stated that, "the grand houses, except taverns, had street doors, and those led mostly through a common passage to the court and kitchens."[71] Side entrances were alien to the Spanish courtyard house because of the common wall they shared[72] and the narrow side facing the street.

Spanish houses had the larger side facing the street, unlike English houses, which often had the shorter side facing the street and, therefore, the entrance was on the side of houses that were detached from each other, as can be seen in many U.S. cities. This is also what dictated different roofing solutions: courtyard houses with the larger side facing the street were covered with roofs with slopes that drained to the front and back, to the street and to the courtyard; compact houses with the shorter side facing the street were covered with roofs with slopes on both

[71] Cited by Manucy, *The Houses of St. Augustine*, 31. The emphasis is ours.

[72] By then, most of the houses were built separately on their respective lots, as can be seen in drawings from the mid-eighteenth century, but, conceptually, the Spanish house had its entrance through the main façade.

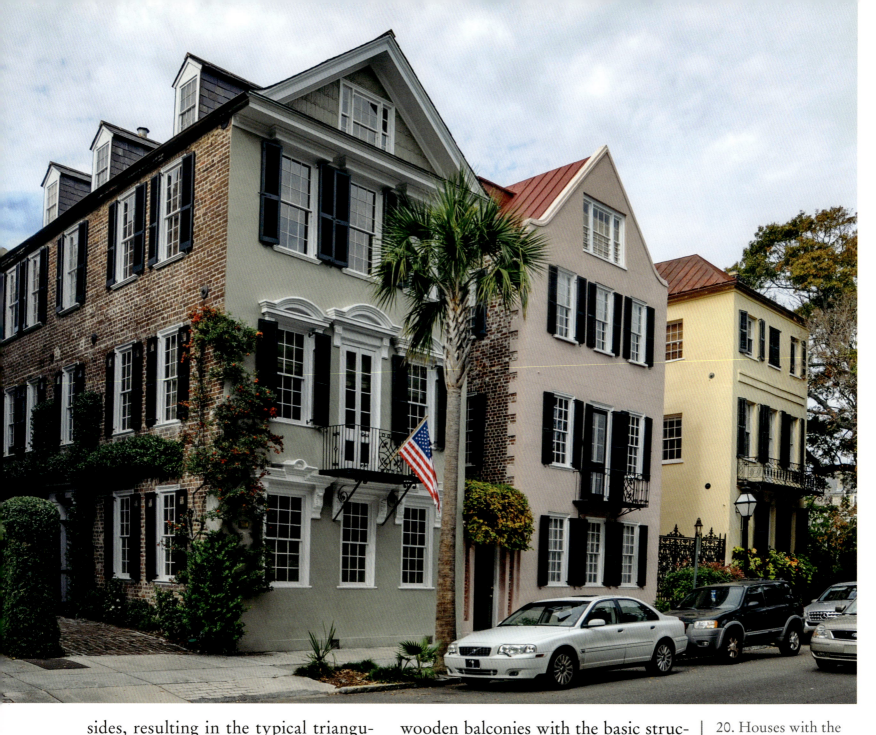

sides, resulting in the typical triangular roof that characterized most English and northern European houses (Fig. 20).

According to Bartram, Spanish houses did not have pitched roofs, but, rather, flat roofs with parapets, they had wooden grilles on the façades, and two-story houses featured "covered balconies, supported by double beams fixed in the wall at convenient intervals;"[73] that is,

[73] Cited by Manucy, *The Houses of St. Augustine*, 31.

wooden balconies with the basic structure of the balconies common in the Spanish colonial context, from the Canary Islands to Spanish America.

If we compare the houses depicted in a drawing of St. Augustine, East Florida—in particular the one identified with number 19—with the houses, for example, on Tacón Street in Havana, we can see the similar layout of both, despite the obvious loss of the wooden balcony (Fig. 21). A side access opening, in addition to the main one located

20. Houses with the narrow side facing the street, side entrance and open spaces in between, 18th century, Charleston, South Carolina {JL}

21. House numbered 19 in the engraving "View of St. Augustine, East Florida. Drawn and Engraved on the Spot by John S. Horton." Compare it to the one at 12 Tacón Street in Old Havana. St. Augustine Historical Society

in the center, suggests the existence of annexes/stores. However, the chimney and the shape of the roofs are indicative of the influence of English building traditions.

They were houses like the ones described in appraisals dated 1763. Of note in the Governor's house is the Spanish style portal: "the large door … in Doric style architecture,"[74] the "16 pillars," the "capitals," "the main stairway," the wooden frame covered with *tejamaní* (wood shingles), the wooden roofs of the dining room and galleries, the banisters of the stairs, the thresholds of the openings, the ceilings of various rooms like the kitchen and pantries, the boards of the main door, the wooden elements of the stables, the observation tower, the stove and the auxiliary doors of the patio, a rear patio and the fences. It was organized around a courtyard with galleries on its sides and the corresponding rear patio and orchard with flower and

[74] "Appraisal of the House of the Governor", 1763, in Charles W. Arnade, "The Architecture of Spanish St. Augustine."

fruit trees, such as sweet and sour oranges, lemons, peaches, pomegranates, fig trees, grapefruit trees and a grapevine.[75]

The appraisals of private houses provide us with information on two-story houses made of masonry or stone, with mezzanines, balconies covered with shed roofs, stores on the lower floors, flat roofs covered with suspended ceilings and frameworks covered with shingles, chimneys and glass in windows, the latter elements representing novelties in comparison with the Spanish houses. The kitchen had an oven. Also described are the gutters situated on the edges of the roofs for collecting water in cisterns, as is also common in Spanish-American houses.[76] The front distribution of these houses consisted of parlor and bedrooms: "5 doors (*puertas*) and 3 windows (*ventanas*) in the drawing room . . . (*sala*) and the bedroom (*aposento*)," as it commonly appeared in Havana houses and which corresponded to the exterior and intermediate openings. The rear openings are also detailed: "3 doors (*puertas*) and 2 windows (*ventanas*)."[77] From these appraisals we also know that the dining rooms were located in the galleries: "the lumber (*maderas*) of the dining rooms (*comedores*) or the corridor (*pasadizo*)."[78] In the house that belonged to Don Juan Blanco, another dining room is mentioned in the space below the mezzanine. This suggests that it was used as an annex for tenants.[79] As for the house that belonged to Salvador de Puertas, there is a mention of a corner store, which is typical of Havana and Spanish-American houses.[80]

When it was handed over to the English, the city, comprising 342 houses, 124 of stone, 140 of rammed earth and 78 of wood,[81] underwent an urban and architectural transformation:

> Augustine, now, is in a very ruinous condition to what it was when the Spaniards lived there. The soldiers have pulled down above half the town, for the sake of the timber, to burn. Most of the best houses stand yet, several of which are much altered by the English, who drive the chimney through the tops of the house roofs, and the sun begins to shine through glass, where before its light was admitted between the banisters.[82]

But from the 1770s onwards, after a period of inactivity that followed the

[75] "Appraisal of the house of Don Antonio Rodriguez and Don Juan de Salas, located on Main Street" (Charles St.) and "Appraisal of the house of Don Juan Blanco, located on Governor Street" (St. George St.), 1763, in Arnade, "The Architecture of Spanish St. Augustine."

[76] Ibid.

[77] "Appraisal of the house of Don Juan Blanco, located on Governor Street" (St. George St.), 1763, in Arnade, "The Architecture of Spanish St. Augustine."

[78] Ibid.

[79] Ibid.

[80] "Appraisal of the high house of Salvador de Puertas, located on the corner of Marina," 1763 (Marina St.), in Arnade, "The Architecture of Spanish St. Augustine."

[81] Manucy, *The Houses of St. Augustine*, 33.

[82] Griffin and Manucy, "The Development of Housing."

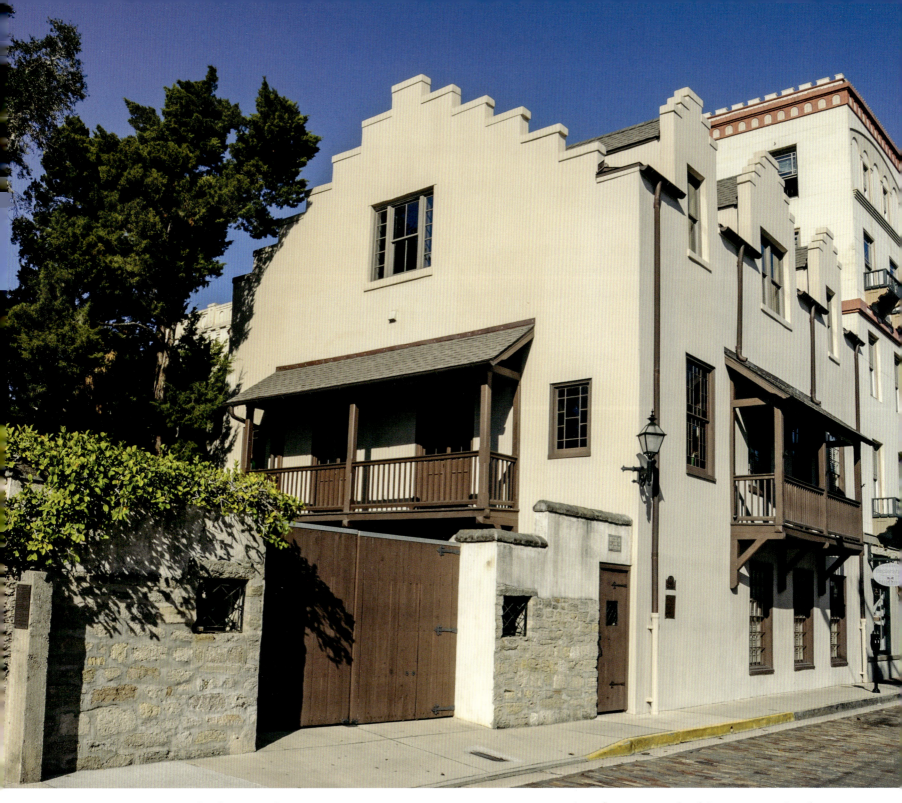

22. Horruytiner House (ca. 1788), 214 Saint George St., St. Augustine, Florida {JL}

change from one sovereignty to another, the city began to take off.[83] The houses featured new roofing solutions. The ceilings were covered with wooden frames hidden from view by suspended ceilings. Bar grates were replaced by glass sash windows. Wood took over the floors, and chimneys raised their smoke vents above the roofs. It is very likely that this was the time when separate kitchens in the second patios became widespread. The first gardens appeared, along with their respective side entrances: "The English have houses with more windows, especially on the street side.... Almost every house had its little garden, of which

[83] See Daniel L. Schafer, "...not so Gay a Town in America as this..." 1763-1784.

splendid lemon and orange trees are not the least ornaments."[84]

Most of the houses had a Spanish layout on the first floor while the upper floors were laid out in the English style (FIG. 22). In the British period, we must mention the arcaded and/or wooden galleries leading to the courtyards. The upper floors, often made of wood and usually built in this period, were accessed by stairs located in these first-floor galleries. Wooden balconies were built and/or maintained on the front or on the shorter sides, and were visible from the street. These houses are of the type that Albert Manucy calls the St. Augustine Plan, in which he recognizes "two forms. The more popular one has a loggia … centered on the side. The other version substitutes a sheltered porch for the loggia. In both cases, the main entrance was through either the loggia or porch, which opened onto the yard."[85] Manucy believes that the two dozen or so of the best houses of the British period were built in this manner.[86]

With the return of the Spaniards in 1783, this type of house persisted (FIGS. 23 and 24), as the English did not leave and the Spaniards adopted it, while new waves of immigrants contributed to a decidedly multiethnic and multicultural population made up of "Negro, Britisher, Minorcan, Greek, Italian, Spaniard, Canary Islander and *Floridano*."[87] In the last quarter of the eighteenth century, Cuba's ties with both Floridas were very strong and Havana was a well-known and close reference point. During the prosperous Second Spanish Period, a grand house with a distinct identity emerged. This type of house can be associated with the Havana store and house model, although it was certainly stripped of the aristocratic pretensions that characterized the Cuban model. This type of dwelling is termed by Manucy as the "Wing Plan" and it is characterized by "a main structure of two or more rooms, plus a substantial wing or two which makes the plan an L, U, or H."[88]

One architectural jewel of this model is the Ximenez-Fatio House. "A prominent St. Augustine merchant, Andres Ximenez, built and lived in a substantial stone house on the street of the Royal Hospital in 1798. His new home, which was somewhat representative of the era, clearly showed the architectural influences of both Spanish and English traditions. In addition to providing domestic shelter, this building's ground floor served as a well-stocked general store."[89] The new type of store and house-courtyard garden "within sight from the street" is a hybrid house of great beauty (FIGS. 25 and 26).

The galleries on the sides of the courtyard represent one of the key features of the houses of Spanish origin while the garden is a substantial component of the English house. The fusion of the Spanish patio or courtyard with the English garden came about in St. Augustine, Florida, in the late eighteenth

[84] Cited by Manucy, *The Houses of St. Augustine*, 40.

[85] Ibid, 55.

[86] Ibid.

[87] Ibid, 43.

[88] Ibid, 58.

[89] Robert W. Harper III and Rebecca Yerkes Rogers, *Ximenez-Fatio House*, 2.

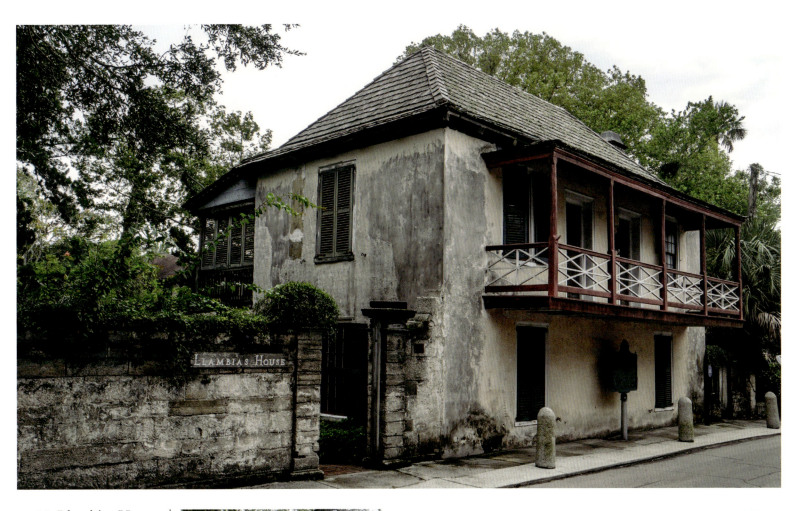

23. Llambias House, 31 Saint Francis St., second half of the 18th century/first third of the 19th century, St. Augustine, Florida {JL}

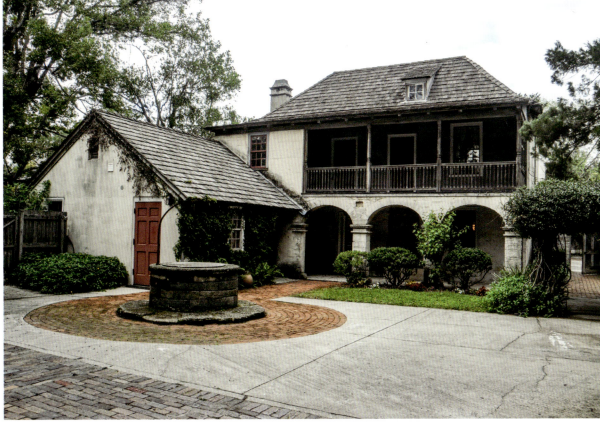

24. Gallery and courtyard, Llambias House {JL}

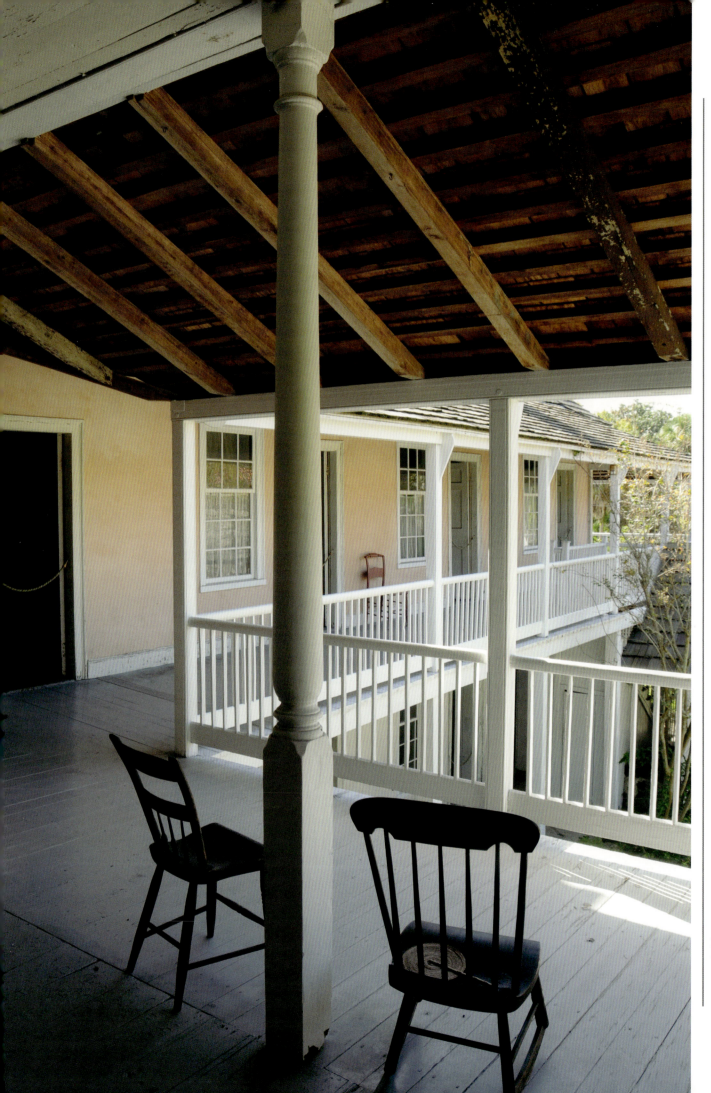

25. Upstairs gallery, Ximenez-Fatio House (1798), St. Augustine, Florida
{JL}

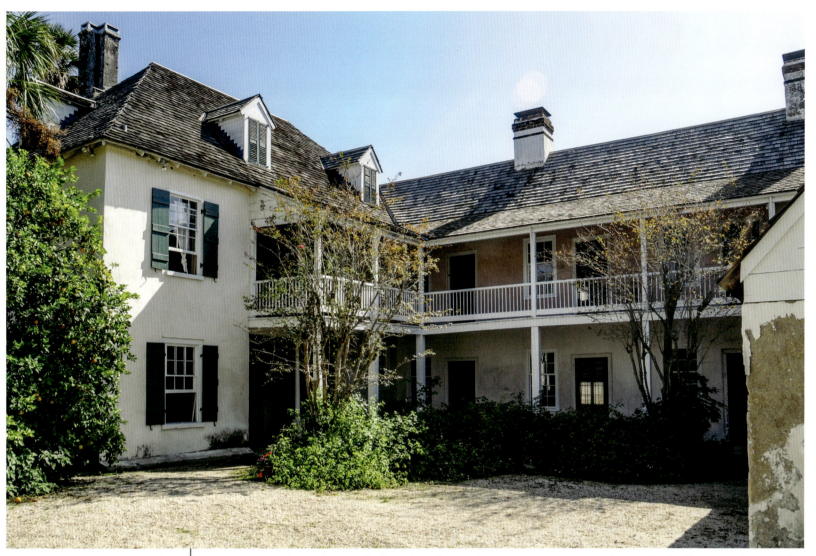

26. Courtyard garden, Ximenez-Fatio House {JL}

century and took its definitive form in the following century. From that moment on the courtyard garden became part of the typological repertoire of architecture in the United States. In the mid-nineteenth century, William Cullen Bryant described the unique city of St. Augustine, Florida, as follows:

> The old houses, built of a kind of stone which is seemingly a pure concretion of small shells, overhang the streets with their wooden balconies, and the gardens between the houses are fenced on the side of the street with high walls of stone. Peeping over these walls you see branches of the pomegranate and of the orange tree, now fragrant with flowers, and, rising yet higher, the leaning boughs of the fig, with its broad luxuriant leaves.[90]

[90] Cited by Manucy in *The Houses of St. Augustine*, 47.

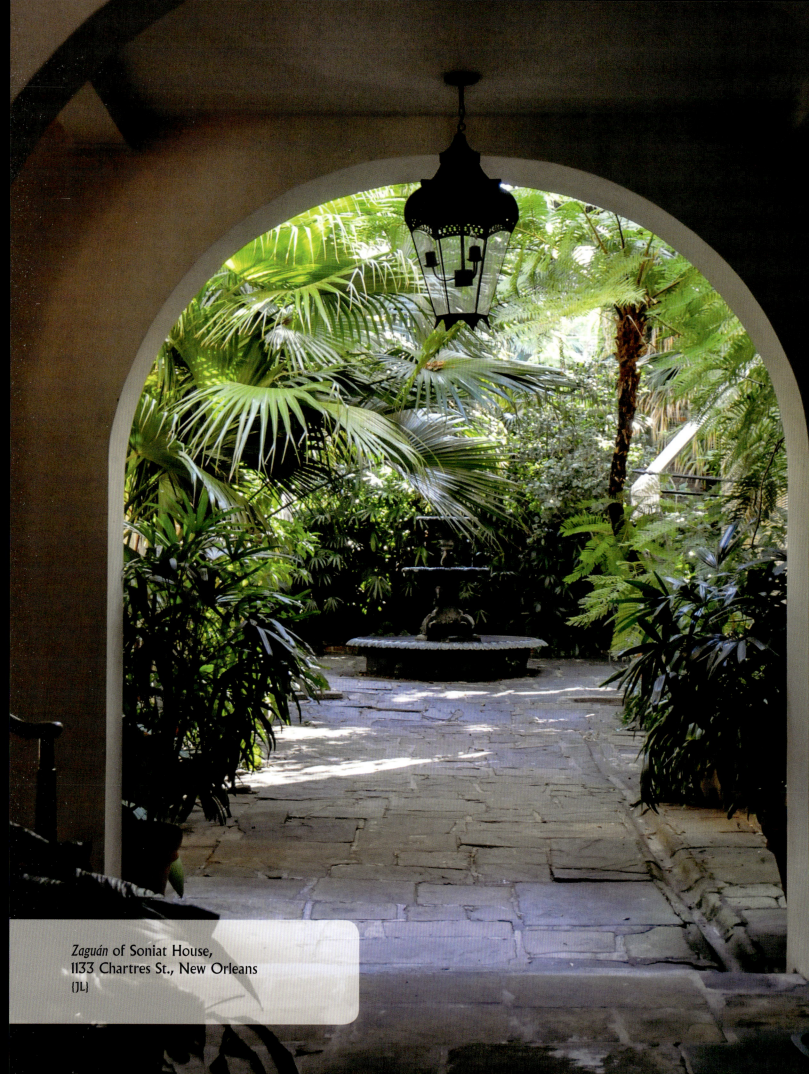

Zaguán of Soniat House, 1133 Chartres St., New Orleans
{JL}

NEW ORLEANS: WHERE FRENCH AND SPANISH MEET

The city of New Orleans is one of the first examples in the Americas of French town planning using a grid pattern,[91] the way the Spanish laid out most of the cities of Spanish America beginning in the third decade of the sixteenth century. It is believed that it was in French Saint-Domingue where the French adopted Spanish urbanism based on "practically a single model, since these were always grid towns, with the only difference being the location of the town square, which was either central or off-center."[92] In 1698, Saint-Louis was founded following a grid plan with the square in the center. It was the first town to be established by the French according to this model, which was repeated in Léogâne (1710), in Fort Dauphin (1727-1728) and in Les Cayes (1726), in the latter case with the square along the seafront, as the military engineer Adrien de Pauger (?-1726) had already done in New Orleans in 1723 (Fig. 27).

French cities, however, integrated their buildings into the natural environment, a concept foreign to early Spanish urban planning in the West Indies. The original plans for New Orleans did not place the houses at the edge of the street line, but set them back a bit, with gardens in front, and required that they be bordered by a palisade. The original approach was eventually modified, but it was a new way of designing cities and houses. During the French rule, green spaces and specially designed gardens were of paramount importance.

Jay Edwards considers that early houses "were constructed of *poteaux en terre*, or posts in the ground. The spaces between the posts were filled with *bousillage* (mud and moss laid on a lattice of sticks) and then covered with vertical or horizontal boards. The roofs were hipped and covered with bark. Chimneys were of mud laid over a latticework of sticks."[93] This construction system is derived from European medieval trusses, which in turn are indebted to early medieval timber architecture. The manner in which they appeared in Louisiana is related to the building traditions of French Normandy, from where they may have spread to England: "In Normandy, for example, vertical, closely spaced rooms predominated, contrasting with the shape of the houses, which were generally long and low. In some places, inclined struts reinforced this framework."[94] Bricks in different geometric patterns formed the walls, which were delimited by posts, although there were

[91] French American cities did not follow a single urban typology, as Spanish cities did, but rather offered different layouts depending on the region. See *Les villes françaises du Nouveau Monde. Des premiers fondateurs aux ingénieurs du roi (XVIᵉ–XVIIIᵉ siècles)*, 108-119.

[92] Ibid.

[93] Jay Edwards, *An Architectural History of the Property at 417-419 Decatur Street, in New Orleans*, 5.

[94] Georges Doyon and Robert Hubrecht, *L'architecture rurale et bourgeoise en France*, 210.

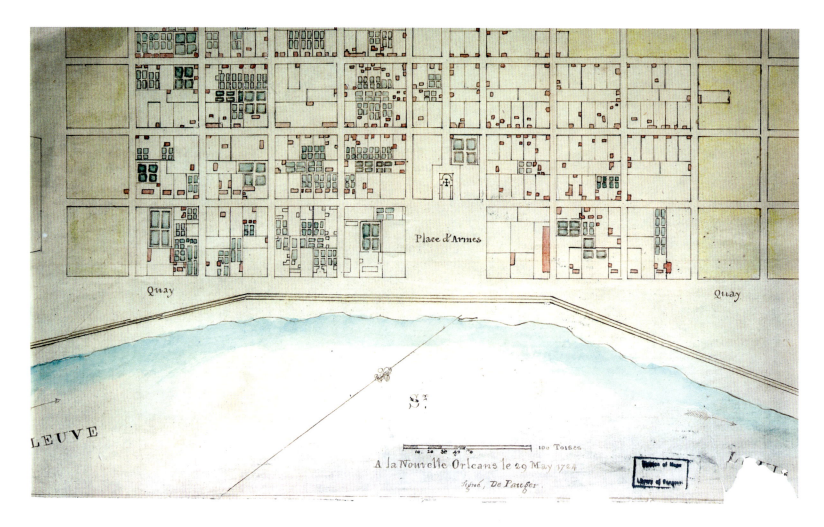

also examples of rammed earth and masonry walls (Fig. 28).[95]

By the mid-eighteenth century, French dwellings had cemented their characteristics:

> A typical house was laid out around a salle-et-chambre core, with the salle being near-square and the chambre, more narrow. Other rooms might be added in line, and, in addition, shed rooms called allonges were often attached to one or both ends of a house. Vernacular buildings were inevitably one room deep....
>
> Both windows and doors were covered with 3-batten wooden shutters, hung on iron strap hinges.... Glass was imported after Ca. 1728, so casement windows appeared early. In some cases, oiled paper or cloth were used in the place of glass.... Roofs were covered with *merrains*—split planks about ten feet long—or with wooden shingles (*bardeaux*). Roofs were generally ... broken pitch roofs—steep in the interior and low over the gallery.

27. "Plan de la Ville de la Nouvelle Orléans. Ou est marquée la levée de terre qui la garantit de l'inondation et l'augmentation des maisons faites depuis le 1.er septembre 1723. Signed by De Pauger, « A la Nouvelle Orleans le 29.e may 1724" Library of Congress

[95] Charles E. Peterson recognizes several construction systems in the houses of St. Louis, Missouri, which he calls stone masonry, palisades construction, frame construction, and horizontal logs. See Charles E. Peterson, *Colonial St. Louis. Building a Creole Capital*, 32-47.

28. Gabriel Peyroux House (1780), 901-07 Burgundy St., New Orleans {JL}

Brick chimneys were set inside the walls of the house....

Full-length or encircling galleries were added, as they had been previously to houses in the West Indies....

The second feature associated with Creole domestic architecture is the use of cabinet rooms and loggias. Cabinets were small rooms attached to the rear corners of the houses. They were placed under the gallery roofs and functioned as storage rooms and as spare bedrooms or servants' quarters. Generally, two cabinet rooms were employed, and an open space was left between them. These spaces—loggias—functioned as rear galleries in many of the houses. Indeed, in Louisiana Creole they were known as *ti galeries*, or petit galleries. Based on previous patterns already established in French West Indies, a system of expanding the Creole house by surrounding it by galleries, cabinet rooms and loggias developed.[96]

In 1784, the British military engineer Thomas Hutchins stated that at that time there were "between seven and eight hundred houses in this town, generally built of timber frames raised about eight

[96] Edwards, *An Architectural History*, 15-18.

29. Madame John's Legacy (1788), 632 Dumaine St., New Orleans {JL}

feet from the ground, with large galleries around them, and the cellars under the floors level with the ground. ... Most ... have gardens."[97] (FIG. 29).

But only a few of the urban structures built in the eighteenth century survived due to the destruction caused by two devastating fires that occurred in 1788 and 1794. In order to prevent further fires, Francisco Luis Hector, Baron de Carondelet, Spanish governor of Louisiana from 1791 to 1797, enacted "Building Codes" in 1795 that would determine the appearance of the houses and the city. Regarding the former, it was stipulated that "the two floors of two rooms to be built shall be made of bricks or planks, and the spaces between the straight posts shall be filled with bricks,"[98] that is, placing bricks between the posts in the typical French manner mentioned above. It also stated: "All houses built of brick or planks must necessarily have their fronts facing the street, and no one shall be allowed to build them with their backs or sides facing the street, except for those persons whose lots have a front of less than 300 feet."[99] This rule introduced the Spanish way of placing houses in relation to the street, that is, with the larger side at

[97] Cited by José Miguel Morales Folguera, *Arquitectura y urbanismo hispanoamericano en Luisiana y Florida Occidental*, 53.

[98] Ibid.

[99] Ibid, 179.

the edge of the street. The city that has been handed down to us is therefore the one that was rebuilt according to mixed models, given that, far from disappearing during the Spanish rule, French features persisted, while Spanish features per se were introduced from that time onwards.

This type of house, which could well be called "*château* with galleries," with a rectangular floor plan in a horizontal direction, the main façade on the longer side and two or three rooms on the sides, had a timber roof that was different from the Spanish one, in which the frame was mounted on the perimeter walls and the gallery roof rose from the wall, and because it was not the continuation of the roof, it could be easily attached to an existing structure. The roof of French houses in Louisiana and surrounding geographic areas was a single unit that covered both the interior space and the gallery space, hence its typical shape in the form of a wide-brimmed, flat-topped witch's hat. For this reason, it was very difficult to add a porch to an existing structure because it would mean rebuilding the entire roof. The *château* with galleries spread throughout the interior of the territory connected to the Mississippi basin.[100] It is beyond the scope of our analysis to determine the direction in which this type spread: from south to north, or vice versa, or whether it was a simultaneous process in both directions, which would be the most logical, given that it is an epochal model adopted by the French-American community since the late seventeenth century.[101]

Interestingly, these dwellings bear little resemblance to French urban or rural dwellings (FIG. 30). The urban houses, "with a few folkloric and local exceptions... seem to reflect the architecture of monuments and palaces fashioned under the influence of Renaissance Humanism."[102] And the rural ones were very simple dwellings, usually made up of two spaces: a multifunctional parlor with an adjoining stable. This was a basic unit that could have rooms added to it and very often had a garden in front of it.[103] Neither of them had galleries, except for the porches for trade situated on the ground floor of the houses located in medieval squares, or the wooden roofs of staircases placed on the façades, rustic solutions in the manner of "covered galleries supported by posts and combined with staircases to access the main floor of masonry houses."[104] Those built in New France were also simple structures, without galleries, consisting of "two rooms of approximately equal size, separated by a stone bearing wall penetrated by two doors. ... Some houses ... had only a single multipurpose room on the ground floor—a survival of the *chambre* of medieval France—that was used for eating,

[100] On the early adoption of this type in Illinois, see Natalia Maree Belting, *Kaskaskia under the French Regime* and Charles E. Peterson, *Notes on Old Cahokia*.

[101] Excavations led by Gregory Waselkov at the original site of Mobile yielded "no evidence of true galleries, the distinctive wrap-around porches characteristic of later creole architecture, at this earliest stage of French settlement." See Gregory Waselkov, "French Colonial Archaeology at Old Mobile: An Introduction."

[102] Doyon and Hubrecht, *L'architecture rurale*, 3.

[103] Ibid, 60.

[104] Ibid, 207.

receiving guests, sleeping, and various domestic activities."[105] The point is that although no references to French models are acknowledged, "[a]rchitectural history texts generally credit the French for introducing the gallery to Colonial Louisiana,"[106] a statement that raises an intriguing question: When and where did the French who settled in the United States adopt the rectangular floor plan with cabinet rooms and galleries? Prominent scholars have considered that the answer to this question is complex.[107]

In our opinion, this is a very old process of cultural borrowing, which has obscured its recognition. In Saint-Domingue, at the end of the seventeenth century, the French appropriated the urban and architectural types of the Spanish as their own, given that both the grid layout and the galleries are unquestionable Spanish contributions.[108]

30. Place Royale, with Notre-Dame-des-Victoires Church, 18th century, Historic District of Old Québec City, Canada {JL}

[105] Harold Kalma, *A Concise History of Canadian Architecture*, 46-47.

[106] Philippe Oszuscik, "Passage of the Gallery and Other Caribbean Elements from the French and Spanish to the British in the United States."

[107] Jay Edwards, "The Complex Origins of the American Domestic Piazza-Veranda-Gallery."

[108] There is an extensive bibliography on Spanish urban planning and architecture. See Antonio

31. Palace of Viceroy Diego Columbus (1511-1514), Santo Domingo, Dominican Republic {Photo by Tomás García Santana}

In the Tropics, the gallery took on a new meaning because it offered excellent protection from the sun and rain, which is why it was adopted not only by the French, but also by the British and others who took advantage of its benefits.

The history of transmission is that of the cultural mix of the nations that converged in the area. At a very early date, from 1511 to 1514, a palace of Italian origin was built in Santo Domingo, Hispaniola, for the Spanish Viceroy, Diego Columbus (Fig. 31), similar to residences such as the Villa Chigi della Volte, near Siena, built around 1500 by Baldassarre Peruzzi.[109] The floor plan of the Viceroyal Palace is rectangular in the horizontal direction, with arched galleries on columns at the front and back, located between two lateral structures in the manner of the rooms known as cabinets. This layout was replicated in the houses of the first sugar plantations in the Americas, around the city of Santo Domingo—among others, the houses in the Engombe and Palavé sugar mills (Fig. 32).

Bonet Correa et al, *Bibliografía de arquitectura, ingeniería y urbanismo en España (1498-1880)*.

[109] Enrique Marco Dorta: *Arte en América y Filipinas*, 21.

The three-room layout of the first bay—a central room used as parlor and the side rooms as bedrooms—and the use of exterior galleries was a common arrangement in Spanish urban and rural areas, both in Cuba and in other islands later occupied by the British or the French. In 1689, the British described the houses in Spanish Town, Jamaica: "The buildings of the Spaniards on this island were usually one story high, having a porch, parlour, and at each end a room, with small ones behind for closets."[110] The houses in plantations had galleries on all four sides.[111] When Jamaica fell to the British in 1655, vernacular traditions did not die out. This is evident from a mid-eighteenth-century description of Spanish Town: "The houses of this town [St. Jago de la Vega] . . . [i]f I was to describe them truly, I could only say, the people live in the King's highway, with a cover over them to protect them a little from the sun and rain; . . . the piazzas . . . are the most useful part of their houses."[112]

32. Plantation home at the Engombe Sugar Mill, first quarter of the 16th century, Santo Domingo, Dominican Republic {Photo by Tomás García Santana}

[110] Jay Edwards, "The Evolution of Vernacular Architecture in the Western Caribbean."

[111] Ibid.

[112] Ibid. Edwards also discusses the use of galleries in British dwellings in the eastern colonies.

As for the French, it happened that the western part of Hispaniola was abandoned by the Spaniards in the seventeenth century and occupied by French pirates and buccaneers who had settled on the island of Tortuga. The French colony of Saint-Domingue was founded in 1681 and the "pirates and buccaneers" became planters who adopted the Spanish model for the sugar mill houses. Philippe Oszuscik believes that, from then on,

> there was a very effective way that interaction took place. The elements that came together in the Creole cottage most likely evolved on the small islands off Haiti and on Haiti Island in international communities of buccaneers. Buccaneers came from virtually all the European nations that had colonies in the Caribbean as well as from descendants of Arawaks, Caribs and Africans. At the time of the cottage's development in Haiti during the seventeenth century, the French were the dominant nationality in the buccaneer towns that soon became French colonies. ... By the late-seventeenth century those who returned to islands of their ethnic origins created the seed that permitted the spontaneous growth of the Creole cottage by 1700.[113]

At the end of the seventeenth century, Father Jean-Baptiste Labat traveled across the French territories of the West Indies and stated that the houses were not made of masonry but of wood,[114] which explains the transformation of stone columns into wooden uprights. Labat also said that "glass was not used on our islands, they were content with closing the windows with balusters and shutters or, sometimes, with light-colored canvas frames."[115] The windows with balusters were the wooden grilles that characterized early Spanish-American colonial houses. Towards the end of the century, "Father Du Tertre recalled . . . the modesty of the first cities. . . . The dwellings of the humble inhabitants are still only palisaded with reeds. . . . These dwellings have only low rooms, divided internally into two or three rooms, one of which is used as a living room, the other as a bedroom, and the third as a pantry. . . . The kitchen is always separate from the house."[116] There are no remains of this early period. However, its descendants exist, such as the dwelling in the Balata Garden (Jardin de Balata), in Martinique, with the front galleries and the typical galleries at the back between the cabinet rooms.[117]

The rural house model received scholarly confirmation in Book VI of Sebastiano Serlio's (1475-1552) *Treatise on Architecture*. Although this book was

[113] Oszuscik, "Passage of the Gallery."

[114] See R. P. Labat, *Viajes a las islas de la América*.

[115] Ibid, 50.

[116] Marie-Emmanuelle Desmoulins, *Basse-Terre, patrimoine d'une ville antillaise*, 177.

[117] It is impossible to deal with the complexity of Caribbean dwellings after the nineteenth century, where Creole types linked to the different nations once again came into contact with each other and architectural solutions were transferred, resulting in highly original and versatile buildings. A classic on the subject is David Buisseret's *Historic Architecture of the Caribbean*.

not printed during his lifetime,[118] Serlio's ideas were made known by Andrea Palladio (1508-1580), whose influence on English architecture was far-reaching.[119] James S. Ackerman has stated that "most housing was built without architects, and there was a vast potential market for standardized models in the latest style such as Book VI would have provided had it been available in print."[120] In terms of the history of architecture, Serlio's Book VI is of paramount importance. By supporting his proposals with the knowledge of real-life examples, it is not only a treatise, but also a testimony to the trends and variety of domestic architecture following the social and economic boom brought about by the rise of the bourgeoisie. The scholars of the Renaissance were concerned not only with palaces, but also with the dwellings of the middle classes, both urban and rural, and inspired the productions of the Old and the New Worlds.

Plantation houses similar in design to Diego Columbus' house were built in English Jamaica. One example is the impressive Colbeck Castle, now in ruins, built in 1655, which consisted of a central rectangular building with towers at the four corners and galleries in loggias between the towers on all four sides.[121] In the eighteenth century, this model, albeit in a simpler version, appeared in high-end French examples such as the residence of Château Dubuc (1740-1771), also in ruins (FIG. 33), in Martinique.[122] In some cases, the galleries were designed with wooden columns similar to the Spanish ones, a solution adopted for the buildings of the French military engineers established in Louisiana. They appeared, therefore, via both a cultured and a popular route. The popular versions spread throughout the northern continent and the Caribbean islands, in a geographical area of diverse cultural links, mixing floor plans of Spanish, English, French and other origins. In Cuba, beautiful plantation houses were built in the nineteenth century "in the French manner," such as the one at the Angerona coffee plantation and mill, which is sadly in ruins (FIG. 34). The loss of these three structures is a cultural catastrophe, since, together with the palace of the Viceroy Diego Columbus, they constitute the temporal testimony of the expansion,

[118] Myra Nan Rosenfeld explains that Serlio was forced to publish the books of his treatise one by one. The first was Book IV in 1537, in Venice. The others were printed later, except for Book VI, which deals with domestic architecture, of which "there are two preparatory manuscripts ..., one on parchment in the Bayerische Staatsbibliothek in Munich ... and a second on French paper in the Avery Architectural Library of Columbia University. Parts of the Avery Library version were published in 1942.... The ... publication of the complete manuscript for Book VI provides access to new information about his career as an architect and the character of his treatise." See *Sebastiano Serlio on Domestic Architecture. Different Dwellings from the Meanest Hovel to the Most Ornate Palace. The Sixteenth-century Manuscript of Book VI in the Avery Library of Columbia University*, 17.

[119] "Palladio was an early beneficiary of this achievement; no doubt he was inspired by Serlio." See James S. Ackerman, "Introduction," in *Sebastiano Serlio*.

[120] Ibid.

[121] Patricia E. Green, *The Evolution of Jamaican Architecture 1494 to 1838*.

[122] See *Le patrimoine des communes de la Martinique*, 412.

33. Ruins of Château Dubuc (1740-1771), Martinique
{Photo by the author}

34. Ruins of the dwelling house at the Angerona coffee plantation, mid-19th century, Artemisa, Cuba
{JL}

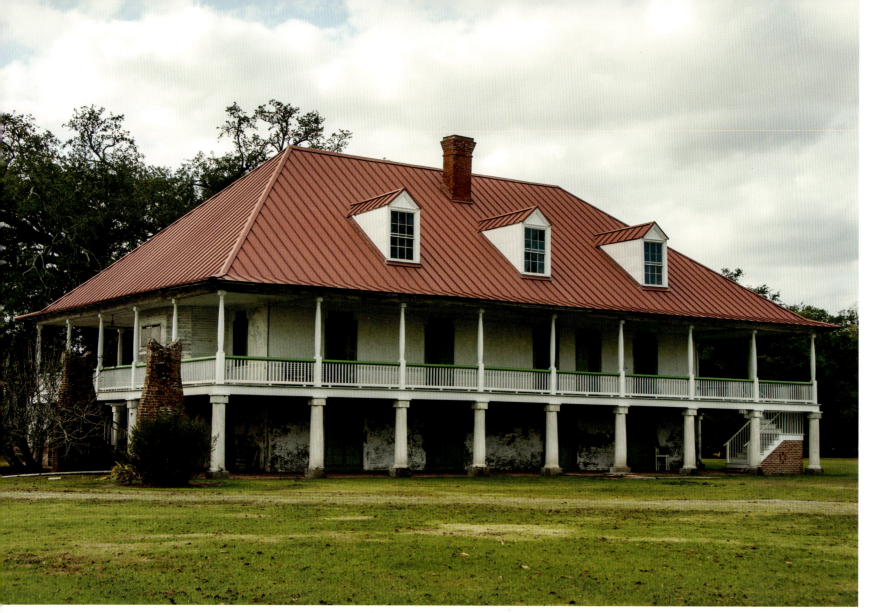

35. Homeplace Plantation (1790s), Hahnville, Louisiana {JL}

evolution and survival of the model in the insular Caribbean.

The "*château* with galleries" is also the ancestor of the "grand houses" of Louisiana plantations associated with an environment transformed into an orchard/garden, a peculiarity inherited from its ancestral rural origin and from the landscaping spirit of French Renaissance and Baroque architecture. There are old examples of French plantations in which the garden plays a leading role.[123] Neoclassicism gave Louisiana plantation homes their definitive look (Fig. 35).

An urban version of the *château*, known as the Creole cottage, became widespread in New Orleans after the fire of 1794. It is a dwelling that appears initially without galleries to the street (Fig. 36), with the façades arranged in door and window, although some have large doors made of one-piece boards, "in the Spanish style." The façades of single-story houses could be topped with parapets and/or with wooden cornices with molded ornaments (*corniches en bois*) or linteled cornices (*corniches en bois* à *Troyes*), solutions common in traditional Spanish and French architecture. At the rear, the classic arched or wooden gallery separated

[123] Chevalier de Préfontaine, *Maison rustique, à l'usage des habitans de la partie de la France équinoxiale, connue sous le nom de Cayenne. / Par M. de Préfontaine, ancien habitant, chevalier de l'Ordre de Saint-Louis, commandant de la partie du nord de la Guyane.*

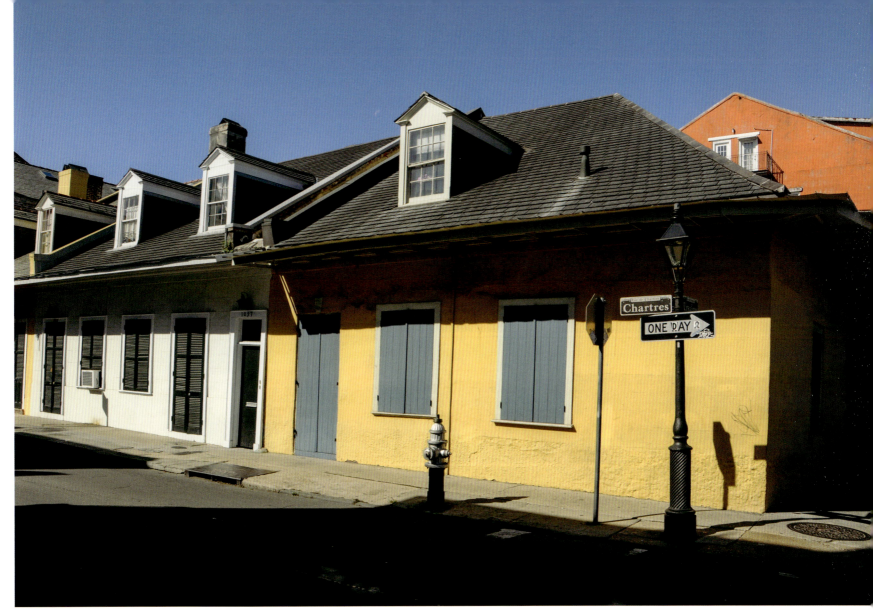

36. 1031-1043 Chartres St. (1824), New Orleans {JL}

the cabinet rooms. The kitchen, the privy, stables and slave quarters were located behind or to one side of the main house. The walls show the typical French solution of bricks between posts or entirely of bricks. The sloping roof frame, which is hidden from view with flat ceilings, contains the attic with dormer windows. The chimneys rise above the roofs, which are covered with clay or wooden shingles—*tejamaní* in Spanish, *bardeaux* in French.

After the fire of 1794, wooden corridors were added to the façades (FIG. 37) in compliance with the provisions of the famous ordinances dictated by the Baron de Carondelet, whereby "the principal façades of the buildings with the front facing the street . . . shall have arcaded galleries to protect the pedestrians and the owners from the sun and rain."[124] Cast iron galleries/porticos/corridors became widespread and gave rise to one of the most beautiful arcaded cities in the region, adapted to the hot, humid climate of the Louisiana Lowlands, some of which were veritable swamps. The new Enlightenment-inspired urban model was replicated in numerous Spanish cities throughout the nineteenth century.

In the late eighteenth century, a different type of dwelling appeared in New Orleans. It had two or more stories,

[124] "Actas Capitulares. Cabildo 9 de octubre de 1795: 'Reglas de Construcción para los edificios de Nueva Orleans,'" 55-56, cited by Morales Folguera, *Arquitectura y urbanismo*, 197.

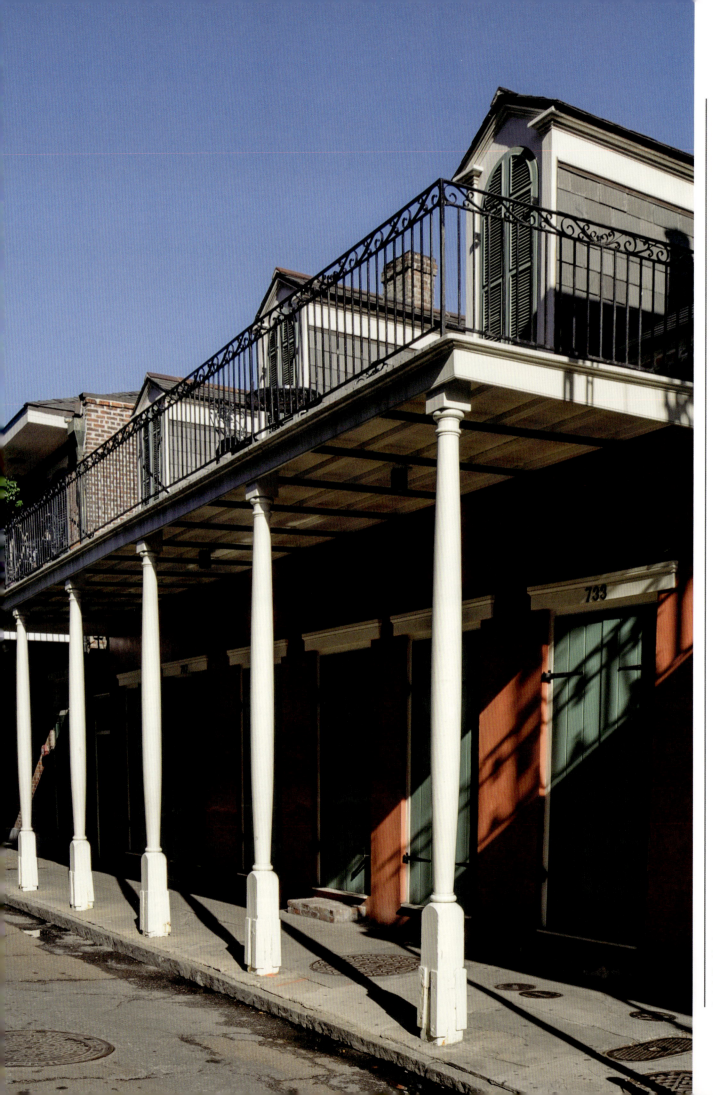

37. 731-733 St. Ann Street, first half of the 19th century, New Orleans
{JL}

similar to the so-called "store and house" of numerous port cities in southern Spain and the Spanish Caribbean, such as Cadiz, Sanlucar de Barrameda, Jerez de la Frontera, Havana, Santiago de Cuba, San Juan in Puerto Rico, Veracruz, Merida, Cartagena de Indias, La Guaira, Puerto Cabello, Coro and others, the list of which is endless. It is a type whose version of New Orleans has been baptized by Jay Edwards as[125] *porte-cochère* house and patio:

> Almost immediately following the fire of 1794 a new architectural type was introduced—the two-story townhouse. This type was well suited to the commercial nature of the new city. Stores or shops could be placed on the ground floor to attract pedestrians, while the living apartments were located above on the cooler *premier* étage. Townhouses were generally located on bifurcated lots. . . . Townhouses with flat or gabled roofs could be placed side by side, forming a continuous façade at the street. . . .
>
> The rear courtyard was partially surrounded by stables, a kitchen and wash buildings, a privy, and a one- or two-story *garçonnière* (young men's house) or slave quarter which extended straight back behind the house on the side opposite the *porte-cochère*. . . . Full-length galleries provided access to the first and second stories. The courtyard was protected from the view of neighbors by a tall brick wall.[126]

The *porte-cochère* house reflected the growing commercial activity of port cities linked to the plantation economy at a time when trade relations between New Orleans and Havana were increasing (FIG. 38). During Carondelet's rule, the relations between the two seaport cities were very close, because, in addition to shared interests, Carondelet was brother-in-law to Luis de las Casas,[127] governor of Cuba from 1790 to 1796. Around that time, "the Cabildo [governing body] and other residents of the city of New Orleans began to turn increasingly to Havana for ideas on how to develop the colony. Havana's street lighting system, for example, was the inspiration and model for the New Orleans', almost at the end of the period of Spanish rule."[128] The transfer of New Orleans to the United States, far from weakening these ties, contributed to strengthening them, since tobacco and sugar had the dual role of making the leading merchants of both cities into competitors as well as partners, in addition to the lucrative businesses of smuggling and the slave trade.

The story of the relationship between the New Orleans "merchants" Pedro and Juan Laffite and Havana officials and merchants illustrates the depth of the ties between them.[129] At the time, Havana

[125] Jay Edwards, "Early Spanish Creole Vernacular Architecture in the New World and its Legacy," 4.

[126] Ibid, 7-8.

[127] Luis de las Casas was the son of Manuel de las Casas y de la Cuadra and María de la Concepción Aragorri y Olavide, who after being widowed married Juan Felipe de Castaños y Uriarte, the parents of María Concepción Castaños Aragorri, half-sister of Luis de las Casas and later the wife of the Baron of Carondelet.

[128] Annie McNeill Gibson, Case Watkins, James Chaney and Andrew Sluyter, "Vínculos históricos entre Nueva Orleáns, Luisiana y Cuba."

[129] For more information on the Laffites in Havana, see José Luciano Franco, *La batalla por el dominio del Caribe y el Golfo de México. Política continental americana de España en Cuba 1812-1830*.

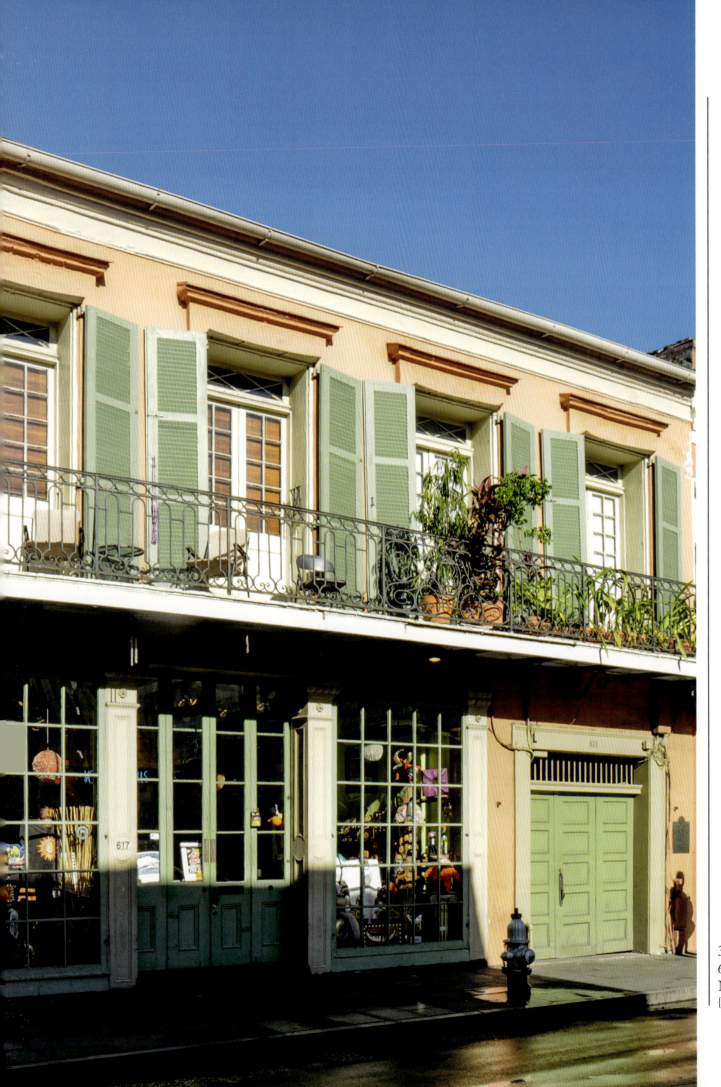

38. Bosque House (1795), 617-619 Chartres St., New Orleans
{JL}

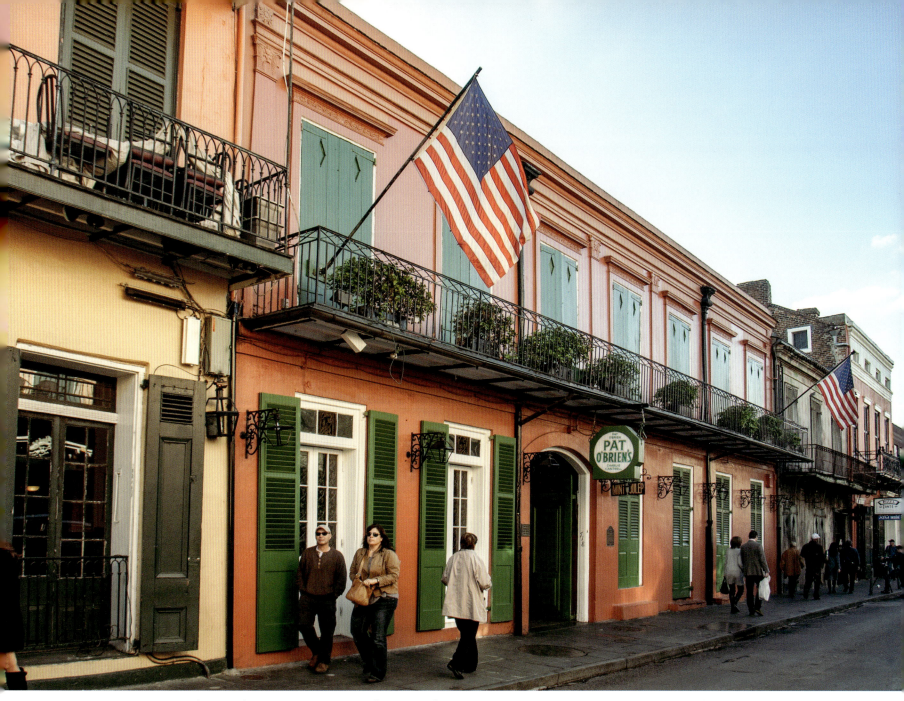

39. Pat O'Brien's Bar (1791), 718 St. Peter Street, New Orleans {JL}

was becoming a city of magnificent residences, similar to the ones built in New Orleans in the late eighteenth and early nineteenth centuries. The similarities are striking when we look at the façades: a large door gave access to a *zaguán* located on the side or in the middle of the façade in which there were openings for communication or light; on the upper floor, the openings gave way to a continuous open balcony that ran the length of the façade and was protected by iron railings (FIG. 39), whose use in Havana appeared after the construction of the Palace of the Post Office or *Intendencia* (1773-1783). In New Orleans they were attributed to Marcelino Hernandez, a skilled craftsman and native of the Canary Islands, who created the wrought-iron work on the railing of the Cabildo, completed in 1799.[130]

Despite the similarities, however, there were differences that can be explained by the different mentality of the owners and by the place of the slave servants in the house. The lack of perimeter galleries around the courtyard of the *porte-cochère*

[130] Morales Folguera, *Arquitectura y urbanismo*, 217.

townhouse[131] was the main difference. The Havana and Spanish-American store and house was organized around a courtyard surrounded by arched galleries on columns or wooden galleries that were not only an element of architectural composition, but were also the link that articulated the interdependence of the spaces of a house whose center of life was precisely the courtyard. This is a model of aristocratic appearance derived from Cádiz, in which the door of the *zaguán* featured the coat of arms that indicated the family's noble birth. This *zaguán* ran across the front part, which consisted of a single bay to which the front gallery of the courtyard was attached. In this gallery was the staircase that led to the private rooms. On the upper floor, the bedrooms started from the front rooms and continued in a row towards the back of the property, connected to the upper galleries. At the front, the living areas overlooked the street. At the back of the courtyard were the service rooms and the servants' quarters. This area was of course separated from the family rooms, but the building itself did not exclude them.

But the *porte-cochère* townhouse, whose Spanish-style carriageway entrance or *zaguán* gave it its name, was organized internally in a different way from the Spanish-Creole store and house. The *porte-cochère* townhouse was a bourgeois dwelling that followed the common organization of the British/North American townhouses, a model also found in the houses of St. Augustine, Florida, and in other similar ones that belonged to the Spanish territory of the United States, where the North American influence was decisive after the independence of the British colonies. They are confused with houses of the same type, called Creole townhouses by Lloyd Vogt, which were introduced in New Orleans at the end of the eighteenth century, although they became widespread in the middle of the next century.[132]

Both types of store and house coexisted and differed only in the way they were accessed: the *porte-cochère* had a large carriageway entrance in the form of the *zaguán* mentioned above, while in the Creole townhouse the openings on the first floor are the same in design, height and width (FIG. 40). However, both types of urban store and house, usually without a mezzanine, were designed with three clearly delimited sections: the front for public use on the first floor, the rear for servants and maintenance work, and the upper floor for the family. The courtyard was a working space and the structures on its sides were located at its edge (FIG. 41), without galleries, except for the one at the front, which, in the case of the *porte-cochère* townhouse, led to the staircase that went up to the private rooms. The rooms reserved for the family and the servants were completely separated by the structure of the building itself.

The front section had different shapes, square or rectangular; the service section at the side of the courtyard was rectangular and often had an intermediate service staircase, which can be seen in houses in Charleston, a city that had an enormous influence on the region.

[131] Term used by Lloyd Vogt in *New Orleans Houses. A House-Watcher's Guide*, 18.

[132] Ibid, 17.

40. 837-839 Royal St. on the corner of Dumaine, creole townhouse and porte-cochère townhouse, respectively
{JL}

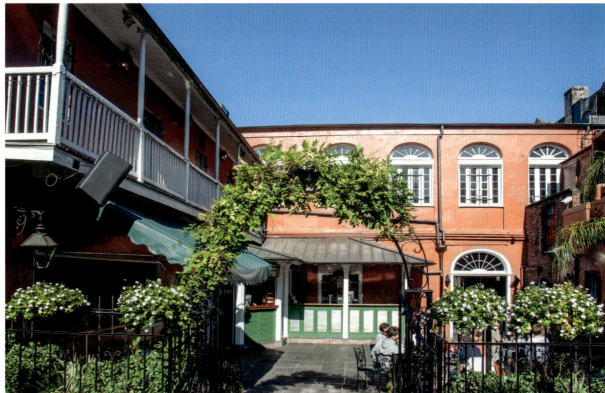

41. Courtyard, John Garnier House (1817), home to Pat O'Brien's Bar
{JL}

The layout of the spaces of the New Orleans store and house was the same as in the cities of the United States,[133] with the difference that instead of being separate and independent within the urban lot—delimited only by a low fence and, occasionally, without any bordering element, with free spaces between one house and another—they had a courtyard following the residential section or next to the service section, surrounded by rammed earth walls, in such a way that the house and the courtyard were physically delimited and attached to the next building, which is a characteristic feature of Spanish domestic architecture and urban planning.[134] But it was common to see the upper floors from the street and, sometimes, to catch a glimpse of the courtyard.

In the period influenced by the Adam or the Greek Revival style, the front part of the building assimilated the two-parlor layout popularized by Neoclassicism, under whose influence the domestic models of the late eighteenth and early nineteenth centuries took shape. This not only radically changed the appearance of the buildings, but also introduced a new space in domestic architecture, the two drawing rooms or double parlor, which was incorporated into the *porte-cochère* townhouse and the Creole cottage. This consisted of placing two parlors one next to the other, connected by a linteled triumphal

42. Double parlors, Gallier House, (1859-1860), home to the Gallier House Museum, residence of architect James Gallier, Jr., 1132 Royal St., New Orleans {JL}

[133] A notable study on the subject is Bernard L. Herman's *Town House. Architecture and Material Life in the Early American City, 1780-1830.*

[134] Various authors have attempted to explain the differences without knowing the characteristics of Spanish urbanism and domestic architecture. This has deviated the analysis towards distant references or others brought up by the origin of the owners, which may have an influence, but is almost never a determining factor. The building tradition prevailing in a given territory at a given time is the main source regarding domestic architecture.

43. Courtyard, Gallier House {JL}

arch, either a semicircular arch or other designs, and/or by a sliding door joining or separating them at will (FIG. 42). In the architecture of the nineteenth and twentieth centuries—and even in today's architecture—the living room/parlor and living room/dining room relationship was heir to those spaces whose presence represented the definitive removal of public or work activities on the first floor.

The houses took on a distinctly residential character. The entrance hall, or *zaguán*, disappeared and was transformed into an English-style hall with a staircase leading to the upper floors. A new type of house was born, the American townhouse, which differed from the Creole townhouse only in the location of the staircase.[135] In the Hermann-Grima House, the domestic slave quarters were built on one side of the courtyard, with no connection to the front of the house.[136] A perfect example of the American townhouse is the house of the famous American architect James Gallier (1798-1868), which rejected the attachment to the neighboring house and was separated from it by a narrow alley. The service area at the side of the courtyard was functionally independent, with its own staircase leading to the upper floors, although it remained connected to the front by the gallery on the first floor and the upper balconies (FIG. 43). The house-hall-patio-two parlor version would have a huge impact on nineteenth-century domestic architecture in the United States and, under its influence, in the Caribbean islands. It is unquestionably a shared treasure of the Spanish-Creole, French-Creole and North American cultures.

[135] Lloyd Vogt, *New Orleans Houses*, 23.

[136] This solution appeared in numerous residences in the United States, some of them very notable and early, like the one built by the English architect William Jay for the merchant Richard Richardson in 1817-1819 in Savannah.

Courtyard, 359 Church St., Mobile
{JL}

MOBILE: THE CONTRIBUTION FROM THE UNITED STATES

The Gallier house is a reference to a domestic type that could well be considered "American." Mobile offers examples of this "new" but not exclusive type, as they are shared with other cities. East Florida, West Florida and Louisiana have examples that can only be explained by the cultural mix of Spanish, French, British and North American cultures. But Mobile's mid-nineteenth-century houses, built at a time of the city's economic and social splendor, are paradigmatic.

Founded in 1702 as the capital of Louisiana, the city was relocated to its definitive site near the bay in 1711. From the beginning, relations with the Spanish were intense because of its proximity to the presidio of Pensacola and, consequently, to the Spanish establishments in the region: "the consequent near-perpetual scarcity of provisions induced some colonists to sail on speculative trading ventures to Veracruz and Havana, ports previously closed to all but Spanish shipping."[137] West Florida was an intermediate territory between East Florida and Louisiana, and therefore the architectural proposals entered into a relationship similar to what had happened in the neighboring territories. But Mobile is an excellent testimony to the fusion in the nineteenth century of contributions stripped of the lineage of their origin, assumed as elements of their own and interpreted in accordance with the prevailing Neoclassicism.

Until the last quarter of the eighteenth century, it is difficult to recognize the impact of stylistic trends in the architecture of a territory that went from vernacular to Classicism, without hardly passing through the Baroque, a trend that characterized the Spanish and Spanish-American architecture of the century. There are links between Baroque and Neoclassicism, but the differences are enormous. To begin with, the contrasting colors that characterize the buildings of the former and the predominant white of the latter show that we are dealing with different worlds. In recognizing the Spanish architectural legacy in East Florida, West Florida and Louisiana, the absence of forms derived from the Baroque is striking. This fact leads us once again to recognize the importance of the English influence on the French and Spanish.

The reoccupation of Louisiana and then West Florida by the Spanish meant assuming "the governance of territories that had been administered by foreign hands for half a century, developing a new policy of settlement, emigration and financial development and implementing a renewed defensive approach."[138] Repopulation took place through the creation of new settlements and, in the case of West Florida, the rebuilding of the two most important cities, Pensacola and Mobile, located on the coast of the Gulf of Mexico and open to the influences of the Caribbean.

[137] Gregory Waselkov, "French Colonial Archaeology at Old Mobile: An Introduction."

[138] Pedro Cruz Freire, "La llave de Nueva España. Proyectos defensivos para los territorios de Luisiana (1770-1775)."

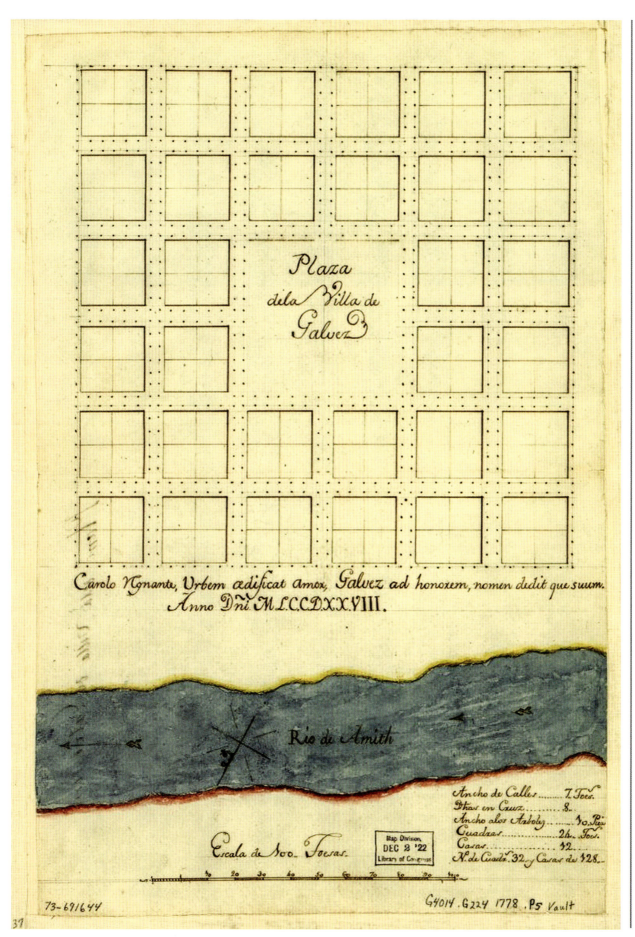

44. "Plaza de la villa de Gálvez" (1778) Digital Collection of the Library of Congress.

Galveztown, founded in the parish of Iberville near New Orleans, was the place where the English and Americans who did not want to participate in the War of Independence settled. Galveztown was laid out according to a grid plan (1778), with the town square in the center,[139] but with a novel innovation: the streets "were lined with rows of trees and porticoes, not only on the main street, but also on all the other streets."[140] Both the trees and the porticos were unprecedented elements of urban design, possibly a reference for New Orleans years later, and the first American project of its kind. (FIG. 44).[141] The use of trees for shade represented the philosophy that would prevail in the nineteenth century: that of the garden city. The houses "were 32 feet long and 16 feet wide, with a gallery in front and the appropriate doors and windows with their iron fittings. The roof was always gabled and the material was mainly wood."[142]

The plan for the "New Movila" (1781) was commissioned to the military engineer Juan Enrique Grimarest, who was appointed governor of Mobile. In 1780, at the time of the attack of the forces commanded by Bernardo Gálvez, the city was organized in two areas delimited by the river—on one side was the residential area with a rectilinear though not strictly orthogonal layout, and on the other was Fort Condé with provisional buildings (FIG. 45). This layout followed the original plan drawn up by Adrien de Pauger in 1725. Grimarest respected the existing zoning, but drew up a hypodynamic plan that bordered

> on the south by Fort Louis and on the east by the Mobile River. There were four main streets, each 17 feet wide, running north to south and intersected by five other perpendicular streets. They were called Real, San Carlos, San Luis and De la Concepción. The perpendicular streets were called Del Gobierno, Delfina, San Francisco and Santiago. The main square here was eccentric, located between the port and one of the shorter sides of the rectangle that made up the city, and where the most important buildings were located: the church in the center, and from left to right in blocks that covered half of the rest of the blocks, the government house, the town hall, the King's storehouses, the cooperage, the gatekeeper's house, the forge, the porter's house, the officers' quarters, the barracks, the Royal Hospital, the hospital employees' lodgings, and the bakery.[143]

[139] The orthogonal plan was theoretically sanctioned in such texts as the *Tratado de fortificación, ó Arte de construir los edificios militares, y civiles / escrito en ingles por Juan Muller...* (1769), known in Spain through the translation of Miguel Sánchez Taramas. Muller, aware of the work of French town planners, considered the checkerboard plan, organized around a central square.

[140] José Miguel Morales Folguera, "Fundación de ciudades en Luisiana y Florida con canarios en el siglo xviii."

[141] The project presented by the engineer Luis Huet in 1784 for the redevelopment of the town of Güines, located in the present-day Cuban province of Mayabeque, was clearly inspired by that of Galveztown.

[142] Morales Folguera, "Urbanismo hispanoamericano en el sudeste de los EE.UU. (Luisiana y Florida). La obra del malagueño Bernardo de Gálvez y Gallardo (1746-1786)."

[143] Morales Folguera, "Urbanismo hispanoamericano."

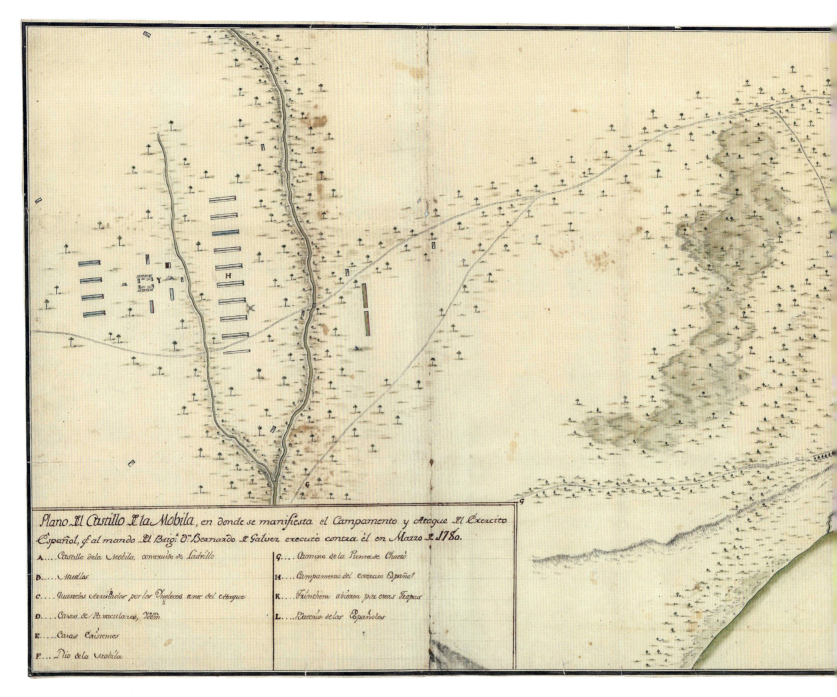

It was a design that functionally did not conform to the norms of colonial urban planning as the city was divided into two zones, residential and services, certainly a novelty for a "Spanish" city and for the period in general.

In a formal sense, it was a new layout that clearly reflected the influence of the Frenchified urbanism adopted by the Spanish who led the colonization of the territory under the orders of Bernardo Gálvez, the great Spanish hero of the War of Independence of the Thirteen Colonies. The new concepts were found not only in the layout of the streets and the functional organization of the city, but also in the characteristics of the city lots: the blocks were divided into "8 lots: the four corner lots were occupied by one-story houses and the central lots were occupied by gardens and orchards. Real

45. "Plano del Castillo de la Mobila en donde se manifiesta el campamento y ataque del ejército español qe. al mando del Brigr. Bernardo de Galvez ejecuto contra el en Marzo de 1780." Taken from https://bibliotecavirtual.defensa.gob.es/BVMDefensa/es/consulta/registro.do?id=114075

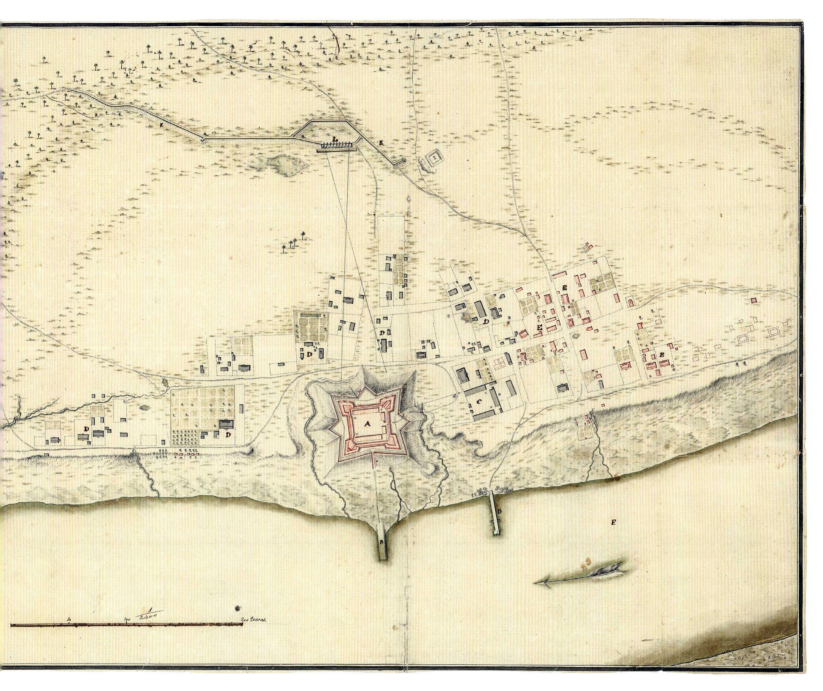

Street, on the other hand, had a continuous row of houses on the west side, which meant that gardens and orchards were located at the back of the houses."[144] It is important to note that a space was intentionally set aside for gardens and orchards.

In the early nineteenth century, Claude C. Robin, in his book *Voyages dans l'intérieur de la Louisiane, de la Floride occidentale, et dans les îles de la Martinique et de Saint-Domingue*,[145] described the houses of Louisiana and

[144] Ibid.

[145] *Voyages dans l'intérieur de la Louisiane, de la Floride occidentale, et dans les isles de la Martinique et de Saint-Domingue pendant les années 1802, 1803, 1804, 1805 et 1806. Contenant de nouvelles observations sur l'histoire naturelle, la géographie, . . . et les maladies de ces contrées . . . Suivis de la flore louisianaise. Avec une carte nouvelle, gravée en taille-douce. Par C.C. Robin.*

West Florida as having the typical galleries on all or some of the sides, a useful protection from the sun and the rain, used for eating and even sleeping. But Robin documented an important change: the houses "are of the most varied form, some built of wood, surrounded by galleries ... others built of brick are surmounted with a gallery in the Italian manner."[146] This account highlights two aspects: first, the use of brick and wood, the latter of which was very widespread and persistent; second, the symbolic enhancements of historical styles, with their source in the English-American architecture, in whose domains "[f]rom the crude shelters of the first settlers it developed first to the medieval style of the seventeenth century and then to the Renaissance formalities of the eighteenth. It extended through regions as disparate as New England and California, Florida and the Midwest, the Atlantic seaboard and the deep South."[147] The Creole cottage represented a major shift in the organization of spaces in response to the influence of English-American architecture. It evolved toward the adoption of a floor plan organized around a hall as an element of spatial articulation—"Central hall houses became popular in Alabama during the 1830s and in New Orleans were referred to as American Cottages, different from the French and Spanish-influenced residences"[148] (Fig. 46).

[146] Cited by Barry Jean Ancelet, Jay D. Edwards and Glen Pitre in *Cajun Country*, 129.

[147] Hugh Morrison, *Early American Architecture: From the First Colonial Settlements to the National Period*, 3.

[148] "Thematic Group Creole and Gulf Cottages in Baldwin County," document prepared by John, S. Sledge.

Philippe Oszuscik believes that the transformation of the Creole cottage took place in the cities along the Gulf Coast of Mexico:

> The British inherited fully developed Creole structures with galleries, steep pavilion and double pitched roofs, raised cottages, and basic Creole plans. . . . Many French on the Gulf Coast . . . saw the receptive British as a lesser evil than having to live under the Spanish in Louisiana; thus, they remained. Consequently, many of the Creole elements came directly by way of the French population in Pensacola, Mobile, Natchez and the region.[149]

People of different origins lived in these cities: French, Andalusians, Canary Islanders, Acadians,[150] Irish and English Americans, as well as Indians and Africans, a breeding ground for the emergence of a new architectural type, called by Oszuscik "Gulf Coast Cottage" or "American central-plan cottage," which took shape over the course of a long process.

> First generation houses were British plan cottages which accepted French and Spanish Creole elements as well as those of French Creole plans. The second-generation houses in West Florida under the Spanish between 1781 and 1813/1821 were built by former British or Americans moving into the Parish perpetuating the Gulf Coast cottage and other house plans with Caribbean elements. Last, British Creole ele-

[149] Oszuscik, "Passage of the Gallery."

[150] The Acadians were French colonists who settled in today's Nova Scotia, formerly Acadia. They were forced to leave their homeland when French Canada fell to British rule in 1763.

46. Portier House (ca. 1833), 307 Conti St. on the corner of Clairborne, Mobile {JL}

ments were perpetuated by Americans in massive waves after 1813 when the Gulf Coast became American Territory. Some settlers coming from the Carolinas arrived in the former West Parishes with identical plans due to the fact that the French-British Creole housing traditions had become common on the East Coast as well.[151]

With the Carolinas, ties were close and went both ways: "ideas for houses in the Carolinas may have come from the Floridas after 1763.... Developments in Pensacola may have influenced the Carolinas as well as the Felicianas of Louisiana."[152] An important site of such associations was the city of Charleston, South Carolina. Given the abundance of examples, it is not possible to comment on the distribution of houses with a hall as a structural element.[153] In summary, it can be said that in the mid-eighteenth century two well-configured floor plans predominated in Charleston, both with the entrance on the side. In one variant, the structural frame took on a rectangular shape, with the larger side oriented toward the depth of the lot, followed by the service quar-

[151] Oszuscik, "Passage of the Gallery."

[152] Ibid.

[153] See Virgina and Lee McAlester's *A Field Guide to American Houses*.

47. Francis Saltus House (ca. 1820), 6 Water St., Charleston {JL}

48. Poyas-Mordecai House (1796-1800/1837), 69 Meeting St., Charleston {JL}

ters, also located in a rectangular structure, but smaller in size (FIG. 47).

The other layout was quasi-square, with the service quarters separated from the main house and built at the back of the lot. The connection between the square floor plan and the American central-plan cottage is obvious. In the early decades of the following century, both types of Charleston houses added the characteristic side galleries/piazzas[154] that recall the side galleries of late eighteenth-century St. Augustine houses. The piazzas generally flanked a large, open, garden-like space (FIG. 48), a relationship that is the quintessential contribution of nineteenth-century American housing, along with the elegant and distinctive timber interpretation of forms derived from historic styles.

In the period before the Revolutionary War, architecture was under the dominant influence of Palladio and Inigo Jones. This had an impact on very important buildings such as Drayton Hall, the mansion that presides over the plantation of the same name near Charleston, built between 1738 and 1742 (FIG. 49).[155] After independence, "there were political reasons that confirmed the choice of the classical style. The classical forms were charged with ideological meaning, as was the case in France at the time, and they became the symbol of republican virtues."[156] The work of Thomas Jefferson (1743-1826) reflected this situation both politically and architecturally. What followed was

[154] *The Early Architecture of Charleston.*

[155] Daniel D. Reiff, *Houses from Books. Treatises, Pattern Books and Catalogs in American Architecture, 1738-1950: A History and Guide*, 25.

[156] Leonardo Benévolo, *Historia de la arquitectura moderna*, vol. 1, 250.

49. Drayton Hall (1738-1742), Charleston, South Carolina Lowcountry {JL}

a succession of periods identified as the Adam or Neoclassical style (ca. 1750-1790), the Regency, better known as the Federal style (ca. 1790-1830), and from 1830, the Greek Revival, which spread widely through catalogs and building manuals that paid great attention to the wood interpretation of functional and decorative elements. Louvered doors and louvered fan-shaped shutters used by the French since the mid-eighteenth century were adopted among other wood solutions (Fig. 50).

Asher Benjamin's *The American Builder's Companion* (1827) and *The Practical House Carpenter: Being a Complete Development of the Grecian Orders of Architecture* (1830), and Minard Lafever's *The Modern Builder's Guide* (1833) and *The Beauties of Modern Architecture* (1835), which proposed neoclassical wood ornamental additions, were highly regarded and coincided chronologically with the urban consolidation of many American cities. All things Greek became "popular" and symbolically characteristic of all things "American."[157] The American creole cottage "was changed to a symmetrical Palladian revival (late Georgian) style, with a central pediment over the front loggia, turned balusters on the loggia and cornice. . . . Stairs between stories were located on the rear gallery."[158] Façades that resembled classical temples became widespread, with the typical pediments supported by the corresponding colonnades, and double parlors were also incorporated, as can be seen at Georgia Cottage (1845): "The interior plan, little altered

[157] See John S. Sledge, *The Pillared City: Greek Revival Mobile*.

[158] Oszuscik, "Passage of the Gallery."

50. Tadoussac Chapel (1747), on the banks of the St. Lawrence River, Quebec Province, Canada. Note the fan-shaped shutters, perhaps one of the oldest in the Americas {JL}

since construction, consists of a wide central hallway with double parlors to either side."¹⁵⁹ The double parlors complete the elements that characterize the nineteenth-century antebellum Mobile home. Among them are examples that synthesize the highly complex cultural process that characterized the area. Residences such as the one built by the English architect George Woodward Cox (1814-1869) for the German merchant Martin Horst (1830-1878) at 407 Conti St. represent a new and suggestive spatial proposal.

The Horst House was built on a corner (Fig. 51), allowing light and air to enter the rooms from the side, yet conveniently separated from the street by a garden that runs around the front and the side of the house. The exterior garden, an essential element in understanding the houses of the period, is delimited by a wrought iron fence, a style that gained momentum after 1850 when "James Bogardus ... built a large number of commercial buildings in cast iron in New York and elsewhere, and became an unwearying advocate of this new material"¹⁶⁰ although its first exponents came before that time.¹⁶¹ Intricate wrought-iron lacework embellishes "elaborate floral verandahs, some accented with allegorical figures, the better to create the appearance of a country villa."¹⁶²

In terms of its ornamental elements, the two-story Horst House belongs

¹⁵⁹ Sledge, *The Pillared City*, x.

¹⁶⁰ Benévolo, *Historia de la arquitectura moderna*, 258.

¹⁶¹ Sledge highlights the contribution of Robert Wood of Philadelphia, since 1839. See John S. Sledge, *An Ornament to the City. Old Mobile Ironwork*, 10-12.

¹⁶² Ibid, 8.

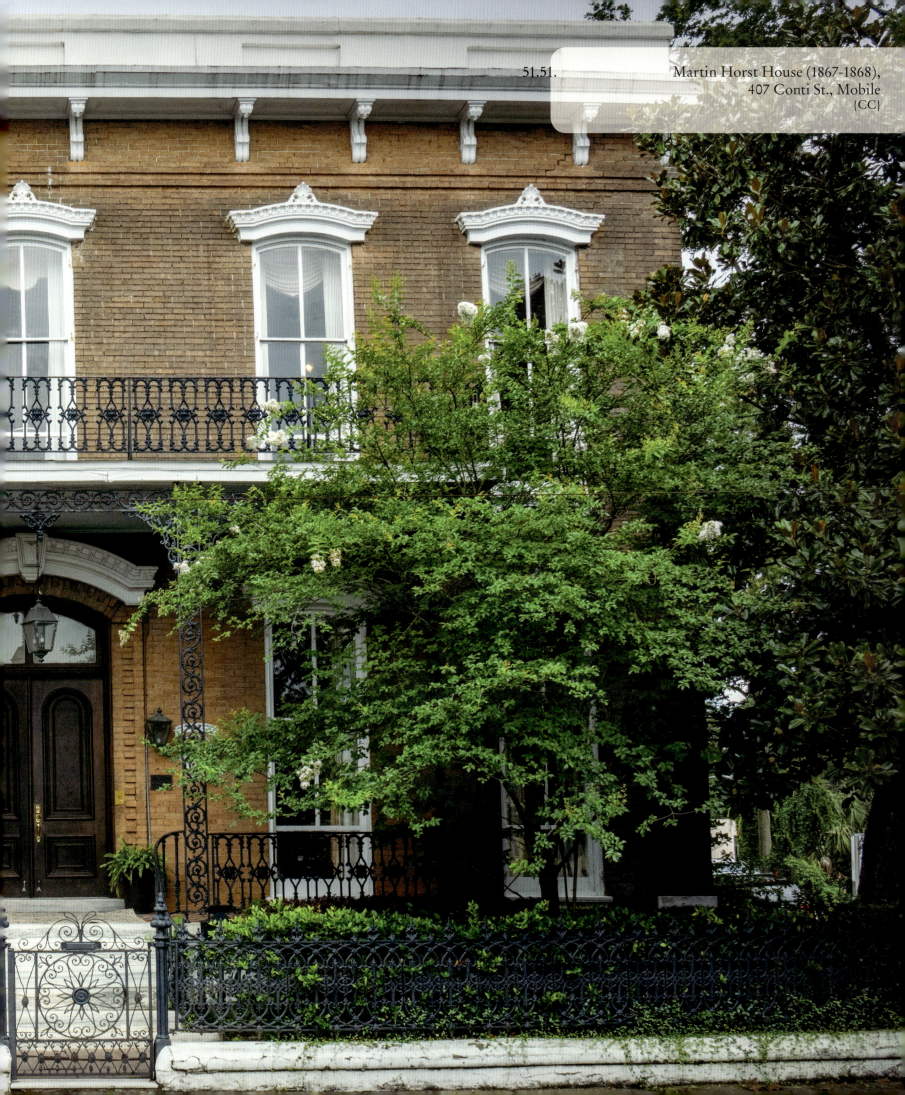

51.51. Martin Horst House (1867-1868), 407 Conti St., Mobile (CC)

52. Hall, Horst House
{JL}

to the Italianate or Neo-Roman style, with the peculiar entablature at the top of the façade, supported by corbels and crowned by the corresponding parapet. The windows, with ornate curved hood moldings, enhanced with modillions and crowned by acroterium, in the Greek style, reflect this trend and stand out in white against the red brick walls, as preferred by British architecture since the Tudor period. The main entrance has steps given that the house is built on a foundation. A decoration of similar design to that of the windows, but larger, frames the main entrance door, which is made of panels with illuminated glass at the top. The doors of the windows and façade are wooden and glass, or *portes-fenétres*, which were used by the French since the seventeenth century for balconies and became widespread in the eighteenth century in many countries.

In plan, the house has two very clearly defined areas, as is common in American homes: the family living area and the servant quarters. The family part of the house consists of a rectangular block with the longer side facing the street, organized around a central hall (Fig. 52) flanked by double parlors on one side and two equal rooms on the other. The parlors are connected by a lowered arch, decorated with motifs similar to the ones on the façade, but in wood, a material also used for the small cornice at the top of the wall where it meets the ceiling (Fig. 53). The staircase leads to the upper floor, which is divided into four symmetrical rooms—the front rooms are separated by a closet with access to the balcony, and the rooms at the rear lead to the rear gallery.

The block described above has a two-story, rectangular structure attached to it, depth-wise, with its own staircase. This is the service wing. What is new about the Horst House, however, is that a double wooden gallery connects both the family section and the service wing, and flanks a patio delimited by walls, but it is a courtyard garden, visible from the street, with its own entrance (Fig. 54). Influenced by the Greek Revival style, the patio galleries (and the exterior galleries, if any) are covered with a lintel roof, which is the main difference when compared to the Spanish ones, which were set on a slope.

The Horst House represents, therefore, a new type that could very well be called the "courtyard garden house," in which Spanish, French and English references are present, although it is an essentially American result in terms of structure, composition and decorative enhancements linked to the dominant Classicism.

The Horst House is not the only example. Others include the Cox-Deasy House, a Greek Revival cottage, and the Rapelje-DeLaney House, both built by George Cox, who was also responsible for the Horst House. The Cox-Deasy House has the characteristic Doric porch in front, but it has a courtyard garden flanked by a wooden gallery. The Rapelje-DeLaney House is notable for the porches at the front and side of the sprawling gardens surrounding the mansion. In other houses, such as the Bush-Sands Memorial, similarly to the Horst House, the courtyard garden is flanked by wooden galleries on both floors and has cast iron porches on the

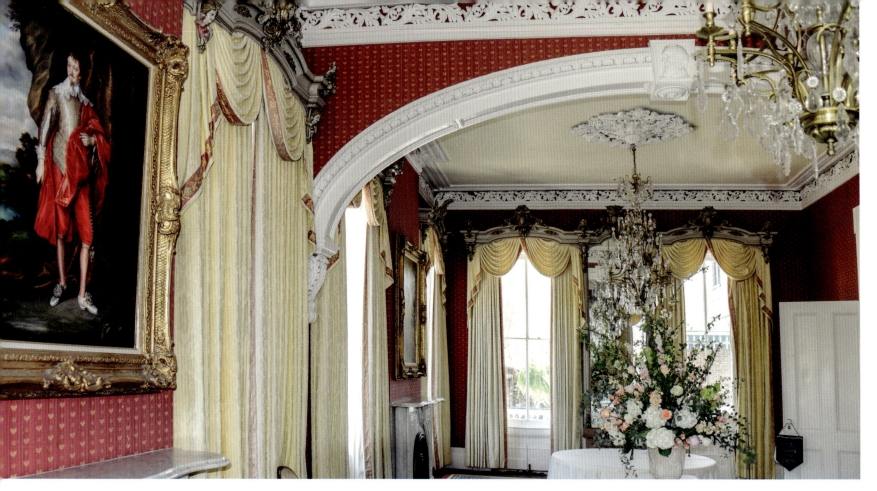

53. Parlors, Horst House {JL}

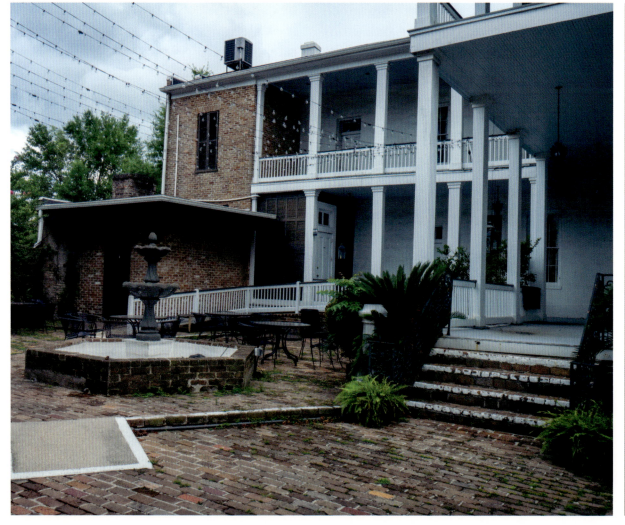

54. Courtyard, Horst House {CC}

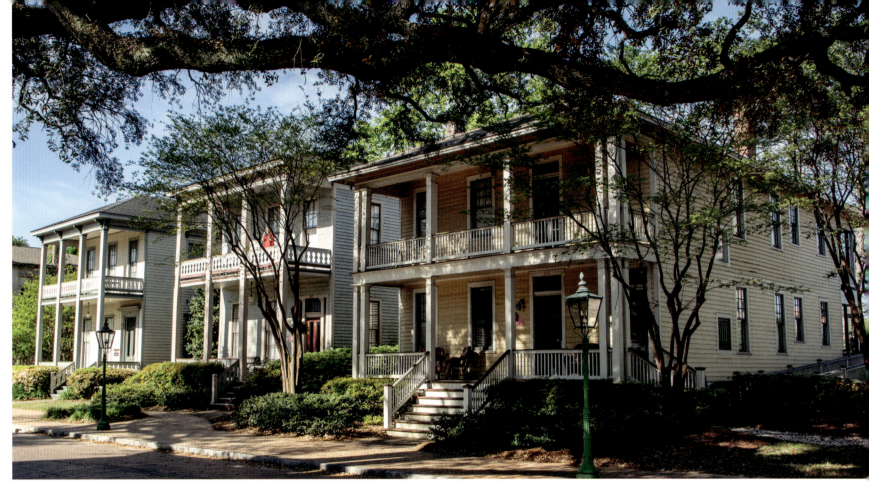

55. St. Emanuel Street, in the foreground Scarpace House (1916) Mobile {JL}

façade, a popular feature in Mobile from the mid-nineteenth century onwards.[163] Grand mansions in the Greek Revival style or under the Italianate influence, all luxuriously appointed, preside over the urban expansions of many cities in the United States, inspiring those built later under the influence of eclecticism, at a time when wooden mansions were of remarkable beauty (Fig. 55).

The exceptional element here—both in the Horst House and in others in Mobile and elsewhere in the United States—is the fusion of a courtyard with a garden. Different cultural worlds gave rise to a new housing model that we have called the courtyard garden house. This is perhaps one of the greatest architectural contributions to the process of transculturation between Spanish, French and British in the United States.

[163] See *The Majesty of Mobile*.

Detail from "Vista de la quinta del Escmo Sor Conde de Fernandina (Cerro)," by Federico Mialhe, in *Isla de Cuba pintoresca*, 1839-1842
José Martí National Library of Cuba

DISSEMINATION OF THE COURTYARD GARDEN HOUSE

The nineteenth century saw the transformation of the houses and cities of the Spanish Caribbean. The novelties were clothed in neoclassicism, split into two aspects: an academic one, carried out by the military engineers who worked on the most important cities established in Spanish territories—Havana and San Juan, Puerto Rico, for example—and also by outsiders hailing from different European countries, most notably the French; the other aspect consisted in the manufacture of wooden decorative motifs of neoclassical/eclectic affiliation, as suggested by manuals and catalogs published in the United States.

In the old centers of capital cities, this last trend was only weakly expressed, since they were built based on a tradition that had been established over three centuries. But in the newly created districts, in the urban expansions and in the "old" or newly created inland towns, the neoclassicism of wood became predominant, to which we must add that the interior layout of houses was transformed according to principles different from the Spanish domestic tradition. It was also during this period that wood became popular as a material for walls in the new cities, especially in the new districts of the port cities and in the *bateyes*, or sugar mill towns, and/or settlements associated with the sugar mills.

Although Old San Juan remained indifferent to the wooden proposals for a long time (FIG. 56), a new type of dwelling emerged in the inland cities of San Germán, Ponce, Mayagüez, and others, which had been urbanized since the mid-nineteenth century. To distinguish them in some way, the people of Ponce called them *ponceño criollo,* or Ponce Creole. This was a courtyard garden house whose façade stood out for the symmetrical arrangement of the openings, and had a kind of low balcony accessible from the sides, as the house was built above street level. The balcony was covered with a linteled roof, supported by wooden posts in the form of classical columns, and even iron posts. The leaves of doors and shutters opened outwards, which was necessary in cold areas but not in warm ones (FIG. 57). The traditional layout of a first bay with living and sitting rooms, and a second bay with dining room and bedrooms was transformed in the same way as seen later in Cuban houses, by connecting the living and dining rooms by a triumphal arch in the manner of a double parlor. Next, a wing went all the way to the back of the lot, with the courtyard at the rear and side, and the respective side entrance.

This basic layout would offer different alternatives, always enhanced with woodwork in Neoclassical, eclectic and Art Nouveau styles, the latter in the early twentieth century.[164] Later, it was common for a hall to be the connecting element of the spaces and for the living

[164] See Rafael Pumarada, "Balcón, sala y comedor: la tipología de la vivienda en San Germán."

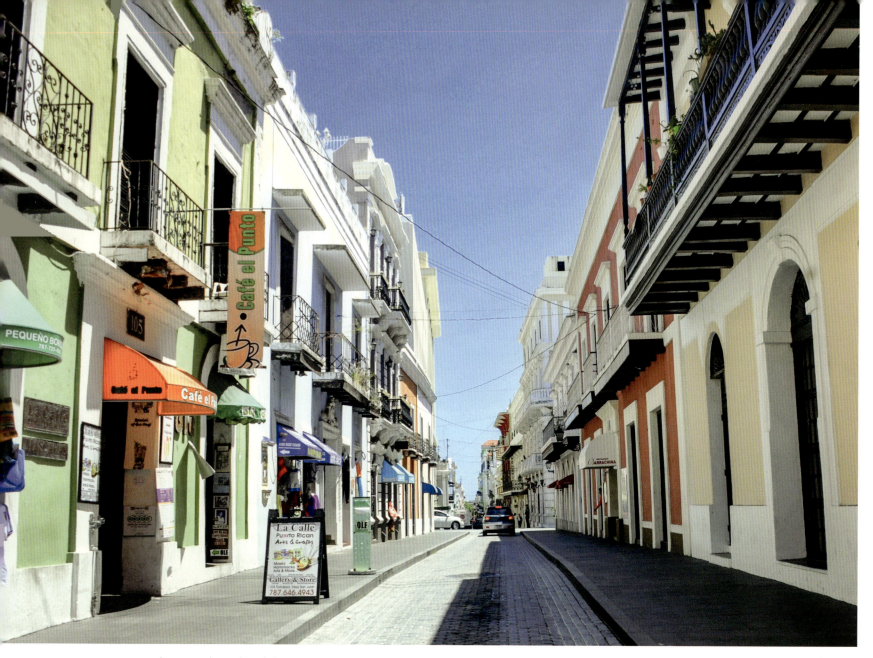

areas to keep the double parlor layout, delimited by beautiful triumphal arches. Typically, these were two twin houses with a dividing wall between them, without an adjoining wall on the opposite side, with the courtyard to the side and the back. The main entrance to the house could be through some of the openings on the façade or, preferably, from the side of the façade, directly in line with the courtyard garden. Other houses had a corridor in the middle of the two houses that led to a narrow inner courtyard, within walls, since the rooms opened up on the opposite side and were entered from a front hall that also connected the rooms facing the street.[165] The courtyard garden in back, which sometimes took over the side of the house, was a common feature in various planimetric versions. Some houses had masonry walls, but more often they were made of wood, a material that also gave shape to the ceilings that concealed the roofs, which were usually made of zinc.[166]

56. Sol Street, San Juan, Puerto Rico {Photo by Carlos García Santana}

[165] On the evolution of this type of housing in the early decades of the twentieth century, see Warren A. James, "Notas para una arquitectura de transición."

[166] The Puerto Rican house in the island's inland towns is one of the best examples of the adoption of the new models arriving from the United States and their relationship with the rest of the Caribbean—at the end of the Spanish-American

57. Thomas Armstrong Toro House (1893), 33 Mayor St., Ponce, Puerto Rico {Photo by the author}

In Trinidad, one of the first Cuban cities, the traditional dwelling was not supplanted, just like in inland Puerto Rican towns in the interior of the island, given the consistency of local construction practices, but the influence from the North changed the layout of the floor plan by adding a new space: the *saleta* (small parlor), then called *contra-comedor* (counter-dining room). Accordingly, the dining room was relocated towards the gallery. One of the first buildings, if not the first, to adopt this new space in Cuba was the Iznaga Palace built in 1826 by the architect Vitruvio Steegers, who also built the Cantero Palace (1829) and remodeled the Brunet Palace (1830). Given the enormous dimensions of the traditional Cuban house, the connection between the two spaces was provided by an immense semicircular arch that allowed communication between the two rooms while separating them (Fig. 58).[167] This

War (1898-1902), Puerto Rico came under United States control. This subject is beyond the scope of this book; however, a notable study on the subject is Carol F. Jopling's *Puerto Rican Houses in Sociohistorical Perspective*.

[167] The two rooms with a wooden triumphal arch first appeared in coffee plantation houses of eastern Cuba, but it was in the city of Trinidad that the peculiar version first emerged in the form of large semicircular arches placed between the living room and the counter-dining room or *saleta*. See Alicia García Santana, *Trinidad de Cuba. Ciudad, plazas, casas y valle*, 199.

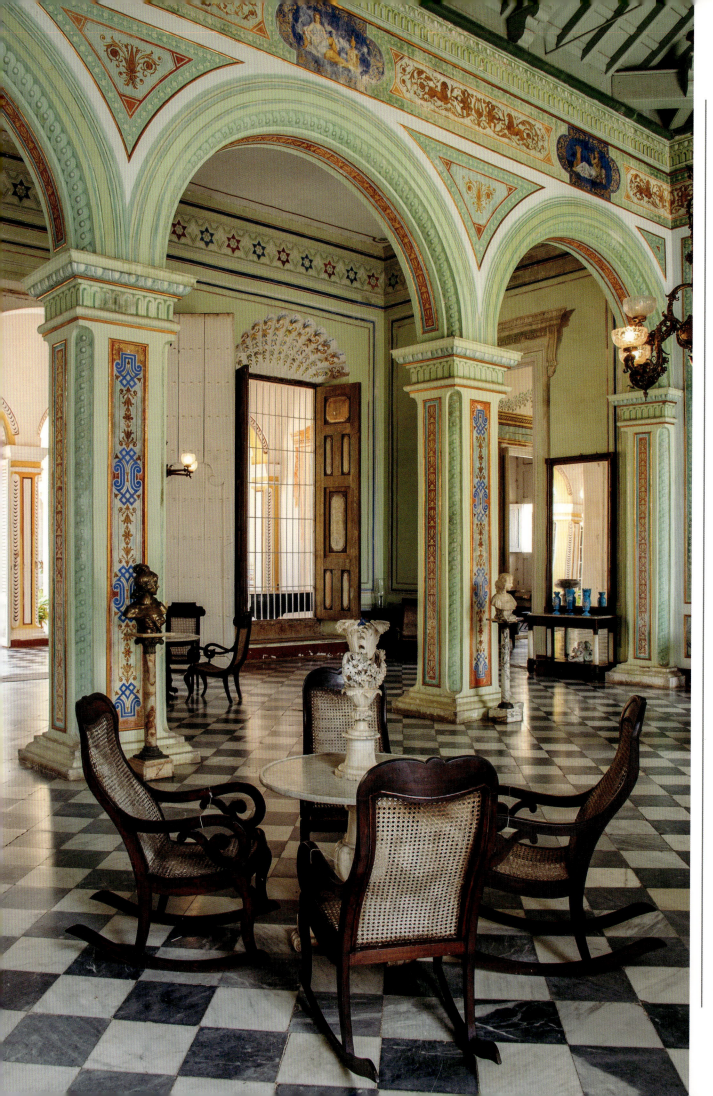

58. Parlors, Cantero Palace (1829), home to the Municipal History Museum, on the corner of Desengaño and Peña streets, Trinidad {JL}

59. Console table attributed to Charles-Honoré Lannuier (1779-1819), originally from the Bequer Palace, in the collection of the Museum of Romanticism, Trinidad {JL}

transformation represented the Cuban interpretation of the American double parlor, a usage that came about as a result of the change in lifestyle rituals, which at that time were geared towards social interaction in the form of get-togethers and, especially, elegant dinner parties.

The Cuban house abandoned the dais of medieval Muslim reminiscence, in which the women's area was conveniently separated from the men's, and gave way to a less rigid relationship. The living room gradually became a place for the furniture of representation, and all that remained of the old dais was the carpet on the floor, on which seldom-used furniture was placed. Then came the rocker, a new type of chair that was brought from the North and, which, for lack of words to identify it, was called *butaca oscilatoria* (oscillating chair).[168] Also from up North came the exquisite Empire style furniture, notably pieces made by Charles-Honoré Lannuier (FIG. 59) and Duncan Phyfe, which are still exhibited in the city's museums,

[168] *Correo de Trinidad*, January 4, 1837, in *Trinidad de Cuba*, p. 212.

60. Fan-shaped blinds and French shutters, Brunet Palace (1830), home to the Museum of Romanticism, Trinidad {JL}

and were imitated by excellent Creole cabinetmakers.

The counter-dining room, or *saleta*, is the most revealing spatial expression of the profound changes that took place in Cuban society in the nineteenth century. Cuban Creole architecture transcended the local to open up to proposals coming from other, non-Spanish, cultural cen-ters. The Cuban upper classes sent their children to study in the United States, a country that also served as a refuge for the politically persecuted or com-promised. On their return home, they brought with them new ideas, ranging from the cultural to the political. Back then, it was easier than today to travel from the city of Trinidad to New York, since it was only a few miles to the port

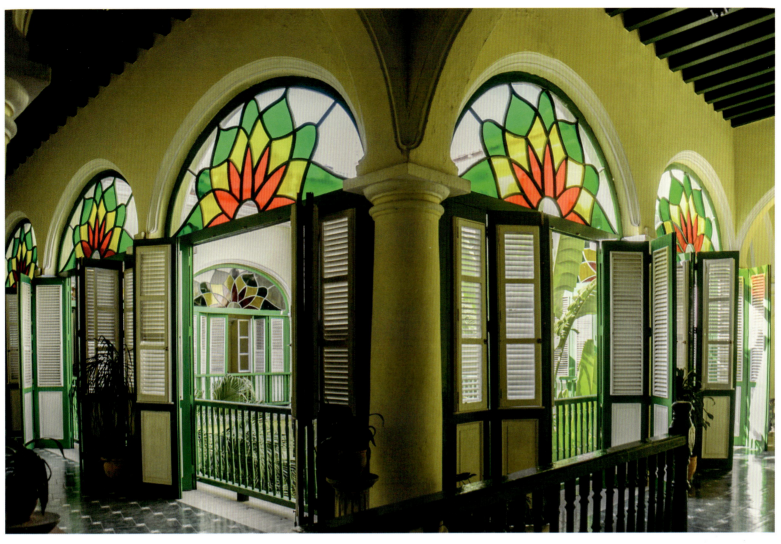

61. Stained-glass fanlights and French shutter doors, home of the Count of Villanueva (1857), 202 Mercaderes St. on the corner of Lamparilla, Old Havana {JL}

of Casilda to board the boat that would take them to their destination.[169]

The new features not only modified spaces and furniture. When the dining room was moved from the second bay to the galleries, it became necessary to close the large arches supported by columns or pillars, or the spaces between the wooden posts. The solution came in the form of "French" shutters, which protected the dining room from the sun and rain while providing the necessary coolness and shade (Fig. 60).

[169] The importance of the Cuban community in the United States, in particular in nineteenth-century New York, is highlighted by Lisandro Pérez in *Sugar, Cigars & Revolution: The Making of Cuban New York*.

Shutters closed balconies in which the balusters were not a Mudejar interpretation of Renaissance stone balusters, but wooden reproductions in the neoclassical style. Shutters came in the form of fan-shaped blinds (Fig. 61) or glass fanlights; the construction of these elements is well documented in manuals published in the United States, and their use is a distinctive feature of the Greek Revival house in the U.S. But unlike the North American fanlights made of transparent glass, our fanlights introduced color, which gave rise to one of the most beautiful expressions of Cuban architecture (Fig. 62).

The doors abandoned the old boards "in the Spanish style" and were made of rect-

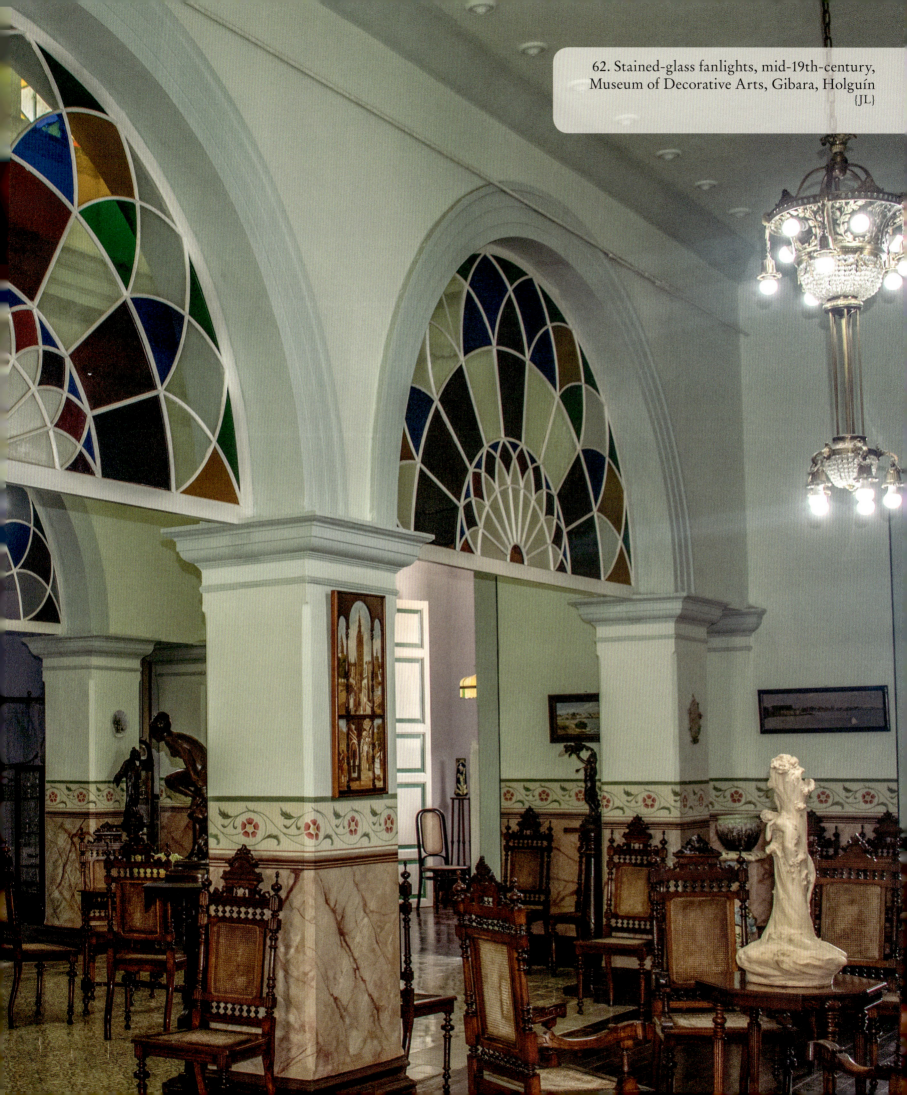

62. Stained-glass fanlights, mid-19th-century, Museum of Decorative Arts, Gibara, Holguín
{JL}

angular panels, in some cases, artificially stained to imitate the grain of European woods, as was popular in North American neoclassical environments. The dividing walls adopted the construction method known as "American-style plastering," which consisted of placing thin wooden slats between wooden supports, covered with the appropriate plaster. This was an absolute novelty for Cuban builders. Brick, in perfect alignment, was the predominant material in buildings that were built in the "American style." The openings were complemented with the typical molded wood trimmings topped with a circle in the manner of a patera—as pointed out by Asher Benjamin—[170] a decoration that was also used on the simulated wooden entablatures of the dwelling house of the Buena Vista sugar mill (1835), one of the earliest examples of a courtyard house with attached garden in Cuba (FIG. 63), possibly built by the same American architect who built the now lost Béquer Palace (1831).[171] Buena Vista, drawn by Eduardo Laplante as a white villa in the Palladio style, was situated on a prominent elevation and surrounded by an impressive garden that descended from the top to the ground. The house was organized around a paved courtyard. In the city, Carmen Malibrán's house has an extraordinary courtyard garden, fortunately well preserved, as well as the neo-Gothic wooden arch that divides the living room from the *saleta* of the house, which is also connected to this courtyard garden, owned by her niece Nicolasa Sanchez.

These innovations were not exclusive to the houses in the city of Trinidad. Santiago de Cuba is the best "traditional" example, with houses in the historic center featuring front spaces with double parlors, very similar to those in Puerto Rico and other Caribbean islands, with their corresponding wooden decorations. Also outstanding are the ones from faraway Baracoa, which show a similarly strong "Caribbean" influence (FIG. 64). In Santiago de Cuba, the houses followed the traditional party wall style of the Spanish urban grid, with some having balconies/galleries/corridors/porches in front. Their origin and layout have not been historically studied[172] despite the enormous interest they hold given that different traditions come together in these examples—the Spanish tradition and the one derived from the North American neoclassical style, thus identifying it as a "Caribbean" model. In Baracoa, corridors were attached to the façades, some of them resembling low balconies like the

[170] During a visit to Trinidad in the company of the American historian Robert S. Gamble, he pointed out the importance of the manuals published in the United States between 1825 and 1855 regarding the generalization of neoclassical decorative motifs. Gamble was kind enough to send me photocopies of Benjamin's and Lafever's books and commented in a letter: "In my own research in the Gulf of Mexico region, I have seen a direct correlation between the stylistic changes in details (frames, moldings, etc.) and the advent of certain manuals that enjoyed great popularity. . . . Both new and remodeled houses exhibited the same trend. In the vast majority of cases, the designs were not copied exactly. They almost always show some change that distinguishes them from their prototype." Letter from Robert S. Gamble to Alicia Garcia Santana, August 1, 1985. From the author's archives.

[171] We believe that the North American architect who built both buildings was Guillermo Hagner, who had been living in the city of Trinidad,

Cuba, since 1829, but we have not been able to document this.

[172] The Provincial Historical Archive of Santiago de Cuba has been closed for years.

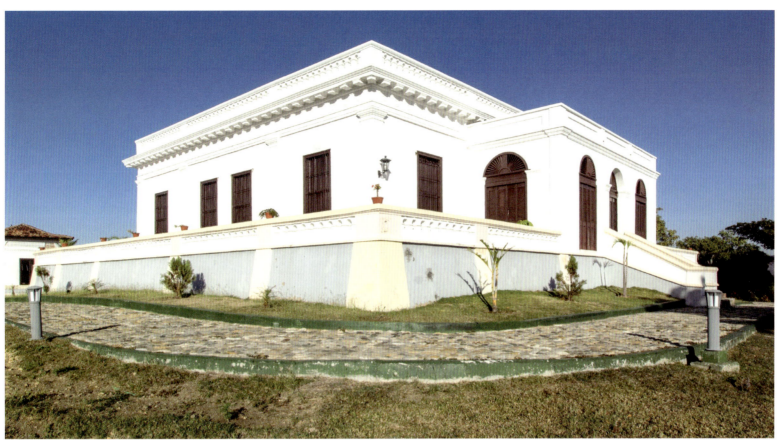

63. Dwelling house, Buena Vista Sugar Mill (1835), Valle de los Ingenios, Trinidad {Photo by Carlos García Santana}

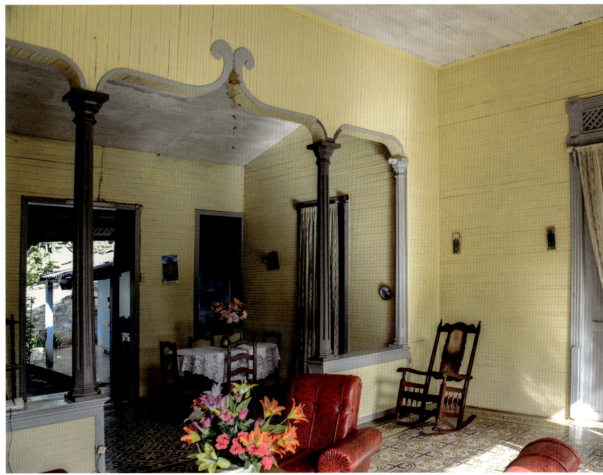

64. Living room and *saleta* of the house on 20 Maceo St. on the corner of Duany (1910), Baracoa {JL}

Puerto Rican ones, but, in general, they rejected party walls with a narrow space separating one house from another.

While it is not possible to list all the Cuban examples, we cannot fail to mention those from Cienfuegos, an important sugar port linked to railroad construction projects, one of the most notable ways of renovating the country's architecture because these works involved the participation of outstanding architects and engineers whose achievements would be reflected in urban planning and architecture. Cienfuegos stands out for its "French-style" grid plan, with corridors attached to the façades similar to those in New Orleans—a layout that unfortunately was not made mandatory—and its villa-houses with three parallel bays, a lateral courtyard garden and porches with linteled columns on the façades, with the second floor set back from the line of the façade, in the unique manner of *casas-quintas* (FIG. 65). It became necessary to open connecting arches between one bay and the other, giving rise to the spatial transparency that characterizes Cuban houses in the second half of the nineteenth century.[173] On a city scale, these houses represented the disappearance of the traditional textures of sloping roofs, which were replaced by the sleek image of well-proportioned and correctly finished geometric structures.

Lastly, in Havana, the "novelties" surfaced around the same time. As the city grew beyond the limits of its walls, it took over the area outside the walls that had been spontaneously populated in previous centuries. An attempt was then made to achieve a different dimension of space by locating buildings on larger plots of land, in contact with nature and in contrast to the existing overcrowding within the city walls. Military engineers led projects that sought to give the new districts a sense of unity, of unquestionable neoclassical inspiration. The use of porticos was recommended as a link between the house and the street, as well as an element of urban ornamentation. Porticos, which attained notable significance in the main thoroughfares of the area we now call Centro Habana, had already been mentioned in the first plan for the expansion of the city drawn up by Havana native Antonio María de la Torre in 1817.

Outside the city walls, a new type of house emerged in Havana: the *casa-quinta*, a Creole interpretation of the American cottage, with gardens all around, in response to the new lifestyles brought about by the rise in education and the refinement of customs. Homeowners sought to be in touch with nature and to isolate themselves while socializing with people of the same social and economic status. Heat, cholera and yellow fever also played a role in the search for environments that were considered healthier. Perhaps the first example of this type of house was the residence surrounded by beautiful gardens built in 1819, opposite the former Campo de Marte, by the illustrious Bishop Espada. Many travelers referred to it as the Jardines del Obispo (the Bishop's Gardens).

Miguel Tacón y Rosique, head of the Island's government from 1834 to 1838, had the Captain General's summer residence, known as Los Molinos, built in the

[173] See Alicia García Santana, "La vivienda en el siglo xix."

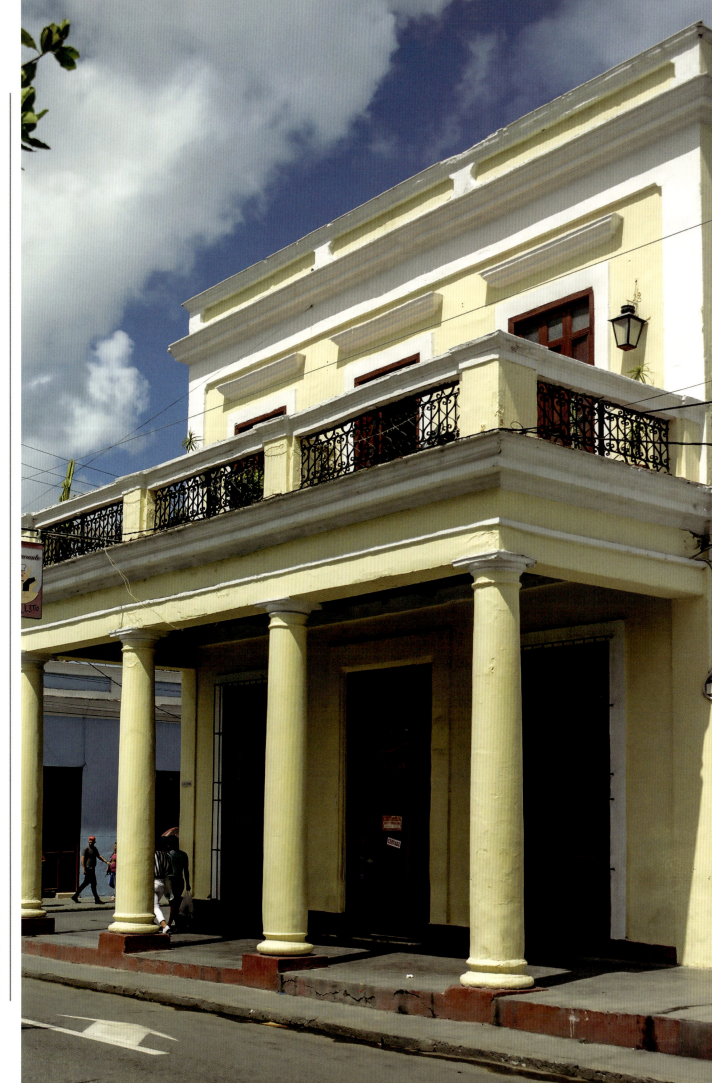

65. Home of José María Avilés y Dorticós (1860), on the corner of Prado and San Fernando, Cienfuegos
{JL}

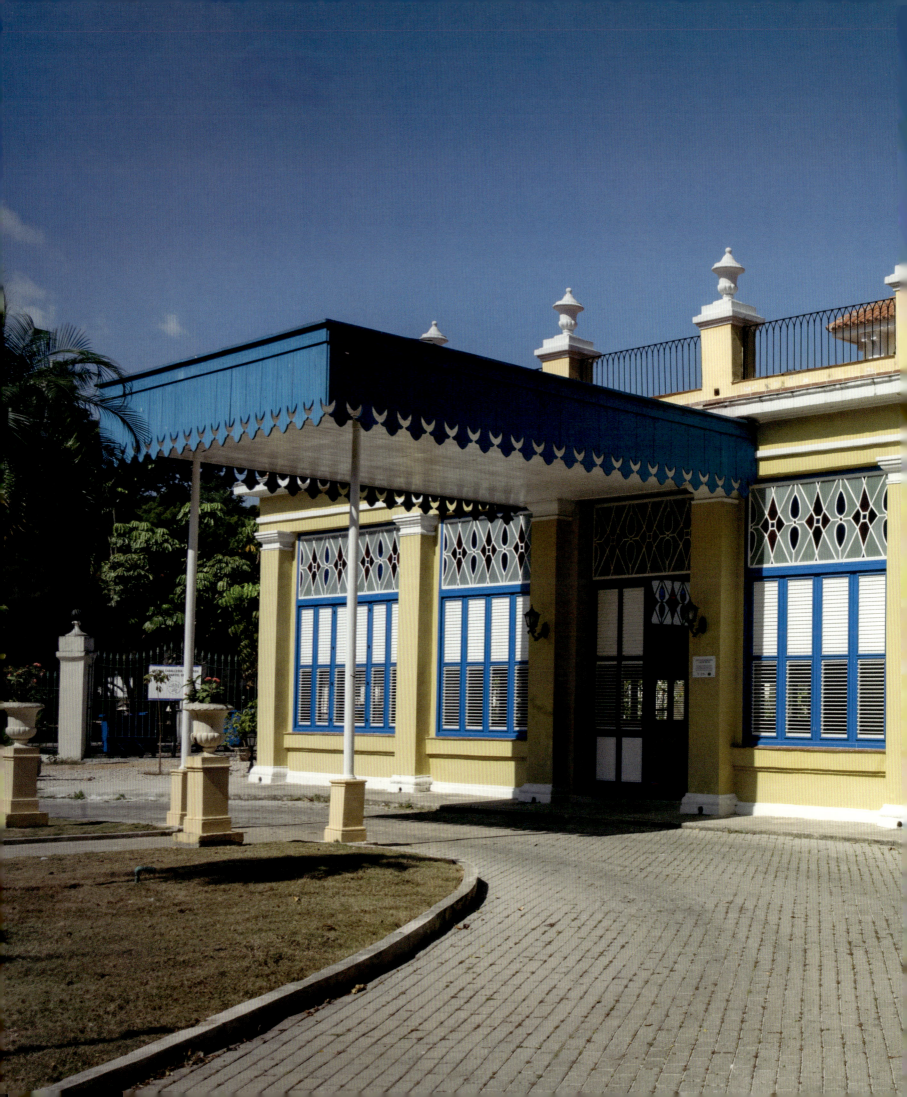

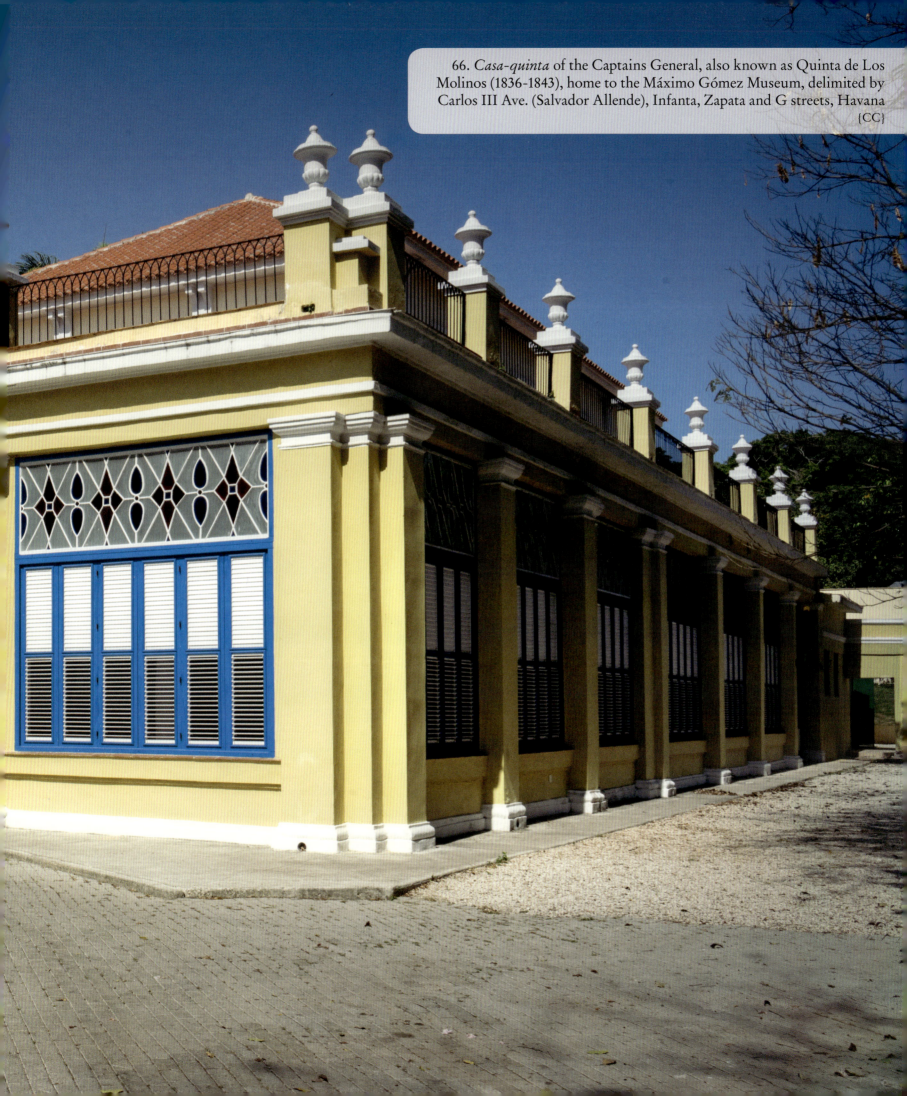

66. *Casa-quinta* of the Captains General, also known as Quinta de Los Molinos (1836-1843), home to the Máximo Gómez Museum, delimited by Carlos III Ave. (Salvador Allende), Infanta, Zapata and G streets, Havana {CC}

brand-new Paseo Militar, surrounded by lush gardens (FIG. 67). At that time, this type of house was common in the El Cerro district, where the Count of Fernandina's summer house, with its side portico resembling a Greek temple and its courtyard garden in full view of the public, separated from the street only by a low fence, must have caused a great deal of surprise. Together with the porches, the gardens were laid out at the front, back and/or sides. Some remarkable residences were

67. *Casa-quinta* of the Count of Santovenia (1832-1841), today operates as the Santovenia Home for the elderly, Calzada del Cerro and Patria Street, El Cerro, Havana {JL}

built with an interior courtyard in addition to the exterior courtyard garden, like the Santovenia, San José, Melgares and many other *quintas* (FIG. 69). The Spanish model of the compact layout was finally abandoned for the suburban garden city plan in the new housing development of El Vedado (1859/1860). José Jacinto Frías, Count of Pozos Dulces (1809-1877), an agronomist educated in the United States, was the mastermind behind the modern layout designed by engineer Luis Yboleón

Bosque in 1859/1860. The houses of El Vedado were built according to a uniform design—arcaded villas surrounded by gardens, the oldest ones with interior courtyards (FIG. 68).

By the second half of the nineteenth century, the prestige model of the Cuban house of that century had taken shape. At that point in history, its components had undergone a long process of evolution, from the moment when the Mudejar courtyard model was adopted, to its Creolization in response to the demands of colonial society and, finally, to its fusion with models from other cultural centers. It is not possible to understand the house without taking into account the interactions between them in that vast geographical-cultural environment that we call the Caribbean, nor, of course, the house in nineteenth-century Cuba, which we no longer call Creole, but simply Cuban.

68. *Casa-quinta* (1883), home to the National School of Ballet, 510 Calzada, between D & E streets, El Vedado, Havana {JL}

SOURCES CONSULTED

ACKERMAN, JAMES S. "Introduction." In *Sebastiano Serlio on Domestic Architecture. Different Dwellings from the Meanest Hovel to the Most Ornate Palace. The Sixteenth-Century Manuscript of Book VI in the Avery Library of Columbia University.* Foreword by Adolf K. Placzek. Introduction by James S. Ackerman. Text by Myra Nan Rosenfeld. New York: The Architectural History Foundation, 1978, 9-12.

ANCELET, BARRY JEAN, JAY D. EDWARDS AND GLEN PITRE. *Cajun Country.* Jackson, MS: University Press of Mississippi, 1991.

ARCHIVO MUNICIPAL. AYUNTAMIENTO DE SEVILLA. ÁREA DE CULTURA. "Ordenanzas de Sevilla de 1527." Facsimile reproduction of microfilm versions.

ARCHIVO NACIONAL DE CUBA. *Catálogo de los Fondos de Las Floridas.* Havana: Imprenta El Siglo XX, 1944.

ARNADE, CHARLES W. "The Architecture of Spanish St. Augustine." *The Americas*, vol. 18, no. 2 (October 1961): 149-186.

Arquitecturas de tierra en Iberoamérica. Compiled by Graciela María Viñuales. Buenos Aires: Impresiones Sudamérica, 1994.

BELTING, NATALIA MAREE. *Kaskaskia under the French Regime.* New Orleans: Polyanthos, 1975.

BENÉVOLO, LEONARDO. *Historia de la arquitectura moderna*, vol. 1. Havana: Instituto Cubano del Libro, 1968.

BENJAMIN, ASHER. *A Reprint of The Country Builder's Assistant, The American Builder's Companion, The Rudiments of Architecture, The Practical House Carpenter, Practice of Architecture.* Plates and Text Selected and Edited by Aymar Embury II, Architect. New York: The Architectural Book Publishing Company, MCMXVII.

————. *The American Builder's Companion or a System of Architecture Particularly Adapted to the Present Style of Building.* Boston: Published by R. P. & C. Williams, 1827.

Boletín del Archivo Nacional (Havana), vol. XLIII (January-December 1944): 1946.

BOND, STANLEY C., JR. "Tradition and Change in First Spanish Period (1565-1763) St. Augustine Architecture: A Search for Colonial Identity." Ph.D. dissertation. Albany: State University of New York, 1995.

BONET CORREA, ANTONIO ET AL. *Bibliografía de arquitectura, ingeniería y urbanismo en España (1498-1880),* 2 vols. Madrid: Turner Libros, 1980.

[BRYANT, WILLIAM CULLEN]. "Cartas de un viajero. Carta XLVI. La Habana." In "La Isla de Cuba en el siglo XIX vista por los

extranjeros." Translated by Luisa Campuzano. *Revista de la Biblioteca Nacional José Martí*, vol. 56, no. 1 and 2 (January-June 1965): 41-49.

BUISSERET, DAVID. *Historic Architecture of the Caribbean.* Portsmouth, NH: Heinemann International Litera, 1980.

Caminos españoles en La Florida. Edited by Ann L. Henderson and Gary R. Mormino. Sarasota: Pineapple Inc., 1992.

COKER, WILLIAM S. "La familia Moreno de la costa del Golfo." In *Caminos españoles en La Florida.* Edited by Ann L. Henderson and Gary R. Mormino. Sarasota: Pineapple Inc., 1992, 221-238.

CRUZ FREIRE, PEDRO. "La llave de Nueva España. Proyectos defensivos para los territorios de Luisiana (1770-1775)." https://ojs.uv.es/index.php/arslonga/article/view/11198/13012

Cultural Traditions and Caribbean Identity: The Question of Patrimony. Edited by S. Jeffrey K. Wilkerson. Gainesville, FL: Center for Latin American Studies, University of Florida, 1980.

DESMOULINS, MARIE-EMMANUELLE. *Basse Terre, patrimoine d une ville antillaise.* Avec la collaboration de Dominique Bonnissent, Hubert Maheux et Thomas Romon. Pointe-à-Pitre, Guadeloupe: Editions Jasor, 2006.

DOYON, GEORGES AND ROBERT HUBRECHT. *L'architecture rurale et bourgeoise en France.* Paris: Edité par Vincent, Fréal et Cie., MCMLXIX.

EDWARDS, JAY. *An Architectural History of the Property at 417-419 Decatur Street, in New Orleans.* The Jean Lafitte National Historical Park and Preserve. Manuscript copy. New Orleans, 1989.

_____. "Early Spanish Creole Vernacular Architecture in the New World and its Legacy." Manuscript in the archives of the Geography and Anthropology Department, Louisiana State University. Baton Rouge, 1993.

_____. "The Complex Origins of the American Domestic Piazza-Veranda-Gallery." *Material Culture*, vol. 21, no. 2. (1989): 3-58.

_____. "The Evolution of Vernacular Architecture in the Western Caribbean." In *Cultural Traditions and Caribbean Identity: The Question of Patrimony*, edited by S. Jeffrey K. Wilkerson. Gainesville, FL: Center for Latin American Studies, University of Florida, 1980, 291-339.

FERNÁNDEZ ÁLVAREZ, JOSÉ RAMÓN. *Las damas de La Habana y sus joyas. Un mito persistente en la historia de Cuba.* Miami: Ediciones Universal, 2015.

FRANCO, JOSÉ LUCIANO. *La batalla por el dominio del Caribe y el Golfo de México: Política continental americana de España en Cuba, 1812-1830.* Havana: Instituto de Historia, Academia de Ciencias, 1964.

_____. *Política continental americana de España en Cuba, 1812-1830.* Havana: Archivo Nacional de Cuba, 1947.

FRIOL, ROBERTO. "William Cullen Bryant." In "La Isla de Cuba en el siglo XIX vista por los extranjeros." *Revista de la Biblioteca Nacional José Martí* 56, no. 1 and 2 (January-June 1965): 37-39

Fuente, Alejandro de la. *Havana and the Atlantic in the Sixteenth Century.* With the collaboration of César García del Pino and Bernardo Iglesias Delgado. Chapel Hill: The University of North Carolina Press, 2008.

García Santana, Alicia. *Las primeras villas de Cuba.* Photographs by Julio Larramendi. Guatemala City: Ediciones Polymita, 2008.

———. "La vivienda en el siglo XIX." In Irán Millán Cuétara et al, *Cienfuegos, la perla de Cuba.* Photographs by Julio Larramendi. Guatemala City: Ediciones Polymita, 2019, 95-135.

———. *Los modelos españoles de la casa cubana*, vol. I. Photographs by Julio Larramendi and Carlos García Santana. Guatemala City: Ediciones Polymita, 2022.

———. *Matanzas, la Atenas de Cuba.* Photographs by Julio Larramendi. Guatemala City: Ediciones Polymita, 2009.

———. "Pedro de Medina y el barroco andaluz en La Habana de finales del siglo XVIII." *Quiroga, Revista de Patrimonio Iberoamericano*, no. 5 (January-June 2014): 60-73.

———. *Trinidad de Cuba. Ciudad, plazas, casas y valle.* Havana: Consejo Nacional de Patrimonio Cultural, 2004.

———. *Urbanismo y arquitectura de La Habana Vieja, siglos XVI al XVIII.* Havana: Ediciones Boloña, 2010.

Gasparini, Graziano and Luise Margolies. *Arquitectura popular de Venezuela.* Caracas: Armitano, 1986.

Gibson, Annie McNeill, Case Watkins, James Chaney and Andrew Sluyter. "Vínculos históricos entre Nueva Orleáns, Luisiana y Cuba." http://scielo.sld.cu/pdf/uh/n283/uh04283.pdf

Gjessing, Frederik et al. "Evolution of the Oldest House." *Notes in Anthropology*, vol. 7. Tallahassee: Florida State University, 1962

Gold, Robert L. *Borderland Empires in Transition. The Triple-Nation Transfer of Florida.* Carbondale, IL: Southern Illinois University Press, 1969.

Green, Patricia E. *The Evolution of Jamaican Architecture 1494 to 1838.* Master's Thesis. Philadelphia, University of Pennsylvania. https://core.ac.uk/download/pdf/76382144.pdf

Griffin, John W. and Manucy, Albert. "The Development of Housing in St. Augustine to 1783." In *Evolution of the Oldest House. Notes in Anthropology*, vol. 7. Tallahassee: Florida State University, 1962, 3-19.

Harper III, Robert W. and Rebecca Yerkes Rogers. *Ximenez-Fatio House.* National Society of Colonial Dames of America in the State of Florida, 1993.

Herman, Bernard L. *Town House: Architecture and Material Life in the Early American City, 1780-1830.* Chapel Hill: University of North Carolina Press for the Omohundro Institute of Early American History and Culture, Williamsburg, Va. 2005.

Hilton, Sylvia L. "El Misisipi y La Luisiana colonial en la historiografía española, 1940-1989." *Revista de Indias*, vol. 50, no. 188 (1990: 195-212. https://revistadeindias.

revistas.csic.es/index.php/revistadeindias/article/view/1139/1213

Isla de Cuba pintoresca. Havana: Litografía de la Real Sociedad Patriótica, 1839-1842.

James, Warren A. "Notas para una arquitectura de transición." *Plástica, Revista de la Liga de Arte de San Juan*, year 8, vol. 2, no. 15. (September 1986): 5-11.

Jopling, Carol F. *Puerto Rican Houses in Sociohistorical Perspective.* Knoxville: The University of Tennessee Press, 1988.

Kalman, Harold. *A Concise History of Canadian Architecture.* Toronto: Oxford University Press (Canada), 2000.

Labat, R. P. *Viajes a las islas de la América.* Selected and translated by Francisco de Oraá. Havana: Casa de las Américas, 1979.

Lafever, Minard. *The Beauties of Modern Architecture.* New York: Da Capo Press, 1968.

_____. *The Modern Builder's Guide.* New York: Dover Publications Inc., 1969.

Le patrimoine des communes de la Martinique. Paris: Fondation Clément, 2014.

Les villes françaises du Nouveau Monde. Des premiers fondateurs aux ingénieurs du roi (XVIe-XVIIIe siècles) Paris: Somogy Éditions d'Art, 1999.

López Guzmán, Rafael. *Arquitectura mudéjar.* Madrid: Cátedra, 2016.

Malcolm, Heard. *French Quarter Manual. An Architectural Guide to New Orleans Vieux Carré.* New Orleans: Tulane School of Architecture, 1997.

Manucy, Albert. *The Houses of St. Augustine, 1565-1821.* Gainesville, FL: University Press of Florida, 1992.

Marco Dorta, Enrique. *Arte en América y Filipinas.* Madrid: Editorial Plus Ultra, 1958.

Martín Rodríguez, Fernando Gabriel. *Arquitectura doméstica canaria.* Santa Cruz de Tenerife: Editorial Interinsular Canaria S.A., 1978.

McAlester, Virginia and Lee. *A Field Guide to American Houses.* New York: Alfred A. Knopf, 1995.

Millán Cuétara, Irán et al. *Cienfuegos, la perla de Cuba.* Photographs by Julio Larramendi. Guatemala City: Ediciones Polymita, 2019.

Montequin, François-Auguste de. "El proceso de urbanización en San Agustín de La Florida, 1565-1821. Arquitectura civil y militar." *Anuario de Estudios Americanos*, no. 37 (1980): 683-647.

Morales Folguera, José Miguel. *Arquitectura y urbanismo hispanoamericano en Luisiana y Florida Occidental.* Foreword by Santiago Sebastián López. Málaga: Secretariado de Publicaciones de la Universidad de Málaga, 1987.

_____. "Fundación de ciudades en Luisiana y Florida con canarios en el siglo xviii." https://revistas.grancanaria.com/index.php/CHCA/article/view/7774/6761

_____. "Urbanismo hispanoamericano en el sudeste de los EE.UU. (Luisiana

y Florida). La obra del malagueño Bernardo de Gálvez y Gallardo (1746-1786)." *Castillo de España*, no. 93 (June 1987): 41-50. https://ceclmdigital.uclm.es/viewer.vm?id=0002831186&page=1&search=&lang=es&view=prensa

Morrison, Hugh. *Early American Architecture: From the First Colonial Settlements to the National Period.* New York: Dover Publications, Inc., 1987.

Nicolini, Alberto. "Sobre la arquitectura y el urbanismo iberoamericano." Lecture delivered at the Faculty of Architecture of Tucumán, Argentina, 1988.

Ortiz, Fernando. *Contrapunteo cubano del tabaco y el azúcar.* Introduction by Bronislaw Malinowski. Havana: Consejo Nacional de Cultura, 1963.

Ortiz Garay, Andrés. "El fluir de la historia. El río Mississippi: encrucijada de América." https://revista.correodelmaestro.com/publico/html5102015/capitulo2/el_fluir_de_la_historia.html

Oszuscik, Philippe. "Passage of the Gallery and Other Caribbean Elements from the French and Spanish to the British in the United States." *Pioneer America Society Transactions*, P.A.S.T., vol. 15 (1992): 1-14.

Parker, Susan Richbourg. "St. Augustine in the Seventeenth-Century: Capital of La Florida" *The Florida Historical Quarterly*, vol. 92, no. 3, Article 8 (2013): 554-575. https://stars.library.ucf.edu/cgi/viewcontent.cgi?article=4680&context=fhq

Pérez, Lisandro. *Sugar, Cigars & Revolution: The Making of Cuban New York.* New York: New York University Press, 2018.

Pérez de la Riva, Juan. *Los culíes chinos en Cuba.* Havana: Editorial de Ciencias Sociales, 2000.

Peterson, Charles E. *Colonial St. Louis: Building a Creole Capital.* Tucson: The Patrice Press, 1992.

_____. *Notes on Old Cahokia.* Cahokia, IL: Jarrot Mansion Project, Inc., 1999.

Pinon, Pierre. "Saint-Domingue: l île à villes." In *Les villes françaises du Nouveau Monde: Des premiers fondateurs aux ingénieurs du roi (XVIe-XVIIIe siècles)*. Paris: Somogy Éditions d'Art, 1999, 108-119.

Placer Cervera, Gustavo. *Ejército y milicias en la Cuba colonial.* Havana: Editorial de Ciencias Sociales, 2015.

Plástica, Revista de la Liga de Arte de San Juan, year 8, vol. 2, no. 15, (September 1986).

Prat Puig, Francisco. *El prebarroco en Cuba. Una escuela criolla de arquitectura morisca.* Havana: Burgay y Cía., 1947.

Préfontaine, Chevalier de. *Maison rustique, à l'usage des habitans de la partie de la France équinoxiale, connue sous le nom de Cayenne. Par M. de Préfontaine, ancien habitant, chevalier de l'Ordre de Saint-Louis, commandant de la partie du nord de la Guyane.* Paris: Chez Cl. J. B. Bauche, Libraire, 1763.

Prieto Rozos, Alberto. "Prólogo." In Gustavo Placer Cervera, *Ejército y milicias en la Cuba colonial.* Havana: Editorial de Ciencias Sociales, 2015, XIII-XVI.

Pumarada, Rafael. "Balcón, sala y comedor: la tipología de la vivienda en San Germán."

Plástica, Revista de la Liga de Arte de San Juan, year 8, vol. 2, no. 15, (September 1986): 68-72.

Reiff, Daniel D. *Houses from Books. Treatises, Pattern Books and Catalogs in American Architecture, 1738-1950: A History and Guide.* University Park, PA: The Pennsylvania State University Press, 2000.

Romero, José Luis. *Latinoamérica: las ciudades y las ideas.* Buenos Aires: Siglo Veintiuno Editores, 1986.

Schafer, Daniel L. "…not so Gay a Town in America as this…" 1763-1784. In *The Oldest City: St. Augustine, Saga of Survival.* Edited by Jean Parker Waterbury. St. Augustine, FL: St. Augustine Historical Society, 1983, 91-123.

Schoenauer, Norbert. *6.000 años de hábitat: De los poblados primitivos a la vivienda urbana en las culturas de oriente y occidente.* Barcelona: Editorial Gustavo Gili, S.A., 1984.

Sebastiano Serlio on Domestic Architecture: Different Dwellings from the Meanest Hovel to the Most Ornate Palace. The Sixteenth-Century Manuscript of Book VI in the Avery Library of Columbia University. Foreword by Adolf K. Placzek. Introduction by James S. Ackerman. Text by Myra Nan Rosenfeld. New York: The Architectural History Foundation, 1978.

Sledge, John, S. *An Ornament to the City: Old Mobile Ironwork.* Photography by Sheila Hagler. Athens, GA: The University of Georgia Press, 2006.

_____. *The Pillared City: Greek Revival Mobile.* Photography by Sheila Hagler. Athens, GA: The University of Georgia Press, 2009.

Smith, Sidney D. *Descendants of John Mendall, Sr. (ca. 1638-1720) of Marshfield, Mass. (by ca. 1660).* Baltimore: Gateway Press, Inc., 1984.

The Early Architecture of Charleston. Edited by Albert Simons, A.I.A., and Samuel Lapham, Jr., A.I.A. Columbia, SC: University of South Carolina Press, 1970.

The Majesty of Mobile. Text by Jim Fraiser. Photography by Pat Caldwell. Foreword by John Sledge. Gretna, LA: Pelican Publishing Company, 2012.

"Thematic Group Creole and Gulf Cottages in Baldwin County." Document prepared by John S. Sledge. National Register of Historic Places. Inventory–Nomination Form, Alabama Historical Commission, Mobile, 1987. https://npgallery.nps.gov/NRHP/GetAsset/NRHP/64000012_text

The Oldest City: St. Augustine, Saga of Survival. Edited by Jean Parker Waterbury. St. Augustine, FL: St. Augustine Historical Society, 1983.

Torres Balbás, Leopoldo. "De algunas tradiciones hispanomusulmanas en la arquitectura popular española." In *Al-Ándalus*, vol. 2. Madrid: Instituto de España, 1947, 415-417.

Tratado de fortificación, ó Arte de construir los edificios militares, y civiles / escrito en ingles por Juan Muller; traducido en castellano, dividido en dos tomos […] por […] Miguel Sanchez Taramas […], vol. 1. Barcelona: Thomas Piferrer, 1769.

Trull Ródenas, Antonio. "Análisis y comparativa. Arquitectura popular inglesa y arquitectura popular del arco mediterráneo de España." Undergraduate thesis. Escuela

Técnica Superior de Gestión en la Edificación, Universidad Politécnica de Valencia. Tutor: José Miguel Sanchis. https://riunet.upv.es/bitstream/handle/10251/60628/Trull%20R%c3%b3denas%20Antonio_An%c3%a1lisis%20y%20comparativa.%20Arquitectura%20popular%20inglesa%20y%20arquitectura%20popular%20del%20arco%20mediterr%c3%a1neo_Memoria.pdf?sequence=1&isAllowed=y

Van Norman William C., Jr. *Shade-Grown Slavery: The Lives of Slaves on Coffee Plantations in Cuba.* Nashville: Vanderbilt University Press, 2012.

Voyages dans l'intérieur de la Louisiane, de la Floride occidentale, et dans les isles de la Martinique et de Saint-Domingue pendant les années 1802, 1803, 1804, 1805 et 1806. Contenant de nouvelles observations sur l'histoire naturelle, la géographie, [...] et les maladies de ces contrées [...] Suivis de la flore louisianaise. Avec une carte nouvelle, gravée en taille-douce. Par C.C. Robin. Tome I. Paris: Chez F. Buisson, Libraire, 1807.

Waselkov, Gregory. "French Colonial Archaeology at Old Mobile: An Introduction." *Historical Archaeology*, vol. 36, no. 1. Philadelphia: Society for Historical Archaeology, 2002, 3-12.

──────────. *Old Mobile Archaeology.* Tuscaloosa: The University of Alabama Press, 1999.

Waterbury, Jean Parker. "The Castillo Years, 1668-1763." In *The Oldest City: St. Augustine, Saga of Survival.* Edited by Jean Parker Waterbury. St. Augustine, FL: St. Augustine Historical Society, 1983, 57-89.

──────────. *The Gonzalez-Alvarez Oldest House: The Place and its People.* St. Augustine, FL: St. Augustine Historical Society, 2000.

Zéndegui, Guillermo de. "Panorama histórico a modo de preámbulo." In *Catálogo de los Fondos de Las Floridas*, Archivo Nacional de Cuba. Havana: Imprenta El Siglo XX, 1944. v-x.